GIRLS WILL BE BOYS

GIRLS WILL BE BOYS

Cross-Dressed Women, Lesbians, and American Cinema, 1908–1934

LAURA HORAK

RUTGERS UNIVERSITY PRESS
New Brunswick, New Jersey, and London

Library of Congress Cataloging-in-Publication Data
Horak, Laura.
 Girls will be boys : cross-dressed women, lesbians, and American cinema, 1908–
1934 / Laura Horak.
 pages cm
 Includes bibliographical references and index.
 ISBN 978–0–8135–7483–7 (hardcover : alk. paper)—ISBN 978–0–8135–7482–0
(pbk. : alk. paper)—ISBN 978–0–8135–7484–4 (e-book (epub))—ISBN
978–0–8135–7485–1 (e-book (web pdf))
 1. Motion pictures—United States—History—20th century. 2. Male imperson-
ators in motion pictures. 3. Lesbians in motion pictures. 4. Lesbianism in motion
pictures. 5. Sex role in motion pictures. I. Title.
 PN1995.9.I43H67 2016
 791.43′653—dc23
 2015012447

A British Cataloging-in-Publication record for this book is available from the British
Library.

Visit our website: http://rutgerspress.rutgers.edu

Manufactured in the United States of America

For Mom, Dad, Shana, Betty, and Gunnar

CONTENTS

ACKNOWLEDGMENTS

I have never met the person who first launched me on this project: Jaye Kaye. That marvelous individual ran the website "Jaye Kaye's Transgender Movie Guide," an enormous list of movies with "transvestite / cross-dressing / drag / transgender / transsexual" content. This website revealed to me the huge constellation of films that had gone missing from cultural memory. Sadly, the site was taken down in 2012, but it can still be accessed by typing the following URL into the Internet Archive's Wayback Machine: http://members.fortunecity .com/jayekayetv/tmovies/5.htm.

My research on cross-dressed women in the movies began years ago at Yale University. At Yale, I am grateful to John Mackay and Michael Raine, whose enthusiasm for film studies inspired me to change disciplines; to Laura Wexler and Jonathan Ned Katz, who introduced me to the temptations of the archive; to Graham Boettcher, who first pointed out that not many people had written about cross-dressed women in film; and to Charlie Musser, who persuaded me to spend spring break at the Library of Congress—a major turning point in my career. Thanks, too, to my high school teacher, John Wiser, who aroused my curiosity for history and encouraged me give a presentation to my ninth-grade class on the Stonewall riots.

This project came into its own at the University of California, Berkeley. Thank you to Mark Sandberg, who pushed me to formulate, test, and reformulate my conclusions; to Kristen Whissel, who had a knack for summarizing just what I was trying to say; to Linda Williams, who modeled the public engagement to which I aspire; and to Mel Chen, who encouraged me to ask different kinds of questions. Tony Kaes, Russell Merritt, and Anne Nesbet exemplified the joyful engagement with students, history, and old films that make me glad to be a scholar. Susan Stryker guided my thinking in important ways. Maxine Frederickson was a source of strength and calm.

For their laughter, support, and intellectual provocation, I am grateful to Robert Alford, Nicholas Baer, Michelle Baron, Doug Cunningham, Amanda Doxtater, Patrick Ellis, Kris Fallon, Christopher Goetz, Sanjay Hukku, Anupama Kapse, Dean Krouk, Erica Levin, Kristen Loutensock, Jennifer Malkowski, Kate Mason, Rielle Navitski, Megan Pugh, Althea Wasow, Ashley White-Stern, Allen Young, and Damon Young. Special thanks to Jen and Michelle for keeping me on track; to Amanda, Dean, and Allen for feedback on my chapters; and to Nick for always being willing to talk through an argument. Thanks also to Kaizar

Campwala, Joel Chaidez, Maria Gould, Ethan Guillen, Luke Habberstad, Jon Lehman, Emily Teitsworth, and Nadia Sussman for pulling me back into the world outside of higher education.

I revised this manuscript during a post-doc at the Department of Media Studies at Stockholm University. Thanks to the American-Scandinavian Foundation and Stockholm University for funding my stay. In Stockholm, I thank Sofa Bull, Anne Bachmann, Kim Fahlstedt, Joel Frykholm, Katariina Kyrölä, Christopher Natzén, Ingrid Ryberg, Ashley Smith, Nadi Tofighian, and Malin Wahlberg. Thanks, also, to Dagmar Brunow, Åsa Burman, Elefteria Olsson, Kalle Röcklinger, and Annamari Vänskä. Doron Galili and Margaret Hennefeld provided incisive feedback on this work in its final stages.

Now that I am at Carleton University, I thank my writing group, Laura Banducci, Rena Bivens, Amrita Hari, Irena Knezevic, Merlyna Lim, Megan Rivers-Moore, and Benjamin Woo, for providing the carrots and sticks that inspired me to complete this book.

My work has benefited from regular conversations with Richard Abel, Jennifer Bean, Charlie Keil, Shelley Stamp, and Patricia White. Thanks, too, to the many people who sent me additional titles and information, including Mark Lynn Anderson, Robert Birchard, Rob Byrne, Mark Garrett Cooper, Allyson Field, Jane Gaines, Jenny Horne, Rob King, Jenni Olson, and the folks at Nitrate-Ville and the Association of Moving Image Archivists. My work has also been improved by the feedback I've received at meetings of Women & the Silent Screen, Domitor: The International Society for the Study of Early Cinema, the Berkeley Conference on Silent Cinema, and the Society for Cinema and Media Studies.

I am particularly thankful for the archives that are doing the important work of preserving and sharing this material and to the archivists who lent their vast knowledge and research skills to my project. The institutions and their staffs include the Library of Congress Motion Picture, Broadcasting and Recorded Sound Division (especially Mike Mashon and George Willeman), UC-Berkeley Media Resource Center (especially Gary Handman and Gisèle Binder), UCLA Film and Television Archive (especially Mark Quigley, Jan-Christopher Horak, and Jeffrey Bickel), UCLA Performing Arts Special Collections (especially Diana King and Julie Graham), Margaret Herrick Library (especially Barbara Hall and Jenny Romero), Academy Film Archive (especially May Haduong), New York Public Library for Performing Arts (especially Steve Massa, who shared his personal collection of cross-dressing comedies with me), Museum of Modern Art (especially Charles Silver and Ashley Swinnerton), George Eastman House (especially Jared Case), EYE Film Institute Netherlands (especially Elif Rongen, who always goes above and beyond), British Film Institute (especially Kathleen

Dickson, Bryony Dixon, Rachael Keene, and Kelly Robinson), Archives Françaises du Film (especially Hermine Cognie), Bibliothèque du Film, Deutsche Kinemathek, Bundesarchiv-Filmarchiv (especially Wolfgang Schmidt, Maya Buchholz, and Ute Klawitter), Det Danske Filminstitut (especially Thomas Christensen), Svenska Filminstitutet (especially Jon Wengström), Cineteca di Bologna and Filmoteca Catalunya (especially Rosa Cardona). Thank you also to the folks at the online Media History Digital Library (particularly David Pierce and Eric Hoyt) and the Internet Archive (particularly Rick Prelinger) for making digitized material free and open to the public.

The UC-Berkeley Pacific Film Archive has been a particularly important source of support. The film curatorial staff answered last-minute research questions and gave me the opportunity to program a series on cross-dressed women in September 2007. Many thanks to Judy Bloch, Kathy Geritz, Nancy Goldman, Jonathan Knapp, Edith Kramer, Lucy Laird, Susan Oxtoby, Jason Sanders, and Steve Seid. Thanks also to the San Francisco Silent Film Festival for cultivating the love of silent film in this city and for welcoming me into the fold. Thanks, in particular, to Stacey Wisnia, Anita Monga, Rob Byrne, Jeremy O'Neal, and Lucia Pier, as well as Brian Darr, Richard Hildreth, David Kiehn, Shari Kizirian, and Margarita Landazuri.

For their help securing images, I thank Mark Lynn Anderson, Jeffrey Bickel, Robert Birchard, Cowan's Auctions, Nancy Duff, Jan-Christopher Horak, Mike Mashon, Louis Pelletier, Elif Rongen, Ned Thanhouser, and George Willeman. I am particularly grateful to Jason Bahling, who formatted, equalized, and arranged the images on a short deadline. For the financial support that made my archive visits possible, I thank Stockholm University, the Departments of Film and Media and of Women and Gender Studies at the University of California, Berkeley, and the Marshall Fishwick Travel Grant to Popular Culture Studies/American Culture Studies Research Collections.

I want to thank everyone at Rutgers University Press and also my anonymous reviewer, whose excellent advice I have done my best to follow. My editor, Leslie Mitchner, could not have been more enthusiastic or efficient. Many thanks to my copyeditor, Gretchen Oberfranc, for great suggestions and good catches. Thank you also to the University of Texas Press for permission to print a revised version of the article "Landscape, Vitality, and Desire: Cross-Dressed Frontier Girls in Transitional-Era American Cinema," published in *Cinema Journal* 52, no. 4 (Summer 2013): 74–98, and the University of Indiana Press for permission to reprint a significantly revised version of the chapter "Queer Crossings: Greta Garbo, National Identity, and Gender Deviance," which appeared in *Silent Cinema & the Politics of Space*, edited by Jennifer M. Bean, Anupama Kapse, and Laura Horak (Bloomington: Indiana University Press, 2014), 270–94.

I have dedicated this book to my parents, Fay and Stan, my sister, Shana, my grandma Betty, and my partner, Gunnar. Thank you Mom, Dad, Shana, and Grandma for your unfaltering love and support all these years. And thanks for taking me to the movies for as long as I can remember. Gunnar, I don't know how I would have finished this book without you. Thank you for your curiosity; for constantly telling me about all the films I still need to see; for reminding me that I can do it; and for your love.

GIRLS WILL BE BOYS

INTRODUCTION

Girls will be boys in the movies, as well as anywhere else.
—"THEY LOVE ACTING IN BOYS' CLOTHING,"
Manitowoc Daily Herald (August 24, 1917)

MARLENE DIETRICH LIGHTS a cigarette, straightens her bow-tie, and adjusts her top hat. Clad in a black tailcoat, she strides onto a modest stage. She is met with jeers. While she waits for quiet, the camera lingers on her sculptural face, sharply drawn eyebrows, and ironic smile. She saunters over to the audience, leans on a railing, and begins to sing. After the song, she accepts champagne from a male admirer, then spies the man's date. She looks the woman up and down; the woman titters nervously. Dietrich plucks a flower out of the woman's hair, lifts it to her face and smells it, then leans down suddenly, takes the woman's chin in her hand and kisses her firmly on the mouth. The audience laughs and applauds, the woman hides her face in pleased embarrassment, and Dietrich smiles, sniffs the flower, and flicks the brim of her hat. Dietrich turns toward the audience and raises her hat, accepting the applause.

This scene from *Morocco* (Paramount, 1930) is one of the most famous cross-dressing scenes in cinema history. Queer viewers have embraced it as an isolated and cherished expression of lesbian desire and sensual androgyny.[1] Alongside Greta Garbo's cross-dressed monarch in *Queen Christina* (MGM, 1933/34) and Katharine Hepburn's cross-dressed con woman in *Sylvia Scarlett* (RKO, 1935/36), Dietrich's Amy Jolly is often characterized as one of the lone early representations of women cross-dressing and expressing desire for other women in American cinema.

Furthermore, the meaning of women dressing like men in these movies seems obvious. They are transgressive. They challenge patriarchy and the gender binary. Their clothing probably also signifies lesbianism, at least to those "in the know." Many viewers assume that the only way movies could represent

1

lesbianism back then was through masculine clothing. They also assume that neither cross-dressed women nor lesbians showed up much in American films.

As it turns out, none of these assumptions is true. Where previous accounts have identified only thirty-seven silent American films featuring cross-dressed women, I have discovered more than four hundred.[2] Far from being inherently transgressive, cross-dressed women in early twentieth-century America were associated with wholesome entertainment.

In the first part of this book I will show that the American moving picture industry used cross-dressed women in the 1910s to help the medium become respectable and appeal to audiences of all classes. Cross-dressed actresses embodied turn-of-the-century American ideals of both boyhood and girlhood. The second part of the book traces the emergence of lesbian representability in American popular culture between the 1890s and 1930s. Only in the late 1920s, in the wake of the multi-year censorship battles over the play *The Captive*, did codes for recognizing lesbians begin to circulate among the general public— codes that included, but were not limited to, male clothing. This development tarnished cross-dressed women's wholesomeness and inspired the first efforts to regulate cinema's cross-dressed women. It also established the transgressive meanings with which we are familiar today. This book ends where other accounts of cross-dressed women and lesbians in American cinema begin—with Dietrich, Garbo, and Hepburn.

Previous scholars have read representations of cross-dressed women as mirrors of their own concerns and identities. That is, feminist scholars have read cross-dressed women as feminists;[3] lesbian scholars have read them as lesbians;[4] and queer and postmodern scholars have read them as queer and postmodern.[5] Transgender scholars have considered cross-dressed individuals as examples of historical gender variance, though they usually stop short of claiming them as trans.[6] Indeed, the open meanings of cross-dressed women are a key part of their appeal. But scholars' interpretive zeal has obscured the ways that representations of cross-dressed women were understood at the time they were made and circulated. Reading cross-dressed women as embodiments of contemporary concerns flattens and sometimes misrepresents the cultural work that they were doing in their own times. While my interest in historical representations of cross-dressed women is inspired by my present-day experiences of gender and sexuality, in this project I have tried to stay open to what they meant in their own contexts. One of the surprising things I discovered was that cross-dressed women were not inherently subversive and were sometimes mobilized in support of nationalist, white supremacist ideologies. Rather than making abstract identitarian claims for these figures, this book explores the multiple, contradictory meanings attached to them, how these interpretations developed, and why they changed. Following the lead of transgender studies scholars, I attend to the diversity and

specificity of historical gender expressions rather than thinking of them as mere prototypes for later identity categories. As I will show, cross-dressing has never meant any one thing, and it is impossible to describe its meanings without examining specific cases and contexts.

Scholars have overstated the connection between female-to-male cross-dressing and deviant sexual identities during the first decades of the twentieth century. This tendency may arise because sexologists had already theorized the female "sexual invert" by 1870 (when "the homosexual [became] a species," according to Michel Foucault) and because male pansies were a recognized sexual type on late nineteenth-century New York streets, as George Chauncey has shown.[7] Lesbian historian Lisa Duggan has argued that the 1892 trial of Alice Mitchell for the murder of her female lover spread the concept of the "murderous mannish lesbian" around the country.[8] However, I found that none of these factors dominated public understandings of female-to-male cross-dressing during the 1910s and early 1920s. Instead, the long traditions of cross-dressing women in both performance and folklore largely determined how cinema's cross-dressed women were understood and framed them in a positive light.

If movies did not explicitly declare characters to be lesbians or inverts, how can we know when these meanings existed? Scholars have taken many approaches to detecting lesbians in historical material. Writer-activists like Vito Russo, Andrea Weiss, and others have scoured old films for anything that might be interpreted as gay or lesbian.[9] While valuable, these accounts tend to read historical representations in the light of today's codes and identities, instrumentalize gender nonconformity as a sign of homosexuality, and construct a progressive, continuous trajectory from the "bad old times" to the enlightened present. More recent attempts to "queer" historical texts also sometimes privilege today's codes and identity categories. This approach can distort the meanings these representations had in the past, as Sharon Marcus's remarkable re-reading of female friendship in Victorian England has shown. Women's passionate attachments to other women did not "queer" bourgeois heterosexual culture, Marcus argues, but were essential to its workings.[10] Scholars also sometimes investigate their own and contemporary artists' affective relationship to traces of the past and freely imagine past sexual subjectivities that evidence could never capture, a method Elizabeth Freeman has called "erotohistoriography."[11] These various approaches can be both intellectually and politically productive, but they also miss the opportunity to be truly surprised by a past radically different from the present, a past that might prompt us to imagine a radically different future.[12]

In this book, I take a cultural historical approach to understanding cross-dressed women and lesbians in American cinema. Of the 476 titles I discovered, I have viewed almost every one that is known to survive (around 200 films, some only in fragments). Most of these films can be seen only in archives scattered

around North America and Europe, though a handful are available on DVD and online. (I have listed the films and where they can be viewed in the appendix.) I also watched many other films of the period to get a sense of the formal and narrative norms. To comprehend these performances, I investigated how they functioned within multiple, concentric circles: (1) the formal, narrative, and generic strategies of the films themselves; (2) publicity material, newspapers, magazines, and censorship reports; (3) the broader horizon of representation in the United States, which included theater, vaudeville, dance, literature, and journalism; and (4) cultural debates over childhood, gender, health, sexuality, race, and American identity. Local and national newspapers proved particularly helpful in revealing what ordinary Americans were expected to understand. Scrapbooks, clippings files, and other collections held at archives were essential to my research, as were the digitized periodicals in the Media History Digital Library, the Library of Congress's Chronicling America, ProQuest's Historical Newspapers Database, and NewspaperArchive.com. By making millions of pages of local, community, and national newspapers and film magazines searchable, these digital collections allowed me to track films as they moved around the country and terms for lesbianism as they emerged and spread. This study takes as a theoretical foundation the idea that categories of gender and sexuality are historically constructed, changeable, and always under contest, and that they are intimately intertwined with politics, economics, and aesthetics. Mass media like cinema not only reflect common understandings but also act on them.

Because we cannot assume, a priori, that cross-dressing was viewed as a sign of lesbianism or sexual inversion, I instead looked for instances in which cross-dressing aligned with other narrative, formal, and intertextual signs of lesbianism or inversion. I also searched for instances in which critics and censors named characters as lesbian or inverted, either directly or by using established codes. This approach allows us to trace when and where lesbianism achieved mass legibility (and, conversely, when and where it was obscured). While I recognize that individuals' ability to "read" lesbianism depended on many idiosyncratic factors, I use national, local, and community newspapers to gauge when journalists imagined that their readers could catch these references. This approach admittedly prioritizes the understandings of the general public over those of lesbians and inverts themselves. However, when mass legibility emerged, it must have profoundly affected the lives of lesbian and inverted individuals; they found themselves under new surveillance, but also with new capacities to recognize each other and build far-flung communities.

COMPETING FRAMEWORKS

To understand the cultural work done by cross-dressed women in the early decades of the twentieth century, we need to acquaint ourselves with the competing frameworks that were available for understanding them at the time. In the past, scholars have overemphasized spheres in which cross-dressing was understood to be disreputable, like the anti-suffrage movement and sexology, and underemphasized those in which it was regarded as wholesome, like theater, folklore, and the physical culture movement. Likewise, scholars have read cross-dressed women as embodiments of new types, such as the female invert, the mannish lesbian, and the New Woman, but these were not, in fact, dominant readings of these representations at the time.

It has been common to interpret early twentieth-century representations of cross-dressed women as vicious parodies of the women's movement.[13] From the mid-seventeenth through the early twentieth centuries, women struggled to win the rights and privileges of white men—to vote, run for office, go to college, work, earn equal pay, hold property in marriage, and inherit property. Opponents ridiculed these demands as a desire to "become" men. Editorials, vaudeville acts, and early film comedies predicted that if women won the right to vote, they would soon sport men's clothing and even facial hair, and engage in working-class vices like gambling, drinking, and fighting.[14] (Men, on the other hand, would become vain, effeminate nursemaids.) Critics were only encouraged by feminist dress reformers like Amelia Bloomer, who in 1851 encouraged women to wear loose harem pants beneath shortened skirts, an outfit soon termed the "Bloomer costume." This was when the expression "to wear the pants" (or trousers or pantaloons) began to be applied to women who usurped their husbands' authority.[15] However, Bloomer and her circle abandoned the outfit after a few years, seeing it as a distraction from more important issues.[16] These types of representation did indeed frame women's usurpation of men's clothing as laughable, destructive, and even grotesque, but they were in the minority.

An even more disreputable framework for understanding cross-dressed women was the burgeoning field of sexology. In the decades around the turn of the century, medical researchers began to develop theories to explain the diverse bodies, desires, and behaviors they encountered in their clinical practice. One key theory was "sexual inversion," which interpreted same-sex attraction, cross-gender identification, and ambiguously gendered bodies as symptoms of a single basic pathology. Austro-German sexologist Richard von Krafft-Ebing famously characterized female inverts as possessing a "masculine soul, heaving in the female bosom."[17] Though Krafft-Ebing warned physicians to suspect inversion in the cases of women "who dress in the fashion of men," the British sexologist Havelock Ellis disagreed: "[A] woman who is inclined to adopt the ways and garments of men

is by no means necessarily inverted."[18] Also, Krafft-Ebing, Ellis, and other research-
ers acknowledged that some women who had sex with women had no trace of mas-
culinity. Sexologists disagreed about almost every aspect of inversion—whether
the condition was physiological or psychological, innate or acquired, degenerate
or benign, and what subcategories might exist. It is important not to regard inverts
as simply "mannish lesbians."[19] Various people who were called invert at that time
might today identify as transgender, transsexual, transvestite, genderqueer, or
intersex, as the transgender studies scholar Jay Prosser reminds us.[20]

Gender historian Carroll Smith-Rosenberg has argued that sexologists used
inversion to discredit politicized women.[21] American physician William Lee
Howard, for example, declared "the female possessed of masculine ideas of inde-
pendence" to be "that disgusting antisocial being, the female sexual pervert."[22]
However, Smith-Rosenberg fails to acknowledge that Howard was an extrem-
ist in the medical community, described as "an eccentric, irresponsible charac-
ter" in the 1928 *Dictionary of American Medical Biography*.[23] Furthermore, most
sexological literature was not readily accessible to the American public. It was
published in expensive editions, sometimes required a degree to buy, and often
used Greek and Latin. While Lisa Duggan has found that American journalists
did refer to theories of sexual inversion when reporting on the 1892 Alice Mitch-
ell trial, I found that newspapers did not continue to circulate these theories.
In chapter 3, I show that after the 1890s, sexual inversion theory receded from
mass-market periodicals until the mid-1920s. The specter of sexual inversion did
not haunt the cross-dressed women of cinema's first decades.

Inversion theory competed with other ways of understanding same-sex
desire. Already by the seventeenth century, the terms "Lesbian love" and
"Sapphism" were used to describe sex acts between women.[24] These acts
were often believed to be caused by hypersexuality or boredom, to which
actresses and prostitutes were often prey. Same-sex desire was also concep-
tualized as an eroticized mother-daughter or sisterly relationship.[25] Some
described women who sought sex with women as masculinized, but this was
not their defining feature, as it was in inversion theory. In the nineteenth
century, educators and parents even encouraged passionate attachments
between young women as a salutary preparation for marriage. Inversion
theory did not stamp out these alternative understandings. By the time film
came along, sex between women was not discussed publicly (as it had been
in revolutionary France, for example), and some writers assumed that most
Americans had never heard of it. When American cinema first began to rep-
resent female same-sex desire in the 1920s, it invoked multiple, competing
concepts, not only sexual inversion. The sign of masculinity was only some-
times used.

The anti-suffrage movement, sexual inversion theory, and lesbianism pro-
vided frameworks for reading cross-dressed women as disreputable. However,

many other contexts positioned cross-dressed women positively. Because most early filmmakers and actors came from theater, the stage set the most important precedent for cross-dressing in cinema. Theater critics writing about the latest actress to cross-dress on stage often reminded their readers of the long and esteemed lineage of this practice (fig. 1). In a series of articles with titles like

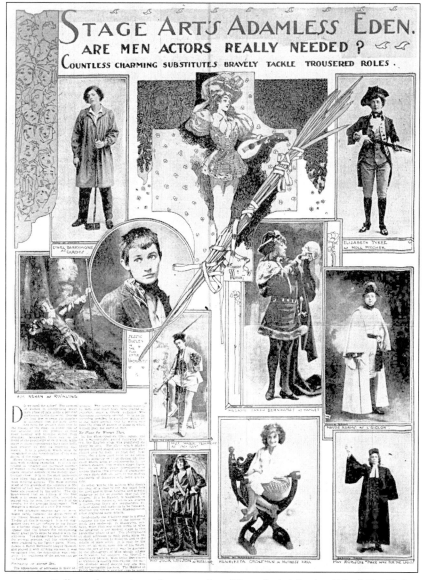

FIGURE 1. Collage of cross-dressed actresses from "Stage Art's Adamless Eden," *New York Herald* (July 10, 1904).

"When Stage Beauties Have Donned Manly Attire," journalists recounted the many cross-dressed women in chivalric romances and baroque dramas (like Shakespeare's *As You Like It* and *Twelfth Night*), as well as the names of actresses who had played male and gender-disguise roles.[26] The *Baltimore Post* claimed that "every famous actress from the days of [Mary] Betterton [ca. 1637–1712] to the present day has donned the doublet and hose."[27] Critics reminded readers of stars like the British Peg Woffington, who played the comic libertine Sir Henry Wildair in *The Constant Couple* for seventeen years starting in 1740, and the American Charlotte Cushman, who earned a cult following for her Romeo performances in the 1840s. Journalists also recalled the actresses who played prankster boys and vulnerable orphans, the singing and dancing cross-dressed women of burlesque and musical theater, and the male impersonators of vaudeville. English impersonators like Vesta Tilley and Ella Wesner imparted a sense of class to vaudeville as they showed off London fashions and performed gentlemanly types.[28] At the turn of the century, "the Divine Sarah" Bernhardt had undertaken three adolescent boy roles—Lorenzaccio, Hamlet, and l'Aiglon—at the age of fifty. Critics were divided about her performances (it was no longer in fashion for grown women to play boy roles), but audiences loved them. Then, in 1905, Maude Adams became America's first Peter Pan. Adams toured the country as Peter for over ten years and became, according to one scholar, the "most famous American actress of her generation" and the wealthiest.[29] By 1909, the *Chicago Daily Tribune* could declare that it was "so common for the stage heroine to turn herself into a stage hero that the sensation of seeing a favorite star in the role of a boy cannot any longer be called a sensation."[30] Onstage, women played many different characters in a range of genres, and moving pictures initially picked up much of this variety.

With a few exceptions (which I discuss in the next chapter), cross-dressed stage performances were considered both respectable and wholesome. Though some cross-dressing actresses like Cushman and Adams had female lovers, this information did not seem to circulate.[31] Furthermore, critics did not read these cross-gender performances as feminist or symbolic of the New Woman, and some actresses distanced themselves from these identities. In 1903, for example, actress Henrietta Crosman told a journalist that she recommended knickerbockers, but warned, "Don't laugh or get the impression that I am a 'new woman' or the originator of the dress-reform movement. I despise such things, but I do think [knickerbockers] would add to women's comfort and health."[32] Likewise, a profile of male impersonator Kathleen Clifford asked if she was "at all interested in suffrage" and then asserted that, on the contrary, "she is far too busy selecting clothes for the 'smartest chap in town,' and . . . looking after the most elaborate wardrobe owned by any vaudeville star to bother about such things as ballots. . . ."[33] The journalist framed Clifford's male clothing as an

extension of female consumerism rather than a symbolic entry into the political sphere. Most polemical was Vesta Tilley, who told the *Pittsburgh Gazette Home Journal*, "While my business is that of impersonating male characters, I heartily detest anything mannish in a woman's private life."[34] These performers may have distanced themselves from feminist politics for strategic reasons, but their statements show that cross-dressing should not be read as a simple feminist statement.

Just as familiar as the Anglo-American theatrical tradition of cross-dressing were American folkloric accounts of individuals assigned female at birth who lived as men. (I use the term female-bodied man rather than passing woman to describe historical individuals in order to respect the publicly claimed gender. I explain this choice later on.) Cowboy songs, chapbooks, memoirs, and dime novels told stories of women who assumed male guise to seek their fortune, go to war, or enact revenge. One popular genre described the experiences, real and invented, of women fighting as soldiers in the Revolutionary and Civil Wars. Additionally, American newspapers regularly pointed out people believed to be male who were discovered to have female bodies. These individuals justified their choice by pointing to men's higher wages, freedom of movement, and safety from sexual predation. Journalists accepted their reasons and often sympathized with the so-called men-women.[35] There was little suggestion of pathology, even when the man-woman had married a woman. Journalists often contextualized these stories by listing other recent and historical cases.[36] The cross-dressed girl was a regular trope of the frontier, in particular, as Peter Boag has shown, which laid the groundwork for the frontier films I discuss in chapter 2.[37] Though cross-dressed women were considered endemic to the West, female-bodied men were in fact found throughout the country. While they may have been considered disreputable on an individual basis—after all, many areas had laws against cross-dressing—as a whole, they were praised as an expression of American vitality and self-inventiveness.

The physical culture movement was also a key framework for reading cross-dressed women. Concerned that Americans were becoming weaker and more anxious due to rapid industrialization and urbanization, an array of health reform movements championed exercise, sports, and engagement in the outdoors. Many reformers argued that traditional women's clothing was contributing to the nation's sickliness. Tight-laced corsets made it difficult to breathe and put pressure on internal organs. Low décolleté chilled the top of the body, while layers of petticoats overheated the bottom. Tight garters prevented circulation in the legs, and the sheer weight of the clothes (as much as twenty-five pounds) dragged at the body. Female water-cure physicians continued to develop, wear, and proselytize for women's trousers for decades after women's rights advocates like Bloomer had given them up.[38] By the end of the century, bloomers

had become standard attire for women in gym classes, calisthenics exercises, sports, mountaineering, and bicycling. While some traditionalists complained that these activities violated social decorum, physical culturists argued that only healthy women could mother strong, virile sons to lead the country and assert its dominant position in the world. Though the women's movement largely abandoned dress reform, the physical culture movement turned gym bloomers into women's patriotic duty.

Closely connected to this development was the rise of the tomboy. The 1860s through the 1930s was a golden era for tomboys in American literature.[39] Starting with Elizabeth Stuart Phelps's *Gypsy Breynton* (1866) and Louisa May Alcott's *Little Women* (1868), a cycle of novels celebrated outspoken and athletic girl protagonists. Tomboys embodied the ideals of the physical culture movement—strong, healthy, and wholesome—and stood against older ideas of womanhood as passive and decorous. However, there was a time limit to being a tomboy. The experience was intended to prepare girls for the duties of wife and mother, not offer an alternative to them. As literary scholar Michelle Ann Abate points out, many stories about tomboys are actually about taming tomboys— through life-threatening injury, heterosexual romance, or the strict discipline of urban relatives.[40] Tomboys were just as popular in movies as in literature. Many movie tomboys did not cross-dress, but most cross-dressed movie women were considered tomboys.[41] One journalist even called cross-dressing roles "tomboy roles."[42] Though tomboys defied norms of female conduct, they were innocent of sexuality and embodied American values like courage, loyalty, and forthrightness. They were the opposite of the vamp, who was sexually experienced, manipulative, and foreign. The contrast between wholesome tomboy and dangerous vamp begins to reveal why cross-dressed women were considered such a respectable influence on moving pictures.

Were cinema's cross-dressed women New Women? This label is the primary way silent cinema scholars have understood them.[43] Indeed, there is justification for this reading. Cinema scholars have characterized the New Woman as energetic, independent, and engaged in the world outside the home. Certainly some cross-dressed movie women displayed these characteristics. However, the equation of cross-dressed women with New Women is too simplistic. The first problem is that the term was applied to whatever commentators considered "new" about the way women lived their lives, which changed significantly over the years. Gender historian Martha H. Patterson observes that the New Woman could equally be a "degenerate highbrow, evolved type, race leader or race traitor, brow-beating suffragette, farmer, prohibitionist, mannish lesbian, college girl, eugenicist, savvy professional woman, barren spinster, club woman, saleswoman, restless woman, bicyclist, anarchist, or insatiable shopper."[44] The term was so vague that calling cross-dressed actresses New Women does not

tell us very much. Also, many versions of the New Woman looked very feminine, such as the Gibson girls of *Life* magazine, and thus were not connected to cross-dressing.

Another problem with calling cross-dressed women New Women is that moving pictures used cross-dressed women in ways that drew on centuries-old performance and storytelling traditions, and thus they were not particularly "new." Furthermore, I have not found a single review that characterizes a cross-dressed actress as a New Woman. Some even explicitly distinguished between wholesome cross-dressed performers and the New Woman.[45] Thus, while the popularity of cross-dressed women was surely connected to the social, economic, and political changes that sometimes went by the name New Womanhood, simply equating cross-dressed movie women with New Women prevents us from getting at their more complex cultural role. Cross-dressed women were about nostalgia at least as much as novelty.

In its first decades, American cinema looked to the cross-dressed women of theater, folklore, and the physical culture movement to appeal to diverse audiences. Critics praised these films as wholesome alternatives to violent and sexualized fare. Only at the tail end of the silent era did American cinema acknowledge a connection between cross-dressing and lesbianism. The mannish invert and the New Women are only part of the story of cross-dressed women in the early twentieth century. The more than four hundred films that I found tell quite another.

ROAD MAP

American films featuring cross-dressed women clustered in three distinct waves. Cross-dressed women began to show up in American cinema around 1908, when the industry undertook to improve its reputation and attract middle-class audiences. The first and biggest wave of cross-dressed women lasted from 1908 to 1921, a period that roughly corresponds to the transitional era (1908–1917), when American filmmaking shifted from an artisanal "cinema of attractions" to an industrial cinema of narrative integration.[46] The first wave continued several years past the supposed endpoint of the transitional era, revealing a certain continuity between this era and the next. The second wave of cross-dressed women lasted from 1922 to 1928, a period when film budgets grew ever larger, film stars ever more famous, and movie theaters ever more luxurious. The industry transitioned to synchronized sound between 1927 and 1930, which is also when the second wave gave way to the third, which stretched from 1929 to 1934. This final wave coincided with the so-called pre-Code era, when Hollywood films toyed with taboo subjects, and ended in 1934, the year the Production Code began to be enforced more strictly.[47]

The three sections of this book do not map directly onto the three waves. Part I explores the first wave of cross-dressed women in American cinema, which was dominated by wholesome interpretive frameworks. An Intermezzo looks back to the late nineteenth century to see what codes for sexual deviance existed when moving pictures emerged and why American cinema's cross-dressed women were not suspected of deviance during the medium's first decades. Part II analyzes the second and third waves, when wholesome meanings vied with more transgressive ones and American cinema helped circulate codes for lesbianism. Overall, the book traces the role of cross-dressed women and lesbians in American cinema and how cinema helped to shift the meanings of these figures.

As shown in Part I, the characters played by cross-dressed women during the first wave embodied ideals of American boy- and girlhood. They were largely young, white, pre-sexual, and aligned with British and American entertainment. The industry used them to appease critics and attract diverse audiences. This first wave of films featuring cross-dressed women was by far the largest: more than 360 films (around three-quarters of the films examined in this book).[48] On average, American companies released 26 films featuring cross-dressed women every year.

These films differ from later cross-dressing films. Queer film scholar Chris Straayer argues that films in which a character temporarily disguises his or her gender, which she calls "temporary transvestite" films, have remarkably consistent generic conventions. The films are almost always romantic comedies and provide a narrative justification for gender disguise. The disguise is believable to other characters but not to viewers. Romantic encounters are mistakenly interpreted as homo- or heterosexual. The films end with a dramatic unmasking, followed by the formation of a heterosexual couple.[49] Straayer perceptively outlines the conventions of most contemporary cross-dressing films, but the temporary transvestite genre is both bigger and smaller than she contends. It is bigger because these rules also describe the gender disguise comedies of theater, which date back to the baroque era. It is smaller because it does not describe all types of cross-dressing on film, particularly those of this first wave. Straayer also observes that films rarely cast actors as characters of another gender; when that happens, she argues, it can spark radical gender and sexual effects.[50]

As it turns out, the majority of the first-wave films do not adhere to the rules of the temporary transvestite genre. A third of the films in this wave featured actresses playing boy roles. Moving pictures borrowed the convention from theater, so audiences did not find it surprising or disconcerting. While it did allow female bodies to represent idealized boyhood, audiences did not experience a radical unmasking of the gender system. Furthermore, in these cross-cast films, there was no narrative justification for the cross-dressing and no unmasking.

In some films, the gender disguise was entirely convincing to diegetic charac-
ters and film spectators alike. In at least one case, a critic referred to the young
performer as male. Another important difference is that only 30 percent of the
first-wave films were comedies; the other 70 percent were dramas and thrillers.
Thus, female-to-male cross-dressing was far more often associated with bravery
or tragedy in this period than laughter. More than half the films (around 60 per-
cent) did not include a romance and, thus, had no misleading romantic encoun-
ters or formations of heterosexual couples.

In Chapter 1, I analyze the ways that women in boy roles, which I call "female
boys," contributed to the effort to attract middle-class women to moving pic-
tures. While female boys had passed their heyday onstage, cinema adopted the
practice to assert its connection to genteel Anglo-American theater, a common
tactic of the "quality film" movement. According to sentimental ideals of child-
hood, girls and women made "better" boys than real boys could—more expres-
sive, more beautiful, more innocent, and more vulnerable. These types of boys
were imagined to appeal particularly to "Fauntleroy-crazed" mothers and grand-
mothers. The sentimental films in which they appeared demonstrated cinema's
potential for moral education.

Despite their prevalence and universally positive reviews, women in boy
roles declined precipitously after 1915. Though the most celebrated female boys
appeared in the 1920s, such as Mary Pickford's Little Lord Fauntleroy and Betty
Bronson's Peter Pan, they were the last gasp of a dying practice. Contrary to jour-
nalists at the time who claimed that women in boy roles disappeared due to cin-
ema's penchant for realism, I argue that female boy roles declined because of the
simultaneous ascendance of a "red-blooded" ideal of boyhood and a star system
that emphasized actresses' recognizability and attractiveness. Though post-1915
female boy films attempted to reconcile sentimental and red-blooded boyhood,
this goal was successfully accomplished only by a "real" boy, Jackie Coogan. In
the 1920s, actors like Coogan took over the boy roles formerly played by women
and girls.

And yet, female bodies were quite capable of expressing the red-blooded
ideal through cross-dressing cowboy girls and girl spies, as I discuss in chapter 2.
About a quarter of the female-to-male cross-dressing films of this first wave
were set on the frontier or battlefront. These films drew on American folklore
to appeal both to working-class dime novel readers and middle-class theater-
goers enamored of plays like David Belasco's *Girl of the Golden West*. Many of
the films centered on a dramatic, cross-dressed chase sequence, which showed
off a woman's physical vitality within the types of landscape that had mythi-
cally forged her. Disguised as men, white female characters could get into dan-
gerous situations and demonstrate their bravery, while their white and female
identity generated pleasurable anxiety for audiences who feared for their safety.

These dramas contrasted with comedies showing feminist ranch takeovers that used the dangers of frontier life to undo single-sex camaraderie in favor of heterosexual coupling. However, another set of films used cross-dressed women to address the erotic dangers of the homosocial frontier. Hardened frontier men avoided the temptation of coupling with non-white women, prostitutes, or other men by falling in love with a male companion who turned out to be an eligible white woman. Many of the films contrast white women's healthy, temporary appropriation of masculinity with black and Native women and Chinese men's unhealthy, intrinsic gender deviations.

Because frontier women often incorporated male garments and styles into their dress, it can be difficult to tell when women in frontier films dress "like men" or when they merely wear masculine-styled women's clothing. However, attending to this distinction helps us see when and how men's garments became acceptable garb for women. One of the effects of these films was to separate masculine styles from feminist politics and associate them with American vitality, paving the way for the fashion industry to adopt these styles. These first two chapters explore meanings of cross-dressed women that have receded from view and how these meanings were harnessed to the moving picture industry's pursuit of cross-class audiences.

Between 1908 and around 1915, the distance between camera and performer and the lack of a developed star system created the opportunity for particularly convincing performances of female masculinity. However, after 1915, closer camera distances and the burgeoning star system prompted filmmakers to emphasize movie actresses' femininity, even when cross-dressed. Women playing boy roles dropped off abruptly. Athletic female characters increasingly adopted masculine-styled women's clothing rather than male disguise. Films continued to feature cross-dressed actresses after 1915, but they were less convincing, less accomplished, and more often comedic. Their numbers also started to drop off, reaching a nadir between 1920 and 1923.

The Intermezzo and Part II investigate when and where cross-dressing was used to signify lesbianism and female inversion. They demonstrate the key role that the mass media played in conveying the codes for recognizing lesbianism from elite to popular audiences. The Intermezzo asks why lesbian and inversion were *not* the dominant ways of reading cross-dressed women during cinema's first decades, contrary to what many scholars have thought. Chapter 3 explores the relationship between cross-dressing and deviant identities by tracing the surprising reception of the novel, play, and film *A Florida Enchantment* (1892, 1896, 1914, respectively). By representing sexual inversion quite literally—characters swallow magic seeds that change their sex—*A Florida Enchantment* offers a useful limit case for gauging when and where viewers read cross-gender behavior and clothing as a symptom of pathological identity. While an elite few read the play's

characters as perverse, the film adaptation was received as a wholesome, family-friendly comedy. This discrepancy suggests that the tendency to read actresses who dressed and acted like men as sexual deviants did not become increasingly common after the 1890s, but receded for several decades. Whether or not a critic read the play as perverse was tied to contests over cultural hierarchy. Some New York critics declared that only "sophisticated" theatergoers educated in Roman history and criminology could understand the play's perversity, while others claimed that the elitist critics who objected to the play were themselves perverse. The reception history of this unusual work suggests that public recognition of cross-dressing as a symptom of pathology was tied not only to sexology or the backlash to the women's movement, but also to contests over cultural hierarchy. Because of film's lowly status, it was not suspected of encoding messages of sexual perversion during its first decades. This perception changed in the late 1920s, when the industry made a concerted effort to enlist mass audiences as "sophisticated" viewers, as I discuss in the last two chapters.

Part II explores the rise of trousers in women's fashion and increasing legibility of lesbianism in American cinema. These simultaneous trends informed the second and third waves of films featuring cross-dressed women. In contrast to the first wave, in which convincing cross-dressing was at odds with the burgeoning star system, during the 1920s, cross-dressing was incorporated into the star system as a way to inflect attractive femininity. Some actresses (like Anna Q. Nilsson and Marion Davies) played a series of cross-dressing roles. More controversially, others (like Greta Garbo and Marlene Dietrich) began wearing trousers and other men's clothing off-screen. Youthful, wholesome types of cross-dressing continued, and in some cases, female trousers were associated with a distinctively American spirit of liberty. But at the same time, Hollywood increasingly looked to Europe for settings, stars, directors, and writers to establish its sophistication. One of the character types haunting Hollywood's European dancehalls was the lesbian. Representations of antiquity also began to include female same-sex desire. At the same time that lesbians began making cameo appearances, Hollywood's cross-dressed women became older, more sexual, and more often aligned with European decadence.

During the second wave (1922–1928), films featuring cross-dressed woman were produced at half the rate of the first wave, an average of ten per year (totaling around seventy-four, of which three-quarters were features). While cross-dressing actresses of the first wave ranged in age and acting style, in the second wave they were almost exclusively young, slim flappers. Actresses hardly ever played male roles anymore. Two-thirds of the films featured romance, and almost half were comedies. Romantic comedies featuring gender disguise became more common. Chapter 4 explores the relationship between this second wave of cross-dressed woman films and American cinema's first explicit

representations of lesbians and inverts. In the 1920s, American movies—as well as plays, newspapers, and magazines—began to address their audiences as if they were part of the sophisticated in-crowd. In response to the multi-year, coast-to-coast censorship battles over Édouard Bourdet's play *The Captive* (1926–1928), newspapers instructed the public in codes and terms for deviant sexuality, which films and fan magazines then exploited. Films like *Four Horsemen of the Apocalypse* (Metro, 1921) and *Wings* (Paramount, 1927) used lesbian couples to establish Parisian nightclubs as exotic spaces. Other films, like *What's the World Coming To?* (Hal Roach, 1926) and *The Crystal Cup* (Henry Hobart, 1927), made more subtle insinuations by dressing characters to resemble real-world inverts such as Radclyffe Hall. A knowing, blasé attitude toward lesbianism became a signifier of worldly cosmopolitanism. At the same time, the fashion industry embraced female trousers and other mannish styles, and big-budget films showcased a new generation of stars in men's garb. In fashion, masculine clothing signified youthful modernity more than deviance. Occasionally during the 1920s, lesbian representation and masculinized women's styles intersected, but the two trends stayed largely separate, and cross-dressing retained its longstanding semantic openness.

This situation changed in the 1930s, as new stars like Garbo and Dietrich began wearing men's clothing off-screen and studios looked for ways to capitalize on the public's fascination with sexual deviance, as I show in chapter 5. In earlier decades, cross-dressed women had contributed to making American movies wholesome, but in the 1930s they became one of Hollywood's many improprieties. During this third, and most famous, wave of cross-dressed women (1929–1934), American studios produced an average of five films per year featuring cross-dressed women (all but one were features). They also made a handful of films with explicit references to lesbianism, and these became some of the most famous films of the period. Capitalizing on the interest generated in the late 1920s, American cinema engaged more actively with lesbianism between 1930 and 1934 than ever before. Film journalists began to use cross-dressing as a euphemism for lesbianism, and cross-dressed performances came under new suspicion from censors. The ability to spot lesbians was no longer limited to the educated elite. The general public became "sophisticated." At the same time, women around the country emulated Garbo and Dietrich's masculine styles, prompting debates over women's trousers in the popular press. Though increasingly associated with sexual deviance, masculine styles also symbolized modernity, autonomy, and disregard for convention. The relationship between men's clothing and lesbian identity continued to be complex. On the one hand, a journalist could use the phrase "ladies who prefer pants to petticoats" to mean lesbians; on the other, fashion magazines could endorse trousers as a charming fashion statement available to all woman.

Still, something fundamental about the meaning of cross-dressed women changed. In 1933, for the very first time, an American censorship body worried about them. The newly empowered Production Code Administration (PCA) warned the producers of two movies well within established cross-dressing genres, *Queen Christina* and *Sylvia Scarlett*, to avoid insinuations of lesbianism. The insinuations remained, but these films were the last to be so explicit. After 1934, the number of cross-dressed women in American movies dropped. Cross-dressed female characters became more visibly feminine and obviously heterosexual, and they were confined to a smaller set of genres—musicals, romantic comedies, and biopics. This book charts the twenty-six-year period during which cross-dressed women went from being a wholesome, appealing solution to Hollywood's reputation problem to being part of the problem. They did not disappear from American screens in the mid-1930s, but they never again participated with such frequency or in such diversity.

LANGUAGE AND SCOPE

The act of wearing clothing at odds with one's assigned gender has gone by many names. Writers in the early twentieth century did not use any single term to describe the phenomenon, referring variously to girl boys, trouser roles, the breeches brigade, and tomboy roles. Scholars have also called these figures temporary transvestites, male impersonators, in drag, *en travesti*, and *hosenrollen*. In this study, I use the terms *cross-dressed women* and *female-to-male cross-dressing* because they are general enough to incorporate many different practices, and they lack the psychiatric connotation of *transvestism* or implied transgressiveness of *drag*. The terms have their own problems, though. Using the word *woman* privileges the actor and character's assigned sex over the performed one. While this practice would be disrespectful to historical individuals who claim a gender other than the one assigned them at birth, in the performances I examine the performers do identify as female, and their presentation of maleness occurs only within fictional frameworks.[51] Furthermore, the word *cross-dressing* problematically assumes the existence of two separate and opposite sexes and implies that the body instantiates one's "real" sex. Though I want to contest these assumptions as they are applied to real people, they do reflect the way these roles were understood at the time.

As noted previously, I use the term *female-bodied man* rather than *passing woman* to refer to historical individuals who were assigned female at birth but lived as men. Cultural historians Stephen Cromwell, Peter Boag, and Erica Rand make a persuasive case for abandoning the term passing woman.[52] In recounting a 1908 incident in which Ellis Island authorities discovered that Frank

Woodhull, a Canadian entering the United States, had a female body and had been named Mary Johnson, Rand argues that to use "she" to refer to Woodhull "is to align oneself with a state that polices gender normativity and against the right of people to name their gender identity and gender presentation."[53] Like Rand, I try to respect the gender that these individuals publicly claim, while remaining agnostic as to their felt gender identity.

What counts as cross-dressing is another vexed question. It depends on what is considered to be male and female clothing in a particular time and place. Because women's fashion has continuously appropriated styles from men's clothing, a garment that might have been considered to represent cross-dressing in the 1910s may have been regarded as perfectly acceptable for a woman in the 1920s. For example, some studies consider a woman of the 1920s in a riding jacket and jodhpurs to be an example of cross-dressing, though these items were by then considered women's clothing. What was considered cross-dressing is thus a moving target. For the purposes of this study, the category "cross-dressed women" includes actresses playing male characters, female characters who disguise themselves as men, and female characters who dress in clothes that a film identifies as men's clothing, even without gender disguise. I do not consider actresses wearing masculine-styled women's clothing to be "cross-dressing," though I discuss these women, too.

Why examine films between 1908 and 1934 rather than a more standard period? I cast a broad net in my initial research, and the films I found determined the temporal borders of the project. Though American moving pictures first appeared in the 1890s, few featured cross-dressed women until around 1908. Conversely, if I had concluded the study at the end of the silent era, I would not have been able to track how cross-dressing became associated with lesbianism or consider how the most famous cross-dressing performances related to those that preceded them. After 1934, cross-dressed women in American films began to assume the forms we are familiar with today.

The question could also be raised, why look at film? There is already work on cross-dressed women and lesbians in theater, modernist fiction, poetry, and painting in this period.[54] However, those arts were primarily consumed by cultural elites in major metropolitan areas. As a mass medium, cinema was part of the everyday lives of people in big and small towns throughout the country. It was accessible to children, immigrants, people of color, women, and the working class. Even though only a small number of mostly white, mostly middle-class people made movies and wrote about them, films and newspapers circulated widely, between far-flung places and across social boundaries. While we cannot know what most people thought of these films, we know that they watched them. These films allow us to get closer to the lives and

understandings of the general public than we otherwise could. Popular films can reveal the assumptions and values of an era better than more expressly artistic works, because they are produced rapidly, by committee, and with the intent of attracting as wide an audience as possible. They therefore reveal the implicit assumptions of the people making the film, which are presumed to be shared by viewers. Films also act on people, influencing what they take to be normal, ideal, and erotic. Finally, investigating cinema shows how an industry devoted to making a profit can (perhaps inadvertently) open up surprising possibilities for social change.

This study focuses on films made and watched within the confines of the United States. Indeed, it reveals that there was something particularly productive about cross-dressed women for American identity. If we were to widen the scope to consider cross-dressed women around the world, we would discover that they were important to many film cultures, but in different ways. For example, many early French films featured *danseuses en travesti*, while German films adapted popular *hosenrolle* plays, and Chinese films presented legends of cross-dressed female knights (*nüxia*).[55] Understanding how movie cross-dressing worked in all these places would mean drilling down into local traditions and dominant understandings of sexuality there, a task beyond the scope of this book. However, Hollywood's increasing dominance of global markets between 1908 and 1934 means that people all over the world watched these films. Collaborations between scholars working in different countries are beginning to reveal the complex contours of transnational exchange, and I hope that my U.S.-grounded study will provide an impetus for research in other locations.

What about cross-dressed men? Cross-dressed men were far more numerous than cross-dressed women in silent cinema, but also far less varied. They appeared almost exclusively in comedies or occasionally crime films. On the one hand, men playing women had a longer and more distinguished stage history than women playing men; on the other, male effeminacy had already been pathologized to a greater extent than female masculinity. The traditions and meanings of cross-dressed men were so different from those of cross-dressed women during this period that we cannot generalize across the two practices. In this study, I discuss cross-dressed and gay men only when their paths crossed those of cross-dressed women, lesbians, and inverts.

During the silent and early sound eras, film journalists liked to declare a particular year's cross-dressed women to be brand new and never before seen, willfully forgetting the hundreds of women who had preceded them. The forgetting continues today. This book argues that cross-dressed women were a crucial part of American cinema between 1908 and 1934. For much of that time, moving pictures took up cross-dressed women from theater and folklore to attract

audiences of varied classes, ages, genders, and regions. Female bodies contributed to ideals of boyhood, American whiteness, and womanhood. During this period, there was a real appreciation for certain kinds of female masculinity. This book uncovers the importance of cross-dressed women and lesbians to the development of the early film industry and of cinema to new concepts of sexual and gender identity.

PART I CROSS-DRESSED WOMEN AS AMERICAN IDEALS (1908–1921)

1 ▶ MOVING PICTURE UPLIFT AND THE FEMALE BOY

Ι N 1915, the thirty-two-year-old Broadway star Marguerite Clark appeared in a film adaptation of *The Prince and the Pauper* as the two boy protagonists (fig. 2). The *New York Day* raved, "Marguerite Clark performs the most artistic work of her entire stage and screen career and renders an interpretation of characters containing at once so much poetry and power, so much force and beauty, that it will inevitably rank with the few greatest characterizations yet contributed to the screen."[1] Film critics around the country heaped praise on Clark and the film. The *Detroit News* pointed out that "Miss Clark is building up a following of men, women and children whose enthusiasm for film attractions has been a matter of luke warm enduring [*sic*] until the elfin leading woman thrust her personality into their world."[2] It was precisely this following that cinema's female boys aimed to attract.

Around 1908, the American film industry worked to "uplift" moving picture culture in order to avoid government regulation, attract middle-class audiences, and establish the movies as a legitimate art form.[3] Filmmakers adapted literary and theatrical works already consumed by genteel audiences and innovated formal methods to communicate moral judgments, while exhibitors forged alliances with cultural institutions and improved the decor, safety, and air circulation of exhibition spaces. Middle-class women were deemed particularly central to this project: their presence was imagined to endow theaters with a sense of respectability, and they were likely to bring their husbands and children with them. Exhibitors courted middle-class women through matinee screenings, prize giveaways, and "ladies' nights."[4]

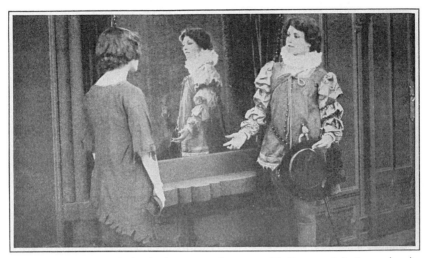

FIGURE 2. Marguerite Clark as both prince and pauper in *The Prince and the Pauper* (1915), from *Film Fun* (January 1916).

Filmmakers also courted middle-class women by adopting practices from theater, including actresses in male roles. Casting actresses as boys was not a minor, anachronistic practice. Actresses appeared in male roles in more than one hundred films during the silent era, made by "quality" companies like Vitagraph, Biograph, and Thanhouser, as well as "school of action" companies like Kalem, Selig, and Keystone. The characters they played were almost exclusively young, white boys.[5] Critics sometimes referred to these roles as "girl boys," but for clarity I call them "female boys."[6] More than three-quarters were played by girls aged seven to thirteen. Female infants and toddlers also sometimes played boys. Additionally, thirteen films—the most highly publicized of the group—starred women between the ages of eighteen and thirty-eight playing young boys. These included two adaptations of *The Prince and the Pauper* (Edison, 1909, and Famous Players, 1915), two adaptations of *Oliver Twist* (General, 1912, and Lasky, 1916), *Hansel and Gretel* (Edison, 1909), *Treasure Island* (Maurice Tourneur Productions, 1920),[7] *Little Lord Fauntleroy* (Mary Pickford Productions, 1921), and *Peter Pan* (Famous Players–Lasky, 1924). Many of the films starred actresses famous for their work on stage, such as Cecil Spooner, Marie Doro, and Marguerite Clark.

Female boys connected moving pictures to centuries-old theatrical traditions. Furthermore, they made a specific appeal to middle-class mothers and grandmothers by embodying a sentimental ideal of boyhood. Female boys were considered more expressive, more beautiful, more innocent, and more vulnerable than boys played by male actors. By modeling and inspiring sympathy, female boys demonstrated that moving pictures could function as sentimental

moral education. These films show that the work of the female boy was not lim-
ited to the nineteenth-century stage. They also reveal that cross-gender casting
did not necessarily undermine the dominant gender system, as scholars like
Chris Straayer have suggested.[8] While one might argue that cross-gender cast-
ing in cinema was short-lived because it contradicted the medium's penchant for
realism, I argue that the decline of female boys was a result of the increasing stig-
matization of the sentimental boy and the demand of the emerging star system
that female performers be readily recognizable and consistently attractive. In the
1920s, female boys like Mary Pickford's Fauntleroy tried to balance sentimen-
tal and "red-blooded" boyhood, but by this time only "real" boys, like the child
actor Jackie Coogan, could successfully embody these contradictory ideals.

 While theater and cultural historians like Elizabeth Mullenix and Katie Sut-
ton have argued that casting women in boy roles was a reactionary attempt to
delegitimize women's political demands, I argue that these roles also performed
a sentimental politics, showing how the adult world of capitalist individualism
could be remade through a child's expression of empathy and generosity.[9] These
roles also created the opportunity for female bodies to help produce and affirm
cultural ideals of masculinity. The contribution of female masculinities to mas-
culinity as such is regularly overlooked, as transgender theorist Jack Halberstam
has observed.[10] The early twentieth century was a moment in which female per-
formances of masculinity were central to the cultural production of boyhood.

FEMALE HAMLETS AND COMIC OPERA LADIES

As explored in the introduction, moving pictures had an array of theatrical cross-
gender casting practices to choose from. The American stage had a rich lineage
of women in dramatic Shakespearean roles, and in musical theater, comic opera,
burlesque, pantomime, and ballet, attractive young women often played male
roles in revealing tights and tunics. Finally, girls and young women played boys
in hundreds of melodramas, tragedies, children's stories, and comedies. Given all
these choices, why did American filmmakers gravitate exclusively to the senti-
mental female boy?

 I suspect that women playing dramatic male roles were too politically vola-
tile by 1908 for the American moving picture industry. The beloved Peg Woff-
ington and Charlotte Cushman had built their careers on dramatic male roles in
the eighteenth and nineteenth centuries; but when Bernhardt resuscitated this
tradition in the 1890s, American critics responded with disbelief and derision.
The most hyperbolic response came from *New York Journal* critic Alan Dale,
who wrote a full-page article in 1898 titled "Why an Actress Cannot Wear Trou-
sers Like a Man."[11] Dale argued that biological sex was so fundamental that it
was impossible to disguise: "In real life sex is a distinctly dominant quality that

is born and not acquired. It triumphs over clothes, wigs and caps." Even if a woman could convincingly look and act like a man, the effect would be grotesque: "If it were possible to secure an actress who could infallibly present the eccentricities of the other sex, we should have no use for her whatsoever. She would repel us, and we should insist that she was vulgar and objectionable." Dale's warning echoes conservative American physicians and religious leaders who described political women as physiologically monstrous.[12] Regarding Bernhardt's earnest attempt to render masculinity, Dale asserted, "Sarah was cornered, flabbergasted and utterly demolished by the inexorable deficiencies of her sex." He argued that women playing dramatic male roles were received as little more than the leg shows of musical theater: "Women play male roles because in this way they are enabled to be more graphically womanly than ever. And audiences go to see them because this is the case. They deceive none but the idiots in the cast, and managers don't propose that they shall ever try to do so."

Though most American critics were more favorably disposed to women in dramatic male roles, they sometimes connected actresses' desire to play serious male roles with women's entrance into politics, business, and higher education. "The women of the stage are growing constantly more aggressive in their usurpation of men's parts," stated the *American Journal Examiner* in 1901.[13] Two years later, the New York *Morning Telegraph* insisted that "roles written for men" could "be properly represented only with an attitude of authority which no womanly woman can assume."[14] This statement puts cross-cast women in a double bind: either the characters they performed would lack authority, or their own womanliness would be denigrated. Like Dale, many critics dismissed Bernhardt's male performances as a version of chorus girls' tights and tunic roles. Considering this widespread ridicule, it is not surprising that American moving pictures shied away from adult women in dramatic male roles.[15] One rare exception was Mathilde Comont's portrayal of the Persian Prince in *Thief of Bagdad* (Douglas Fairbanks Productions, 1924). But in this case the actress's ample, feminine body calls into question Persian masculinity. In general, casting adult women in dramatic male roles seems to have been too controversial to appeal to American moving picture makers.

One would think that the "graphically womanly" performances of women in tights and tunic roles would be better suited to the moving pictures, considering the medium's emphasis on the display of the female body. Onstage, these performances ranged from children's pantomimes and *féerie* extravaganzas like *The Wizard of Oz* stage show to sexualized, parodic burlesque performances in the vein of Lydia Thompson's "British Blondes." When Thompson and her troupe first arrived in the United States in 1869, literary critic William Dean Howells famously complained, "[T]hough they were not like men, [they] were in most things as unlike women, and seemed creatures of a kind of alien sex, parodying

both. It was certainly a shocking thing to look at them with their horrible pretti-
ness, their archness in which was no charm, their grace which put to shame."[16] In
response to public pressure, mainstream burlesque became less sexual and less
political, while a sexualized form of burlesque migrated to all-male working-class
venues. By the turn of the century, tights and tunic roles had become fairly mun-
dane. Even Dale, in his 1898 polemic, admitted, "The comic opera lady can don
tights whenever she feels like them, and the public has grown so accustomed
to it that it has almost ceased to interest."[17] Six years later the *New York Herald*
observed, "The appearance of actresses in male parts in the comic opera is com-
mon to the point of monotony."[18]

Although European films regularly featured women in tights and tunics,
American films did not. The few American examples are L. Frank Baum's Oz
films and Fox's all-children fairy tale films.[19] It is likely that American filmmakers
did not produce many films with tights and tunic roles because French compa-
nies like Pathé Frères and Gaumont had already cornered the market in these
genres and American studios could not compete with their extraordinary color
processes. American filmmakers may also have avoided these roles because the
costumes were too revealing or because of their associations with sexualized
burlesque. Film historian Richard Abel has documented the way American stu-
dios pushed Pathé out of the domestic film market by criticizing sexually explicit
foreign productions.[20] If Americans studios at first failed to capitalize on the
stage popularity of women in tights and tunics, they may have later shunned this
"European" practice as part of their broader strategy of Americanizing domes-
tic film exhibition. Filmmakers instead turned to a third form of cross-gender
casting—the female boy—which was perfectly suited to their needs.

THE APPEAL OF THE FEMALE BOY

Women playing boy roles had been common in nineteenth-century theater, but
by the turn of the twentieth century they were believed to appeal only to moth-
ers and grandmothers. Theater historian Elizabeth Mullenix has shown that in
colonial America, actresses played boys only when there were no young male
players in their company; in the eighteenth century, actresses played pages and
young princes; and in the nineteenth century, women played weightier, melo-
dramatic, boy protagonists.[21] According to Laurence Senelick, "the outcast
gamin, . . . played by small women, became a virtual line of business in the
nineteenth-century theatre"; on the American stage, he adds, "street-wise news
vendors and errand boys were almost exclusively the property of actresses from
the 1850s onward."[22]

While women played a range of boy roles, the most celebrated were vulner-
able youths in whom the ideals of the Romantic child, sentimentalism, and

melodrama converged. A good example is the following review of a woman playing a peasant boy in an 1832 production in New York: "Her resignation to the will of heaven, the noble assertion of her innocence, her air, voice, and manner, was—we cannot express it. The eye gazed, the mind exulted, and the heart sympathized with the suffering boy."[23] As this review suggests, the female boy was considered particularly capable of expressing pious resignation, nobility of spirit, and suffering. S/he could generate an intense affective response from spectators. In contrast to Puritan and Enlightenment conceptions of the child as fallen or flawed, the Romantic child was innocent, spiritual, and wise. The child's beauty attested to its goodness. The ideal was essentially androgynous, but was considered somewhat feminine because it was cultivated by mothers within the domestic sphere. Romantic children were common role models in nineteenth-century sentimental literature, in which the innocent child, like Christ, suffers and dies to redeem the wicked and powerful.[24] Sentimental heroes modeled enlightened empathy with the suffering of others and elicited the reader's empathy (and tears) for their pitiful fate. For some sentimental novelists, the cultivation of empathy through fiction had the potential to remake the world into a place ruled by empathy rather than selfishness and greed. Theatrical melodrama incorporated many elements of the sentimental ethos, including the suffering of innocents and the solicitation of the audience's empathy and tears. Melodrama also used gesture, posture, music, and mise-en-scène to express the linguistically inexpressible. While actresses playing girls also embodied these ideals, actresses in boy roles expressed the essential androgyny of the child.

As the nineteenth century drew to a close, many men promoted a new, more masculine ideal of boyhood in the face of the nation's social and political changes: the shift from an agrarian to an industrial economy; women's, immigrants', and black people's challenges to white men's monopoly on political and economic power; the closing of the frontier; and the country's new imperial ambitions.[25] A new generation of critics condemned sentimentalism in theater and literature, which they blamed on women's influence over these media. In spite of these complaints, sentimental boyhood became increasingly tied into consumer culture. The jostling of these conflicting ideals can be seen in the almost simultaneous publication in 1885 of Mark Twain's *Huckleberry Finn*—a classic "red-blooded" boy—and Frances Hodgson Burnett's serialized story *Little Lord Fauntleroy*—a classic sentimental boy. In Burnett's story, the young American Cedric Errol reforms his curmudgeonly British grandfather by demonstrating sympathy, kindness, and generosity.

Fauntleroy became a flashpoint in the contest over boyhood. In 1888, the novel was adapted to the stage in London and New York, with young actresses in the role of Fauntleroy. The productions launched a Fauntleroy craze, with forty touring companies presenting the play across the United States. According

to Burnett's biographers, women could buy Fauntleroy "playing cards, writing paper, toys, perfume, and even chocolate," as well as the iconic "Fauntleroy suit," modeled on eighteenth-century aristocratic boys' clothing.[26] The fashion for Fauntleroy suits spread when working-class and rural women encountered urban, middle- and upper-class boys in the suits at the 1893 Chicago World's Fair.[27] Following *Fauntleroy*'s success, Broadway producers adapted Twain's *The Prince and the Pauper* and revived Charles Dickens's *Oliver Twist*, all starring young actresses in the lead roles.

Despite their disdain for "kid dramas," critics noted that they were a surefire lure for middle-class women. *Life* magazine's 1890 review of *The Prince and the Pauper* typified their objections: "Such children as Elsie Leslie makes of Little Lord Fauntleroy, Tom Canty, and Edward, Prince of Wales, invariably die before they are ten years old. . . . If they did live through chicken-pox, measles, scarlet fever, and the other ills to which childish flesh is heir, their intense sweetness would become painful and insufferable."[28] Illustrating the review was an image of a woman peering over a chair at an androgynous child in a Fauntleroy suit (fig. 3). She hovers parasitically over the child, her body and hair blending into the shadow behind her. The text implicitly pathologizes the woman's intent gaze at the child and, by extension, women's compulsive consumption of spectacles of sentimental childhood. The critic for the *New York Times* agreed that *The Prince and the Pauper* "is not a good play"; but because "[a]ll mothers like to see pretty children exhibited to good advantage," the critic concluded that "what pleases mothers and children will prevail."[29] The female boy's beauty is demoted to prettiness. It no longer communicates goodness, but merely affords a pleasant spectator experience. Likewise, the empathetic connection between performers and audience becomes a cheap strategy to which only middle-class women are susceptible.[30] When *Little Lord Fauntleroy* was revived in New York in 1903, one critic called Fauntleroy "the most unmitigated little prig that ever wore knickers" but noted that the "horde of mothers and grandmothers at the matinee on Tuesday were loud in their applause."[31] Although critics regularly condemned the sentimental boys played by women on the stage, they believed that these roles exerted an irresistible attraction for middle-class women—which made the female boy a perfect tool for American filmmakers hoping to convince middle-class women to make moviegoing part of their consumer habits.

THE FEMALE BOY AND EDISON'S "LONG STEP UPWARD"

Film historians William Uricchio and Roberta Pearson have described how Vitagraph adapted stories from Shakespeare, the Bible, and history in order to establish the film medium as "high class."[32] Adaptations of sentimental Anglo-American children's literature and theater also contributed to the American

FIGURE 3. A female spectator
gazing at a sentimental child in
Life (January 30, 1890).

high-class film movement. A key step in the gentrification of cinema was the pro-
motion of actors' names, particularly those who worked in theater. According to
film historian Richard deCordova, one of the first times this practice occurred
was in the Edison Company's publicity for its adaptation of *The Prince and the
Pauper*. The film starred thirty-four-year-old Broadway actress Cecil Spooner.
In August 1909, the company announced: "Miss Cecil Spooner was especially
employed to enact the difficult role of Tom Canty, the pauper boy, and Edward,
the boy prince of Wales in Mark Twain's celebrated story, *The Prince and the
Pauper*. Graceful, effective and polished as an actress, her finished art has con-
tributed much to the beauty and strength of this notable silent drama."[33] The
announcement highlights several "high-class" elements of this project: Spooner's
reputation, the acting prowess needed to perform a dual role, Mark Twain's
name, and the subject matter itself, that is, a sentimental children's story and
popular play. In this announcement, Spooner represents both the art of acting
and gentility. In fact, she was not the most genteel or established of Broadway
actresses, but she was petite, popular, and experienced in cross-dressing roles.[34]

Critics judged the film and Spooner's performance to have achieved the Edison Company's lofty aims. *Moving Picture World*, for example, called the film "perhaps the best work the Edison Company has ever done."[35] Of Spooner, the critic wrote: "it is needless to say that little was left to be done to make the dramatic quality perfect. . . . The real prince, even in his pauper rags, is always the prince, while the few glimpses of the pauper, even though in the palace . . . is still the pauper. . . . Perhaps in work of this sort lies the germ of all successful motion picture making." According to this critic, Spooner's ability to make visible two layers of class identity at the same time represented genuine acting, but her facility in playing across genders was never mentioned, probably because this kind of casting was so conventional. The *New York Dramatic Mirror*, though less enthusiastic about Spooner's acting ("good but by no means exceptional"), agreed that the film "marks a long step upward by the Edison people."[36]

The Edison Company evidently judged Spooner's performance a success, because she played Hansel in its adaptation of *Hansel and Gretel*, released two months later. The 1893 opera had set a precedent for female Hansels that the silent film continued (though the player's vocal range was not an issue, as it obviously was in opera). Although the *Dramatic Mirror* was not overly impressed, *Moving Picture World* praised the film, concluding: "The illusive and imaginative quality of the fairy tale has been fully preserved in this Edison production, and those who have read the story, or who have heard the opera, will find new interest in it."[37] The film thus exploited the legitimacy and mass appeal of the opera and preserved its tradition of cross-gender casting.

Female boys were less central to Vitagraph's quality film strategy than to Edison's. In May 1909, Vitagraph released a nine-minute *Oliver Twist* starring Elita Proctor Otis as Nancy Sykes (reprising her 1895 Broadway role) and an unidentified boy as Oliver, though the part had been played by a girl, Katharine Dooling, in the Broadway production. In this film, Oliver's tribulations take a backseat to Nancy's dramatic, extended death scene. Vitagraph did occasionally cast girls in boy roles, though. In December 1909, it released *A Midsummer Night's Dream* with thirteen-year-old Gladys Hulette as Puck. It also adapted three cross-dressing Shakespeare plays: *The Merchant of Venice* (1908) and *Twelfth Night* (1910), with Florence Turner as Portia and Viola, respectively, and *As You Like It* (1912), starring English actress Rose Coghlan as Rosalind. Reversing the Elizabethan practice of casting boys in female roles, in *Twelfth Night* Edith Storey played Sebastian, Viola's twin brother. The choice put an additional twist on the play's dizzying gender confusion but allowed the twins to look genuinely similar in the film's final tableau. Gladys Hulette also played a boy in Vitagraph's John Bunny comedy *Captain Barnacle's Baby* (1911) and in an Edison drama, *The Winds of Fate* (1911). Although Vitagraph did not exploit the popularity of the female boy to the extent that Edison did, it nonetheless included female boys

like Hulette and adapted cross-dressing Shakespeare plays alongside the adaptations that Uricchio and Pearson describe. For the Edison Company, however, the female boy was an important tool to assert the artistic worth and cultural legitimacy of their products.

YOUNG FEMALE BOYS AT THANHOUSER AND BIOGRAPH

The vast majority of female boy performers were girls between the ages of seven and twelve. They were small, thin, and glowingly white, and radiated both fearlessness and fragility. They often appeared in two-reel melodramas from Thanhouser and Biograph, two companies particularly dedicated to respectability. The most prolific was Marie Eline, who played boys in at least thirty-seven films between 1910 and 1914, when she was between the ages of eight and twelve (fig. 4). Only five of the films are known to survive. Eline's nuanced performances demonstrate the typical appeal of the female boy.

Eline was the Thanhouser Company's biggest star between 1910 and 1912. Following the lead of companies that promoted their Biograph Girl and Vitagraph Girl, Thanhouser began to promote Eline as its very own Thanhouser Kid. Thanhouser did not hide Eline's sex, but her moniker was gender neutral. Eline played both girl and boy roles (at a ratio of two to one) and appeared in both female and male garb in publicity photographs, which were labeled only "Thanhouser Kid." The announcement of Eline's new moniker in *Moving Picture World* also touted her first boy role: "'The Thanhouser Kid!' of course she is Marie Eline. . . . By the by, this same 'Thanhouser Kid' renounces her girlishness and becomes a boy—an Italian boy—in *The Two Roses* She makes a dandy 'Dago' boy, too, with her rich black hair and her great black eyes. Maybe you'd never recognize her if we did not tip you off. Don't pass the tip to others in your place, but see if their little favorite doesn't fool them completely in her masculine makeup."[38] Even today, Eline's boy performance in *The Two Roses* (1910) is utterly persuasive. She has short, messy, black hair and skinny, white legs and arms. The framing emphasizes her fragility by subsuming her little, white body within a dark, cluttered train yard (where she gets run over by an automobile). Her acting style is the most naturalistic of the female boys. She walks carefully but boldly, and her physical movements are small. Her character spends much of the time collapsed, either on the ground, in a chair, in bed, or in his father's arms. In 1912, *Photoplay* called Eline "one of the greatest child actresses on the screen or the legitimate stage."[39] After *The Two Roses*, Eline played a succession of messenger boys, stowaways, lame boys, and even truant boys. Twice she played black boys who save the lives of white military men. Unfortunately, both *The Judge's Story* (1911) and *Washington in Danger* (1912) are lost, so it is impossible

FIGURE 4. A cabinet card of the Thanhouser Kid, Marie Eline. Courtesy of Thanhouser Company Film Preservation, Inc.

to analyze these rare, non-white female boy roles, given the importance of whiteness to the performances that survive.

The Biograph Company's first female boy was likely the protagonist of *The Boy Detective* (1908). In *Moving Picture World* and the *New York Clipper*, Biograph announced the film as the first in a series of "film stories recounting the experiences of Swipesy, the newsboy, whose acute sagacity wins for him fame as a juvenile Sherlock Holmes."[40] In the film, Swipesy trails two kidnappers and outsmarts them by impersonating the woman they mean to kidnap and then using a cigarette case shaped like a pistol to hold them at bay. In a short epilogue,

we see Swipesy in a medium close-up for the first time, which reveals that this "boy" detective is played by a young woman. This reveal undoes the spectator's presumed visual mastery. I have not been able to discover how audiences received this complicated film, but the Biograph Company did not continue the Swipesy series.

However, Biograph did produce a number of films featuring a female boy three years later. In June 1911, a year after the Thanhouser Kid's debut, D. W. Griffith cast the eleven-year-old vaudeville performer Edna "Billy" Foster as a newsboy in *Bobby the Coward*.[41] The critic for *Moving Picture World* did not mention Foster directly, but apparently she fit seamlessly into the film's "[r]eal street scenes," in which "slum crowds passing unconsciously were used as a background."[42] Between June 1911 and March 1912, Foster appeared in seventeen of Griffith's Biograph films, playing boys in at least fourteen. Unlike Eline, Foster played male roles almost exclusively. Like Eline, she combined innocence and boldness, but leaned toward naughtier boys and more passionate outbursts. In *A Country Cupid* (1911), for example, Foster's character falls madly in love with a schoolteacher and becomes jealous of her sweetheart. In *The Baby and the Stork* (1912), Foster's character is so jealous of his new baby sister that he steals the infant and leaves it with the stork at the zoo. When Foster's character in *As in a Looking Glass* (1911) sees his drunken father flirting with the maid and throwing temper tantrums, he invites the neighborhood children over and reenacts his father's bad behavior for laughs.

Foster's characters are a version of what literary historian Leslie Fiedler calls the "Good Bad Boy": "crude and unruly in his beginnings, but endowed by his creator with an instinctive sense of what is right," which he equates to "America's vision of itself."[43] Although most of Foster's characters were adventurous, they were also repeatedly placed in peril, menaced by tramps (*The Adventures of Billy* [1911]), Native Americans (*Billy's Stratagem* [1912]), gangsters (*A Terrible Discovery* [1911] and *The Transformation of Mike* [1912]), and a drunken father (*As in a Looking Glass*). Biograph likely used Foster rather than a male performer because of the theatrical precedent and because her face and body were more expressive than those of the "real" boys of early cinema. Her active body and mobile features transparently display affection, hope, fear, and resignation. Her gestures draw more directly from melodrama's externalization of emotions than Eline's more naturalistic style. She frequently returns to a defined set of gestures to communicate terror, such as opening her eyes and mouth wide and placing her hands on her cheeks or waving her arms in the air with fingers splayed.

While Thanhouser promoted Eline as the semi-androgynous Thanhouser Kid, Biograph developed a "picture personality" for Foster attached to the name "Billy." In a 1914 interview with the trade journal *Motography*, Foster

explained that Biograph "got a series of boy pictures ready and asked me what name I wanted to have in them and I said 'Billy.' So the series was named 'The Adventures of Billy' and I've been called 'Billy' ever since that by everybody."[44] Although the "Billy" of each film is a different character, the repeated use of the name created a sense of continuity. Foster played a Billy in *A Country Cupid*, *The Ruling Passion*, *The Adventures of Billy*, and *Billy's Stratagem*.[45] She also played lead characters named Billy in two films for the Reliance Company, *Prince Charming* (1912) and *The District Attorney's Conscience* (1912).[46]

Because Biograph refused to reveal the names of its performers, critics seem to have taken Foster for a boy. Publicity bulletins and plot synopses in the trade press make no mention of the cross-gender casting. The *Dramatic Mirror* even praised "the appealing and lifelike presentation of the little boy" in *The Baby and the Stork*.[47] Only after Foster appeared in the Reliance pictures in 1912 did her name and gender become known to critics and fans.[48] Even then, Foster cultivated a boyish persona. In the *Motography* interview with Foster and her older sister Flora, Edna admitted that "I love to play with boys and outside of school, I always do. I like base-ball and rugby." "And she drives a big Packard," Flora added. "She really is just like a boy."[49] Edna showed off her biceps to the interviewer, who pronounced them "round and hard as the proverbial rock": "It was a muscle that a boy of more than Billy's age would be proud of." Foster is the only example I have found of a studio building a male persona around an ostensibly female performer. Her athleticism and professed love for boyish activities would be taken up by the frontier girls and girl spies analyzed in the next chapter.

Beyond Eline and Foster, a handful of child actresses played boys, usually with an explicitly theatrical style. "Thanhouser Kidlet" Helen Badgely had occasional boy roles between 1912 and 1917, when she was between the ages of three and seven. Unlike Eline, Badgely was chubby, cute, and definitely feminine. Flora Foster played the young David in the first part of Thanhouser's *David Copperfield* (1911). Her acting is much like that of her younger sister, but with even more exaggerated gestures. (In the *Motography* interview, Flora claimed that she took the role because "I like sad parts—Billy doesn't.") Violet Radcliffe played boy roles in at least eighteen films between 1915 and 1917, from age seven through nine. She specialized in comedies and fairy tales in which all the actors were under the age of ten. Radcliffe played a series of loveable villains for Majestic, including the reoccurring character "Dan" in *The Straw Man*, *Billie's Goat*, *The Little Cupids*, and *The Little Life Guard* (all 1915). She then went on to Fox's all-children fairy tales, including the role of Al-Talib in *Aladdin and the Wonderful Lamp* (1917) and Long John Silver in *Treasure Island* (1917). (*Aladdin* seems to be the only one of her films to survive.) Like Badgely, Radcliffe was pudgy and feminine, trading on cuteness.

Marie Eline and Edna Foster left the movies in 1915 (at the ages of thirteen and fifteen, respectively) and Radcliffe in 1918 (at age ten). They and their peers played a range of boy characters in a range of styles, but always combined boldness and vulnerability. By importing a centuries-old performance tradition from theater, they connected moving pictures with the more legitimate art form. However, when they left the movies, they were replaced by young male performers, as I will discuss in the last part of this chapter. For a time, these girl-boys helped attract middle-class women to cinema, even as they made a space for females to embody idealized boyhood.

THE OLIVER TWISTS OF 1912

The year 1912 marked the centenary of Charles Dickens's birth. In February, *Oliver Twist* was revived on Broadway with American stage star Nat C. Goodwin as Fagin and thirty-year-old Marie Doro as Oliver. Although Goodwin was the main attraction, the *New York Times* deemed Doro "a lovely and highly sympathetic little Oliver."[50] The show's success set off a wave of film adaptations. In May, the General Film Publicity and Sales Company released a five-reel version, also starring Goodwin, but with twelve-year-old Vinnie Burns as Oliver. In September, the Hepworth Company released its own five-reel version in England, with Ivy Millais as Oliver. They were among the first five-reel films produced in the United States and England intended to be screened at a single sitting. *Moving Picture World* called the U.S. film a "Forerunner of What Is to Come."[51] In addition to these high-profile adaptations, Republic released a one-reel drama, *The Queen of May*, in which a poor girl wins the lead role in a production of *Oliver Twist*, and Biograph offered *Brutality* (1912), a two-reel drama in which an abusive husband reforms after watching a performance of *Oliver Twist*.

In both feature-length versions of *Oliver Twist*, the actresses playing Oliver employ a more classical acting style than Eline or Foster. Vinnie Burns, shown exclusively in long shots, acts with her whole body, clasping her hands in supplication, crouching nervously, and collapsing on the ground. The bigness of her gestures evokes Foster's style, though without Foster's energy. Unlike Foster or Eline, Burns is immediately identifiable as female. *Moving Picture World* declared that she was "easily the equal of Miss Marie Doro."[52] Burns's performance style is consistent with the film's overall theatrical aesthetic, which was shared with the Vitagraph quality films that Uricchio and Pearson analyze. Advertisements by the General Film Publicity and Sales Company explicitly pointed to the film's faithful reproduction of the theatrical experience.[53] In the Hepworth film, Ivy Millais's Oliver is even more feminine, with dark eyeliner and ringlet curls extending to his/her chin. Like Burns, Millais cowers, crouches, and faints in a series of held positions. In her most iconic pose, she stands contrapposto, her

head dropped and face covered by a bent arm. Four years later, Doro adopted a similar pose in publicity photos for a 1916 film adaptation. It is likely that this was a standard pose of theatrical Oliver Twists.

Burns's performance as Oliver must have been judged a success, because French-American director Alice Guy-Blaché next cast the young actress as the title character in *Dick Whittington and His Cat* (Solax, 1913). This film adapted a British Christmas pantomime play, which always featured a young actress as "principal boy." Like *Oliver Twist, Dick Whittington* follows an impoverished English boy into London, where he is worked almost to death before a *deus ex machina* ending that grants him sudden wealth. In this film, Burns recapitulates her wistful poses from *Oliver Twist* almost exactly.

As the cinematic Oliver Twists of 1912, actresses employed a classical movement vocabulary in order to convey the boy's pathos and vulnerability. Critics found no fault with this casting choice, which helped connect moving pictures to genteel theater. In fact, in the one-reel *Queen of May*, the boy who originally plays Oliver falls sick and is replaced by a young girl who does a better job. At this point, girls were still imagined to bring a special delicacy to the role that male performers lacked.

MARGUERITE CLARK AS THE PRINCE AND THE PAUPER

Marguerite Clark's virtuoso performance in Famous Players' 1915 adaptation of *The Prince and the Pauper* was both the apogee of the female boy in American cinema and a turning point. As the quotations at the beginning of this chapter attest, critics hailed the extravagant five-reel production as an achievement in film art and a triumph for the actress. (Unfortunately, the film does not seem to have survived.) As in the earlier Edison production with Cecil Spooner, the dual casting foregrounded Clark's acting talents and ability to make class differences visible through movement and expression.

Like the rising screen star Mary Pickford, the diminutive Clark (reportedly only 4 feet, 10 inches) was promoted as an eternal girl. She won fame playing Snow White in a 1912 stage production, a role she reprised in Famous Players' 1916 film adaptation. However, Clark also played more boyish roles, such as a girl disguised as a boy thief in the play *Are You a Crook?* (1913), a barefoot tomboy in the film *The Crucible* (Famous Players, 1914), and a young woman raised as a boy in *The Amazons* (Famous Players, 1917), adapted from an Arthur Pinero play of the same name. Critics considered Clark to be particularly well cast in *The Prince and the Pauper.* "A better choice for the portrayal of both the stripling royalty and the beggar boy," noted the *Philadelphia Ledger*, "could hardly be conceived than dainty Marguerite Clark, who is as winsome as a boy as she is in her natural estate."[54]

However, for the first time, film critics called into question a female's ability to enact a boy role. Despite effusive praise for the film, a Hartford, Connecticut, critic wrote: "The only drawback to a complete interpretation of the double role is that the part has to be played, not by a boy, but by a girl. Marguerite Clark is so thoroughly a charming little girl that she cannot completely lose her real character. . . . As a result the prince in the play is a trifle effeminate."[55] Whereas a "touch of the feminine" had long been an asset for girls playing boys, this critic read femininity as effeminacy, giving it a negative cast. The performance was redeemed, however, when the critic went on to project the effeminacy away from American boys and onto the English aristocracy: "Prince Edward was a somewhat effeminate boy in a thoroughly feminized court and the type of good little boy who was doomed to die young." This type, which had been a staple of the sentimental kid drama, was now tarred with the brush of effeminacy.

In 1915, the Hartford critic's concern was in the minority. The reason for the film's success, according to the *New York Evening Mail*, was that "Miss Clark's versions of the prince and the pauper have a faithful resemblance to exactly what our idea of the prince and the pauper has always been," even though she could hardly "fool any one into believing she was a boy."[56] The *Detroit News* agreed that "there are few film stars who could come so near idealism in personality alone" and that "again we know that the little actress can be most satisfying in making visible our dreams."[57] The female boy performer was valued not for her verisimilitude but rather for her ability to make visible the ideal of boyhood.

Critics praised *The Prince and the Pauper* as "infinitely superior" to other moving pictures, with the potential to win over those who spurned the medium. It had expensive staging, artistic cinematography, acting prowess, and a clear moral lesson. Kitty Kelly at the *Chicago Daily Tribune*, for example, wrote that "one goes away from the picture with a cheery feeling around the cockles of the heart that there is room and welcome for such thoroughly pleasant things in pictureland. Hectic melodrama and delirious triangles aren't the whole field for film entertainment."[58] Kelly compared the film favorably to the melodramas that were popular with audiences but worrisome to censors and community organizations. The *New York Times* critic concurred.[59] The film—including the casting of Clark in the boy roles—evoked nostalgia for more "innocent" entertainments. The *New York Evening Mail* affirmed that, even though "experts" may have written off the costume drama, "there will always be plenty of room for pictures of this sort."[60]

The critical reception of Clark's *The Prince and the Pauper* sums up the cultural work of female boys in American moving pictures. Not only did female boys permit filmmakers to exploit the name recognition of a Broadway actress and establish cinema as a medium for dramatic acting, but they also made visible a Victorian ideal of boyhood. Films with female boys were designed to attract

middle-class audiences skeptical of the cinema's dubious moral and aesthetic qualities. Although male performers could also play sentimental boys, the female boy symbolized Victorian values and genteel theatrical traditions. Already in 1915, however, the controversial aspects of this boy ideal had to be negotiated. In *The Prince and the Pauper*, "effeminate" boyhood was projected onto a European, aristocratic past in order to avoid clashing with new conceptions of American boyhood. The female boy became less and less tenable and soon disappeared from American screens.

QUESTIONING THE FEMALE BOY

As war in Europe wore on, critics expressed qualms about the compatibility of female bodies with boy characters. The qualities of grace, vulnerability, and beauty that female performers lent to boy roles became suspect. In the next few years, the reservations raised by the Hartford critic became more widespread. In December 1916, a year after *The Prince and the Pauper* was released, the Lasky Feature Play Company (newly consolidated with Famous Players) produced a new adaptation of *Oliver Twist*. This time Oliver was played by thirty-four-year-old Marie Doro, the actress from the Broadway show four years earlier. The film attempted to exploit the critical success of *The Prince and the Pauper*, as well as Doro's reception in the play. Indeed, many film critics found Doro to be an ideal Oliver and echoed the praise that had been showered on female boys since the early nineteenth century. Grace Kingsley at the *Los Angeles Times* wrote that Doro "transferred to the screen all the pathetic wistfulness of that hapless little pawn of Fate, investing it with a thousand delicate shades of appeal."[61] A film reviewer in Milwaukee even argued that Doro's femininity enhanced the characterization: "there is just the proper touch of the feminine to realize the shrinking timidity of the unhappy little workhouse runaway."[62]

However, other critics expressed new doubts about a female performer's ability to play a boy. For example, in *Moving Picture World* George Blaisdell conditioned his "high praise" for Doro's portrayal in an important way: "She imbues him with the spirit of the book, as well as that need be expected of one playing a role of opposite sex."[63] The qualification implied that female performers could never play male roles to complete satisfaction. The *Cleveland Leader* aired further misgivings about Doro's ability to play this role. Alongside a photograph of Doro in costume, the critic remarked: "This is Marie Doro as 'Oliver Twist' in the forthcoming picturization of Dickens' story. Makes a charmingly girlish appearance as a boy, doesn't she? Somehow these pretty feminine stars who pose in the costume of the male never find suits too large for them" (fig. 5).[64] For this critic, cross-dressed young women had become monotonous by 1916 (indeed, there were at least thirty cross-dressing films produced in that year and forty-three

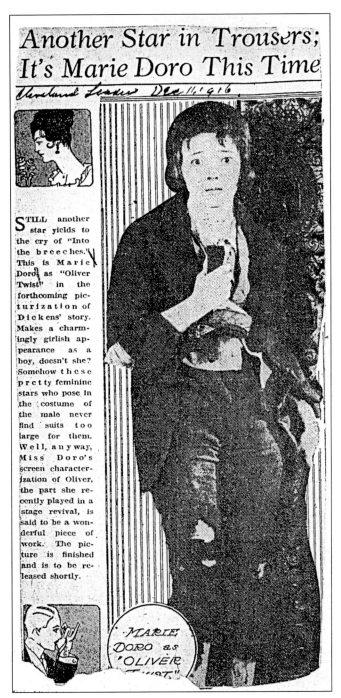

FIGURE 5. "Another Star in Trousers; It's Marie Doro This Time," from the *Cleveland Leader* (December 11, 1916).

the year before). The argument recapitulated Alan Dale's assertion almost two decades earlier that women play male roles only to display their bodies and further implied that femininity is fundamentally incompatible with boyhood.

After *Oliver Twist*, only three more big-budget films featured women in leading boy roles: *Treasure Island* (1920), with twenty-year-old Shirley Mason as Jim Hawkins; *Little Lord Fauntleroy* (1921), with twenty-nine-year-old Mary Pickford as both Fauntleroy and his mother; and *Peter Pan* (1924), with eighteen-year-old Betty Bronson in the title role. In each case, critics questioned the casting of a woman in the leading role. A critic for *Moving Picture World* remarked that "Shirley Mason's only shortcoming in the character of Jim Hawkins is due to her inability to disguise her sex."[65] The *New York Times* complained that the "greatest weakness" of *Little Lord Fauntleroy* was that "Miss Pickford does not maintain the illusion that she is a sturdy little boy."[66] When Famous Players–Lasky announced the production of *Peter Pan*, two widely read male critics campaigned to have Jackie Coogan play Peter instead of an actress.[67] Male writers were the most critical of female boys, while female journalists like Kitty Kelly and Grace Kingsley remained favorable to them. Only girls five and under continued to appear frequently in male roles.

Why did film critics object to female boys after 1915? It is true that the practice was associated with theater and that moving pictures abandoned many of the signifiers of theatricalism after 1915, such as canvas backdrops and unrecorded spoken dialogue. However, other non-naturalistic practices continued into the 1920s and beyond, including cross-racial and cross-age performance. These visibly artificial conventions remained acceptable even in otherwise "realistic" films, so why not cross-gender casting? As I outlined in the introduction, the decline of female boy performances was due not to a desire for greater realism but to the stigmatization of the sentimental boy and the emergence of the star system. Films began to render female performers more visually identifiable, which hindered narrative immersion when they were playing boys.

The sentimental boy had been under attack since at least the 1886 publication of Burnett's *Little Lord Fauntleroy*. And yet the moving picture industry had been willing to promote this controversial character type during the early 1910s because it was understood to be popular with middle-class women. But the stigmatization of the sentimental boy was escalating. For example, in June 1914, Michael Monahan complained in *The Forum*, a monthly general-interest magazine, that "we abandon our children in the crucial, formative years to weakness, hysteria, inferiority and incompetence [that is, to mothers]. . . . As a necessary result we are producing a generation of feminized men ('sissies' in the dialect of real boys) who will be fit only to escort women to poll or public office and to render such other puppy attentions as may be demanded by the Superior Sex!"[68] Monahan condemned mothers and correlated their dominion over young boys

with women's attacks on male political power. The sentimental boy becomes a "sissy" man in this account.

The outbreak of war in Europe politicized boyhood even more. As young European men marched into battle, many commentators argued that a nation's political, military, and economic strength depended upon the physical vitality and moral fortitude of its young boys. Cross-dressing on stage declined in France at this time, theater historian Lenard Berlanstein has argued, because the bodies of young boys became a symbol of national potency.[69] Although the United States did not send soldiers to the conflict until 1917, a similar phenomenon occurred. The war loomed in American imaginations when a German submarine sunk the British passenger liner *Lusitania* in May 1915, killing 128 Americans. Two months later, the United States demonstrated its imperial might by invading Haiti, beginning what was to be a nineteen-year occupation. The United States worked to differentiate itself from "degenerate" Old World nations by asserting its frontier-forged masculinity as the key to its success as an imperial world power.

The triumph of the red-blooded American boy is nowhere more apparent than in the dizzying ascent of Douglas Fairbanks. The athletic Broadway actor made his screen debut in November 1915. As Gaylyn Studlar has shown, the boy culture championed by Theodore Roosevelt and Ernest Seton crystallized in the figure of Fairbanks, who became "the movies' most vigorous embodiment of a realized ideal of American character as perpetual youthfulness and uninhibited, playful physicality."[70] Fairbanks's first film, *The Lamb* (Triangle, 1915), showed the progression of an effeminate, East Coast "mollycoddle" into an athletic frontier hero. Though Fairbanks was already thirty-two by this time, he embodied and actively promoted so-called boy culture. Following the film's unexpected success, Triangle released a new Fairbanks film almost every month, often tales of feminized young men discovering a more physically powerful form of masculinity. Journalist George Creel wrote a profile of Fairbanks in December 1916 in which he concluded: "Let no one quarrel with [Fairbanks's] popularity. It is a good sign, a healthful sign, a token that the blood of America still runs warm and red, and that chalk has not yet softened our bones."[71] Fairbanks's success was connected to the nation's masculine potency. Given the importance of boys' physical strength to the nation's conception of its global power, boys who were frail, timid, and otherwise feminine became an affront to national identity. When critics complained that female boys were not "realistic," they were implicitly delineating which qualities a "real" boy should possess. Whereas a "charmingly girlish appearance" had once been valued, it was now rejected. Although female boys on screen were never subject to the vitriolic attacks that vilified stage women in adult male roles, evolving ideals of boyhood—and raised stakes for virile masculinity—changed the ways that boys could be represented on screen.

"HE'S NO SISSY": MARY PICKFORD'S FAUNTLEROY

United Artists' 1921 film adaptation of *Little Lord Fauntleroy* illustrates how one female boy tried to adapt to the new standards of boyhood.[72] Mary Pickford, one of the most popular actresses in the world and one of the most powerful women in Hollywood, produced the film and starred in it. Using in-camera special effects, she played both Fauntleroy and his mother. The contradiction of trying to reconcile Fauntleroy—an emblem of feminized boyhood—with America's new standards of masculinity becomes apparent in the film's deviations from the novel and in its polarized reception. Whereas the novel establishes Cedric Errol as an ideal sentimental boy, the film characterizes Cedric as a rambunctious fighter as well. In contrast to the novel, which introduces Cedric comforting his grieving mother, the film opens with Cedric flying by on a bicycle, a bully in pursuit. Cedric and the bully land in a puddle, and the bully shouts, "You curly-headed sissy!"—thereby folding the real-world critiques of Fauntleroy into the world of the film. But this Cedric is no sissy. He throws mud at the bully and later attacks a gang of working-class boys who ridicule his hair. Cedric even looks wistfully into a barbershop at one point, longing for a haircut. His discontent places him in league with the young boys "plagued" by their mothers' infatuation with Fauntleroy. Of course, the visual spectacle of Pickford's body undermines Cedric's red-bloodedness to some extent: even if Cedric is vigorous and assertive, he is at the same time pretty and feminine. For all their girlishness, though, Pickford's characters were also often quite boyish. Pickford had cross-dressed in seven earlier films, and her characters often instigated fights.[73] Indeed, she likely chose this role in order to make her cutesy persona more boyish. And yet, Fauntleroy's status as a "real" (red-blooded) boy was very much in question. When Cedric goes to England, the film increasingly showcases his beauty and empathy, although a rough-and-tumble fight with a boy posing as the Fauntleroy heir (Frances Marion) again displays his physical prowess (fig. 6). While the novel describes Fauntleroy as an androgynous, sentimental boy hero, the film portrays him as both sentimental hero and red-blooded boy.

For some critics, Fauntleroy simply could not be reconciled with modern American boyhood. A few went so far as to compare Pickford's performance of boyhood with that of her new husband, Douglas Fairbanks. A reviewer in *Exceptional Photoplays*, an organ of the National Board of Review of Motion Pictures, remarked that "Mary Pickford seems bent upon keeping pace with her energetic husband in presenting us with the past favorites of the library; she has matched Douglas Fairbanks in 'The Three Musketeers' with herself as 'Little Lord Fauntleroy.'" In comparison with Fairbanks's laudable adaptation, Pickford's source was "a little mawkish and most decidedly snobbish." The

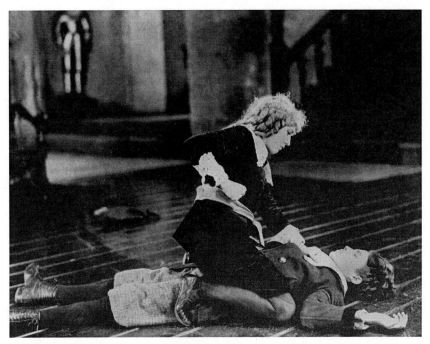

FIGURE 6. Cedric Errol (Mary Pickford) is both cute and feisty as he challenges the false heir (Arthur Thalasso) in *Little Lord Fauntleroy*, from the author's collection.

critic complained precisely about Fauntleroy's incompatibility with the new ideal of American boyhood, the Boy Scout: "It is hard to imagine the book being much read at the camp fires of the American Boy Scouts, and there is no surer way to put a real boy into a rage than to rig him out in curls and sashes and to call him a little Lord Fauntleroy."[74] The athletic, playful masculinity of Fairbanks's D'Artagnan, the critic implied, was much more compatible with contemporary values. Furthermore, the critic noted that Pickford's visible femininity and cutesy mannerisms simply could not be reconciled with a boy identity.

Other critics praised the film and Pickford's performance, though not for feminine wistfulness or timidity, as in earlier reviews of female boys. Grace Kingsley at the *Los Angeles Times* affirmed this new brand of vigorous boyhood: "He's no sissy, this Fauntleroy of Mary's; there's real boyishness in him."[75] *Variety* concurred, praising Pickford for bringing both her husband's and her brother's athleticism to the role:

Only Jack [Pickford] could have introduced the whimsical and always amusing touches of raw boyishness in the fighting, grimacing, scheming, lovable kid that Mary Pickford again turns out to be, but this time she is more boy

than girl; heretofore her charm in boy parts has been her glorious girlishness; now it is her genuine youthful Tom Sawyer masculinity, a scrapping, two-fisted kid who tears off his laces and velvets and goes to it with the dirty-eared roughnecks.

At other times Doug's classic propensities are obviously exhibited. She jumps off high perches onto other boys' backs, she wrestles and does trick jiu-jutsus [*sic*], she dodges and climbs and leans and tumbles and hand-stands.[76]

The *Variety* reviewer accepted the film in precisely the spirit it was intended: as a showcase for Pickford's acting ability and a demonstration of a female boy in sync with modern ideals. Unlike the film's detractors, this critic found Pickford to be "more boy than girl" and affirmed her alignment with the red-blooded ideal of "Tom Sawyer masculinity." The film, like all Pickford vehicles, was financially successful, but neither Pickford nor any other established actresses appeared in boy roles after this one. The growing restrictions on the range of acceptable boy identities led to an increasing reluctance to accept female bodies in boy roles.

CROSS-GENDER CASTING AND THE STAR SYSTEM

The rise of the star system also contributed to the decline of the female boy. In the 1910s, filmmakers worked to make female performers more identifiable and sexually attractive through closer shots of their faces, more feminizing makeup, and more form-fitting, fashionable clothing. When these techniques were applied to female boys, the result interfered with viewers' immersion in the world of the film. A shot from the 1916 *Oliver Twist* offers a particularly clear example of the competing claims of narrative and the star system. Although the film is lost, *Motion Picture Magazine* reprinted a series of frame enlargements. In the film's prologue (which also sometimes appeared at the end of the film), actress Marie Doro appears as Oliver on the left side of the screen and as "herself" on the right side, all within a single frame (fig. 7). The shot showcases Doro's skill by illustrating how different the "real" Doro is from the character she plays. It also highlights the film camera's unique ability to allow spectators to compare two moving versions of the same body. However, the analytic gaze that this shot invites interfered with the immersion that allowed the body of Doro to be taken for a boy. In *Moving Picture World*, George Blaisdell complained about precisely this problem with "the picture of the bedraggled child on one side of the screen and on the other Marie Doro all fussed up in her best. It jerks the spectator out of the spell of the story into the realm of feminine vanity; it is unpleasant and it is inartistic."[77] But rather than blame "feminine vanity," it seems more accurate to fault the star system, which was working to market film actresses as young,

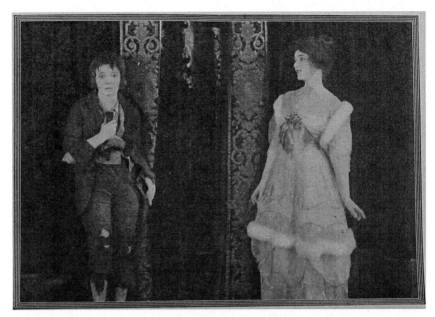

FIGURE 7. Marie Doro as Oliver on the left and as "herself" on the right, from "Marie Doro as Oliver Twist," *Motion Picture Magazine* (February 1917).

attractive women and make them recognizable as such in every role. Indeed, this criticism is a version of the same complaint that the *Cleveland Ledger* had levied against Doro, that "these female stars never seem to find suits that are too big for them."

In a sense, this way of presenting female boys brought together the comic opera tradition of displaying the female body via tight-fitting male costumes and the melodramatic tradition of young women in serious boy roles. The two modes of spectatorship did not lie easily together. Of course, a theatergoer watching a female Oliver Twist was well aware that the body onstage was female. However, the audience's distance from the performer and the possibility of reading femininity as an expression of sentimental boyhood meant that the fictional male persona was just as persuasive and that the spectator had to do a certain amount of visual and mental work to read the body as only female. In the films of 1916, in contrast, performers were shown in medium and medium close-up shots, and actresses were made up and lit to look unmistakably female, so the boy character was harder to maintain.

Although audiences had always been expected to recognize the established Broadway actresses playing female boys in moving pictures, critics had difficulty reconciling an identifiable film actress with a male role. Of Pickford's Fauntleroy, for example, the critic for the *New York Times* wrote:

The present writer, at any rate, cannot deny that he finds [Pickford's] Lord Fauntleroy delightful. But this admission does not mean that Miss Pickford's performance is entirely approved. It cannot be. It gives the spectator much pleasure, yet it disturbs him. It annoys him because it is always tempting him to lose himself in the story of which it is a part and at the same time forever forcing upon his consciousness the fact that it is Mary Pickford, a grown woman dressed and acting as a boy and not the boy himself whom he is watching. . . . In enjoying her you are enjoying Mary Pickford, not Little Lord Fauntleroy.[78]

As with *Oliver Twist*, the critic found the female star persona to be at odds with narrative immersion. Pickford's prior films and publicity had made the actress so recognizable that the presence of her twenty-nine-year-old female body made it impossible for the critic to believe in the boy character. Furthermore, the use of split screen to display Pickford as both a young male and an older female also invited viewers to adopt an analytic, spectacle-oriented mode of viewing that disrupted their immersion. Interestingly, critics found the mother role more of a stretch for Pickford than the boy role and praised her newly revealed ability to play an adult.

In 1924, critics received Betty Bronson's performance as Peter Pan more favorably. Because she had never appeared in films before, spectators did not have to contend with the spectacle of a popular actress interfering with their immersive viewing. "She bring[s] to the screen a personality unfettered by the association with other roles," wrote one critic in *Motion Picture World*.[79] Additionally, the film maintained the self-consciously theatrical elements of the play. Humans in costume play the dog Nana and the crocodile, and at one point Peter looks directly at the camera and asks the film audience to clap their hands to save Tinker Bell's life. Furthermore, Bronson adopted the movement style of a dancer, pausing in dynamic poses and hovering on her toes like a balletic wood sprite. The film is so stylized that realism is beside the point. Finally, author J. M. Barrie had veto power over who could play Peter and insisted on exclusively female performers. Thus, the film's casting was consistent with theatrical practice and the author's express demand.

In contrast to the standard explanation for the failure of cross-gender casting in cinema, which assumes that cross-gender performance is inherently unrealistic and cinema realistic, I argue that filmmakers chose to make women in boy roles more visibly feminine in order to promote the performers as attractive, recognizable stars. Critics did not find the lack of realism a problem when femininity was considered a valued attribute of boyhood, but it became unacceptable when a more masculine ideal of boyhood became dominant.

DISAVOWING THE FEMALE BOY

In the 1920s, journalists and publicists went out of their way to overlook the roles that women had played behind the camera, as Shelley Stamp has shown, but also to deny that female boys had ever had a place in American cinema.[80] When French director Maurice Tourneur cast Shirley Mason as Jim Hawkins in his 1920 *Treasure Island*, the film's pressbook framed this choice as a novel and unexpected caprice on the part of the foreign director. A promotional article from the pressbook asserted that Tourneur "searched far and wide for a boy actor to play the role of young Jim Hawkins" and "interviewed several youthful aspirants," until "the thought flashed through his mind that a girl could probably lend more charm and piquancy to the part than any boy could hope to attain."[81] This claim obscures the fact that stage adaptations of the story had always featured actresses in the role of Jim. Another article claimed that "Shirley Mason recently realized a life-long ambition. She has always wanted to be a boy so she could 'go barefoot.'" In fact, Mason had already appeared in two films—*Sloth* (McClure Pictures, Inc., 1917) and *The Little Chevalier* (Edison/Conquest Pictures, 1917)—in disguise as a boy. An article about *Sloth* also claimed that Mason had always wanted to be a boy (in this case, so she could ride in a plane).[82] By ignoring these precedents, the publicity for *Treasure Island* suppressed the memory of cross-gender casting as a longstanding industry practice and pitched it as a whimsical innovation of this particular production.

Likewise, a 1924 *Los Angeles Times* article, "Girls Will Be Boys!" claimed that female-to-male cross-dressing was a new phenomenon in American cinema: "The films have been practically immune from such impersonations, except in rare and isolated instances."[83] The only precedent the journalist could recall was Pickford's Fauntleroy, which was "far from satisfactory." Disregarding the previous fifteen years of filmmaking, the journalist summoned the traditional argument that cross-gender casting was contrary to cinema's realist impulse: "The opinion prevails that the screen demands more reality in every respect." Thus, the standard version of American film history—one that does not include cross-gender casting—was already being established by journalists in the mid-1920s. This narrative stemmed from both a desire for perpetual novelty and a distancing from earlier modes of filmmaking. Disavowal of cross-gender casting was also evident in the process whereby Jackie Coogan took over the roles that were formerly the specialty of female performers.

JACKIE COOGAN AND THE LEGACY OF THE FEMALE BOY

Male performers had always played boys alongside female boys, but very young male actors became the new norm in the 1920s. Like the female boys, Jackie Coogan had soft, delicate features and combined mischievousness and vulnerability. In his first major film role, *The Kid* (Charles Chaplin Productions, 1921), Coogan played a young orphan adopted by the Tramp. His celebrated performance set the template for his roles to come. As film historian Rob King has noted, Coogan played an orphan or abandoned child in all but two of the sixteen films he made as a child.[84] These are precisely the roles previously associated with actresses. Like earlier female boys, Coogan's Kid oscillates between naughtiness, affection, grief, and terror. The Kid's wrenching entreaties when he is taken to the orphanage are reminiscent of female Oliver Twists like Vinnie Burns and Marie Doro. Overall, though, Coogan looks and acts like a smaller, feistier version of Marie Eline. But at five years old, Coogan was younger and smaller than even Eline, who was eight when she began acting. His oversized clothing accentuated his smallness, as did scenes in which the Tramp picks him up with just one hand.

Rob King perceptively argues that Coogan's star image bridged late Victorian and modern consumer culture by integrating the discipline, filial piety, and dependence of the Victorian child with the spontaneity and playfulness of the modern child and by interpellating children as consumers.[85] King does not consider, however, that Coogan entered into a tradition of sentimental boy performance that had been dominated by actresses and that while balancing Victorian and modern ideals of childhood, Coogan also negotiated shifting gender norms. When Grace Kingsley of the *Los Angeles Times* called Coogan "a Raphael's cherub of the tenement back yards, a Little Lord Fauntleroy of the alleys" later that year, she mobilized the language of sentimental boyhood that had been used to praise female performers.[86] In fact, she lauded Coogan for achieving the same effect she had praised in Marie Doro's performance five years earlier.

Coogan's usurpation of the female boy tradition became more aggressive in 1922, when he starred in a new adaptation of *Oliver Twist*. While the film was in production, the *Los Angeles Times* announced that producer Sol Lesser had paid $50,000 to purchase the negative and all existing prints of an older version of *Oliver Twist*, which he intended to destroy. Coogan was to strike the match. Lesser explained:

> It was expedient to put out of the way forever this old picture that was threatened as a parallel production with ours. And when I say 'put out of the way forever,' I mean just that. We shall have a brief, but glorious blaze and 'Oliver Twist,' as

made twelve years ago, with paper scenery, will join the elements. . . . It is not extravagance that destroys such relics of the past. It is economy, for if they are permitted to jeopardize new productions, bewilder the public with counter claims to attention, and interfere with the normal progress of the art, they will do inestimable damage.[87]

Lesser's determination to take the old film off the market and destroy it forever suggests something more than a desire to prevent unscrupulous distributors from pawning it off as his film. Through this publicity stunt, Lesser disavowed a cinematic past embarrassingly beholden to theater. While it is not clear which version of *Oliver Twist* Lesser intended to burn and whether it featured a female Oliver, female Olivers were unquestionably part of the medium's admiring relationship to theater. Lesser implicitly consigned these female Olivers to the medium's ignoble past, an embarrassing deviation from "the normal progress of the art." However, his strategy seems curiously ineffective, as there were already at least thirteen different versions of *Oliver Twist* in circulation.

To further demonstrate the superiority of Coogan and modern filmmaking, Lesser showed an excerpt from an earlier *Oliver Twist* before the press screening of his new version (perhaps from the film he had planned to burn?). According to a critic at *Theatre Magazine*, it was "a rather notable production made ten or a dozen years ago with Marie Doro in the part of Oliver and the late Nat C. Goodwin in the part of Fagin."[88] The critic evidently misremembered: Doro and Goodwin were in the 1912 Broadway production together but never appeared in a film adaptation together, so the footage was from either the 1912 version with Goodwin and Vinnie Burns or the 1916 version with Doro. The critic praised Goodwin and described the Oliver as "at least an acceptable actress," but admitted that "this old film now seemed ridiculous because of its technical deficiencies." That is, he essentially endorsed Lesser's teleology that aligned female Olivers with the "technical deficiencies" of an earlier generation of moving pictures. Female boys, who had been so useful for filmmakers hoping to lure middle-class women viewers during the 1910s, were consigned to the dustbin with other hopelessly theatrical practices like canvas backdrops and tableau staging.

While the novel and previous stage productions of *Oliver Twist* emphasized Oliver's undernourishment, fainting spells, and timidity, Coogan brought the American ideals of playfulness and physical vitality to his Oliver. He is much more physically active than Burns or Millais, and less victimized. He mugs for the camera and incorporates regular comic bits. At six, he is also significantly younger than the actresses who usually played Oliver. As in *The Kid*, the film emphasizes his smallness via costumes, mise-en-scène, and framing; adults lift him with one hand and throw him across the room. Coogan's smallness

and the extradiegetic knowledge that his gender matched that of his character set his performances apart from the female boys. But the characters he played were entirely in line with the sentimental boys that had been the specialty of female performers, and his appearance resembled theirs. Unlike the short styles that were the norm for boys at the time, Coogan wore his hair in an old-fashioned pageboy.

Some prominent male critics argued that Coogan should take over all remaining female boy roles. When Famous Players–Lasky announced its intention to adapt *Peter Pan*, Robert E. Sherwood at *Life* magazine had "already nominated my selection" for the title role: "He is Jackie Coogan, the perfect embodiment of *Peter* as Barrie described him. . . . Of course, the part has always been played on the stage by a mature woman; but the broad screen is not so trammeled. I earnestly urge all those who happened to read these remarks to write at once to their Congressmen and demand that the engagement of Jackie Coogan for *Peter Pan* be made compulsory."[89] While Sherwood's hyperbole is humorous, it nonetheless conveys his strong opinion that the female boy should be replaced by the *male* boy. He was not alone in this opinion. Edwin Schallert at the *Los Angeles Times* also declared Coogan the logical choice: "There is, of course, no reason why Peter Pan should be played [by] a girl on the screen. . . . [T]here is a possibility that a boy would give more reality to the screen interpretation."[90] Both critics argued that a male performer would be more realistic than a female performer and that the moving pictures should shed theatrical conventions. They also suggested that Coogan had the rare ability to embody the androgyny that had previously been considered the province of young women. In this case, the Coogan supporters were disappointed, and eighteen-year-old Betty Bronson got the part, which turned out to be the last major female boy performance in American cinema.

Coogan's on-screen androgyny was moderated by assertions of his virile masculinity off-screen. These stories displayed Coogan's fundamental divide from femininity and femaleness. In a March 1921 article, for example, Grace Kingsley affirmed, "Jackie is a true boy in that he can pick up without a tremor any old worm that ever wriggled."[91] "The kid star is a good sportsman," she continued. "He is a fair shot, and owns his own rifle, and he can beat his dad playing golf." Likewise, several reports noted Coogan's alleged penchant for gambling. The *New York Times* proclaimed, "Chaplin's Five-Year-Old Co-Star Likes to Play Poker and Rhummy and to Shoot Craps."[92] In a public letter to his fans emphasizing good hygiene, Coogan assured readers: "You don't have to be a sissy to do these things. I'm not."[93]

Coogan also demonstrated his "true" masculinity through rather misogynist interactions with girls. A 1921 profile of the child star noted approvingly that the boy "Treats Girls Rough."[94] Reputedly, when a young neighbor girl refused his

invitation to go out and play, he "looked at daddy and he motioned to me with his elbow, so I grabbed [her] like that and that, and she went out. That's the way to do, treat 'em rough." These off-screen displays of virile, even misogynist, masculinity legitimated Coogan's on-screen performances of an androgynous ideal. Female boys, of course, would not have had access to this form of legitimization; audiences would not have wanted a female performer to demonstrate that she was a "real boy" off-screen. Coogan managed to carry on the legacy of the androgynous, sentimental boy that had been a specialty of female performers by emphasizing the genuineness of his gender.

Although film historian Lea Jacobs argues that the 1920s witnessed the "decline of sentiment" in American moving pictures, Anke Brouwers quite rightly points out that sentimentality continued merrily along in many of the era's most popular productions, particularly in the films of Mary Pickford.[95] Indeed, Coogan's popularity during this period attests to the continuation of a sentimental ethos, albeit one tempered by comedy and demonstrations of red-blooded boyhood. Big-city male critics may have turned away from overt sentimentality, but it did not disappear as an organizing principle of American filmmaking. However, the girls and women in boy roles who had embodied sentimental boyhood in more than a hundred productions during the 1910s dropped abruptly out of the picture. Between 1908 and 1921, female boys helped connect moving pictures to genteel theatrical practice and the consumption patterns of middle-class women. They offered a wholesome alternative to the sex and violence popular with working-class audiences and brought none of the concerns of other forms of cross-gender casting. Though the actresses who played female boys were of all ages and performed in a variety of acting styles, they were generally small, thin, white, and photogenic, and their performances combined boldness and vulnerability. Their femaleness allowed them to convey fragility and androgynous beauty. These performances demonstrate that cross-gender casting, which may seem like an inherently transgressive practice to twenty-first-century scholars, can also uphold conservative gender, class, and racial regimes. At the same time, the performances cannot be dismissed as reactionary or antifeminist, because they embodied middle-class women's sentimental politics and created a space in which women's bodies had an important role in producing an idealized masculinity. In the case of Edna "Billy" Foster, the practice provided the rare opportunity for a production company to build a male picture personality around a female performer.

Although the films were praised by critics, they may not have achieved their producers' goal of enticing middle-class female audiences to the movies, or they may have alienated regular picture-goers. I have not been able to find sales or

rental receipts for these films. Regardless of audience behavior, though, it is clear that the attitudes of film critics changed in the mid-teens. They began to find female boys less realistic because femininity was no longer a valued characteristic of boyhood. However, young women did have a part to play in promoting a new, overtly masculine national identity as virile cross-dressing cowboy girls and girl spies.

2 ▸ COWBOY GIRLS, GIRL SPIES, AND THE HOMOEROTIC FRONTIER

Upon receiving a telegraph message that her sweetheart's regiment has been ambushed by Sioux Indians, Eva Reynolds (Anna Little) slips into men's clothing, mounts a white stallion, and gallops to the rescue with the cavalry (fig. 8). Dead men and horses lay strewn across the scene of the ambush, and the cavalry rides on. Eva races to a telegraph pole, where she finds her sweetheart, Bob Evans (Francis Ford), collapsed. She lifts him onto her horse and conveys him to the safety of the fort. The film is Bison's *The Post Telegrapher* (1912). Of Little's performance in this and other films, a critic for *Moving Picture World* wrote: "One woman sweeps on the screen like a whirlwind. She is Anna Little, a corking rider, full of vim in action, and one of the best actresses in her role I have ever seen. . . . It is a pleasure to see a heroine who can do something more than smile, roll her eyes, and embrace. The American girl is best typified by those of energy, never by the chalk-faces who stand at street corners on the Rialto."[1] While film critics increasingly questioned the "girl boys" described in the last chapter, they celebrated frontier and wartime "boy girls" like Anna Little for embodying a virile national ideal. Between 1908 and 1921, American frontier and war films regularly featured heroic cross-dressed rescuers like Little, as well as romances between men and disguised girls, although these films are largely absent from scholarship on silent cinema, the western, or cross-dressing in film.

American folklore is full of girls and women disguising themselves as boys to go to war or make their fortune out West. Newspaper articles and memoirs attest

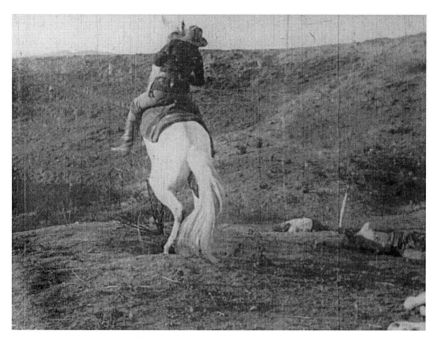

FIGURE 8. Eva's horse rears before she gallops off to find her injured sweetheart in *The Post Telegrapher*. Courtesy of the EYE Filmmuseum/Desmet Collection.

to a great number of female-bodied individuals living as men in the American frontier.[2] (As I discuss in the introduction, I call historical individuals who were assigned female at birth but lived as men "female-bodied men" rather than "passing women" in order to respect their publicly claimed gender.) Female-bodied men show up in a range of popular representations, from dime novels to cowboy songs. Tough Western women are also the subject of more genteel entertainments, such as David Belasco's ambitiously staged *Girl of the Golden West* (1905) and Giacomo Puccini's operatic adaptation, *La Fanciulla del West* (1910). At the same time, athletic Western women showed off their shooting and riding skills in Wild West shows that attracted cross-class audiences all around the United States and Europe. American moving picture producers drew upon familiar stories of cross-dressing cowboy girls and girl spies in order to appeal simultaneously to working-class and genteel audiences, with hopes of establishing cross-class, trans-regional audiences like the ones attending Wild West shows.

Many American films during this first wave (1908–1921) depicted masculinized young white women as a positive, national ideal and expanded familiar narratives through uniquely cinematic means. Although gender disguise was not necessary to enable a woman's heroic actions, it was very common and occurred in more than eighty frontier and war films during this period. A little more than

half were set on the frontier and the rest on the battlefront, mostly of the Civil War. Two key tropes were the cross-dressed chase and a romance between a man and a disguised girl, which I call the "range romance." The films exploited audiences' twin fascinations with masculinized young women and the American landscape, juxtaposing the two in a fashion that surpassed even Belasco's remarkable stagecraft. The cross-dressed chase and range romance were built upon the potentially threatening possibilities of women taking over for incapacitated men and of sexual desire between men. For these reasons, American moving pictures celebrated cross-dressed cowboy girls and girl spies only so long as their masculinity was confined to a particular time—girlhood—and a particular space— the frontier or battlefront. This temporary female masculinity was distinguished from the ostensibly permanent gender deviance of people of color as well as from politicized, East Coast, white women. Female heroics were not simply a form of female emancipation but participated in a nationalistic, racialized frontier ideology and the production of a vital, white, American race and the middle-class, heterosexual family. As production companies increasingly moved west, films helped to align the moving picture industry with American frontier vitality. Although that vitality remained the crucial attraction of a new round of female stars in the mid-teens—the serial queens—full-on cross-dressing became less common as films adopted a visual regime that made femininity and femaleness more immediately recognizable.

This chapter argues that American moving pictures used cross-dressed cowboy girls and girl spies to appeal to cross-class, trans-regional audiences and affirm a virile national ideal. The first part analyzes the strategies of the cross-dressed chase sequence in the early teens and the comparative feminization of female action stars in the serials of the mid-teens. The next part explores the contradictory ideological structure of range romances in two-reelers of the early teens and prestige feature films of the late teens. It is likely that the representation of cross-dressing as a temporary, pleasurable activity in so many frontier and war films helped depoliticize masculine styles of women's clothing—or, more accurately, that it helped unsettle the link between masculine styles and radical feminism and strengthen the link between masculine women's styles and American imperial ideology.

COWBOY GIRLS AND GIRL SPIES

The frontier and the battlefield have long been imagined to be exclusively male spaces. White women are either excluded entirely or function as small force fields of "civilization," while Native and Latina women are relegated to the landscape.[3] This approach, however, obscures the contribution of female bodies to ideals of American masculinity and erases the historical presence of masculine

women—and female-bodied men—on the frontier and the battlefront, as well as their presence in representations of these spaces.[4] There was profound slippage between the frontier and the battlefront in the popular imagination during this period. Both battlefront and frontier were imagined to be temporary, masculine, and beyond the bounds of civilization. Furthermore, the frontier *was* a battlefront—a prolonged, shifting space where the "white" and the "red" races faced off. Conversely, the battlefront could also be conceived of as a frontier. When the Western frontier was declared closed, Theodore Roosevelt and others argued that the United States should seek out new battlefronts in order to preserve the country's frontier virtues, as cultural historian Gail Bederman has shown.[5] Thus, while the Civil War and the frontier were spatialized along different axes (North-South; East-West) and racialized differently ("white" versus "white"; "white" versus "red"), both narratives helped forge the symbolic boundaries of the American nation and the virile character of its citizens. Also, in both spaces young women could embody the most prized traits of a powerful, masculine, American identity. Girl spies as well as cowboy girls display what were understood to be distinctly "frontier" attributes, such as athleticism, horsemanship, and outdoor skills.

As film subjects, both the frontier and the Civil War provided filmmakers with the opportunity to set spectacular conflicts in the American landscape. Richard Abel writes that the decision of the Bison 101 Film Company in 1912 "to begin making Civil War films inextricably linked them with westerns . . . as uniquely American sensational melodramas focused on war."[6] Indeed, reviewers evidently considered frontier and Civil War cross-dressing films to be variations on each other. When Champion released *A Western Girl's Sacrifice* a month and a half after Biograph's *The House with Closed Shutters, Moving Picture World* noted the plot similarities: "Whether it was merely coincidence, or whether one or the other producer was duped into accepting a scenario already used by another, one cannot say. But with location changed this is the same story as was told in 'The House with the Closed Shutters.'"[7] Frontier and Civil War settings offered a surprisingly interchangeable field upon which young white women could display their athletic heroism.

Richard Abel has called attention to the presence of cross-dressed heroines in transitional-era American westerns and Civil War films.[8] He notes that "what a good number of the westerns so popular here and abroad in the early 1910s had at their center was a vigorously active heroine, a 'Western species' of what the Europeans perceived as a distinctly *American* New Woman [emphasis in original]."[9] Juvenile book series such as *The Ranch Girls* and female Wild West performers provided an important context for these films; but not all frontier heroines cross-dressed, Abel notes, nor were all "cowboy girl" films action-packed.[10] While my research largely supports Abel's conclusions, I found that

frontier heroines were not always aligned with the concept of the New Woman. One 1915 brochure, for example, asserted that the 101 Ranch cowgirl "is a development of the stock-raising West comparing with the bachelor girl and the independent woman of the East. She is not of the new woman class."[11] I build upon Abel's research by considering the formal strategies of surviving films and investigating range romance films, which fall outside his investigation.

In contrast to Abel, comparative media scholar Nanna Verhoeff treats the "young wild women" of early westerns theoretically, arguing that they illustrate her point that "film inherently deconstructs the categories it puts forward."[12] Cross-dressing is a powerful expression of Western women's symbolic and spatial mobility, she argues, and demonstrates the instability of stereotypes even as it requires these stereotypes to achieve its effects. Verhoeff echoes literary theorist Marjorie Garber's argument that cross-dressing enacts "not just a category crisis of male and female, but the crisis of category itself."[13] While Verhoeff sees cross-dressing as inherently and fundamentally transgressive, I contend that the cross-dressing in question, while offering white women a temporary freedom from the burdens of middle-class femininity, also worked to support white supremacist, heterosexual American national mythology.[14] Like Abel, she contends that women of the West "are embodiments of the 'New Woman,'" which simplifies the complex functions of these figures.[15]

Abel also discusses the popularity of girl spies in Civil War films during the same period, which drew on the storytelling tradition of Revolutionary and Civil War "confidence women" and perhaps offered a "model of transformation for immigrants and particularly working class immigrant women."[16] Film historian Elizabeth Clarke has also shown that the period 1908–1915 was a golden age for active women heroines in American war films, wedged between the masculine displays of Spanish-American War actualities and the gritty male heroics that corresponded with America's entry into the First World War.[17] Clarke argues that female heroes were prominent during this period because their defense of home and country dovetailed with the national discourse of "preparedness" and because the stories channeled women's political and social ambitions into nationalist aims. Building on this work, I explore the connections between cinematic warrior women and the frontier ideology so popular in this period.

These frontier and battlefront films expand our understanding of cross-dressing in cinema. The chase films fall completely outside Chris Straayer's temporary transvestite genre: they are action thrillers, not comedies; the disguised women excel at "male" tasks; the gender disguise is often convincing to the film audience; the disguised character is only sometimes unmasked; and there is only occasionally a heterosexual love story.[18] While the range romances fit more comfortably into the temporary transvestite genre, they complicate its comedic aspects because audiences likely knew stories about real-life female-bodied

men on the frontier and in the Civil War from popular autobiographies and newspaper accounts.

The American landscape was imagined to be key to American vitality. In particular, as medical historian Alexandra Stern writes, eugenicists "conceived of the West as a savage frontier where men afflicted by neurasthenia and the deleterious effects of urbanization and industrialization could be restored through mountaineering, bareback riding, and communing with the primeval forest."[19] Many observers feared that the shocks of city living combined with the deadening routine of white-collar and factory work sapped individuals' vitality, endangering the health of the white American "race." Men and boys—as well as some women and girls—flocked not only to the West but also to local recreation areas and city parks in the hope that active contact with the American outdoors would restore this vitality. For example, after being mocked as a "Jane Dandy," the young Theodore Roosevelt retreated to a Dakota ranch to refashion himself as a powerful Western frontiersman.[20] The rugged topography of the American landscape offered an obstacle course for the aspiring outdoorsman (and woman) to hone his physical abilities. The requirements of outdoor living cultivated strength of body and strength of character. More metaphysically, some eugenicists believed that organisms could inherit traits directly from their environment, and they promoted California as the ideal setting from which to construct a vigorous new American race.[21] Organizations such as the Woodcraft Indians, Sons of Daniel Boone, Boy Scouts, and Young Men's Christian Association sprung up to mold boys' bodies and characters through exposure to the outdoors. At the same time, girls organized their own scouting troops, learned outdoor skills, and appropriated their brothers' dime novels. Series fiction like the Ranch Girls, Outdoor Girls, Automobile Girls, Girl Aviators, and Moving Picture Girls followed the adventures of plucky young women on and off the range.

American landscapes were also used to symbolize the might and majesty of the United States. Exploiting the popularity of landscape painting, photography, illustrations, and postcards, American film companies marketed their ability to present real American landscapes. Essanay, for example, advertised films "made in the West . . . amidst scenes of beauty which are alone well worth viewing. The Essanay Western pictures are genuine, and that's the reason they are so successful."[22] The outdoor settings in which films were shot tapped into the cultural meanings that had been assigned to American landscapes. Mythologies of the frontier became more important to the American moving picture industry as production companies moved west. The first generation of production companies was concentrated in New York, Chicago, and the surrounding areas. To keep up with demand, companies sent production units to sunny locations during wintertime, including Florida, Texas, California, Cuba, and Jamaica. In the winter of 1909–1910, a handful of companies, including Selig, Biograph, and

the New York Motion Picture Company, set up studio spaces in Los Angeles, though few intended to stay permanently. The next winter, even more companies arrived, and Essanay and Lubin established permanent studios in California. By April 1911, *Moving Picture World* could declare Los Angeles "second only to New York" in the field of motion picture production. That winter the Nestor Company established the first studio in "Hollywood" proper, though the area was still a sleepy town. Over the next couple of years, many companies continued to commute between the East and West Coasts, but by 1915 the Los Angeles Chamber of Commerce boasted that 80 percent of the country's motion pictures were produced there.[23] As production companies migrated westward, the vital frontier girl became more important to the industry. She was one of the uniquely "American" spectacles that production companies could present to audiences, along with real frontier landscapes.

Cross-dressing frontier women offer an important counterpoint to film history accounts of men racing to the rescue of confined women and the assumption that films could not represent desire between men. These figures demonstrate the importance of female bodies to the construction of American masculinity and of masculinity to American womanhood. They exceed the generic conventions of the temporary transvestite genre and demonstrate how important ostensibly deviant expressions of gender and sexuality were to the construction of normative, national ideals.

THE CROSS-DRESSED CHASE

Cross-dressed cowboy girls and girl spies were few and far between before 1908. When Edison filmed the famous sharpshooter Annie Oakley in 1894, she wore her trademark dress and corset. Ten years later, Selig's *The Girls in Overalls* depicted a day in the lives of seven sisters running a Colorado farm. The film contains many elements that characterize later cross-dressing films. Even as it explains men's clothing as a practical necessity for these women and part of an authentic glimpse of Western life, the clothing is exploited as a comic spectacle and symbol of women taking over for incompetent men. Selig's publicity bulletin promised an entertaining juxtaposition of incongruous elements: "The sight of bright-eyed, smiling girls driving a horse hitched to a rake is quite amusing, but when the girls wear overalls and high-heeled shoes and even black lace [shirt]waists under the bibs of the jeans [it] is doubly interesting. Think of a girl carrying straps and buckles and pieces of wire in one pocket of her trousers and a box of cream candies in another!"[24] The girls function simultaneously as comic spectacle and a glimpse of "authentic" Colorado farm life.

A few years later, Selig released *The Female Highwayman* (1906), about a female thief who disguises herself as a man to avoid pursuit, and *The Girl from*

Montana (1907), in which a cowgirl rides to the rescue of her boyfriend, although she does not disguise her gender.[25] Vitagraph's *The Spy, a Romantic Story of the Civil War* (1907) is the first cross-dressing Civil War film I have found. A soldier and his girlfriend exchange clothes so he can escape. In 1909, cross-dressing heroines in frontier and Civil War films took off. The cross-dressed chase sequence is an essential element of the films that survive.

Cross-dressed chase sequences united the attractions of popular stage melodramas and Wild West shows and extended these established devices via cinema's unique ability to present real-world outdoor space. While many races to the rescue used parallel editing to depict vulnerable white women pursued into ever-smaller interiors, cross-dressed chases used linear editing to display white women's spatial mastery. In these sequences, women in male garb ride and run through a series of outdoor spaces, successfully evading a band of male pursuers. While the narratives played on contemporary anxieties that the economic and political gains of middle-class white women were linked to the decline of white men, they also proffered women as embodiments of a national ideal.[26]

One of the first surviving examples is the Edison Manufacturing Company's *On the Western Frontier*, released in April 1909. In a convoluted plot, a frontier girl discovers that her sweetheart, an officer assigned to deliver a message to his commander, has been drugged while eating dinner at her house. She borrows his clothes and horse and takes the message to his commander. As in *The Post Telegrapher*, we see the girl leap onto a white horse and gallop off. When she delivers the message, however, she discovers that it is an order for her brother's arrest. Horrified, she races back to the house to warn him, pursued by soldiers on horseback. The girl outruns the soldiers and warns her brother, who escapes. As the soldiers arrive, the girl embraces her now-awake sweetheart, and the film ends. The film displays characteristics typical of the cross-dressed chase: a young woman steps in for an incapacitated man, navigates a series of outdoor spaces faster than the men who pursue her, and shows off her riding skills. What makes this early example different from the ones that would follow, though, is that, in this film, the majestic Western landscape behind the girl's cabin is represented by a painted canvas backdrop. The spaces she rides through are real, although the dirt roads of New Jersey are not nearly as spectacular as the California and Florida landscapes of later films.

Indeed, cross-dressing action heroines proliferated in frontier and Civil War films. Frontier examples include: *A Cowboy Argument* (Lubin, 1909), *The Red Girl and the Child* (Pathé, 1910), *A Western Girl's Sacrifice* (Champion, 1910), *The Sheriff's Daughter* (Pathé, 1911), *The Post Telegrapher*, and *A Girl Worth Having* (Kinemacolor, 1913). Gene Gauntier, a pioneering director, screenwriter, and actress at Kalem, launched a cross-dressing girl spy series in May 1909: *The Girl Spy: An Incident of the Civil War* (1909), *The Further Adventures of the Girl*

Spy (1910), *The Bravest Girl in the South* (1910), *The Love Romance of the Girl Spy* (1910), and *The Girl Spy Before Vicksburg* (1910).[27] Gauntier reprised the role in *The Little Soldier of '64* (Kalem, 1911) and *A Daughter of the Confederacy* (Gauntier Feature Players, 1913). Kalem made a variation set in North Africa, *The Girl Scout; or The Canadian Contingent in the Boer War* (1909), and D. W. Griffith directed two significantly more melodramatic versions at Biograph, *The House with Closed Shutters* (1910) and *Swords and Hearts* (1911). Selig joined the trend belatedly with *Pauline Cushman, the Federal Spy* (1913).

As Abel and Clarke remind us, not all action heroines in frontier and Civil War films disguised their gender. Cross-dressing, though, provided a visual referent for the woman's assumption of a male role, the spectacle of a novel costume, and a connection to popular and genteel entertainments. On the one hand, the gender disguise could be considered conservative, as it implies that women must temporarily stop being women in order to be active agents, and it preserves the essential maleness of the frontier and battlefield. At the same time, male guise allows female bodies to participate in masculinity and evokes stories of real-life female-bodied men.

Last-minute rescues by girls on horseback were common on the melodramatic stage. In *Winchester*, for example, the heroine races on horseback to secure a pardon for her boyfriend.[28] In 1897, the sequence was staged with a treadmill and moving backcloth, but in 1909 a live horse and moving picture projector were added. Equestrian melodramas brought horses and riders to the stage, and melodramas went to new lengths to bring exterior locations into the theater. In *The Girl of the Golden West*, Belasco rolled a giant painted backdrop to "pan" from a mountain peak down to the valley below and spent three months trying to achieve a California sunset.[29] In outdoor arenas, Wild West shows could display women's riding and shooting skills more easily, but only by removing them entirely from the Western landscape (fig. 9). Motion pictures, on the other hand, could combine the attractions of an athletic, cross-dressed young woman on horseback with real views of the American landscape. In fact, Anna Little, who played Eva in *The Post Telegrapher*, was one of the many Wild West performers that the Bison Company acquired when it merged with the Miller Brothers 101 Ranch to become Bison 101.

These chase sequences offer a useful counterpoint to the better-known races to the rescue in films like *The Lonely Villa* (Biograph, 1909) and *Suspense* (Rex, 1913).[30] In the climactic final sequence of *The Lonely Villa*, for example, male thieves break through one door after another to get at a white woman and her three daughters, who retreat farther and farther into the house, while the husband races home in a gypsy wagon. The film cuts between the thieves, the women, and the husband. The trope of the imperiled white woman retreating into ever more claustrophobic spaces occurs in a wide variety of films, even

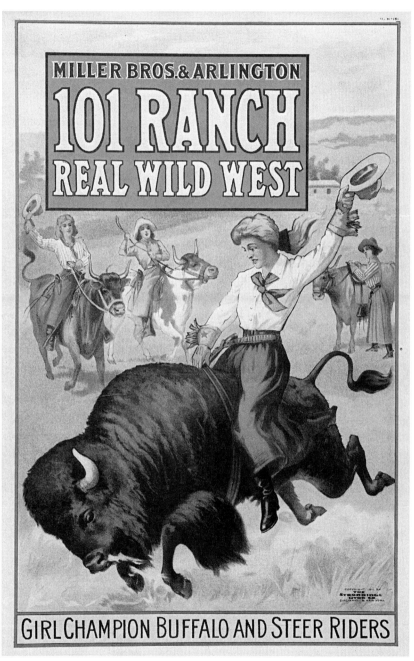

FIGURE 9. Girl riding a buffalo on Millers Brothers 101 Ranch poster (1911). Courtesy of Cowan's Auctions Inc., Cincinnati, Ohio.

those like *The Lonedale Operator* (Biograph, 1911) that invest the woman with a certain amount of ingenuity.

In contrast, the cross-dressed chase sequences that appeared at exactly this same time are initiated not by a threatening man but by the young woman herself, who ventures forth to deliver a dispatch, complete a secret mission, lead enemies away from a sweetheart, or rescue an injured man. Whereas films like *A Lonely Villa* split hero and victim roles along gendered lines, the young cross-dressed women are both heroes and potential victims. In this respect, they anticipate the combination of "power and peril" that film historian Ben Singer attributes to the "serial queens," the female action stars who populated serialized adventure films from 1913 onward.[31] But where the serial queens are often imperiled through confinement (being tied up in a burning house, for example), these earlier action heroines are always on the move. *The House with Closed Shutters*, for example, highlights a cross-dressed girl's mastery of space by comparing her heroic ride to her brother's terrified flight.[32] In fact, I have not yet found a cross-dressed chase in which the girl gets caught. The only examples of confinement that I have come across are when Nan hides down a well and later in a potato sack in *Further Adventures of the Girl Spy*. However, these tight spaces are only pauses in Nan's unstoppable trajectory.

Rather than merely inverting the male and female roles of the traditional, cross-cut race to the rescue, the cross-dressed chase uses a simpler, linear trajectory through space and time. Many of these films employ parallel editing at other points, but during the chase sequences, they depict only a single line of action. Echoing an earlier era of chase films, the girl enters the frame first, rides or runs across it, and then exits. The pursuers then repeat this trajectory. The camera cuts to a new space, and the whole sequence repeats. The chase ends when the pursuers unknowingly ride past the girl or when the girl reaches a protected space (a fort, encampment, or house).[33] This sequential style of editing, with fairly lengthy shots as all the characters get across the frame, was already old-fashioned by 1909. Still, it offered viewers the added visual attractions of cross-dressing and of a woman accomplishing athletic outdoor stunts. That such chase sequences managed to thrill audiences is evident in the *Moving Picture World* reviews of *The Girl Spy* ("not a moment of dullness") and *The Girl Spy Before Vicksburg* ("a succession of thrills which will satisfy the most obdurate audience").[34]

The relationship between hero and victim becomes more complex when the young woman impersonates her brother or sweetheart in order to mislead his pursuers. This conceit occurs in *A Cowboy Argument, On the Western Frontier, A Western Girl's Sacrifice, The Sheriff's Daughter, A Girl Worth Having, The House with Closed Shutters,* and *Swords and Hearts.* In these films, the woman takes on the man's vulnerability. In *The House with Closed Shutters,* for example, a Confederate

soldier, Charles (Henry B. Walthall), is too frightened to deliver an important dispatch, so he rides home and faints. His patriotic sister, Agnes (Dorothy West), cuts her hair, takes his uniform and horse, evades enemy soldiers, and delivers the message. Once on the front, she leaps over barricades to rescue a Confederate flag, but is shot from behind and falls toward the camera, the flag in her hand. To save the family honor, their mother makes Charles hide at home for the rest of his life, posing as his sister. Film scholar Susan Courtney argues that Agnes "takes on the role of masculinity [Charles] cannot bear to play. . . . she does not just die in the likeness of her brother, but for him, taking on the risk and the pain from which he ultimately hides."[35] According to Courtney, this film, along with *Swords and Hearts*, illustrates a broader shift in Griffith's films, in which male failure is transformed into female suffering.[36] I am not convinced, however, that this shift can be discerned in Griffith's wider body of work. In fact, of all the cross-dressed chase films that I have located, *The House with Closed Shutters* is the only one to stress the pathos of a young woman stepping in for a man. The film's depiction of the brother's emasculation is particularly hyperbolic: Charles has a hysterical fit, wears a feminine smoking jacket, and is imprisoned within his mother's house. Although we might expect that this message of male incapacity would displease audiences, *Moving Picture World* observed that, "No picture that we have seen for many days . . . so roused the enthusiasm of a large audience."[37]

More typically, films stressed the dynamism of the chase rather than men's failures and resolved lingering gender trouble through heterosexual coupling. In fact, Griffith's next cross-dressed chase film, *Swords and Hearts*, is more characteristic of this type of film. A Confederate officer, Hugh Frazier (Wilfred Lucas), visits his sweetheart, unaware that Yankee soldiers are pursuing him. A secret admirer, Jenny Baker (Dorothy West again), borrows his jacket and horse to mislead his enemies. Though she is shot, she recovers and marries Hugh at the end of the war. The heterosexual resolution suggests that Jenny's appropriation of male risk is merely a temporary, wartime aberration. Likewise, *On the Western Frontier, The Post Telegrapher, The Little Soldier of '64*, and *The Girl Scout* all end with the formation of heterosexual couples. In the war films, this conclusion often coincides with the end of the war. Gauntier's girl spy films are some of the only examples that eschew a love story altogether. In fact, *The Girl Spy* and *The Girl Spy Before Vicksburg* both end with Nan still in male guise. Still, most films legitimized female masculinity as a necessary expedient during a temporary disruptive period, one that dissolves when normalcy is restored.

The Post Telegrapher is one of the few examples in which a woman actually races to the rescue of a man. By the time Bob telegraphs for help, the audience (if not the heroine) knows that his regiment has been decimated and that the Sioux have departed. The heroine's ride is too late even before it starts, though she

is able to bring her injured sweetheart back to the fort. This female-led rescue is followed by a more predictably gendered rescue: in the film's climactic finale, the cavalry rush back to the fort to defend it from the attacking Sioux.

The interaction of the active female body and the landscape is key to the appeal of these chase sequences. An important difference between the traditional race to the rescue and these chases is that the cross-dressed women are successful because of their physical and outdoor skills, not because they commandeer modern transportation technologies like trains, planes, cars, and boats, as the men and later serial queens do. Through superior navigation of diverse, rugged American terrains, the cross-dressed heroine embodies a national fantasy of spatial mastery. The women gallop at full speed from the moment they mount a horse. In many films, the heroine is the only actor whose horse rears up on its hind legs. Oftentimes her horse is white or has a white marking on its forehead, whereas the pursuing men's horses are dark, which sets her apart and aligns her with justice. The films also frequently oppose a lone girl hero versus a group of male pursuers. The fact that these horseback chase scenes were one of the significant attractions of these films is supported by a review of *Pauline Cushman, the Federal Spy*, which raved, "Miss [Winifred] Greenwood looks well on horseback, and her dashing 'get-aways' in the saddle . . . are full of spirit and create enthusiasm."[38]

Generally, this triumphant conquest of nature was accorded only to white bodies, but *The Red Girl and the Child* is a rare exception. The film stars Lillian St. Cyr, a Winnebago Indian who performed under the name Red Wing, and was directed by her husband, James Young Dear (born J. Younger Johnson), who was also Winnebago. This is one of the few films in which a non-white woman disguises herself as a man. More common were films that ridiculed Native women's ostensibly innate masculinity and compared them unfavorably to tomboyish white women, as in *The Taming of Jane* (IMP, 1910) and *Mickey* (Mabel Normand Feature Film Co., 1918). Yet Native women were imagined to have horsemanship and outdoor skills potentially exceeding those of white frontiersmen. There was, however, an important difference between the relationship of athletic white women to the landscape and that of athletic Native woman. While the white woman was imagined to triumph *over* nature, the Native woman was presumed to be *of* nature. In films apart from *The Red Girl and the Child*, Native women's masculinity was not a healthy phase but a racial defect.

Although the landscape is important to all of these films, the way they engaged with it depended on where they were shot. Gauntier's girl spy films, made in Florida, use the exotic, diverse landscapes as an obstacle course that Nan must go under, over, around, and through. In *The Girl Spy Before Vicksburg*, for example, Nan dashes across a stream on a narrow plank while an enemy soldier wobbles and falls in (fig. 10). In another scene, Nan hides underwater and

FIGURE 10. Nan (Gene Gauntier) races across a narrow plank in *The Girl Spy Before Vicksburg*. Courtesy of the EYE Filmmuseum/Desmet Collection.

waits for her pursuers to pass. Likewise, in *Further Adventures of the Girl Spy*, Nan lowers herself into a well to hide and later jumps from a tree branch onto an enemy soldier's horse. In each case, she proves herself more skillful than the men who chase her. Gauntier's stunts are shot in long and medium long framings, so that viewers can clearly see her athleticism and the roughly human-sized obstacles she encounters. Gauntier treats the natural world like a playground, much as Douglas Fairbanks would do in the years to come, as film historian Gaylyn Studlar has argued.[39] By depicting the athletic white girl navigating this space triumphantly and even playfully, the film echoes the recreation and scouting movement that sought to refigure the American out-of-doors as a playground for neurasthenic urbanites.

A Post Telegrapher, on the other hand, which was shot in California, uses extreme long shots to show off the contours of the landscape. Humans are minuscule compared to the enormity of Western geological formations. This framing exploited conventions of Western landscape painting that emphasized the monumentality and untameability of the land. However, shots that highlighted the landscape panorama rendered the cross-dressed woman indistinguishable from a man (fig. 11). The spectacle of the cross-dressed female body is sacrificed for the spectacle of the landscape. Later films, like *Rowdy Ann* (Christie Film Co.,

FIGURE 11. The disguised Eva blends in with the cavalry in an extreme long shot in *The Post Telegrapher*. Courtesy of the EYE Filmmuseum/Desmet Collection.

1919), used the gender illegibility of a figure on horseback seen from afar as a sight gag.

Finally, the landscape is less of a spectacular attraction in films shot in New Jersey, such as *On the Western Frontier*, *The House with Closed Shutters*, and *Swords and Hearts*. Framed in long shots, women ride down dirt roads through deciduous forests and grasslands. Still, their ability to navigate this space more quickly and cleverly than men enables them to elude the enemy and accomplish their missions. Although the *New York Dramatic Mirror* could gripe about the setting of *A Cowboy Argument*, "A cowboy picture acted in Eastern country is not as satisfactory as one performed in the West," the other films were warmly received.[40]

Instead of the claustrophobic retreat typical of women in race to the rescue sequences, the cross-dressed chase depicts white women heroically negotiating a series of outdoor spaces and challenges. Showing off their horsemanship and outdoors skills, they embody an American ideal of physical vitality and courage. The pathos of male failure is converted to thrills and often resolved through heterosexual union. These films hoped to draw the working-class and genteel audiences already hooked on the athletic heroines of the periodical press, dime novels, memoirs, elaborate stage shows, and Wild West performances.

FEMINIST RANCH TAKEOVERS

In contrast to women's heroic competence in the chase films, some comedies depicted uppity East Coast women "tamed" by the dangers of the frontier. These films contrast the unhealthy political aspirations of the New Woman with the healthy apolitical prowess of the frontier girl. The task of many a film was to convert the first kind of masculine woman into the second. A group of young white women from the East commandeer a Western ranch, expel the men, and remake it in the style of a women's college. Eventually, frontier dangers like bears, horse thieves, and predatory Mexicans—either real or impersonated by the displaced white cowboys—convince the women to allow the men back on the ranch and to take them for husbands. Examples include: *The Cow Boy Girls* (Selig, 1910), *The Cowboys and the Bachelor Girls* (Méliès Star-Film, 1910), and *The Girl Ranchers* (1913).[41] (Only the last film survives.) A subgenre of the "when women rule" comedy, these films explore what it would mean for women to take over paradigmatically male spaces, although they do not feature explicit cross-dressing.[42] They imagine the women's college and ranch as utopic spaces of fun and camaraderie, but undo both spaces as part of the necessary development of the West. Like the chase films, the ranch takeover films visualize women replacing men, but tame any potential anxiety through an emphasis on spectacle, in this case a comic spectacle of disjuncture and anarchy. Unlike the range romances that I will discuss, these films frame young women's entrance into heterosexual coupling as a battle to be won through threat of violence. Furthermore, the films participate in a broader cultural process whereby white female masculinities of the frontier—youthful, active, and apolitical—are opposed to white female masculinities of the city—unattractive, adult, and radically political.

"'Vassar,' 'Wellesley' and 'Bryn Mawr' colleges have supplied almost every profession with intellectual young women, and now they have invaded the cattle herders' trade," announced the Selig bulletin for *The Cow Boy Girls*.[43] In *The Cowboys and the Bachelor Girls*, the women are more politicized: the president of a female "Bachelor Club" inherits a ranch and decides to run it with her clubmates, "a la suffragette fashion."[44] Upon arriving at the ranch, the women refashion it in the style of a women's college. The women in *The Cow Boy Girls*, for example, change the ranch's name from "L.Z." to "Lizzie," and the bunkhouse is labeled "Dormitory." In *The Girl Ranchers*, sisters change the ranch's name from "Rough Neck" to "Maiden's Rest" and decorate the house with flowers and doilies.

A women's college would seem to be the exact opposite of a ranch: an upper-middle-class, feminine, and respectable site of intellectual toil versus a working-class, masculine, and vulgar site of physical labor. Indeed, part of the humor is the incongruity of blending the two spaces. However, the films also make visible the ways in which the two were analogous.[45] Both spaces were

imagined to cultivate boisterous, single-sex camaraderie and utopian communalism. Although the films can be read as burlesque inversions of ranch life, they also visualize a feminist fantasy. Indeed, in 1913 feminist writer Charlotte Perkins Gilman published a short story about a group of college women who found a utopian women-run town out West.⁴⁶ In both Gilman's story and *The Cowboys and the Bachelor Girls*, the president of a women's club receives an inheritance that allows her to fulfill this dream.

The films frame the women's takeover as a threat to the manhood of the workers by using playful but pointed symbols of castration. In *The Girl Ranchers*, the women demand that the men shave their large moustaches. In *The Cow Boy Girls*, when a white cowboy named Bud sneaks back to the ranch, the women tie him up, lock him in the woodshed, and get their Chinese servant to exchange his chaps for a dress.⁴⁷ Much as the white woman in *What Happened in the Tunnel* (Edison Manufacturing Co., 1903) uses her blackface maid to play a racist joke on a presumptuous white man, in this film the white women use their Chinese manservant to contest Bud's white male authority. That a Chinese man removes a bound white man's chaps and replaces them with a dress suggests a racialized, sexualized assault. Furthermore, the film relies on a racist logic that does not count a Chinese man as a man.

As in many of the chase films, the doubt cast upon white male authority eventually dissipates. In the face of external threats, the women give up their authority, allow the men back on the ranch, and even take them as husbands. In *The Cowboys and the Bachelor Girls*, for example, the girls are attacked by desperadoes (actually cowboys in disguise), then by a bear (another cowboy), and then by a "real" Mexican. Each time, one of the white cowboys saves the woman in danger, thus winning her love and submission. In these films, the racial and natural threats of the frontier (even when falsified) steer women back to normative heterosexual coupling. Although the young women are a good match for the West in their energy and athleticism, their temporary appropriation of men's authority cannot ultimately replace men. Unlike Gilman's short story, these films can only envision the single-sex sociality of the ranch (male *or* female) as temporary. Although the films frame the women's commitment to "bachelor" life as the problem the narrative must solve, they also implicitly problematize the cowboys' off-screen homosociality.

While we might imagine that spectacles of college girls rejecting male authority and a Chinese servant unmanning a white cowboy would unnerve audiences, critics received the films positively. *Moving Picture World* called *The Cow Boy Girls* a "lively picture," noting, "There is plenty of life and action, lots of fun and wholesome activities as the picture runs."⁴⁸ Of *The Cowboys and the Bachelor Girls*, *Variety* concluded, "Picture is entertaining."⁴⁹ Comedy, as a genre, was

adept at presenting questionable material within the framework of harmless fun; anyone who objected could be dismissed as humorless.

These films sold the West as a destination for playful, athletic tourism. The threats are only playacted, as at a Wild West show. Just as Western travelogues domesticated frontier spaces by including tourists in the frame, as film historian Jennifer Peterson has argued, the women in these films domesticate frontier spaces—this time literally.[50] Conversely, the frontier domesticates these unruly women. Ranch life, the films show, offers a more productive channel for New Women's energies than fencing or suffrage activism. This message is even more explicit in *The Suffragette, or The Trials of a Tenderfoot* (Selig, 1913), in which the dangers of the frontier (again fabricated by white men) discipline a mannish suffragist from the East. The film stars Myrtle Stedman as Miss Samantha Roundtree, "a Homely Old Maid Suffragette." Stedman had already appeared as a suffragette in *When Women Rule* (Selig, 1912) and as a cross-dressing cowgirl in *The Cowboy's Best Girl*. Unlike the cross-dressing frontier girl, the suffragette is too old, too plain, and too politically ambitious for her masculinity to be attractive.

Like the bachelor girl, however, she is curable. According to the film's publicity bulletin, a cowboy named Waggy Bill (William Duncan) and his friends disguise themselves as Native Americans and abduct Samantha, tie her to a tree, and "pile brush about her as if to make a funeral baked feast."[51] The Native Americans' literal appetite for Roundtree stands in for an implied sexual threat. Waggy, however, changes back into cowboy clothing and "empties blank cartridges at the crowd with such effect that he decimates the Indians and rescues Samantha." Samantha clings to Waggy and, "having gotten a man, forgets all about votes for women." The scene resembles a Buffalo Bill performance and resonates with white men's appropriation of Native American rituals in order to resuscitate their "primitive" masculinity.[52] Here they playact a scenario of racialized sexual conquest.

A comparison of the suffragette and the frontier girl suggests that the "good" female masculinity of the frontier was often produced in opposition to the "bad" female masculinity of the city. The "good" form was the young, attractive, physically active girl whose independence does not interfere with her incorporation into heterosexual domesticity when she comes of age. The "bad" form was the adult woman seeking to impinge on men's political authority. We can see this same polarization in the 101 Ranch brochure quoted above. The publicist carefully separated the physical skills of the cowgirl from the actions of the "new woman class," who try to "ape the man." Although some scholars assert that the cowboy girls of silent cinema emblematized the New Woman, frontier women were also discursively constructed *against* this figure.

This discourse obscured the politicization of actual Western women.[53] Western states and territories were in fact the first places where women won suffrage: the Wyoming Territory in 1869, Utah Territory in 1870 (rescinded in 1887), Washington in 1910, and California in 1911. By the time the U.S. Congress passed the Nineteenth Amendment in 1920, women already had suffrage in every Far West state. In 1912, 101 Ranch riders in particular were identified with suffrage activism. The *Toledo Blade* reported, "Girls with Wild West Show to Help Women Gain Equal Suffrage."[54] The 1915 brochure was thus struggling to contest a connection that had already been forged.

These films created a fantasy vision of the young frontier woman as a girl passing through a boyish phase that made her energetic and physically fit but ultimately happy to surrender her masculinity and independence. These girls, it was imagined, had nothing to do with women's desire for more permanent incursions into masculine political and economic spheres. They likely helped shift the political valence of cross-dressing from a radical feminist incursion into the male sphere to a nationalistic display of America's physical vitality.

CROSS-DRESSING AND THE SERIAL QUEENS

Though female heroism became even more common in the serial films of the mid-teens, the use of cross-dressing in these heroics declined. Serial queens like Pearl White, Helen Holmes, and Ruth Roland were renowned for their athleticism and fearlessness, but they rarely disguised themselves as men.[55] Among the approximately three hundred silent serials made in the United States, each of which included between ten and one hundred episodes, I have found only a few cases of female-to-male cross-dressing: one episode each of *The Romance of Elaine* (Pathé, 1915), *The Girl Detective* (Kalem, 1915), *The Red Circle* (Balboa, 1915–1916), *Gloria's Romance* (Kleine, 1916), *Grant, Police Reporter* (Kalem, 1917), *The Adventures of Ruth* (Ruth Roland Serials, 1920), and *The Mystery Mind* (Supreme, 1920) and series-long plotlines in *The Broken Coin* (Universal, 1914–1915), *The Mystery of the Double Cross* (Astra, 1917), and *Idaho* (Pathé, 1925).[56] Cross-dressed female soldiers and spies also declined in American war films after 1915, as Elizabeth Clarke has shown.[57] After the mid-teens, cross-dressed women became incapable of accomplishing the most basic of male tasks. In *Her Father's Son* (Morosco Photoplay Co., 1916), for example, a Southern girl disguises herself as a boy to receive an inheritance, but chokes on a sip of alcohol, sneezes at a pinch of snuff, and ignores a gift of dueling pistols to admire her cousin's flouncy dress. Likewise, when women cross-dress to join the armed forces in 1920s comedies, they rarely exhibit anything like athletic heroism.[58]

Instead of using male disguise to justify women taking on dangerous tasks, the serials feminized women with ostensibly masculine traits. Serial queens piloted

airplanes, scaled buildings, and leapt across train cars in silk stockings, chic dresses, and stylish hats. Even when they adopted some articles of men's clothing, it was usually in styles that emphasized their curves, such as jodhpurs. This adaptation was typical of the way men's clothing was being incorporated into women's fashions at the time. According to a September 1914 article in the *Los Angeles Times*, "the girl of today is cleverer than her mannish sisters of only a few years ago. Miss 1914–1915 has a fancy for togs masculine, but she adapted them and remodeled them and feminized them, and wears them with a finish and a flourish that we cannot but forgive and admire."[59] Thus, rather than putting on men's clothing, as the earlier cross-dressing performers had done, serial queens wore men's styles that had been "remodeled" and "feminized." They also wore feminizing makeup and appeared closer to the camera, which allowed the audience to recognize not only their identity but also their unquestionable femininity. Moving pictures likely contributed to the incorporation of masculine styles into women's fashions by circulating these looks, but also perhaps by lessening the connection between masculine-styled clothing and radical feminist politics.

Journalists emphasized the serial queens' femininity and beauty, as if these attributes could compensate for their "masculine" skills and tastes. *Photoplay*, for example, found that Kathlyn Williams, star of the serial *The Adventures of Kathlyn*, "furnishes a genuine surprise" in private: "So closely associated has she been of late with deeds of daring and dangerous exploits that one expects to find a dashing, mannish woman arrayed in more or less masculine attire. So it is almost disconcerting to find a decidedly womanly lady."[60] Likewise, when *Cosmopolitan* profiled Ruth Roland, the journalist argued that her "blond beauty" prevented her various masculine tastes from "bewildering" her admirers.[61] As in the cross-dressing films, the qualities of whiteness, youth, and beauty counterbalanced Roland's inappropriately gendered on-screen behaviors.

Publicity about these women expanded the connection between the vital frontier girl and the moving picture actress. Helen Holmes, for example, told interviewers that she grew up "in a family of railroad workers," writes Shelley Stamp, and Kathlyn Williams "on a Montana ranch."[62] The *Cosmopolitan* profile of Ruth Roland called her a "distinct type of the American girl of the West" and "a buoyant, breezy, wholesome daughter of the California Sierras."[63] Even Pearl White, who became an emblem of urban cosmopolitanism, stressed her upbringing in a log cabin in the Ozarks, gender historian Hilary Hallett points out.[64] No matter where in the country they were from, serial queens emphasized their rough-and-tumble engagement with the out-of-doors. Furthermore, many serials took place on the frontier, including *The Girl and the Game* (Signal, 1915), *The Girl from Frisco* (Kalem, 1916), *The Lass of the Lumberlands* (Signal, 1916), and *Carmen of the Klondike* (Selexart, 1918). A promotion for *Runaway June* (Reliance, 1915) even offered female fans the opportunity to

take a train to California.[65] While Singer and Stamp rightly describe the ways in which serial queens negotiated the pleasures and perils of urban modernity, these figures also drew upon the mythology of the American frontier girl.

The decline of capable cross-dressed female heroines that took place in the mid-teens was likely due to a combination of industrial and social factors, including the development of the star system, moving picture companies' increasing connection to the fashion industry, the intensification of the suffrage debate, and the legitimation of athletic women. Film historian Richard deCordova sees 1913 and 1914 as the key years during which the "picture personality" transformed into the "star" and the "player's existence outside his or her work in film became the primary focus of discourse."[66] During these years, fan magazines and trade journals increasingly emphasized the youth and beauty of American moving picture actresses. For example, Richard Abel shows that the coverage of movie actresses in Scripps-McRae newspapers began to emphasize their appearance over their physical accomplishments.[67] The serials expanded the connections between the movie industry and the fashion industry.[68]

On a broader social level, the year 1912 also marked an intensification of the debate over woman suffrage, provoked by the November presidential election. On May 4, 1912, more than ten thousand women and a thousand men marched in New York City demanding suffrage. Woodrow Wilson, the Democratic candidate who beat Republican incumbent William Howard Taft by a landslide, did not endorse federal suffrage legislation at this time, although Arizona and Oregon passed ballot initiatives permitting women to vote in those states. In the face of this escalating social conflict, audiences may have been uncomfortable watching women in men's clothes replacing incapacitated men; instead, they flocked to films of women in feminine clothes accomplishing the same kinds of tasks. The shift may also reflect changing attitudes toward women's physical fitness: gender disguise was not needed to justify women's heroic physical feats.

THE RANGE ROMANCE

During the heyday of the cross-dressed chase film, another set of films explored the relationships between older men and disguised girls in a frontier setting. Where the chase films presented the spectacle of white women's physical vitality, the range romance narrativized the process of revitalizing white womanhood. Furthermore, these films simultaneously made visible and undid the affective bonds between men cultivated by frontier spaces. Typically, a young woman travels to the frontier as a boy in order to find work. An affectionate relationship develops between the disguised girl and an older male worker. The instant the older man discovers that his companion is female, he kisses her, or proposes marriage, or both. A wedding often means a return to the East.

Transitional-era films that follow this formula include: *Billy the Kid* (Vitagraph, 1911), about a ranch girl who is brought up as a boy and eventually marries a fellow ranch hand; *The Argonauts* (Selig, 1911), about a disguised girl who falls for a gambler on a steamboat to California; *A Range Romance* (Bison, 1911), about a disguised girl who works on a ranch before marrying the foreman; and *Making a Man of Her* (Nestor, 1912), about a disguised girl who works as a ranch cook before marrying the foreman. (Only the latter two films survive.) Disguised women are also the subject of both male and female desire in films such as *The Cowboy's Best Girl* (Selig, 1912), *The Death Mask* (Kay-Bee, 1914), and *She Would Be a Cowboy* (Kalem, 1915), although these do not follow the typical formula. In the second half of the teens, studios returned to the range romance in more exotic frontier settings, such as Alaska and northern Canada, in *The Snowbird* (Rolfe, 1916) and *The Girl Alaska* (Al Ira Smith, 1919).

These films worked from the kinds of stories that had circulated in newspapers, dime novels, and folklore. Western newspapers affirmed the commonness of the phenomenon. One advertisement for an office boy in the *San Diego Herald* cautioned, "no young women in disguise need apply."[69] Historian Dee Garceau and sociologist Clare Sears have argued that rumors of frontier boys being girls helped legitimize men's same-sex desire in these sex-imbalanced spaces.[70] One reason girls disguised themselves as boys was to prevent sexual predation, but this strategy nonetheless sexualizes the figure of the boy. In one late nineteenth-century cowboy song, for example, "The Stampede, or The Cherokee Kid from the Cimarron Strip," the narrator describes his special affection for a young cowboy with a "lithe" and "slim" waist. When the Kid is trampled in a stampede, the narrator discovers that the Kid is female. The Kid confesses her love; the narrator kisses the Kid passionately; but she/he dies in his arms. Stories in which a boy turns out to be a girl bring out a layer of desire already implicit in some frontier literature. Gender historian Geoffrey W. Bateman argues that nineteenth-century frontier literature such as Horatio Alger Jr.'s Gold Rush novels idealized affection between frontier men and boys. Bateman writes that, by "deploy[ing] a colonial imaginary in order to see California as an untrammeled paradise, [Alger's Western novels] open up a space within which [boys] can cultivate sentimental bonds with older men who guide them on their journey through adolescence, the empty beauty of this paradise purifying their desire for each other."[71] Cinema's range romances tell similar kinds of stories, but recuperate pederastic relationships by turning the boys into disguised girls. The acceptability of sentimental bonds between boys and men on the frontier helps explain the flirtation that occurs when the older man believes the boy to be male.

As Boag notes, print journalists usually explained female-bodied frontiersmen as Eastern women who had been seduced and abandoned, then traveled

west to make a living or track down their lovers.[72] In some accounts, they find heterosexual love and return East to resume life as proper, middle- or upper-class women. But moving pictures steered clear of this particular narrative—probably because it was too scandalous—and instead told more innocent stories about very young girls who go west as boys for their safety. However, in both kinds of stories, a young woman's assumption of manhood was imagined to be possible only in the West.

Range romances suggested that a frontier boyhood could make white girls into physically vital adult women. Just as psychologist G. Stanley Hall argued that boys should go through a "savage" phase in order to retain their virility when forced to play by the rules of industrialized adulthood, feminists argued that girls should experience a "boy" phase in order to maintain their health when forced to play by the rules of middle-class womanhood. For example, a lecturer at Chicago's Hull-House recommended: "Make Buster Browns of lace bedecked, frilled and tucked little daughters; cut their hair short, put them in overalls, and do not let them realize that they are not of the same sex as their brothers."[73] Likewise, Charlotte Perkins Gilman wrote in *Women and Economics* (1898), "The most normal girl is the 'tom-boy' . . . a healthy young creature, who is human through and through, not feminine till it is time to be."[74] These recommendations have the same temporal logic as the cross-dressing stories. Girls should not become "female" until sexual maturity. As for men, the Western frontier provided the ideal setting to cultivate women's health, vitality, and physical fitness. Gilman, for example, attributed her own psychological and physical recovery to the eight years she spent in California. She wrote a series of novels and short stories describing neurasthenic girls who grow strong and independent by riding horses, climbing hills, and gardening.[75]

In range romances, innocence, childhood, and maleness are associated with the frontier while sexuality, adulthood, and femaleness are associated with the city. *A Range Romance* dramatizes one girl's movement between these two spaces as part of a larger project of white racial regeneration. At the beginning of the film, we see the ill results of city living. A disgruntled white woman, Mary, sits in a rocking chair in a claustrophobic, middle-class home and throws down a piece of embroidery. Her husband, Bob, enters and they argue. Rather than allow their young daughter, Bessie, to follow in her mother's footsteps, Bob takes Bessie out West, disguised as a boy. They work as ranch hands for ten years, a period elided with an intertitle. We then see Bessie working on the ranch and developing a relationship with the foreman. When the foreman realizes that his boy companion is a girl, he declares his love and kisses her. Shortly after, Mary reunites with Bob and Bessie, and they all return East. In the film's final scene, three years later, we are back East in virtually the same middle-class living room, but this time with a newly revitalized family (fig. 12). Bessie and her husband are strong, healthy,

FIGURE 12. In the final shot of *A Range Romance*, Bessie and her husband hold up their glowing white child as Bessie's parents embrace in the background. Courtesy of the Library of Congress.

and energetic. Laughing, they hold up their child. Bessie's Western boyhood has immunized her from her mother's hysteria without obstructing her maturation into an entirely feminine adult woman. Moreover, Bessie's physically fit body has produced a robust, glowing child—an optimistic symbol of the white American race's continued potency.

The conflation of femaleness, adulthood, and heterosexuality is comically clear in a synopsis of the lost film *Billy the Kid* in the *New York Dramatic Mirror*: "'Billy' is a girl but the boys on the ranch don't know it until she is sixteen, then she marries her pal."[76] The synopsis implies that Billy enters into adulthood, femaleness, and heterosexual union nearly simultaneously. Although *The Argonauts* and *Making a Man of Her* do not have such an explicitly developmental timeframe, the girl protagonists' shift from male to female occurs almost simultaneously with their entrance into sexual availability and marriage. Similarly, films from the late 1910s often sent frontier tomboys to the city at puberty to learn how to be properly female.[77] Even though these tomboys never disguise their gender, the films frame their childhood as a frontier boyhood.

The range romance is a version of the temporary transvestite film that speaks to the problem of sexuality in gender-imbalanced frontier spaces. The scarcity of women was particularly acute in Gold Rush towns like San Francisco, where,

according to official estimates, women were only 2 percent of the population in 1849 and 15 percent in 1852.[78] Likewise, the long-range cattle herding of the 1860s through 1880s cultivated an "all-male nomadic subculture," Garceau writes, and cowboys developed alternative structures of sociality, pairing up as "bunkies" on the range, patronizing prostitutes, and cross-dressing at dances.[79] Refusal to acknowledge the presence of Native and Latina women and prostitutes of all races compounded the perceptions of gender imbalance. According to Sears, "The problem of 'too few women' in gold rush California . . . was more accurately a problem of 'too few women acceptable for marriage to Euro-American men.'"[80] In the sanitized mythology of the frontier, the lack of respectable white women meant that white frontiersmen were consigned to either solitude or platonic male friendships.

An additional paradox of frontier ideology was that the individualist, hyper-masculine frontiersman was unfit for the company of respectable women. Theodore Roosevelt wrote of the first generation of American frontiersmen: "There was little that was soft or outwardly attractive in their character; it was stern, rude, and hard, like the lives they led."[81] Thus, even if there were respectable white women around, the hyper-masculine frontiersman could not be reconciled to them or to married life. This conflict was regularly dramatized in literature like James Fenimore Cooper's Leatherstocking Tales. Cross-dressed frontier girls allowed these men to keep their orientation toward hyper-masculinity even as they were assimilated into heterosexuality. The sleight of hand that turned the boy into a girl made visible same-sex desire even as it was dissolved. Although these films never explicitly acknowledge the possibility that a white cowboy could partner with a non-white woman or hire a prostitute, the cross-dressed girl—who is always white and has never been so much as kissed—implicitly saves him from these possibilities. Thus, the cross-dressed frontier girl had the power to recuperate the hyper-masculine frontiersman for both heterosexuality and racial purity.

She also catalyzed the dissolution of sex-segregated space. In *Making a Man of Her*, for example, the man-"boy" romance starts a matrimonial domino effect. The ranch foreman's proposal to the formerly cross-dressed girl inspires two cowboys to imitate him and propose to some women themselves. The women, who previously would have nothing to do with the cowboys, happily accept in order to experience mimetically the happiness of the coupled foreman and former "boy."

At the same time, relationships between men and disguised girls made the possibilities for same-sex romance on the range visible. Like later temporary transvestite films, *A Range Romance* lingers on images of two apparent men flirting, falling in love, and embracing (fig. 13). Although we may know that one partner is really a girl, these kinds of images encourage simultaneous hetero- and

FIGURE 13. The foreman pulls the disguised Bessie toward him for a kiss, but there is a cut before their lips touch. Courtesy of the Library of Congress.

homosexual readings, as Straayer has pointed out.[82] Though a certain amount of affection between men was acceptable, kisses between the foreman and "boy" seem to have just crossed the line of acceptability: there is an abrupt cut just before the foreman's lips touch Bessie's for the first time. The cut, which may have been made by local censors or an exhibitor, suggests some unease. In the next scene, a kiss is completed, but the foreman and Bessie look around guiltily afterward. I have not found any evidence that censors, critics, or audiences objected to the film's homoeroticism, though. *A Range Romance* played in small towns across the United States and even made it as far as Australia and New Zealand, where it was advertised as a "Bison exclusive drama."[83] While *Moving Picture World* questioned the story's plausibility, it praised the unidentified actresses who played Bessie and Mary.[84]

Kisses between men and disguised women were actually less common in these films than in the later ones Straayer describes. In *The Argonauts* and *Making a Man of Her*, men wait for the disguised women to change into dresses before making a move. But even so, the films depict men's desire for an apparent boy, and vice versa. The disguised girl thus allows cinema to visualize same-sex attraction while fixing this ostensible problem of the frontier.

Range romances displaced the pathology attached to gender and sexual deviance onto racialized bodies. In *Making a Man of Her*, for example, a black

woman played by a white man in blackface is a foil to the white protagonist. The white boy-girl and the mannish mammy compete at the employment office for the position of ranch cook (fig. 14). The white boy-girl gets the job. In the film's concluding joke, the owner hires the blackface woman to guarantee that his cowboys will not marry the cook. Like many early film comedies, the joke relies on the assumption that a black woman is an utterly inappropriate figure for white male desire. Like *A Florida Enchantment*, which I discuss in chapter 3, the film posits interracial desire as even less imaginable than same-sex desire.[85] This joke also highlights the asymmetry between female-to-male and male-to-female cross-dressing. While men's clothing could make women more attractive to both men and women on-screen, women's clothing most often made men undesirable to everyone. The cook's age (old) and size (large) further exclude her from male desire. The final scene contrasts the desirable white, young, cross-dressed woman with the undesirable black, old, cross-dressed man, revealing how asymmetrical the cultural meanings of cross-dressing can be.

In *A Range Romance*, a feminized Chinese man is the counterpoint to the white boy-girl. The film cuts from an image of the foreman flirting with the disguised Bessie to a Chinese man with a long queue running out of the

FIGURE 14. The white cross-dressed woman and blackface cross-dressed man face off at the employment agency. Courtesy of the EYE Filmmuseum/Desmet Collection.

ranch house and into a white cowboy. More white cowboys pour out of the house and push the cook into a wagon that the foreman drives off. The cowboys and a few women in the doorway wave good riddance and shake their fists in his direction. While this particular sequence might seem arbitrary, the strategy aligns with Gold Rush literature and political discourse that sanctified relationships between white men by portraying Chinese men as intrinsically and pathologically effeminate, as Sears, Bateman, and historian Karen J. Leong have documented.[86] Through contrast, the Chinese man's abnormality naturalizes the developing relationship between the white ranch hands. Furthermore, the expulsion of the cook—a racialized wage laborer—paves the way for Bessie's mother to be hired. This exchange enables the white middle-class family to reconcile and ultimately abandon this communal, interracial space. In both *Making a Man of Her* and *A Range Romance*, the white protagonists' temporary transgression of gender or sexual boundaries is shown to be pleasurable and normal through contrast with the inherent gender inappropriateness of a racial Other.

While the attraction between a man and a disguised girl continued to be a popular plot after 1913, it was decoupled from the cherished narratives of American identity represented by the frontier and the Civil War. Romances between men and disguised boys were instead projected into an aristocratic, European past in films like *The White Rosette* (American, 1916). Man-"boy" romances set in contemporary urban spaces, such as *The Subduing of Mrs. Nag* (Vitagraph, 1911), *My Brother Agostino* (Lubin, 1911), *Cutey's Waterloo* (Vitagraph, 1913), and *Mabel's Blunder* (Keystone, 1914), continued, but they were slapstick farces that emphasized the absurdity of gender disguise.

Range romances created a fantasy vision of a frontier boyhood for young women that could make them energetic and physically fit but ultimately happy to surrender their masculinity and independence. The films provided a way of visualizing same-sex desire even as they dissolved homosocial spaces in favor of heterosexual coupling. A young white woman's temporary deviance—and white men's same-sex desire—was legitimated through contrast with the ostensibly permanent deviance of mannish black and Native American women and effeminate Chinese men.

THE PRESTIGE RANGE ROMANCE

Toward the end of the teens, a few production companies returned to the range romance plot in prestige multi-reel features shot in even more spectacular outdoor locations. Like the quality films discussed in chapter 1, these productions hoped to appeal to genteel theatergoers without losing cinema's working-class base. *The Snowbird* (1916) depicts a New York society girl who disguises herself as a boy to finagle a deed from a French Canadian trapper living in the Hudson

Bay region. *The Girl Alaska* (1919) follows a girl disguised as a boy looking for gold in the Yukon. In both cases, as in the earlier films, the disguised girls become the companions of older men whom they eventually marry. Much of *The Snowbird* was shot on location in the Hudson Bay region, and *The Girl Alaska* was shot in Alaska. Indeed, *The Girl Alaska* was advertised as "The First and Only Photoplay Ever Made on Alaskan Soil," a claim that may well be true, if travelogues are discounted.[87] This search for ever more remote film locations reproduced, in a compressed and delayed manner, the quest for new real-life frontiers that had occurred decades earlier. These films united the "vim" and "vigor" of the frontier film with the "class" of theatrical cross-dressing. They also displayed a more complex sexual and gender ideology than their predecessors.

Exotic landscapes were key attractions of the films, and critics praised their location shooting. The "unusually picturesque locality" of *The Snowbird*, according to the *Washington Post*, "has afforded opportunity for really wonderful photography."[88] Critics waxed particularly poetic about *The Girl Alaska*'s spectacular scenary (fig. 15). The *Exhibitor's Trade Review*, for instance, enthused that, "from a photographic standpoint, [*The Girl Alaska*] must be conceded a separate niche in the hall of camera fame. . . . The stern beauty of Alaskan scenery defies adequate description. We are confronted with rugged snow-crowned heights, huge glaciers, desolate gorges, ice-choked rivers, tangled stretches of forest, one can feel the loneliness and majesty of Nature over which broods the silent Spirit of the frozen North, a veritable triumph of realism achieved by the camera's art."[89] Exhibitors invited cinemagoers to identify with the cross-dressed girl adventurer in her explorations of these imposing places. One newspaper ad in Ironwood, Michigan, asked, "Suppose your father had left you alone in the world to make his way up in Alaska and you had grown tired of a monotonous existence and proceeded to follow him. Would you do as Lottie Kruse did in 'The Girl Alaska'—that is don boy's clothes and start out?"[90] The advertisement offers Kruse as a vicarious avatar for the viewer.

Whereas cross-dressed girls in the earlier films navigated the natural landscape with ease, in these later pictures the girls are helpless in the outdoors. In *The Snowbird*, New York society girl Loris Wheeler (Mabel Taliaferro) disguises her gender and tracks down the isolated cabin of declared woman-hater Jean Corteau (Edwin Carewe). Taliaferro (pronounced "Tolliver") was famous for playing fairylike little girls on Broadway, similar to Marguerite Clarke and the female boys discussed in chapter 1.[91] Taliaferro plays Loris as an energetic and assertive modern girl who is nonetheless small and vulnerable. While Loris's athleticism serves her well in the East, she is ill equipped for frontier life. First she faints in a snowdrift, and then she grumbles when Jean makes her fetch water from a stream. In *The Girl Alaska*, Molly McCrea (Lottie Kruse) stows away on a boat heading to the Yukon, but is discovered and almost kicked off before a

FIGURE 15. *The Girl Alaska* showcased spectacular Alaska scenery. Below, Molly (Lottie Kruse) walks on a glacier. Courtesy of the Library of Congress.

genteel fortune hunter, Phil Hadley (Henry Bolton), offers to pay her way. However, neither Molly nor Phil seems particularly cut out for the formidable Alaskan landscape. They meet while seasick and, once in Alaska, are almost crushed by an avalanche. Phil is even less hearty than Molly, though, and she nurses him through a debilitating illness in an isolated cabin.

Combining the divergent attractions of location shooting and a cross-dressed Broadway actress worked well in *The Snowbird*. The film shifts skillfully between exterior shots of thrilling dogsled rides and interior shots of Jean's cabin, where a complex psychological drama between Jean and Loris unfolds. Reviewers praised Taliaferro's performance and the scenery in equal measure. *Variety* critic Joshua Lowe found the film "full of vim, vigor and class."[92] Other critics were less impressed: "Unusual scenery in this subject adds attractiveness to a commonplace story and familiar handling."[93]

The thoroughly familiar man-"boy" romance also exasperated reviewers of *The Girl Alaska*: "The plot is as old as it is implausible, but the feature offers so much from a pictorial standpoint that the narrative becomes the least important factor in the production."[94] The reviewer even suggested that the scenic footage be extracted from the film and presented as a travelogue. While the filmmakers may have intended the cross-dressed romance plot to add a theatrical pedigree to the film, the actors and producers of *The Girl Alaska* had neither the name recognition nor the acting experience of Carewe and Taliaferro, and their performances are significantly flatter. This is the only film in which Bolton ever appeared, and it was Kruse's last.

Although we may expect a film with class ambitions like *The Snowbird* to be in line with middle-class morality like *A Range Romance*, the film shows significantly more deviant forms of frontier sociality than the earlier films. Jean is presented as a "beast" who "hate [*sic*] all women." When he finds the disguised Loris in a snowdrift outside his cabin, he does not offer to take the youth back to town, but declares, "Like a wounded snowbird you have dropped from the sky to share my loneliness—here you can stay and be my boy!" Jean's nomination of Loris as "my boy" could be a paternal move, but, as we have seen, frontier literature often used the language of father-son relations to describe homoerotic bonds. The subsequent scenes suggest that Jean considers Loris "his boy" in another sense, that is, as his male servant, a relationship that comes to be freighted with sexual as well as physical domination.

After declaring Loris his boy, Jean's eyes rove over the youth's body. "Not much muscle but I'll soon fix that. I will put you to work and soon you will be big and strong," he says. Jean flexes his own biceps, which Loris feels appreciatively. Jean then wraps an arm around Loris. The next day, the two play out a sadomasochistic, pederastic scenario. Jean makes his boy fetch water, scrub the floor, and polish his tall, black, leather boots. "Here boy, oil my boots," he commands.

Leather boots had long been a sexually charged symbol in Victorian S/M fantasy.[95] Jean watches Loris work, towering over the crouched figure, lazily smoking a cigarette, and laughing at any signs of resistance. When Loris refuses to oil the boots, Jean pushes her toward the fireplace, locks the door, and grabs a whip, shouting, "You are my boy now and you are going to do as I say!" Jean whips her until she passes out. Her hat falls off, revealing her long hair—and hence, in the codes of male impersonation, her femaleness. Stunned, Jean carries Loris to his bed. Her blond hair fans out angelically. Although at one level this whole interaction can be read as a misogynist taming of a willful woman, the hyperbolic nature of the boots, whip, and servitude pushes it into homoerotic S/M fantasy.

The physical and sexual threat that Jean poses to Loris is compounded by hints that he may be part Native American. Carewe himself was part Chickasaw, and at least one newspaper linked the actor's Native American identity to the character's "elemental" passions: "[Carewe] is especially fitted for the part, as the role is that of a French-Canadian reared in the woods in a primitive state. Mr. Carewe is half Chickasaw Indian, and he gives a fine characterization of this typical man of the great outdoors, whose impulses and passions are elemental in their simplicity and force."[96] Reviews in the major national dailies and trade journals did not note Carewe's Native American heritage, though, and the information does not seem to have become a part of his public persona until 1927, when he directed *Ramona*.[97] *The Snowbird* itself is somewhat coy about the character's ethnicity. Jean is introduced only as "A French Canadian." French trappers and traders in the Hudson Bay region had long intermarried with local Algonquin women, so "French Canadian" could suggest mixed blood. Indeed, Jean's temperament fits stereotypes of the mixed-race French Canadian fur trapper. Furthermore, the town magistrate describes Jean as "a type of the bold French Canadian, possessing a good education that makes him shrewd and cunning." Usually in films of this era, when a "good education" makes a character "shrewd and cunning," that character is of mixed race and has outsized ambitions. The coded suggestion that Jean could be part Native American adds a racial dimension to his domination of Loris, but one visible only to the "wise."

Upon the revelation that Loris is female, the scene veers into a bizarre Oedipal fantasy. Loris dons Jean's mother's wedding dress, ostensibly the only female clothing a single man would own. When Loris appears in the doorway to the bedroom, Jean looks her up and down and says, "You are beautiful, Madame" (not the more appropriate "Mademoiselle"). Enthralled by this girl/mother figure, Jean offers Loris the contract she seeks. But when he discovers that she has already taken it, he becomes enraged and kisses her brutally on the mouth. In a flashback, we see the Parisian coquette who had broken his heart. We then return to the present. Jean kisses Loris again; she fights him off and grabs a knife; but he keeps advancing toward her until she presses the tip of the knife into her own chest. The scene

evokes many films in which a "savage" man advances on a white woman—most famously when Gus, "a renegade Negro," approaches "The Pet Sister" Flora in *The Birth of a Nation* (David W. Griffith Corp., 1915). But where the situation in that film ends in tragedy (Flora falls from a cliff to her death and Gus is lynched), in this case the predator experiences a last-minute conversion. Seeing her determination, Jean declares: "[Y]ou—you are the first good woman I have ever known." He kneels, hands her the whip, and cries at her feet. This conversion, a common device of stage melodrama, was re-staged in one of the film's publicity stills (fig. 16).[98] The passing of the whip from Jean to Loris invests erotic and physical dominance in a prop, which can be handed back and forth, suggesting potential flexibility in the erotic performance of dominant and submissive positions.

The next morning, the couple tentatively playacts pioneer domesticity. Loris, still in the wedding dress, fries eggs on a cast iron skillet while Jean fetches water from the stream. The film presumes that Jean and Loris are in love. Once Loris's former fiancé is peremptorily disposed of, Jean and Loris marry. On one level, this film, like all the others, uses heterosexual marriage to dissolve the perverse sexualities enabled by the isolated, apparently single-sex space of the frontier.

FIGURE 16. Jean (Edwin Carewe) hands Loris (Mabel Taliaferro) his whip in a publicity photo for *The Snowbird*. Courtesy of the Robert S. Birchard Collection.

On another level, though, the couple's relationship takes place largely within a scenario of oscillating domination and submission, compounded by same-sex, incestuous fantasies.

Whereas in films like *A Range Romance* the newly formed couple returns to "civilization" and regenerates the middle-class, racially pure family, the couple in *The Snowbird* refuses this trajectory. At the end of the film, we see Loris and Jean "Back in the land of so-called civilization," according to an intertitle. Loris wears a dress and Jean stands awkwardly in a suit. She leans toward him and whispers in his ear, "I want to go back to the land of the whispering pines—to the great Northland with you!" She evokes the Northland as an intimate, erotic space that they alone share. In the film's final image, the couple stands in matching fur coats on a dogsled in the snowy woods. Jean gestures to the space around him and says, "There is our cabin—and there are the hills—here is the land we love." What, we wonder, will their relationship look like in this isolated cabin? Although they may fall into the pioneer domesticity they playacted earlier, the ending also allows us to imagine them enacting any number of unusual relationships in their cabin. While most narratives cordoned off the frontier as a temporary stage on the way to civilization, *The Snowbird* lingers in the perverse pleasures of the frontier.

Remarkably, critics did not object to Jean's unconventional courtship of Loris, even the sexual assault. *Motography* in fact proclaimed the confrontation the film's "best dramatic situation," and the *Lowell Sun* declared the film "bound to please all."[99] Perhaps critics did not object to these scenes because the trope of the man-"boy" romance was so conventional. Critics may also have read the psychosexual drama as a sign that the film was art. However, reviewers did elide the details of Jean and Loris's interactions, suggesting some discomfort with the S/M seduction. Within a paragraph-long plot summary, for instance, *Motography* described the central dramatic conflict in two short sentences: "Masquerading as a boy, [Loris] is taken into Corteau's cabin. The result is that both are attracted to each other and in the end, after Mitchell has been disposed of, they marry."[100] This description jumps from Loris's arrival in the cabin to the couple's marriage, breezing past the extended scenes of domination and submission. Even more briefly, *Moving Picture World* summarized: "In the wilds [Loris] meets a dominating man and the result is according to precedent."[101] While the "precedent" may refer to the taming of a willful women, it is striking how thoroughly the review avoids the potentially problematic aspects of their encounter. In this high-class version of the range romance, the frontier is a perverse place, and the protagonists refuse to leave. Although the film ends, as the others do, with a heterosexual marriage, there is little to suggest that the sexual dynamics of this potentially interracial relationship will accord with "civilized" sexual norms.

Metro must have judged *The Snowbird* a success. The studio cast Taliaferro in two more cross-dressing roles, in *Peggy, the Will o' the Wisp* (1917) and *The Jury of Fate* (1917). The latter revisited themes from *The Snowbird*. Taliaferro plays a French Canadian girl who impersonates her dead brother. A "half-breed" man loves her and helps her repeatedly, but this time she marries a respectable character with an Anglo-sounding name, Donald Duncan. Far more conventional man-"boy" romances like *The Girl Alaska*, as well as *The Dream Lady* (Bluebird, 1918) and *The Trail of the Law* (Oscar Apfel Productions, 1923), followed this film and met somewhat less critical enthusiasm.

In the late 1910s, the range romance seemed to offer a promising way to marry theatrical prestige and spectacular location photography. Although the most polished attempts were successful, audiences seemed more interested in physically accomplished but feminine frontier girls than in incompetent girls in boys' clothing. Films like *The Snowbird* and *The Girl Alaska* troubled the developmental logic that permitted deviance on the frontier so long as it was temporary, which may have appealed to those female viewers who deviated from the middle-class norm (or wished to), though the films again offered heterosexual marriage as a solution to this disorder.

LANDSCAPE, VITALITY, DESIRE

Cinema's "adolescence" was a time in which female characters were allowed to experiment with different kinds of gender and sexual expression, in a fashion similar to the new leeway permitted to young women during their teenage years. Cross-dressed chase sequences, feminist ranch takeovers, and range romances appealed to the cross-class and trans-regional audiences already consuming representations of frontier women in newspapers, dime novels, plays, and Wild West shows. The films offered the spectacle of heroic women in real outdoor settings and visualized the homoerotic attachments of the gender-imbalanced frontier even while undoing them. Cross-dressing symbolized women's ability to take over for incapacitated men, but also girls' revitalizing experience of frontier boyhood. These films converted pathos to thrilling spectacles and limited female masculinity to a temporary developmental phase, set in a temporary space. Cross-dressing was celebrated as a short-lived, playful experience connected to physical and racial vitality rather than feminist politics. To emphasize this point, many films contrasted the pleasingly masculinized frontier girl with the more threatening, politically ambitious, East Coast New Woman. While women's heroism and "masculine" physical talents continued in the serials, they were increasingly counterbalanced by a visual emphasis on actresses' attractive femininity.

Between 1908 and 1913, young, white women in men's clothing embodied a national ideal of fearless, athletic engagement with the American outdoors.

Moving pictures allowed these active women to be pictured in real landscapes, in motion, for the first time. Even as cross-dressing was increasingly abandoned, American actresses became permanently associated with the "masculine" vitality of the American frontier girl. For example, in 1911, one Vitagraph actress opined that the high quality of actresses from California was due to their apprenticeship to "the men folks of California," who taught them to ride, swim, camp, fish, throw a lariat, and "rough it." "The Western girl," she concluded, "generally possesses the accomplishments of both the men and women of other sections."[102] Although the cross-dressed frontier girl was never again as popular as she was during the transitional era, moving picture women continued to take over heroic and athletic roles formerly reserved for men. Looking back in 1920, *Photoplay* remarked, "The early years of the twentieth century brought to American women the same vast, almost fabulous changes that came to their grandfathers in the middle of the century preceding. What the expansion of the West and the great organization of industry opened up to many a young man, the motion picture spread before such young girls as were alert enough, and husky enough, and apt enough to take advantage of it."[103]

INTERMEZZO CODES OF
DEVIANCE
(1892–1914)

3 ▸ CULTURAL HIERARCHY AND THE DETECTION OF SEXUAL DEVIANCE IN *A FLORIDA ENCHANTMENT*

IN 1896, *A Florida Enchantment*, a comedy about seeds with the ability to change one's sex, opened on Broadway. The play follows a white New York heiress, her "mulatta" maid, and her white fiancé, who swallow the magic seeds while on vacation in Florida. The transformed heiress and maid court every available woman and eventually don men's clothes and identities. The play provoked a critical firestorm. The *New York Times* charged that it contained "a few of the most indecent ideas . . . that mortal man has ever tried to communicate to his fellow-beings."[1] Another critic called it "nauseous" and "the most singular of all the offenses that have been committed upon our stage."[2] Eighteen years later, in 1914, the Vitagraph Company adapted the story to film (fig. 17). In contrast to the play, the film was promoted and received as an innocuous, high-class comedy. A Wisconsin exhibitor exhorted local women, "Mothers Send the Children / THIS IS A GOOD WHOLESOME COMEDY THEY WILL ENJOY."[3]

How can we account for such different reactions to the same story less than two decades apart? Previous scholars have argued that knowledge of sexual inversion and lesbianism became more widespread in the United States from the 1890s onward, and that cross-dressed and otherwise "mannish" women were increasingly suspected of sexual deviance.[4] However, I found that knowledge of inversion and a tendency to connect cross-dressing with deviant identities did

FIGURE 17. Lawrence (Edith Storey) proposes to Bessie (Jane Morrow) in *A Florida Enchantment* (1914).

not become more common during this period. Instead, both emerged in elite circles in the 1890s but remained submerged in popular culture until the late 1920s. Furthermore, audiences' readiness to read cross-dressing as a sign of lesbianism or inversion was not exclusively tied to the rise of sexology and attempts to delegitimize the women's movement.[5] Tracing the reception of the novel, play, and film versions of *A Florida Enchantment* reveals that the circulation of these ways of reading were tied not only to the medicalization of sexuality, but also to contests over cultural hierarchy. More specifically, they involved critics' attempts to ratify an in-group of "sophisticated" viewers aligned with the metropolis, high art, and the Continent and opposed to the provincial, the commercial, and the United States.

By representing sexual inversion quite literally, *A Florida Enchantment* offers a useful limit case for gauging whether viewers were disposed to read cross-dressing and other cross-gender behavior as symptoms of a pathological identity. *A Florida Enchantment* is not a typical cross-dressing play or film: the plot is not about a character disguising her identity, nor is a woman simply cast in a male role. How, then, can it help us understand more typical cases of cross-dressing? First, the look and story of *A Florida Enchantment* belong to the long tradition of gender-disguise romantic comedies, even as the narrative offers a baroque

variation. The gender-changed characters look like contemporary cross-dressed performers, as I will show. The story, too, is similar to comedies in which a woman takes revenge on a straying sweetheart by disguising herself as a man and flirting with the other woman. Second, the magical gender change seems *more* likely to connote sexological inversion than typical cross-dressing because it literally presents an inversion of the characters' gender. *A Florida Enchantment* represents women who not only cross-dress but also declare themselves to be men and proclaim their desire for other women; in addition, two feminine women express desire for someone they believe to be a woman. If audiences were not willing to read these over-the-top characters as lesbians or inverts, they would have been be even less likely to read these meanings into more typical cases of cross-dressing.

Part I of this book ends in 1921. This Intermezzo reaches back to the 1890s to investigate when and under what circumstances audiences read cross-dressing as a sign of sexual deviance. The first two chapters showed how theater, folklore, and the physical culture movement strongly influenced the meanings of cross-dressed women in the 1910s. Within these frameworks, cross-dressed girls and women embodied Anglo-American ideals. Throughout this book I have argued implicitly, and in this chapter I will argue explicitly, that the specter of lesbianism did not haunt cinematic cross-dressed women in the 1910s the way it would in the years to come.

Michel Foucault asserted that in the late nineteenth century, sexologists' attempts to catalog human sexual behavior resulted in "an incorporation of perversions and a new specification of individuals"; that is, they turned sexual behavior and desires into a core aspect of human identity.[6] What's more, sexologists used these behaviors and desires as "a principle of classification and intelligibility."[7] One of these new classifications was the homosexual. Where the state had previously treated the "sodomite" as a "temporary aberration," Foucault wrote, sexologists made the "homosexual" into a "species."[8] Authorities experienced a certain pleasure in "exercising a power that questions, monitors, watches, spies, searches out, palpates, brings to light" these identities, just as others experienced a corresponding pleasure in "having to evade this power, flee from it, fool it, or travesty it."[9] Foucault identified a key break in 1870, when the German sexologist Carl von Westphal published a paper on "contrary sexual instinct." This paradigm change occurred within the ruling classes first, Foucault argued, and only belatedly within the working class.

As historian of sexuality David Halperin points out, Foucault was not a social historian. Foucault described discursive changes within elite institutions, not what individuals did with their bodies and what they thought of their actions.[10] Foucault left open how the changes in medicine and law percolated through broader society. Furthermore, the "homosexual" Foucault delineated

is implicitly male; women were rarely described as "sodomites," nor were their sex acts commonly prosecuted. Although terms for women who had sex with women had long existed, and even though some sexologists (including West-phal) theorized analogous male and female versions of sexual inversion, it took much longer for sexually deviant women to become legible in American popular culture than sexually deviant men. Even after the "pansy" had become a recognizable urban type, women in men's clothing were not automatically under suspicion.

Despite its shortfalls, Foucault's account can help explain the way notions of lesbianism and sexual inversion circulated in American culture. The reception of *A Florida Enchantment* shows that the concept of the female sexual deviant did circulate first among the elites and that they took pleasure in seeking out this deviance and bringing it to light, while non-elites resisted this way of think-ing. However, in the 1920s, as we will see in the next chapter, moving pictures became one component in the overall process through which sexual identities became visible and, hence, known in modern society. This shift accords with film historian Mark Lynn Anderson's argument that the Hollywood star system of the 1920s was "an integral participant in the elaboration of personal iden-tity" and that it popularized "a set of knowledge categories about deviance and identity" from psychology, sociology, and anthropology.[11] Although queer film scholar Susan Potter maintains that cinema began constituting new sexual sub-jectivities around female same-sex desire as early as the 1890s, I would stress that these subjectivities remained incoherent and unnamed until the 1920s.[12] In the 1910s, American critics, censors, and mass audiences read even the most explicit representation of sexual inversion as wholesome family fun.

FLORIDA ENCHANTMENTS

Before beginning my analysis, I will describe the three different versions of *A Florida Enchantment*. The novel was written by the popular British American author, publisher, and playwright Archibald Clavering Gunter and published by Gunter's company in 1892.[13] It follows Lillian Travers, a young, white heir-ess from New York. She surprises her fiancé, Dr. Fred Cassadene, at the Florida resort where he is working. When she sees him wooing a wealthy young widow, Stella Lovejoy, she is heartbroken. She then discovers magic seeds that are purported to change one's sex and decides to take one, in order to "love in the selfish, careless way men do, and be happy!"[14] She wakes up the next day with the instincts and habits of a man and begins to court her longtime friend Bes-sie Horton and every other girl who comes her way. She forces her black maid Jane to swallow a seed, and the two return to New York to reinvent themselves as men, Lawrence Talbot and Jack, respectively. Lawrence returns to Florida and

woos Bessie once more. They become engaged. When Fred accuses Lawrence of murdering Lillian, Lawrence tells him the truth and gives Fred a seed as proof. Fred eats it and turns into a simpering sissy. Out of pity, Lawrence gives the feminized Fred the last seed so that he can transform back into his former self. The novel ends when Lawrence and Bessie marry and sail into the sunset.

In 1896, the novel was adapted into a play. It previewed at the Park Theatre in Boston in April 1896, where it ran for two weeks with the British actress Sibyl Johnstone as Lillian and blackface comedian Dan Collyer as Jane. Six months later, on October 12, 1896, the play opened in New York at Hoyt's Theatre on West Twenty-Fourth Street and Broadway, with Marie Jansen playing Lillian. It ran there for six weeks before moving to the Columbia Theatre in Washington, D.C. No script or detailed summary of the play is known to exist, but from the surviving reviews, the plot remained basically the same, with the addition of song and dance numbers. Jane sings "I've Been Hoodooed" in the second act, and Bessie dances in a nightgown to lure Lillian to bed. In December 1896, a burlesque of the play featuring a 450-pound actress and a "bevy of girls" appeared in the western United States, but little is known about it.[15]

Eighteen years later, in April 1914, the Vitagraph Company announced plans to release four feature-length films adapted from Gunter's novels. *A Florida Enchantment* opened on August 10, 1914. The stage comedian Sidney Drew directed the film and took the part of Dr. Fred Cassadene. Edith Storey, who had played Sebastian in Vitagraph's *Twelfth Night* (1910) and cross-dressed frontier girls in Vitagraph and Star westerns, was Lillian. The white comedian Ethel Lloyd played Jane. Vitagraph scriptwriter Jane Morrow (aka Lucille McVey, soon to become the second Mrs. Sidney Drew) performed as Lillian's friend Bessie, and Ada Gifford had the role of the seductive widow Stella.[16] Although the basic plot remained the same, the film excluded the novel's backstory and many incidents,[17] and there were no song or dance numbers. The biggest change was to the ending. In the book (and presumably the play), "doctoress" Cassadene becomes a man again, and Lawrence and Bessie marry. In the film, townspeople chase Cassadene off a pier. Lawrence spies the drowning person from his balcony—and then the film abruptly cuts to Lillian asleep in a chair with Fred standing behind her. She jerks awake and exclaims (in an intertitle), "Oh Fred, I've had such a horrible dream!" The two laugh at a letter extolling the magical properties of some seeds. The film thus eliminates several potentially scandalous elements of the play, including Bessie's seductive dance and the idea that Bessie and Lawrence could marry and be happy together. Framing the characters' topsy-turvy antics as a dream contains them as fantasy and aligns the film even more strongly with *A Midsummer's Night Dream*, already an intertext for the story.

A Florida Enchantment is the most widely circulated film addressed in this book so far. It first appeared in film scholarship in the 1970s as an example of

early cinema's demeaning portrayal of black people.[18] Gay film historian Vito Russo changed the focus in his groundbreaking 1981 book *Celluloid Closet*, citing the film as an early representation of lesbian desire.[19] Beginning with its screening at the San Francisco International Lesbian and Gay Film Festival in 1989, the film has been shown at LGBT film festivals around the world, and the Library of Congress has released it in three formats: VHS (1994), Laserdisc (1998), and DVD (2001). The film has received cursory mention in many works on American silent cinema, but R. Bruce Brasell's 1997 article, "A Seed for Change," and Siobhan Somerville's 2000 book chapter, "The Queer Career of Jim Crow," have become the defining analyses of the film.[20] Brasell helpfully traces the reception of the novel, play, and film, but he overemphasizes critics' negative reactions and cannot account for the film's generally positive public reception. He also overstates the legibility of the invert to the film's audiences, as I will show.

Somerville perceptively argues that the film's play with gender and sexuality rests upon the reification of racial boundaries. She shows that the film erases the novel's engagement with the slave trade, freak show, and minstrel show and dispenses with the backstory in which white sailors become women and fall in love with black male cannibals. These excisions made the film more respectable and thus more attractive to white, middle-class women, whose increasing attendance at movie theaters during this period instigated stricter racial segregation of these spaces. Somerville also argues that while the film flirts with same-sex desire, it refuses to acknowledge the possibility of interracial desire. At the same time, she observes, "Although the film attempted to construct a stable division between black and white, the very use of blackface and its proximity to drag threatened to break that division down."[21]

Somerville's analysis of the inseparability of emerging discourses of homosexuality and race is groundbreaking. Her insights into Vitagraph's association with white, middle-class respectability also informs my own analysis of the film. However, I disagree with her on a few points. First, the film does depict interracial desire. The transformed Lillian expresses desire for Jane at two points in the film. The morning after swallowing the magic seed, Lillian winks vulgarly at Jane, and Jane starts backward in surprise. Lillian's wink suggests that she expects to enjoy the white, upper-class male privilege of access to black servants' bodies. Lillian also shoves the magic seed down Jane's throat in a violent manner that evokes the white rape of black bodies. Thus, the film does imagine interracial desire, but only in terms of domination.

Second, I disagree with Somerville's argument that Ethel Lloyd's performance of blackness was intended to be naturalistic. Although some blackface performances in early cinema were indeed meant to be viewed as realistic, Lloyd performs in an exaggerated, comedic style derived from the minstrel stage.[22] Jane/Jack and the other servants provide a slapstick counterpoint to the

white characters' comedy of manners. Making feature-length film comedies was a new and unproven endeavor, and anarchic blackface antics could appeal to audiences who might otherwise lose interest during five long reels.

Furthermore, we can think of Lawrence and Jack as two sides of white women's fantasies of male privilege. Lawrence represents power, authority, and legitimate sexual pursuit, or the "ego," while Jack represents sexual and bodily abandon, or the "id." The fact that both characters are played by white women supports this interpretation. Of course, Somerville is correct that the film's representations of black masculinity are racist assertions of sexual voraciousness on the one hand (Jack) and cowardliness on the other (the servant Gustavus Duncan), while the black women are portrayed as mannish, undisciplined, and unattractive. But viewers were well aware that the actors playing black characters were white and that they were based on the conventions of the minstrel show.

Like Brasell, Somerville argues that audiences in 1914 would have read Lillian as a sexual invert.[23] She suggests that critics did not object to the film because the ending "neutralizes Lillian's sex change."[24] However, if general audiences were really reading the three protagonists as pathological sexual deviants, the dream gimmick would not have been enough to save the film from censure, let alone allow it to be recommended to children. Though Somerville's analysis of the racial dynamics of the film is astute, I disagree with her on the legibility of the sexual invert.

A Florida Enchantment has received a fair amount of attention from LGBT viewers and scholars alike, but no one has addressed how such a seemingly transgressive film was produced and distributed at a time when censors, police, watchdog organizations, and politicians attacked many other films. Why did critics decry sexual inversion in the 1896 play but not say a word when a film based on the same story circulated much more widely? I argue that this disjuncture occurred because elitist critics of the 1890s framed the detection of inversion as a skill that characterized an in-crowd of sophisticated playgoers. In the 1910s, by contrast, film critics adopted a more straightforward reading when they discussed cross-dressing in films, and the cross-gender behavior displayed in *A Florida Enchantment* was more strongly connected to old-fashioned entertainment than to deviant identities.

THE NOVEL, 1892

The decade of the 1890s was a period of enormous economic and social instability. Immigrants poured into the United States, and black Americans migrated to the North and West. Many Americans moved from the countryside into cities, where they found work in new factories and shops. While some industrialists made untold sums, the country was gripped by a series of depressions, and

workers organized to resist the oppressive conditions dictated by factory and railroad owners. The political and social demands made by workers, immigrants, women, and people of color pushed against traditional cultural authorities. Historian Lawrence Levine has argued that in the face of this sense of impending chaos, American cultural elites responded by reinforcing the line between high and low cultural forms.[25] According to Levine, the upper class turned to "culture" as "one of the mechanisms that made it possible to identify, distinguish, and order this new universe of strangers."[26] While Levine may overestimate the power of these elites to shape public culture given the declassifying forces of the market, he accurately describes elite attempts to shore up cultural hierarchy.[27] While these elites were "sacralizing" Shakespeare, opera, and symphony orchestras, New York theater shifted from a rowdy, working-class, male space to a genteel, middle-class, female space.[28] Burlesque, variety, and vaudeville likewise cleaned up their acts during this period. Thus, the 1890s were marked by contests over cultural hierarchy fought on the terrain of commercial entertainment culture. These contests were crucial factors in the reception of *A Florida Enchantment.*

When Archibald Clavering Gunter published *A Florida Enchantment* in 1892, its low cultural status apparently exempted it from critics' suspicion. By this time, Gunter was a well-known author of popular novels. Born in Liverpool in 1847, he emigrated to San Francisco with his family at the age of six and worked there in the 1870s as a chemist, mine superintendent, and stockbroker until moving to New York in 1879.[29] Several of his plays were produced, but no one would publish his first novel, *Mr. Barnes of New York*, so he published it himself in 1887. The book was a sensation, and Gunter followed it with a series of novels about cosmopolitan American adventurers.[30] One critic called him "the shopgirl's favorite novelist," disparaging his works as chick lit *avant la lettre.*[31] The literary establishment did not take his books seriously. When he applied to join a New York writers' society, it refused him admission because his books were "not literature."[32] Perhaps to appeal to his most enthusiastic demographic, Gunter framed *A Florida Enchantment* as a comedic critique of upper-class men's carelessness with women's hearts. For working-class female readers, Lillian/Lawrence's delight in the emotional and practical freedoms of life as a wealthy white man provided vicarious wish fulfillment. References to the slave trade, the dime museum freak show, and white sailors falling in love with black cannibal men evidently did not upset the novel's mass audience.

Despite Gunter's popularity, few critics reviewed *A Florida Enchantment.* The *Rocky Mountain News* called it "a wild and highly improbably story" that would be well received by "those who have read Mr. Gunter's other books."[33] The *Los Angeles Times* described it as a "queer, fantastic book which exhibits the great resources of the author's imaginative powers. The plot of the story is so strange it

will read with curious interest to the end.''[34] Though perhaps hinting at patholog-ical sexuality, the critic nonetheless recommended the book to readers. Thus, the first iteration of *A Florida Enchantment* was received as just another of Gunter's mass-market, lightweight novels.

THE PLAY, 1896

Although Brasell argues that the stage adaptation of *A Florida Enchantment* was met with outrage, in fact the reception was split. Elitist critics were indeed offended by the play's suggestions of sexual pathology (among other things), while populist critics called it an innocuous, lightweight comedy. Elitist critics communicated their understanding of the play's characters as inverted or lesbian via intertextual references and used these reading strategies to constitute an in-group of "sophisticated persons" like themselves. Populist critics resisted these interpretations and insisted that even the most literal representation of gender inversion was innocent of immorality.

The most negative reactions to the play appeared in the *New York Times, New York World,* and *The Critic* (a highbrow New York literary journal).[35] The *Times* called for a "chloride of lime" to bleach the stage of Hoyt's Theatre, and *The Critic* called it "the worst play ever produced in this city." Although Brasell attri-butes this hyperbolic language to the shock of seeing sexual deviance, sensation-alism was typical of the "yellow journalism" of the period.[36] The *Times* had used similar language to criticize a Gunter play that contained no sexual deviance at all: "[N]othing human could redeem such a dramatic monstrosity as Archibald Clavering Gunter's play called 'Mr. Barnes of New-York.'"[37] The critics com-plained as much about *A Florida Enchantment*'s construction as its content, call-ing it inept, dreary, stupid, coarse, clumsy, and silly.

The production was all the more upsetting to these critics because of *where* it was staged. As historian Paul DiMaggio shows, in the second half of the nine-teenth century U.S. urban elites worked to "erect strong and clearly defined boundaries" between high and popular culture and to segregate them spatially.[38] By the 1890s, raunchy and erotic performances were, for the most part, con-fined to theaters catering to working-class men.[39] *A Florida Enchantment* glori-fied sexual desire and featured scantily clad women, and yet it was staged at a legitimate Broadway theater. Theater historian Laurence Senelick argues that the play caused a ruckus precisely because of the recent gentrification of the New York stage.[40] The complaint expressed in the *Times* is directed as much to the venue as to the play's content: "Theatricals have never before sunk quite so low in New-York—on a decent stage."[41] Critics were upset that market forces enticed managers to blend the high and low culture that elites tried so hard to separate. The *Times* furthermore likened *A Florida Enchantment* to two French operettas,

which "were thought, hitherto, to be the nastiest things theatrical ever inflicted on New-York," but which had no hint of sexual deviance whatsoever.[42]

At the same time, critics at the *World* and the *Times* also claimed that *A Florida Enchantment* contained immoral meanings comprehensible to only a few theatergoers, suggesting that they objected to the representation of sexual inversion. For example, the *Times* critic, as already noted, found in the play "a few of the most indecent ideas . . . that mortal man has ever tried to communicate to his fellow-beings"; yet "the manner of the playwright is so bungling that none but very sophisticated persons catch his drift."[43] If the play were lamentable solely because of its celebration of lust, one imagines that any playgoer would be capable of noticing. Instead, some uncommon knowledge was required for the indecent meaning to be intelligible. A critic at the *World*, however, went further:

> Unsophisticated people may see humor in complications based entirely upon differences in sex. They may consider that double entendre revolving around the natural laws of sexual attraction and their violation is comic. But metropolitan audiences are not unsophisticated. They have read their Gibbon, and recent criminal records are not unknown to them.
>
> It is impossible to believe that the author has willfully sought to be fin-de-siècle in this respect. He must have played with fire without knowing it.[44]

This critic posits two kinds of playgoer: "unsophisticated people" who view gender-inverted behaviors as simple comedy, and "metropolitan audiences" who infer a more sinister meaning. The way individuals read "complications based entirely on differences of sex" marks them as either sophisticated or unsophisticated.

This critic used a succession of cultural references to indicate just what he felt was wrong with the alleged comedy. The "natural laws of sexual attraction and their violation" evokes Darwinism and sexology. The "Gibbon" these playgoers must have read is undoubtedly Edward Gibbon's *Decline and Fall of the Roman Empire*, which proposed, among other things, that the empire was weakened by sexual decadence that included same-sex sexual practices.[45] Among "recent criminal records" of scandalous relationships were the Oscar Wilde trials of 1895 and the Alice Mitchell murder trial of 1892. "Fin-de-siècle" signals the European cultural movement that celebrated perversity and decadence as a counter to the deadening effects of bourgeois culture. Altogether, these references suggest that, to the educated playgoer, *A Florida Enchantment* raised the specter of the sexual invert.

The most negative critic of the play did not define two types of playgoers as others did, but distinguished between his own reactions—he found the play

"nauseous" and "disgusting"—and those of the general audience, who watched in "dumb astonishment."[46] This critic used scientific-sounding language to describe the plot, which may have evoked sexology for those readers familiar with it: "The unsexed heroine manifested the suddenly acquired masculine instincts and attributes by falling in love with her girl chum, hugging her passionately, and kissing her with paroxysmal delight. . . . Marie Jansen had the misfortune to appear in the role of the bisexual individual." Terms like "suddenly acquired masculine instincts," "paroxysmal delight," and "bisexual" read like a case history from Krafft-Ebing's *Psychopathia Sexualis*. (At this time, "bisexual" referred to an organism possessing both sexes, not a person attracted to both sexes.[47]) The review suggests that the critic could detect the play's depravity because of his familiarity with sexology, while others were simply confused.

The cascading allusions in these reviews fit the rhetorical pattern used to discuss lesbianism in other contexts. Literary historian Sharon Marcus has shown that British critics who wanted to "resolve the conflicting demands of censure and censorship . . . made their discourse circular, repeatedly using negation, ellipsis, periphrasis, and metonymic allusion. . . . Intended as veils that would conceal sapphism, the proper names *Juvenal, Sappho, Catullus*, and *Swinburne* became instead veils that outlined it."[48] The code words used by U.S. theater critics were different, but the effect was the same. Whereas British critics may have genuinely hoped to suppress knowledge of lesbianism through these codes, New York theater critics used knowledge of deviant identities to affirm a cultural hierarchy.

The in-group that critics called "sophisticated" consisted of cosmopolitan, urban elites with a classical education and broad familiarity with contemporary medicine, art, and law. They were aligned with European metropoles and against the masses and the rural, lowbrow, and commercial. The fight to distinguish this cosmopolitan elite from the masses can be seen in the changing meanings of the word "sophistication." According to the *Oxford English Dictionary*, English speakers did not begin to use the word "sophisticated" as a positive attribute until the second half of the nineteenth century. Derived from "sophistry," "sophistication" initially meant "the process of investing with specious fallacies" or "the disingenuous alteration or perversion of something."[49] Only in 1850 was the word first used to mean "worldly wisdom or experience; subtlety, discrimination, refinement." In the 1890s, critics employed a positive version of "sophistication" to clarify cultural hierarchies that the country's economic and social restructuring had confused. At this point, however, "sophisticated" critics were quite moralizing. They had not yet acquired the blasé stance that would characterize "sophistication" after the First World War.

Remarkably, critics did not count Gunter among the people who understood the true meaning of his own play. A headline in the *New York Herald* announced, "Mr. Gunter Can't See It. He Fails to Perceive the Lack of Wit or Decency in

His Latest Play."[50] Thus, the "sophisticated" reading strategy looked beyond the author's intentions to interpret how the performance exceeded those intentions in outrageous ways. In the aftermath of opening night, Gunter defended the play: "Nothing immoral or indecent is intended in 'A Florida Enchantment,' but, of course—'honi soi qui mal y pense.'"[51] In a sense, he agreed that only select playgoers were capable of divining an immoral meaning, but he located that evil meaning in the minds of so-called sophisticated playgoers.

Not everyone decried the play and used coded references to allude to deviant identities. Critics in frontier towns like San Francisco and Galveston, as well as in Washington, D.C., aligned themselves with an appreciative public. For example, the *San Francisco Call* reported that New York papers were "very curt and bitter in their criticisms of the play when it opened, but the public like the ludicrous side of the unique story, and in consequence Hoyt's cozy little theater is filled every night."[52] Likewise, the *Galveston Daily News* reported, "There has been a succession of large audiences since the opening night, and as the 'comedy frolic' does not impress people as being nearly so shocking as they anticipated after reading the newspaper notices, a favorable reaction has set in for the play. The audiences evidently find the play amusing, and there are an abundance of uproarious laughter and curtain calls after each act."[53] These out-of-town critics championed a straightforward reading strategy that did *not* interpret gender inversion as a reference to real-life, pathologized identities. Some saw the inversions as hilariously improbable, and others argued that comedy, by its nature, should not be taken seriously. The San Francisco and Galveston newspapers play up the good-humored, convivial response of the public as a populist rejection of high-culture elitism.

The most explicit rejection of New York critics' "sophisticated" response came from the *Washington Post*. In three separate reviews, the *Post* critic praised the play's merry humor and the actors' performances.[54] In the second, he declared that *A Florida Enchantment* "has been prepared for the stage solely as a bit of fun. It is not intended to discuss or solve any modern social problem, as affecting the sexes, but simply endeavors to show that young men have a great deal better time than young women in the social environment of modern civilization. . . . The play is full of novel features and comical situations, and is presented upon a magnificent scale."[55] When the play opened in Washington, the critic noted, the theater was filled "with an audience which laughed and grew fat through four short but spicy acts." He concluded that the play, "if not taken seriously, is a very amusing and entirely innocuous affair." This critic put himself on the side of the general public, as opposed to critics determined to separate themselves from the masses by taking the play too seriously. He also fit the play into a longer tradition of cross-dressed performance by recalling Jansen's previous boy roles in comic opera and praising her as "one of the best boys on the stage."

One New York newspaper, the *Dramatic Mirror*, sided with audiences and out-of-town critics on this issue. Unlike his colleagues, the reviewer found it unnecessary "to devote any serious criticism to the play so far as its truth to human nature is concerned. Taken as a comedy frolic Mr. Gunter's conceit is not devoid of cleverness."[56] The critic praised many of the actors and called Jansen's performance "capital." It could be that the *Dramatic Mirror* was more open to sexual innuendo and mixing high and popular culture than other newspapers because it was devoted to a range of entertainments and therefore less aligned with high culture.

The complex reception of the 1896 theatrical production of *A Florida Enchantment* does not show that critics and audiences uniformly read cross-dressing and cross-gender behavior as signs of deviant identity, as Brasell has argued, but rather that some critics made this connection as part of a larger project of sorting the American public into sophisticated and unsophisticated camps. These critics used codes to speak to sophisticated readers and affirm their position in the cultural elite. Other reviewers ignored or resisted this way of reading. Some may have been ignorant of sexual inversion or lesbianism, but others obviously preferred a straightforward interpretation that allied them with the masses. Furthermore, the conflict over the play involved not only deviant identity but also the place of sexually suggestive performance in a newly domesticated theatrical sphere.

MOVING PICTURES, CROSS-DRESSING, AND CULTURAL CONTESTS IN THE 1910S

While critics sought to defend legitimate theater from the incursions of the market in the 1890s, film companies and critics in the 1910s worked to raise moving pictures to the standards of middle-class culture. Many commentators worried that movie representations of crime, violence, and immorality would influence impressionable audiences.[57] Fight pictures, white slave films, and slapstick comedies were particularly worrisome to the guardians of culture. One key organization working to elevate moving pictures was the National Board of Review of Moving Pictures (NBRMP). After the mayor of New York City revoked the city's motion picture exhibition licenses on Christmas Eve 1908, exhibitors asked the People's Institute, a civic reform organization, to establish an organization for improving the state of cinema. The board, initially called the National Board of Censorship, issued guidelines to production companies, requested cuts, and promoted wholesome and artistic films.[58] Despite these efforts, censorship boards popped up in a variety of states to cut and ban suspect films. Although representations of violence and sexual immorality were popular with audiences, film companies lost money when their films were removed from theaters or marred

by unsympathetic editing, and they worried that the federal government would form a national censorship board that would further curtail the film business.

The "Policies and Standards" booklets issued by the NBRMP between 1912 and 1916 show great concern for sexual activity between men and women, but little for same-sex activity.[59] The board advised film companies not to present women's bodies in a way that might arouse male audience members (for example, showing bare backs, décolleté, corsets, or "a lavish amount of lingerie") and not to glamorize illicit heterosexual activities, such as adultery, premarital sex, prostitution, or interracial sex. The booklets never mention cross-dressing, same-sex eroticism, or deviant sexual identities. However, three special bulletins did warn against "sexual degeneracy." An October 1914 bulletin aimed primarily at white slave films condemned "scenes of action between men and women or among members of the same sex which disregard, make undue display or make light of the human person or which stimulate sexual thoughts."[60] Another, undated bulletin aimed at slapstick comedies noted that "comedies based on the antics of a pervert and invert or any picture which involves degeneracy will be condemned all together."[61] Finally, sometime around 1916, the NBRMP passed a resolution specifically about "the comedy presentation of the sexual pervert" and prepared a new special bulletin to announce it.[62] The board identified "a growing tendency on the part of directors who are in search of comedy elements to make use of characters portraying sexual perversion as groundwork for comedy situations." Given "the abhorrence with which society in general regards people of this class," the board declared that motion picture producers "are hereby notified that any picture given over entirely to the comedy presentation of the sexual pervert will be condemned and that any part of a picture in which such a character is shown with intention to burlesque will be eliminated."

The NBRMP did not specify what it meant by a "sexual pervert," but correspondence about films that failed to make recommended cuts suggests that the policy was aimed at effeminate and cross-dressing men.[63] Between 1916 and 1919, the board recommended cutting or shortening scenes in at least five comedies depicting men "of effeminate type" and several instances of men dressing like women.[64] In one film, an "incident where the swordsman puts his finger in his mouth as a degenerate" was eliminated at the board's behest.[65] When the board asked Charlie Chaplin to cut parts of a scene in which the Tramp kisses a girl in men's clothing in *Behind the Screen* (Lone Star, 1916), the objection was to the stage manager's pantomimed accusations, not to the girl's male clothing or the kiss between two apparent men. Chaplin was told to cut the manager's intertitle, "Oh! Mercy!" and "the action of the fat man imitating a sissified character," particularly when he "switches [sic] up and down the room."[66] (According to copies of the film that circulate now, the intertitle was indeed cut, but the swishing was not.)

Despite the debates over films presenting violence, scantily clad women, and effeminate men, civic and religious organizations did not begin to worry about films with women in men's clothing until the 1930s. On the contrary, the NBRMP promoted cross-dressing films like *Little Old New York* (Cosmopolitan Productions, 1923) and *Peter Pan* (Famous Players–Lasky, 1924) as "Exceptional Photoplays."[67] Moving pictures were an active field of contest concerning class and cultural norms in the 1910s; but unlike theater productions of the 1890s, movies featuring cross-dressed women were considered to be on the side of respectability.

THE FILM, 1914

The film *A Florida Enchantment* appears today as a merry collage of lesbian, gay, and transgender behaviors unique in silent cinema. At the time, however, it was received as merely a novel twist on the familiar gender disguise comedy. Vitagraph adapted *A Florida Enchantment* because it was by this time associated with both "high-class" and popular culture, and the company did everything it could to reinforce the project's class status and respectability. If New York theater critics in the 1890s were disposed to read cross-gender behavior as a sign of deviant identity, in the 1910s this interpretive framework was apparently not widely in place among filmgoers, and film critics were not yet motivated to use it to prove their sophistication. The strength of the connection between female-to-male cross-dressing and high-class entertainment in the 1910s gave the film freedom to represent sexual inversion and same-sex desire without a backlash.

Through the trope of the magic sex-change seeds, *A Florida Enchantment* represents a kind of sex inversion seemingly analogous to sexology's concept of the invert. Lillian, Jane, and Fred become inverts in a very literal way: Lillian and Jane become men in women's bodies, and Fred a woman in a man's body. After Lillian swallows the sex-change seed, her/his movements become forceful and matter-of-fact. She/he walks, leans, and lights cigarettes with jaunty confidence. Jane, on the other hand, begins to perform a racist caricature of out-of-control black masculinity. She/he guzzles alcohol, attacks Lillian, and chases a black female servant until Lillian sedates her/him with ether. The racial differences are striking: whereas Lillian, as a white man, gains control over himself and others, Jane, as a black man, loses any semblance of control over his own body. When Fred swallows the sex-change seed, he/she becomes prissy, flirtatious, and vain. He/she curls her hair into spit curls, sticks her butt out, and leans over to kiss Lillian (now Lawrence) on the cheek. He/she eventually steals women's clothing and flirts with a group of working-class boys. Characters in the film find Fred's inverted behavior far more grotesque than Lillian's or even Jane's, and they chase Fred through town and eventually off a pier—an evocation of lynching.

Throughout the film, the sex-changed characters perform literal gender inversion, so it is all the more remarkable that critics and filmgoers did not seem to take them for inverts.

Additionally, Bessie and Stella seem to express same-sex desire when they respond favorably to Lillian's advances. Although they apparently still believe Lillian to be female, they return her kisses, make eyes at her, and dance with her. Bessie even tries to persuade Lillian to share her bed. The film suggests that Bessie and Stella are responding unconsciously to Lillian's male nature, but how could audiences read these scenes as anything but expressions of lesbian desire? Perhaps kissing, dancing, and pairing off were still regarded as a normal part of female friendship, as they had been in the nineteenth century.[68] And yet, Lillian's Aunt Constantia and Fred are shocked when they see the women flirting, which suggests that this behavior was not acceptable. Still, the local townspeople are not so shocked that they fetch the police, as happens when Fred begins flirting with men.

The *New York Dramatic Mirror, Moving Picture World, Motography,* and the *New York Dramatic News* all reviewed the film positively. The *Dramatic Mirror* praised the directing, photography, cast, and settings, and called the film "satisfactory Summer entertainment."[69] *Moving Picture World* declared, "It is light and gay throughout. It breathes the spirit of comedy." *Motography* singled out Storey and Drew for praise.[70] The *Dramatic News* review was typical: "Although in five parts, which is unusually long for a comedy, it sustains the interest throughout and is replete with ludicrous incidents and comical situations. . . . An almost perfect cast, which includes Sidney Drew; a background of beautiful scenes, showing world-famous bits of St. Augustine, Fla., and its environments, and an interesting story stamp *A Florida Enchantment* a fascinating picture."[71] None of the reviews treated the film as potentially scandalous. After its month-long run at the Vitagraph Theatre in New York, exhibitors in small and large towns throughout the United States advertised the film in their local newspapers.[72] Some also ran promotional reviews (likely provided by Vitagraph) alongside their ads. There is no evidence in these papers that the film caused any concern in these diverse places. Likewise, the film never came to the attention of the National Board of Review of Motion Pictures.

In fact, some reviews praised *A Florida Enchantment* as a high-class alternative to more worrisome modes of comedy. For example, the critic at the *Dramatic Mirror* noted that audiences "would welcome more comedians of the type of Sidney Drew. Never touching even the border of slapstick . . . he nevertheless manages to crowd laughs with amazing skill into every foot of the film in which he appears."[73] A San Francisco man wrote to *Moving Picture Magazine* to recommend that, "if it is to be comedy, let it be good comedy, and not such ridiculous piffle as is given the public by the Keystone Company. . . . The Vitagraph

Company produces some high-class comedies with Norma Talmadge, Sidney Drew (which reminds me of 'The Florida Enchantment'), and many others. Aren't these real comedies, and not old-fashioned and silly horse-play?"[74] The wide-ranging, warm reception of the film suggests that most filmgoers were not reading the transformed Lillian, Jane, and Fred as inverts, or Bessie and Stella as expressing lesbian desire.

Scholars have misconstrued the film's reception by overemphasizing Sime Silverman's review of the film in *Variety*. Brasell and Somerville argue that Silverman's use of the term "mannish" proves that he was reading Lillian and Jane as sexual inverts and, by extension, that other members of the audience did, too.[75] Not only was Silverman's review not representative of broader critical response to the film, but it has also been misunderstood. The review is worth reading in its entirety to see what Silverman was trying to get at.

> "A Farcical Fantasy" eh? Yes, it is, and besides that it is the most silly inane "comedy" ever put on the sheet. The thing started off like a comic opera, but it lapsed into a weary, dreary, listless collection of foolish things that drove several of the few people at the Vitagraph Tuesday night out of the theatre before the third reel had been run through. There was plenty of "paper" among those present, so the "paper" stuck it out maybe. Before the stereotyped picture audience, groans would have greeted the futile attempts at humor in this film. There is as much fun in it as there is at a Continental battle. The "fantasy" is of a young woman who swallows a seed and becomes a man, and not so much a man in this instance as just mannish. To make it "funnier," she gave a seed to her colored maid, and the maid became mannish. Then the white "man" in woman's clothes made love to the women about, repulsing her own sweetheart, and so forth and so on. Five reels wasted. The Florida landscapes do not help. Nobody's fault but the Vitagraph's, although giving the author, Archibald Clavering Gunter, credit at least for expecting it to be worked out as intended. Even so, however, it is not for the sheet. As a comic opera with the late Della Fox in the principal role, maybe yes, but cold and dispirited before the camera, it is only a senseless mass. None of the actors gained distinction in it. Sidney Drew did as well as he could. Edith Storey played the dual role, and the others were in the cast. The picture should never have been put out, for there's no one with any sense of humor whatsoever, or intelligence either, who can force a smile while watching this sad "comedy." It wound up the worst program that the Vitagraph theatre has yet presented.[76]

Like the New York reviewers of the 1896 theatrical production, Silverman was upset about a number of the film's failings. For one, he argued that the performance practices employed in *live* theater by *talented* actors do not work in moving pictures with incompetent actors. Also, without synchronized sound, the

witty singing and dialogue that characterized comic opera was absent. Moreover, the film was too long and the jokes were not funny. (Indeed, to a viewer watching it today, the film's energy seems to run out midway.) Silverman seems irritated at the pretentiousness of both the production and the upper-class audience (the "paper") who came out to see it. This audience sat politely through the film's attempts at humor, instead of responding with the more straightforward disdain of the "stereotyped" working-class audience. Thus, Silverman did not declare *A Florida Enchantment* to be the "worst program" because it showed tabooed deviant sexualities; rather, he found the "high-class" style of humor praised by other critics to be boring and irritating.

But what does Silverman mean by "not so much a man in this instance as just mannish"? It is definitely possible that he used "mannish" to connote sexual inversion for in-group readers. Silverman lived in New York and engaged with the broader New York theater scene, so he was likely aware of deviant gender and sexual identities. Also, *Variety* became known for cultivating "a clubby feel among the paper's entertainment industry readers," as the magazine itself later put it, through the use of slang.[77] While this kind of slang did not dominate *Variety's* film reviews until later, Silverman could have been trying to cultivate a "clubby feel" among readers by using "mannish" as a double entendre.

And yet, it is a mistake to read "mannish" as an obvious euphemism for sexual inversion, as Brasell, Somerville, and other scholars have done. In 1914, sellers of women's clothing promoted "mannish" gloves, boots, jackets, shirtwaists, and suits for women, using language like "a cute mannish white pique vest" or "fine mannish diagonals."[78] Likewise, some journalists described the clothing of women they profiled as pleasingly mannish. For example, a few days after *A Florida Enchantment's* premiere, an article in the *Chicago Tribune* praised "America's Leading Out-of-Doors Girl": "In her mannish togs she makes a most attractive picture."[79] Even the sexologist Havelock Ellis recognized that a range of women, and not just sexual inverts, were adopting the clothing, careers, and privileges formerly reserved for men.[80] Today, we probably give the word "mannish" so much weight because Esther Newton and Carroll Smith-Rosenberg used the term "mannish lesbian" in their foundational scholarship in the early 1980s to translate the turn-of-the-century concept of the invert into terms familiar to their readers.[81] But "mannish lesbian" was not used during this historical period.[82] When Silverman called Lillian "not so much a man in this instance as just mannish," he could have meant that Storey failed to convince the audience that her character had become a real man and was instead only man-like. But regardless of what Silverman intended, the common use of "mannish" as a positive attribute meant that few of his readers would have automatically read it as a reference to sexual inversion.

The film version of *A Florida Enchantment* was by and large received as an innocuous, high-class comedy, unlike the stage version two decades earlier. This difference suggests that inversion and lesbianism were not matters of "sophisticated" critical response in American film culture of 1914 as they were in theater culture of 1896. The film was able to represent inverted characters and same-sex desire so literally without incurring a backlash because the production looked similar to cross-gender performances that were already the subject of nostalgia and because film critics were not yet motivated to point out the potential secret meanings of films like this one.

The film version of *A Florida Enchantment* drew strongly upon theatrical comedy, comic opera, the music hall, and vaudeville. The trope of magical sex change may have recalled John Lyly's Elizabethan play *Gallathea* and perhaps also the story that inspired it, the tale of Iphis in Ovid's *Metamorphosis*.[83] The dream framework, as mentioned earlier, likely evoked Shakespeare's *A Midsummer Night's Dream*. The two titles are structurally similar: "Florida" is analogous to "A Midsummer Night" as a space of warmth, temporary abandonment, and otherworldly possibility; and "Enchantment" stands in for "Dream." Magical sex change had occurred more recently in L. Frank Baum's *The Marvelous Land of Oz*, published in 1904 and adapted as a stage play in 1905. In this story, the male protagonist, Tip, discovers that he is actually the princess Ozma, transformed by an evil witch into a boy. Entire worlds of gender-inverted people were conjured in vaudeville sketches like "In 1999" and film comedies like *A Lively Affair* (Warner, 1914). Generally intended to ridicule the women's movement, these scenarios featured women in top hats, suit jackets, and bloomers, who left men at home to cook, clean, and take care of the babies. These visions of gender inversion were important intertexts for the inversion presented in *A Florida Enchantment*.

The character of Lillian/Lawrence is a version of theatrical comedy's insouciant girl-boy. Viola and Rosalind provide enduring models for this type. In their male disguise, they inspire love and jealousy in both female and male characters. Vitagraph had already adapted both *Twelfth Night* and *As You Like It* to film (with Storey playing Viola's twin brother), so the studio may have considered *A Florida Enchantment* a continuation of this line of production. Many 1910s films featured disguised girls who seduce the women and men around them, including *Taming a Husband* (Biograph, 1910), *A Mysterious Gallant* (Selig, 1912), *The Caprices of Kitty* (Bosworth, 1915), and *The Danger Girl* (Keystone, 1916) (fig. 18). A 1917 *Moving Picture Magazine* profile of cross-dressing in the movies included Storey's performance in *A Florida Enchantment* as a variation on a well-established theme.[84]

Another type of insouciant girl-boy informing Storey's character was the romantic swain played by women in comic operas, burlesques, and

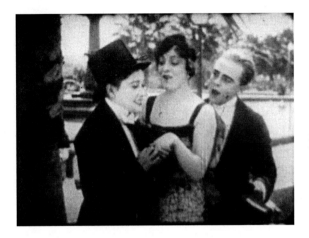

FIGURE 18. A disguised girl (Gloria Swanson) tries to seduce the "danger girl," to Bobby's (Bobby Vernon) chagrin in *The Danger Girl* (1916). Courtesy of the Library of Congress.

extravaganzas. Silverman mentioned Della Fox, who played soldiers, cadets, and men-about-town in musical comedies of the 1890s and then moved into vaudeville. Kathleen Clifford and Kitty Doner also played in boy roles in musical comedies of this period before becoming male impersonators in vaudeville (and eventually film performers, too). According to music scholar Gillian Rodger, the *Police Gazette*, a men's magazine, pictured musical theater actresses in male garb from the late 1880s onward.[85]

Lillian/Lawrence also embodies the "swell" performed by male impersonators in music hall, variety, and vaudeville acts. In particular, Storey is costumed to look like Vesta Tilley, the most beloved of the English male impersonators, who toured the United States five times between 1894 and 1909. When Lillian first dons men's clothing, she/he wears a light-colored, three-piece suit and straw boater—the exact outfit in which Tilley was sometimes photographed (fig. 19). Vitagraph's publicity for the film promised that, "in male attire, Edith Storey is as great a male impersonator as Vesta Tilly [*sic*]."[86] By 1914, Tilley was fifty years old and no longer touring the United States; though she did not retire for six more years, her mode of performance likely seemed old-fashioned by the time of *A Florida Enchantment*. Lillian/Lawrence also used the props common to male impersonators, a cigarette and a cane. Storey's upright, puffed-chest posture when smoking, often with one arm akimbo, is similar to images of Tilley and other impersonators. Furthermore, Storey regaled journalists with the same types of anecdotes about being mistaken for a man that male impersonators did. Storey told *The Green Book* that she had encountered a "big, bluff" Florida tourist who mistook her for a man and tried to convince her to go drinking with him.[87] When she let down her hair, he yelled "Holy mackerel!" and ran off.

Thus, while we might expect that Lillian's demonstrative affection for Stella and Bessie and their positive responses would exceed the bounds of propriety,

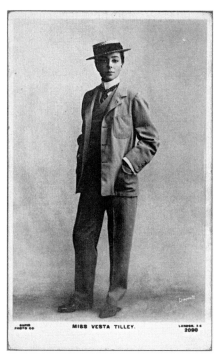

MISS VESTA TILLEY.

FIGURE 19. Lawrence Talbot (Edith Storey) in *A Florida Enchantment* (1914) resembles a promotional photograph of Vesta Tilley (ca. 1900), from the author's collection.

audiences would have been familiar with performances of courtship between women from vaudeville and musical comedy. These courtships may have seemed even more respectable because the male type performed by impersonators after the 1890s was an upper-class gentleman. Though he evidently fell in love easily, the love he offered was sentimental and respectable, unlike that of the bawdy working-class men or profligate "dudes" performed by an earlier generation of impersonators. Perhaps the fact that the male part was played by a woman made the professed love seem *more* innocent, not less. In the film, Lawrence's desire for Bessie leads directly to marriage; the terms of their relationship fit precisely into the bourgeois social order. Jane and Fred's gender inversion also drew from established performance practices. Jane's out-of-control drunkenness, aggression, and vanity modeled the comedic blackface performance in variety and minstrel shows. Fred's simpering performance drew from theatrical comedies like the record-breaking *Charley's Aunt* (1892) and comic female impersonation in vaudeville and minstrel shows.[88]

Vitagraph attempted to enhance the film's association with old-fashioned, legitimate culture. The company had established itself as a genteel purveyor of "respectable" entertainment throughout the transitional era.[89] In the mid-1910s, it continued to adapt famous novels and plays, and also lured well-known Broadway actors like Sidney Drew. The company proclaimed the morality of its actresses and showed off the genteel furnishings in the women's dressing rooms, as Somerville relates.[90] Vitagraph applied the exhibition and reception practices of legitimate theater to *A Florida Enchantment* (and other select films) to convince patrons of film's cultural worthiness. In early 1914, the company opened the Vitagraph Theatre, a luxurious movie palace on Broadway and Forty-Fourth Street, the heart of New York's theater district. In advertisements in the trade press, the company claimed that this theater would "demonstrate that VITAGRAPH FEATURES, when presented in the right way, will not only draw crowds, but will bring Higher Class Patronage at Higher Prices."[91] The theater ran a select line of Vitagraph films, called "Broadway Star Features," which played there exclusively for a month or longer before general release. Vitagraph assured exhibitors that "the attractions have no 'White Slave' or 'Sex' appeal." *A Florida Enchantment* was one such "Broadway Star Feature," and it ran at the Vitagraph Theatre for four weeks. Audience members were given a thick program in the style of a theatrical playbill. This strategy evidently lent prestige to the film, because newspaper advertisements throughout the country noted that the film was a "Broadway Star Feature," and at least one small-town exhibitor added, "As produced at the Vitagraph Theatre, New York."[92] By mimicking the reception practices of legitimate theater via geography, architecture, exclusivity, and accessories, Vitagraph communicated the high-class status of the film.

The film's length also associated it with genteel culture. Slapstick comedies thrived in one- and two-reelers. Longer films could convey the complexity and character development of more esteemed cultural forms like the legitimate drama and the novel. Advertisements for *A Florida Enchantment* never failed to mention its five-act length. However, it remained an open question in 1914 whether film comedy could work in this longer format. Many aspects of stage comedy, like singing and rapid-fire dialogue, were not possible in moving pictures. Film historian Rob King writes that the three-reel film *This Is the Life* (Ramos Company, 1914), released a month before *A Florida Enchantment*, was "one of the very first multiple-reel comedies."[93] A review of the film in *Variety* complained that it was "too long drawn out to get very far with any audience. . . . The fewer of these 'comedies' of more than one reel the better."[94]

Vitagraph turned to the stage star Sidney Drew to create a film version of the society comedies for which he was famous. That Drew represented precisely the kind of wholesome comedy championed by cultural guardians is evident in an internal memo at the National Board of Review of Moving Pictures. Sometime between 1912 and 1916, a board member wrote, "The Board has achieved much in eliminating exhibitions of immorality and crime. Are we to stand still? Can we not progress further and protest against the senseless and unnecessary vulgarity displayed in the 'Slapstick' Comedy? It can be done! The Drews prove that we can have clean comedies."[95] This is the same argument that the writer of the letter to the editor of *Motion Picture Magazine* would make in 1915. The valorization of Drew may seem contradictory; at the end of the *A Florida Enchantment*, he seems to perform precisely the sort of "sex pervert" that the NBRMP condemned. The crucial difference seems to be the context rather than the nature of the performance: male effeminacy in a high-society comedy of errors was acceptable, whereas male effeminacy in a more vulgar, working-class setting was not. It may be that this sissy performance and the blackface antics were considered to be small, manageable bits of slapstick within a more wholesome framework. In any case, showcasing Drew and making the film five reels long affiliated *A Florida Enchantment* with respectable comedy, which seems to have deflected critics or censors from interpreting the film's characters as pathological.

The choice of Edith Storey also linked the film to established modes of female-to-male cross-dressing. Born in Manhattan, Storey was discovered by Vitagraph's J. Stuart Blackton at the age of sixteen. She played in many of Vitagraph's quality films, from *Francesca da Remini* (1908) to *The Battle Hymn of the Republic* (1911). In 1910 and 1911 she worked for Gaston Méliès's Star Films in Texas and developed the persona of a vigorous frontier girl. During this time, she played a feisty suffragette who takes over a Western ranch in *The Cowboys and the Bachelor Girls* (1910) and a young boy who fawns over an older cowboy in *Billy and His Pal* (1911). Back at Vitagraph, she played a girl raised as a boy in

Billy the Kid (1911). These films affiliated Storey with the frontier vitality discussed in chapter 2. As a December 1912 profile put it, Storey was "known to all her studio friends as 'Billy.' . . . She can ride anything that has hair and four legs, can throw a rope and shoot, loves to hunt and is absolutely fearless in crowds, in the dark or in Jericho."[96] In another interview, she declared her allegiance to middle-class conventions of dress: "Neatness is necessary to good looks. No woman can be good-looking unless she is well-groomed. . . . Whether I am playing the part of a street urchin, or a beggar woman, or a queen, I am just as careful to observe neatness. . . . Neatness in attire gives neatness in mind."[97] In other words, Storey had a reputation as a hard-working, straightforward young woman. Though her performance as Lillian/Lawrence is saucy, her persona may have lent it an air of wholesomeness. After *A Florida Enchantment*, Storey starred in a series of films at Vitagraph opposite Ralph Ince and then Antonio Moreno. Although Brasell and Somerville suggest that Storey may have been seen as an invert, it is more likely that she was seen as a frontier girl. Her association with both quality films and frontier films may have inoculated her performance from scandalous insinuations.

The film also allied itself with high-class culture by being shot on location at the exclusive Ponce de Léon Hotel in St. Augustine, Florida. Shooting on location, as Bowser has shown, was one part of the industry's attempt to refine its product.[98] Florida also had a reputation as both dream world and upscale tourist destination, as Somerville notes.[99] The Ponce de Léon was built by Standard Oil millionaire Henry Flagler and designed and decorated by famous architects and painters, including stained glass by Louis Tiffany of New York.[100] Shots of the actors in front of the hotel's manicured lawns and Spanish Renaissance–style buildings gave moviegoers a vicarious peek into high-society life. A scene on a steamboat also allowed audiences to experience the iconic Ocklawaha River cruise. The appeal of this Florida scenery was emphasized in almost every review and many of the advertisements. "If you want to feel warm these cold days," advised one Pennsylvania newspaper, "drop into the Hippodrome theater and see this wonderful picture of the sunny southland."[101] The film's exotic location established it as a big-budget, quality production, distinguishing it from lower forms of comedy.

That Vitagraph intended to make a wholesome comedy is also suggested by its choice of Marguerite Bertsch to write the scenario. As Somerville points out, Bertsch published a manual for aspiring screenwriters in 1917, from which we can glean some aspects of her approach to film writing.[102] Bertsch argued that, if her readers considered how influential movies are upon filmgoers, "It would be impossible . . . to write anything that might stir up in them vulgar feelings or sexual thought . . . and a mind that thinks purely, radiates purity by mental suggestion."[103] In other words, if the author's moral stance pervades a film's scenario,

the film becomes incapable of producing "vulgar feelings" in its audiences. At the end of her guide, Bertsch declared motion pictures to be "the greatest educational force of all times" and a crucial tool for bringing about the Christian millennium, that is, paradise on earth.[104] It is unlikely that Bertsch would have intended *A Florida Enchantment* to suggest desires at odds with Christian morality. In fact, her attitude toward the film's scenario seems to have successfully radiated such purity that it was indeed received as wholesome.

Vitagraph aligned *A Florida Enchantment* with middle-class respectability through the choice of story, length, director, actors, location, and screenwriter. Critics, exhibitors, and audiences, in turn, received the film as the company intended, as a wholesome, high-class comedy. The cross-dressing, gender inversion, and same-sex desire were framed as new iterations of longstanding entertainment practices. As transgressive as they look to us now, they signified an old cultural regime to audiences of the time. The idea of reading cross-dressing and same-sex desire as a sign of a particular, pathologized identity was evidently less widespread in the 1910s than in the 1890s. Also, film critics did not seem to be interested in making "sophisticated" readings of cross-dressing in film. The critics writing for film trade journals were working to boost the industry and thus had no reason to taint a professedly wholesome comedy, and those writing for general interest newspapers and theater papers likely did not see film as a serious art form worthy of penetrating analysis. Therefore, the straightforward readings produced by critics outside New York in the 1890s dominated film criticism in the 1910s.

The complex reception of this novel, play, and film shows that the readiness to read cross-gender behavior as a sign of a distinct, pathologized identity did not emerge and spread in the decades around the turn of the twentieth century, but was practiced by a distinct group at a particular time, and sometimes rejected. Sexology did not introduce a new set of concepts that critics of the women's movement circulated in the general press, which then become widespread and irrevocable, forever tainting female friendships and women in masculine-styled clothing, as scholars like Carroll Smith-Rosenberg and Lillian Faderman have argued. The case of *A Florida Enchantment* shows that in one period, the 1890s, some critics championed a "sophisticated" mode of interpretation that saw cross-gender behavior as a sign of pathological inversion, but others contested this reading, arguing that it was contrary to the American character to go looking for immorality. This straightforward reading strategy dominated film criticism in the 1910s, which allowed the film version of *A Florida Enchantment* to pass as an entirely wholesome, high-class comedy. Inverted and lesbian filmgoers could see some version of themselves on screen precisely because no one else recognized them there. However, this situation changed in the mid-1920s, when film companies and critics invited audiences to be part of the "sophisticated" in-group.

PART II THE EMERGENCE OF
LESBIAN LEGIBILITY
(1921–1934)

4 ▸ ENTER THE LESBIAN

Cosmopolitanism, Trousers, and Lesbians in the 1920s

[F]eminine stars now soliloquize—breathlessly—"to pant or not to pant."

—"NEW FILMS FIND FEMININE STARS IN MALE GARB," *New York American*, September 9, 1923

IN THE 1920S, the American fashion world embraced female trousers for the first time. Perhaps surprisingly, the film industry released fewer films featuring cross-dressed women than it had in past years, but they were longer, more expensive, and received more attention. During this same period, lesbians and inverts appeared in a succession of high-profile movies, plays, and novels, including the infamous play *The Captive* and the novel *The Well of Loneliness*. Around the United States, newspapers and magazines avidly discussed these works, spreading awareness of lesbianism and inversion, the codes to recognize them, and the terms to name them. Reading strategies that had been the purview of "sophisticated" elites became available to anyone who read the daily paper. Journalists, gossip columnists, and fan magazine writers invited general readers to be part of the in-crowd by spreading the "lowdown" on lesbians far and wide. Hollywood's first representations of lesbians and inverts coincided with a second wave of cross-dressed women, but the two trends were largely kept apart during this period.

Part II of this book investigates how American cinema helped make lesbianism legible to American audiences and how this process related to women's

cross-dressing. While the nascent star system had put a damper on cross-gender casting and cross-dressed heroism, the star system of the 1920s and 1930s used other forms of cross-dressing to inflect attractive femininity. Female-to-male cross-dressing shifted from associations with wholesome Anglo-American traditions to alignment with cosmopolitan European decadence. One of the key points Part II will make is that men's clothing was neither *necessary* nor *sufficient* to suggest lesbianism during the 1920s and 1930s. Some scholars have argued that, in American cinema, lesbians could become legible only through masculinity, particularly in the early twentieth century, the heyday of inversion theory.[1] However, as we will see, there were many models of same-sex desire in circulation during this time, some of which involved no gender inversion at all, and they showed up in movies, plays, and films just as frequently as the masculine invert. Masculinity was not necessary for suggesting lesbianism, although it was sometimes used.

Conversely, some lesbian and gay scholars consider almost all masculine women in early films to be proto-lesbians.[2] Though it is seductive, we should be wary of this approach. On the one hand, it instrumentalizes female masculinity as a temporary strategy for lesbian visibility, rather than considering it as viable and compelling in itself.[3] On the other, it flattens the complexity of cross-dressing and obscures the varied appeals cross-dressed women had for audiences of the time. As we have seen, women in men's clothing had wide-ranging meanings, evoking everything from Victorian nostalgia to American imperialism. British scholars like Laura Doan have shown that in England in the 1920s masculine styles worn by women connoted modernity rather than lesbianism— until the censorship trial of *The Well of Loneliness* in 1928.[4] My research suggests that this perception was also widespread in the United States, until the censorship battles over *The Captive* that began in 1926.

Some works mobilized intra- and extra-textual signs to suggest that the men's clothing was intended to be a code for lesbianism, but others left the meanings of women's cross-dressing deliberately open. Rather than claiming all cross-dressed women to be inverts or proto-lesbians, I recognize them as belonging to a wide-ranging genealogy of gender nonconforming people. They were not necessarily politically radical (as Part I makes clear), nor should they be reduced to proto-transgender or genderqueer identities. I will show that some movies, plays, and novels explicitly connected cross-dressing to same-sex desire during this period, but cross-dressing alone was not sufficient to suggest lesbian identity.

We get a better sense of the emergence of lesbianism into popular culture by looking across multiple media, rather than at film alone. Works in one media relied on codes popularized in others. For example, fan magazine writers used codes established in the play *The Captive* and the novel *The Well of Loneliness* to describe Greta Garbo and to explain the German film *Maedchen in Uniform*

(Deutsche Film-Gemeinschaft, 1931). New works exploited the publicity generated by previous works in other mediums. Ultimately, sexology was less important than popular culture in shifting public understandings of sex and gender identity.

Newspapers and magazines brought lesbianism and inversion into the public eye. In the 1920s, American households purchased an average of 1.3 newspapers every day.[5] Daily papers typically cost two cents and magazines between five and fifteen cents, far less than a novel, play, or even a ticket to a movie (which averaged twenty-five cents).[6] Furthermore, newspaper reviews made lesbianism far more explicit than movies or plays did. Thus, periodicals taught American readers the representational codes of lesbianism and provided a vocabulary to name it. They created a public, accessible discourse about same-sex desire. Newspapers and magazines also provide insight into how some audience members read these works.[7] Although critics do not capture viewers' diverse responses, their reviews were often syndicated to hundreds of newspapers around the country and probably influenced many readers. The mass digitization of American newspapers in recent years has allowed me to trace the ways that discourses on lesbianism reached into even the smallest towns during this period.

In this chapter, I analyze the advance of female trousers in American fashion, cross-dressed women in the movies, and lesbians in public discourse between 1922 and 1928. For the first time, journalists invited general readers be part of the sophisticated in-crowd. While some works used cross-dressing alongside other signs to suggest lesbianism or inversion, the practice retained its semantic openness.

MODERNITY, COSMOPOLITANISM, AND *LA MODE GARÇONNE*

In the 1920s, many Americans felt that they were experiencing a uniquely modern age. The First World War had created the sense of a radical break with the past. Traditional values and religious faith were on the wane, while consumerism, leisure, and pleasure were on the rise. Contributing to the feeling of modernity was the spread of electricity and new consumer goods, such as automobiles, radios, telephones, and refrigerators. Advertising encouraged Americans to abandon the thrift and sobriety of the past, and the rising economic tide allowed many Americans to spend freely on new goods and experiences. Big cities became the symbolic centers of American culture. Looking back in 1931, Frederick Lewis Allen wrote that the 1920s had witnessed the "conquest of the whole country by urban tastes and urban dress and the urban way of living."[8] The educated sophistication that critics in the 1890s had assumed to be characteristic of a select few spread throughout the country. Aspiring sophisticates could subscribe to

magazines like *Smart Set* and *The New Yorker* to learn the latest urban trends.[9] Unlike the attitudes of elites in the 1890s, sophistication in the 1920s included disregard for traditional morality. These sophisticates often clashed with moral guardians, whose concerns were voiced by women's clubs, religious leaders, and district attorneys. Where traditionalists worried about the immoral influence of art and commerce, moderns insisted that artistic expression had a duty to take on every subject, no matter how distasteful. These arguments were often brought to bear on works that represented lesbianism and inversion.

The new cosmopolitanism also engendered a more international outlook. The city of Paris, in particular, became a symbol of cosmopolitan modernity. Of the servicemen and women stationed in Europe during the war, a popular song wondered "How'ya Gonna Keep 'Em Down on the Farm? (After They've Seen Paree)." American artists and writers of the "Lost Generation" flocked to Paris, intersecting with international networks of lesbian writers and artists, which included Natalie Barney, Gertrude Stein, Radclyffe Hall, and Romaine Brooks. The 1925 Paris Exposition des artes décoratifs et industriels modernes popularized the *moderne* style that was later dubbed Art Deco.

One part of moderne style was *la mode garçonne*, the slim, boyish look. The ideal female silhouette changed from emphatic curves to straight lines. Corsets were abandoned, and women donned tubular dresses, skirt-suits, and yachting pants. Reversing their resistance to previous attempts to introduce trousers into women's clothing, mainstream Parisian fashion designers like Coco Chanel now endorsed the trend.[10] Women cut their hair short in bobs, shingles, and Eton crops. Young women who adopted these styles were called *garçonnes* in French (a feminized version of the word for "boy") and "flappers" in the United States, where headlines repeatedly announced "Girls Will Be Boys!"[11] One such article, from the *Los Angeles Times* in 1925, proclaimed, "Girlish figures clothed in boyish costumes are seen with greater frequency in these days than ever before. Jane and Dorothy love to come out in white duck trousers and mannish shirts, collars and ties. . . . The boyish bob, which is getting more and more in vogue every day, helps along the transition from femininity to masculinity and greatly heightens the general effect. . . . [S]o far as sex distinction in wearing apparel goes one hardly will be able to tell, at a little distance, which is which."[12] During the 1920s, masculine-styled women's clothing was separated from the women's movement and associated instead with fashion, modernity, and social freedoms. While many lesbians adopted these styles in the 1920s, the fashion was broadly popular and should not be read simply as a sign of lesbianism.[13]

THE SECOND WAVE OF CROSS-DRESSED WOMEN
IN AMERICAN MOVIES, 1922–1928

The vogue for women in trousers was as strong in cinema as in the fashion world, though many journalists seemed to forget that cross-dressed women had already populated American screens for more than a decade. During the first wave of cross-dressed women (1908–1921), American film companies had released an average of twenty-six films featuring cross-dressed women per year. During this second wave (1922–1928), they released an average of ten films per year, three-quarters of which were feature-length. While the cross-dressed women of the 1910s ranged in age and acting style, the cross-dressing actresses of the 1920s were almost universally young, slim flappers. Stars like Clara Bow, Marion Davies, Anna Q. Nilsson, Bebe Daniels, and Leatrice Joy all cross-dressed in three or more movies during this period. Many of their compatriots also cross-dressed in at least one film or wore masculine-styled clothing in publicity photos. The films were often costume dramas adapted from books or plays and designed to show off lavish budgets, like the Marion Davies vehicle *Little Old New York* (Cosmopolitan, 1923). Historical dress allowed actresses to dress as men while continuing to look very feminine.[14] Costume dramas also strengthened film's association with upper-class culture. Other films were set in the urban underworld. Actresses donned blazers, trousers, and golf caps to play thieves, gang leaders, and hobos in films like *Parisian Love* (Schulberg Productions, 1925) and *Going Crooked* (Fox, 1926). While less than half of the cross-dressing films of the first wave included romance, two-thirds of the films from the second wave did. The films increasingly adhered to the conventions of the "temporary transvestite" genre perfected in baroque theatrical comedy and emphasized the apparent homoeroticism of men and boys falling in love.

Articles in the *New York American, Los Angeles Times, Photoplay*, and *Picture-Play* all commented on the "new" popularity of women donning men's clothing in the movies, again asserting that cross-dressed women were appearing for the first time on American screens. "The films have been practically immune from such impersonations, except in rare and isolated instances," the *Los Angeles Times* observed in 1924, "but it is to be inferred from the assemblage herewith that there is quite a chance of their having a vogue now."[15] Under the headline "Girls Will Be Boys," *Picture-Play* displayed photographs of "pretty actresses" in "boy's clothes" in July 1926 (fig. 20).[16] *Photoplay* also highlighted the trend that month and credited it to Marion Davies: "She was the first girl on the screen to disport in pantaloons [in *Little Old New York*, 1923]."[17] These journalists were quick to forget the more than three hundred American films with cross-dressed women released before *Little Old New York*.[18] Their amnesia may have been a marketing strategy, but it erased the many films that had come before.

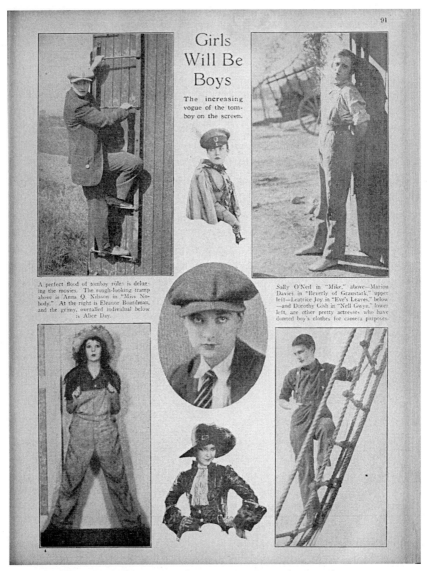

FIGURE 20. "Girls Will Be Boys," from *Picture-Play Magazine* (July 1927)

While cross-dressed women in the films of the 1910s evoked stage conventions and frontier living, in the 1920s observers connected cross-dressed women to the era's jazzy attitudes and women's new physical and social freedoms. The *New York American* attributed the popularity of female trousers to "golf," "feminine freedom," and "the psychology of the times—whatever it is."[19] A critic for the *Los Angeles Times* agreed that "[v]ariety in entertainment, and a lighter, jazzier tone in the screen features" contributed to the new wave of cross-dressed

women but lamented that the trend was "overrid[ing] the persistent call for nat-
uralness in film acting."[20]

LESBIAN CAMEOS IN *FOUR HORSEMEN OF THE APOCALYPSE* (1921) AND *MANSLAUGHTER* (1922)

During this new enthusiasm for cross-dressed women, the film industry also
undertook a few, tentative forays into representing lesbian and inverted women.
Before the 1920s, most Americans could encounter representations of female
same-sex desire in only a few, limited venues: Greek and Roman texts, French
novels, medical journals, and pornography. However, during the 1920s, flour-
ishing networks of lesbians and inverts in Paris, Berlin, New York, and Chi-
cago became more visible to outsiders and entered American popular culture.
Wealthy white lesbians and inverts patronized exclusive Parisian salons.[21] Black
lesbians and gays attended rent parties and nightclubs in Harlem and Chicago.[22]
Formerly law-abiding citizens everywhere came into contact with sexual subcul-
tures when they snubbed Prohibition to frequent speakeasies.[23]

At the same time, movies, novels, and plays began to feature explicitly lesbian
and inverted characters. Daily newspapers reported on these works extensively,
especially when they involved censorship battles. Movies and newspapers were
the most accessible of these media forms. By 1926, 50 million movie tickets
were sold each week. By 1929, weekly ticket sales were up to 95 million (the
equivalent of three-quarters of the population, had each person attended only
once).[24] People of every race, class, and age went to the movies. Because moving
pictures needed a mass audience to recoup their costs, they could not be as overt
in representing lesbians as printed works, but they were sometimes more explicit
than we would assume.

Hollywood films presented sexual desire between women already in the early
1920s. The first few cases were brief but remarkably direct. *Four Horsemen of the
Apocalypse*, Metro's 1921 super-production adapted from the best-selling novel
by Vicente Blasco Ibáñez, was one of the highest-grossing films of the year, even
beating Chaplin's *The Kid*. In a sequence in a Parisian tango palace on the eve of
the First World War, editing and framing establish two female extras as a lesbian
couple. We first see a medium long shot of Julio (Rudolph Valentino) helping his
married love interest, Marguerite (Alice Terry), to a seat at a cabaret table (fig. 21).
We cut from this table to two women at another table. In a visual rhyme, both
couples are shot from the same height, in virtually the same framing, with the
masculine figures seated on the left and the feminine figures on the right. The
woman on the left wears a tailcoat, top hat, and monocle, and holds a long cig-
arette holder. The woman on the right wears a white chiffon dress. They gaze
fondly at each other. As the monocled woman starts to place her hand on her

FIGURE 21. In *Four Horsemen of the Apocalypse*, we see Julio (Rudolph Valentino) and Marguerite (Alice Terry) seated at a cabaret table, a female couple at a similar table, and then Julio and Marguerite again. Courtesy of UCLA Film and Television Archive.

partner's, we cut back to the first couple, and Julio's hand seems to complete the masculine woman's movement as he adds sugar to Marguerite's cup. Framing the female couple in parallel to the male-female couple makes the erotic nature of their relationship clear.

The explicitness of the framing allows us to read the masculine-styled clothing as a signifier of lesbianism more confidently than we otherwise could. If we were to see *only* a woman wearing a tailcoat, top hat, and monocle, we could read her as simply a modern girl disguised as an upper-class playboy, like Gloria Swanson in *The Danger Girl* (Keystone, 1916). However, pairing a cross-dressed woman with a feminine woman and representing them as analogous to a male-female couple makes clear that they are lesbians or inverts. The couple conforms to sexologists' model of same-sex desire as occurring between a masculinized, sexually assertive partner (the "congenital invert") and a feminine, sexually passive partner.[25] While scholars have explored the ways that butch women make their femme partners visible as lesbian, in this case each partner makes the other visible.[26]

Such an explicit representation of a lesbian couple was made possible by both the setting and the shot's brevity. Paris, as mentioned earlier, had a reputation for unbounded sexuality and a visible community of lesbian artists and writers. The female couple authenticates this exotic setting for American audiences; the women are an attribute of this particular space, a prop. They also help establish the dancehall as a space in which sexual desire exceeds normative, middle-class boundaries. It is here that Julio and Marguerite begin their adulterous affair. For American audiences, the women likely represented a sexual other unimaginable within the borders of their own nation, an exotic sexual type of the decadent Old World. The shot of the female couple is only two seconds long. An inattentive viewer could miss it entirely. No reviews from the time seem to have mentioned it. Given this brevity, masculine styles functioned as a useful shorthand to confirm the lesbianism suggested by the editing and mise-en-scène.

The film's scenarist, June Mathis, was likely responsible for this early lesbian cameo. Mathis chose the source novel and director, wrote the scenario, and persuaded the producers to cast the then-unknown Valentino. Film historians Thomas Slater and Gavin Lambert both attribute the shot to her influence.[27] Slater writes that Mathis became acquainted with non-normative genders and sexualities through her work in vaudeville and through close friendships with Julian Eltinge, Alla Nazimova, Rudolph Valentino, and Natascha Rambova. It seems likely that she wrote in the lesbian couple, as well as a scene in which cross-dressed German soldiers attend a party. Mathis later told Katherine Lipke of the *Los Angeles Times* that films should encode sensitive meanings so that children and Midwestern audiences would not be able to understand them:

> Personally my idea is to portray life in such a way that children can't under-
> stand it. . . . Not only does this have to be done for the child, but for hundreds of
> people in the Middle West whose life is most narrow and constricted. In the Ger-
> man banquet scene in the "Four Horsemen of the Apocalypse," I had the German
> officers coming down the stairs with women's clothing on. Now to hundreds of
> people all over the country, that meant nothing more than a masquerade party.
> To those who had lived and read, and who understood life, that scene stood out
> as one of the most terrific things in the picture.[28]

Mathis suggested that "those who had lived and read" would understand the
men's cross-dressing as a sign of sexual perversion, though she does not say so
explicitly. She did not mention the female couple at the tango palace, but we
can imagine that she would make a similar argument about them. Though the
editing makes their relationship explicit, the shot's brevity protected "innocent"
viewers. However, the shot may have prompted some viewers to reevaluate their
understanding of women in men's clothing.

The lesbian cameo in Cecil B. DeMille's *Manslaughter* (Famous Players–
Lasky, 1922) used another common setting for the depiction of same-sex
desire—the Roman bacchanalia—and represented a female couple with no con-
nection to masculinity or men's clothing. In the film, a reckless society girl, Lydia
(Leatrice Joy), runs over a police officer. Her fiancé, Daniel (Thomas Meighan),
likens Lydia's social circle to ancient Rome, and the film cuts between a 1920s
ladies-only pogo race to an ancient "Feast of Bacchus." The sequence was cho-
reographed by Theodore Kosloff, inspired by his days with Sergei Diaghilev's
Ballets Russes, a Paris-based company notorious for erotic, Orientalist specta-
cles.[29] The scene begins with hundreds of women dancing, while a scantily clad
queen, attended by oiled black slaves, watches with delight. The queen throws
coins at the dancers, and the film cuts to a bare-chested man squeezing grapes
onto the face of a reclining woman. Eventually, a gladiator enters the space
through an open door. To the right of the door, two women sit on stairs, clutch
each other, kiss, and laugh (fig. 22). One sits on a lower step and presses her head
to the other's bosom. Both wear togas and have long, dark, curly hair piled on
their heads. After two gladiators start fighting, we see another woman, this time
with curly blond hair, who clutches the hair of a woman in front of her in seem-
ingly orgasmic delight.

This depiction of same-sex desire is more explicit than in *Four Horsemen*:
the women actively touch each other in a sexual way. But where the previous
example used the sexological model of the invert, this one conceptualizes same-
sex desire as a symptom of decadence. Both women on the steps are very femi-
nine, indistinguishable from other women in the scene. The film suggests that
they are so inflamed by passion that they will choose almost any sexual object.

FIGURE 22. In *Manslaughter* (1922), two women on the stairs (right) kiss and embrace. Courtesy of the Library of Congress.

Their desire is similar to the "Lesbian love" observers attributed to actresses and prostitutes,[30] which carried no particular expectation of masculinity. We may not even want to label these women lesbians, because the film suggests that their desire does not arise from an innate identity but is instead an expression of omnidirectional lust. In the case of the woman who grabs another's hair, it is even clearer that she expresses her passion by using the body of whomever happens to be closest.

The Roman orgy had long furnished a setting for painters to represent deviant desires. In silent films, depictions of orgies often featured beautiful slave boys, effeminate eunuchs, and women draped on top of each other.[31] However, *Manslaughter* seems to be the first in which female participants actively touched and kissed each other. The film's director, Cecil B. DeMille, made a career out of films that combined didactic moralizing with erotic spectacle, including quite a few Roman orgies. His later film, *The Sign of the Cross* (Paramount, 1932), featured an even more explicit lesbian seduction using a similar model of same-sex desire, as I will discuss in the next chapter.

As in *Four Horsemen*, the shot of the women embracing in *Manslaughter* is brief—nine seconds in total. Although the women are placed to the side of the main action, it is impossible to mistake the nature of the encounter. Like the

previous film, *Manslaughter* uses a female couple as a prop to authenticate a setting characterized by sexual excess. This setting was removed from American moviegoers not only in space but also in time. Furthermore, the film frames the orgy as a negative example, one that encourages Lydia to give up her freewheeling ways. These two lesbian cameos helped establish their films as cosmopolitan and knowing. However, these brief scenes did not catch the attention of critics or censors. These two examples show that men's clothing could be used as visual shorthand to suggest one half of a same-sex couple, but that movies did not always portray woman-loving women as masculine.

RUMBLINGS ON BROADWAY:
THE GOD OF VENGEANCE (1923)

According to theater historian Kaier Curtin, the English-language stage's first lesbian character appeared on December 20, 1922, three months after *Manslaughter* was released.[32] The play was *The God of Vengeance*, a translation of Sholem Asch's Yiddish-language play *Gott fun nekoma*. It is set in a small Polish town, where the owner of a Jewish brothel, Yankel, strives to keep his daughter, Rivkele, respectable; but she is seduced by Manke, one of the prostitutes. Like *Manslaughter*, the play represents desire between two very feminine women. Rivkele and Manke frolic in the rain, snuggle on a sofa, and spend the night together pretending to be bride and bridegroom. When Yankel finds out, he drags Rivkele by the hair into his brothel and offers her to his patrons. Though the play's narrative punishes Rivkele, some critics found the women's scenes together poetic and lyrical.[33]

The God of Vengeance suggests several models for same-sex desire: first, the omnidirectional passion of a woman who has sex for a living (in Manke), and, second, the vulnerability of any girl to same-sex seduction (in Rivkele). Asch himself suggested that the two women played out a third model, a sensual mother-child relationship. When asked about this aspect, Asch argued that the play portrays "the love of the woman-mother, who is Manke, for the woman-child, who is Rivkele."[34] The metaphor of mother-daughter love was a powerful one for some female couples, as Martha Vicinus has shown, and appeared again in the film *Maedchen in Uniform* (1932).[35] The play avoids the model of the invert and any use of men's clothing.

A German-language version of *God of Vengeance* premiered in Berlin, produced by Max Reinhardt, in 1907. In the following years, it played throughout Europe, in twelve different languages, and on New York's Lower East Side in Yiddish. The Russian office of Pathé Frères even adapted the play to film in 1912 (now presumed lost).[36] Throughout this time, the play was controversial but widely acclaimed. In December 1922, it appeared for the first time in English at

the Provincetown Playhouse, an avant-garde theater in Greenwich Village. Many critics applauded the play, though one confessed that the seduction scene "made us a little sick."[37] *God of Vengeance* definitely upset the *Wall Street Journal* drama critic, James Stetson Metcalfe, and a conservative rabbi, Joseph Silverman, and these men began to campaign against it. Around February 10, 1923, civil liberties attorney Harry Weinberger took over the production and moved it to the Greenwich Village Theatre and then, on February 19, to the upscale Apollo Theatre on West Forty-Second Street. The play's move to the theater district gave traction to Metcalfe and Silverman's campaign against it. Someone, perhaps the New York Society for the Suppression of Vice, lodged a complaint. On March 6, 1923, the producer, actors, and theater owner were indicted for presenting a play that was "obscene, indecent, disgusting, and tending to corruption of the morals of youth."[38] Two months later, a jury trial was held.[39] Weinberger, who was associated with the American Civil Liberties Union (ACLU) and had previously defended Emma Goldberg and Jacob Abrams, represented himself and the others. They were found guilty, but the sentences were minor: Weinberger and the lead actor were fined $200 each, and the other players received suspended sentences.[40] The trial set a precedent that would haunt future attempts to represent lesbianism in New York.

However, the production also set a precedent for the spirited defense of these works by a burgeoning anti-censorship movement. Many of the leaders of this movement were Jewish civil libertarians. In the coming years, American Jewish men played a major role in presenting lesbian books and plays to the American public and defending these works in court. Critics, however, lost no time in connecting the representation of "perversion" with the greed and immorality of immigrant Jews. Some complaints were veiled, others not at all. When *God of Vengeance* moved to the theater district, for example, Metcalfe compared its backers to "sewer rats" "bringing their filth into contact with cleanly people."[41] In another editorial, he wrote, "As a people we are healthy enough to be fairly immune to [managers'] excursions into the problem and sex dramas of London, Paris and the other capitals. When it comes to draining the ghettos of Central Europe of their filth and turning it loose here, it seems about time to call a halt."[42] Sholem Asch was a Jewish immigrant to the United States from Poland, and Weinberger was the son of Hungarian Jewish immigrants. It is no stretch to see Metcalfe's comments on the play as direct anti-Semitic attacks on them.[43]

Although New York newspapers noted the play's troubles only briefly, papers throughout the country reported on the trial and verdict. However, their coverage described the play's sins only vaguely as "immorality" and "obscenity."[44] The usual brief plot summary noted that the play revolved around a brothel but made no mention of the lesbian seduction. This reticence was likely intended to keep lesbianism out of public discussion. Given

that Metcalfe had complained that the play showed some spectators "vivid illustration of practices they had never even heard of," journalists evidently decided not to advertise them to readers outside New York.[45] (This stance did not last long.) Similarly, the proprietors of the New York theater journal *Billboard* made a policy of not naming plays they disapproved of, particularly "the so-called serious drama which attempts to deal with problems more fitted for the clinic than the stage." *Billboard* would not "cater to the smut purveyors."[46] Though the trial of *The God of Vengeance* generated a lot of press, journalists seem to have forgotten it completely when another play featuring lesbianism appeared on Broadway four years later.

The God of Vengeance shows that inversion was not the only, or even dominant, model of same-sex desire in the early 1920s. It also shows that plays venturing into this subject courted condemnation and censorship. Finally, in 1923, journalists were still wary of spreading the knowledge of lesbianism to their readers.

INTERTEXTUAL LESBIANISM: *WHAT'S THE WORLD COMING TO?* (1926)

In January 1926, the Hal Roach Studios' two-reel comedy *What's the World Coming To?* evoked real-world inverts and lesbians through intertextual visual codes. The film parodies contemporary social trends by picturing a world "One hundred years from now—when men have become more like women and women more like men." Earlier gender inversion comedies never suggested that two women could be interested in each other, but this film plays with that possibility. The film portrays the wedding of Billie (Katherine Grant), a blond girl in a tuxedo, to Claudia (Clyde Cook), an effeminate man. A Lieutenant Penelope (Laura De Cardi) interrupts the ceremony, to no avail, and later courts Claudia, who is feeling abandoned by his playboy wife. The (literal) arrival of a stork restores harmony. The actresses in the film conform to the 1920s female masculinities that historian Laura Doan has described.[47] Billie, with her fitted blazer, dark lipstick and eyeliner, and short but feminine hairstyle, evokes the "modern girl," while Lieutenant Penelope, sporting a satin smoking jacket, cane, and slicked-back Eton crop, evokes the female rake. Billie's unnamed best "man" prefers the ultra-mannish look, with a brilliantined Eton crop, tailored jacket, vest, collared shirt, and narrow tie. These actresses evoke not only generalized types, but also specific, prominent lesbians. Lieutenant Penelope, in particular, looks strikingly like Radclyffe Hall (fig. 23).[48] Furthermore, the best man Lyle looks like Jane Heap, editor of *The Little Review* (fig. 24). The reference to real-life lesbians via clothing, hairstyle, and posture was precisely the sort of code that could be picked up only by the "wise."

FIGURE 23. Lieutenant Penelope (Laura De Cardi) in *What's the World Coming To?* (1926) (right) resembles a portrait of Radclyffe Hall (left, standing). Frame enlargement courtesy of Oddball Films/Jenni Olson Queer Film Archive; portrait courtesy of Getty Images.

FIGURE 24. Billie's best "man" (Lyle Tayo) resembles a portrait of modernist publisher Jane Heap. Frame enlargement courtesy of Oddball Films/Jenni Olson Queer Film Archive; portrait courtesy of Getty Images.

The film strengthens the inference of lesbianism by pairing women in the frame. First, the film shows Billie and her best "man" standing close together as Billie waits for her future husband to approach the altar. The two women resemble the sort of gender-differentiated couple depicted in *Four Horsemen*. When Billie asks for the ring, the best "man" accidentally produces a

pair of dice—suggesting that they have spent their evenings together in the homosocial world of the gentlemen's club. Billie is ambivalent about leaving the world of the club for the ostensible comforts of heterosexuality. The best "man" elbows her and whispers, "Buck up, old Pal, think how lucky you are— you've got the sweetest little man in the world!" Billie looks toward the groom with wide, dubious eyes. Indeed, even after the wedding, Billie spends long evenings at the club, presumably with her best "man." Though the film does not explicitly declare these two women a couple, it offers their friendship as an alternative to heterosexual pairing.

The film also visually pairs Billie and Penelope, though they are rivals. When Billie spies Penelope courting Claudia, she seizes a halberd from a nearby suit of armor, kicks down the door, and runs into the room. Penelope grapples with Billie, pushing her down on the couch, forcing her backward, almost lying on top of her. Claudia does little but bounce up and down in the corner. At one point, the two women drive him out of the room with the tip of the halberd. The women are locked together almost as if dancing; their bodies tussle intimately as they expel the man from the frame. Though the film narratively frames the women as fighting over a man, the visuals encourage the audience to consider the kind of couple the two women would make. Their physical intimacy is more sustained and physically proximate than that of any male-female couple in the film. The repeated visual coupling of these new kinds of masculinized women invites viewers to consider them as possible romantic couples. Whereas the earlier gender inversion comedies showed little interest in female couples, *What's the World Coming To?* uses gender inversion to parody Parisian lesbians.

MANNISHNESS ON THE VERGE: *THE CLINGING VINE* (1926)

The Clinging Vine, a feature-length romantic comedy released by DeMille Pictures later in 1926, also presents a woman who dresses and acts like a man, but it is more ambiguous about whether this mannishness suggests lesbianism. The thirty-two-year-old Leatrice Joy (of *Manslaughter*) had developed a persona as a self-confident, elegant Southern woman. However, in 1925, in a fit of pique at either her ex-husband, John Gilbert, or her producer, Cecil B. DeMille, she marched into a barbershop and asked for a man's haircut.[49] She came out with what the British would call an Eton crop, but which was dubbed in Hollywood the "Leatrice Joy bob."[50] DeMille, who had Joy on contract at his new independent company, was livid. An actress's hair was contested terrain during this time, and several actresses had clauses in their contracts prohibiting them from bobbing their hair. Fan magazines largely took Joy's side in her dispute with DeMille and associated her new look with Parisian

cosmopolitanism (fig. 25).[51] Joy's haircut added a new androgynous, even butch, aspect to her persona. She appeared in five De Mille Pictures Corporation films with this ultra-short cut in 1926 and 1927.[52] In two of these films her characters are mistaken for male: in *Eve's Leaves* (1926) she plays the tomboy daughter of a ship captain, and in *The Clinging Vine* (1926) she is a hardnosed businesswoman. Additionally, according to film scholar Johanna Schmertz,

FIGURE 25. Leatrice Joy's new look in *Photoplay* (March 1927).

Joy regularly imitated DeMille's "long mannish stride" to entertain people on the set, and DeMille often called her "young fellow."[53]

A month after *Eve's Leaves* was released, *Photoplay* ran a remarkable "Lark of the Month" describing an evening when Joy, still disguised as a boy, took a streetcar home from the film shoot: "Believing that when in Rome be a Roman, Leatrice gave her seat to a pretty girl, received the award of a dazzling smile, and carefully tipped her hat. Then she retreated to the back platform and got into a brisk flirtation with two high school girls and to add the artistic touch to her masquerade she winked at them as she got off at the corner where her motor was waiting for her."[54] This remarkable "lark" suggests that Joy's male disguise was persuasive enough to fool several young women and that she enjoyed flirting with them under cover of her disguise. News items in which naive bystanders mistook cross-dressed actresses for boys were fairly common. But by linking female masculinity to possible same-sex desire, the Joy story seems to tread on dangerous territory—or, conversely, it shows that this territory was not yet dangerous enough to provoke concern. The connection between mannishness and deviant sexual identity was evidently not strong enough in 1926 for the "lark" to be considered anything more than that. Perhaps it also helped that Joy had been married, that she had a child, and that she was an upper-class woman from the South. Joy's androgynous look during this period foreshadows the stardom of Garbo and Dietrich, but she did not carry the dangerous sexual frisson that those European imports did. Fan magazines highlighted the fact that Joy's haircut was merely a variation on a popular fad, though they sometimes teased that her gender was becoming illegible. An August 1926 *Photoplay* article jokingly drew sideburns onto Joy's cheeks, warning, "Side whiskers are the newest peril from Paris."[55] The next month, *Motion Picture Magazine* captioned Joy's photograph "It's a Girl!" and added, "You cannot be sure these days . . ."[56]

The Clinging Vine exploited Joy's new androgynous persona, but also the pleasures of undoing it. The film was adapted from a popular 1922 Broadway musical by actress-playwright Zelda Sears.[57] Joy plays A.B., an executive at the T. M. Bancroft Paint Company. The film introduces A.B. with a series of close-ups that encourage us to believe that the character is male, until her face is finally revealed. She sports a brilliantined Eton crop, thick eyebrows, and a tailored suit and tie. Worried that she will never experience romance and hurt that her boss's vapid son Jimmie (Tom Moore) thinks so poorly of her, A.B. allows Jimmie's grandmother (Toby Claude) to give her an ultra-feminine makeover (fig. 26). In the end, a very girly A.B. wins Jimmie by hiding, but not losing, her business smarts. In the play, the protagonist starts out messy rather than mannish and goes by Antoinette, but in the film—perhaps to capitalize

FIGURE 26. A.B. the businessman and A.B. the coquette in *The Clinging Vine* (1926).

on Joy's new persona—the protagonist is neat but masculine and adopts a gender-neutral nickname.

The film explores the presumed contradiction for women between authority and desirability. On the narrative level, the film "fixes" the ultra-mannish businesswoman by training her to be properly feminine and sexually desirable to men. In fact, the film trains A.B. to be precisely the type of woman that psychologist Joan Riviere profiled a few years later in "Womanliness as Masquerade" (1929): she uses hyper-feminine coquetry to mask her appropriation of masculine authority.[58] At the same time, elements of the film satirize this trajectory. Joy's performance of femininity is comically exaggerated, while her performance of female masculinity is naturalistic, as Schmertz has pointed out.[59] The title cards adopt a tongue-in-cheek style, and the film shows Jimmie to be so simple-minded that A.B.'s satisfaction with him hardly feels credible. It could be that the film parodies not the mannish businesswoman per se, but the conventions of businesswoman makeover stories. Indeed, the review in *Photoplay* suggested that the story was already a cliché: "Here, once more, is the goofy plot about the efficient young business woman who gets sex appeal the moment she tacks a couple of ruffles on her tailor-made."[60] In the critic's opinion, "The satire of it completely escaped Paul Sloane, the director."

Film historians Heather Addison and Karen Mahar have described the film as a commentary on women's participation in the business world. Abandoning femininity, they say, is the symbolic price A.B. must pay to succeed in business.[61] Schmertz, on the other hand, argues that the film troubles gender essentialism by demonstrating that, for A.B., femininity and masculinity are equally performative. These scholars do not consider whether A.B.'s ultra-mannishness had any connection to lesbian identities, though. In contrast, Richard Barrios claims that "repressed mannish spinsters" like A.B. "spell out a simplified distillation of *Well of Loneliness* Lite," that is, sexual inversion.[62] As these varied accounts suggest, it is difficult to know what exactly A.B.'s masculinity meant at the time.

To what extent did A.B.'s ultra-mannish style suggest lesbianism or inversion? A.B. is more masculine than most cross-dressed women in American film, and her masculinity seems to come more naturally. Might this mean that she is psychologically male and, thus, an invert? The intertitle introducing A.B. reads: "The President's assistant—known as A.B.—who hired, wired and fired men—but had never kissed one.—Leatrice Joy." Does this intertitle imply that A.B. had perhaps kissed someone other than a man? The only woman with whom she has any kind of relationship is the jazzy granny who performs the makeover. However, there is no physical intimacy between the women, and their relationship is largely instrumental, with the goal of preparing A.B. to attract Jimmie. If the film

intends A.B.'s mannishness to be a sign of potential lesbianism or inversion, it is more reticent than other films of the period.

Reviews suggest that most critics did not take A.B.'s mannishness to be a sign of lesbianism. *The Educational Screen* hailed the film as a "Delightful comedy" and declared it "wholesome" for children.[63] Given that lesbianism and inversion were considered the most scandalous of sexual subjects, it seems clear that this reviewer did not see any sexual implications in A.B.'s mannishness. Likewise, *Film Daily* concluded that the film is "[a]musing and gets away from the beaten path."[64] The critic praised Joy's performance of the masculine protagonist, though he or she preferred Joy's more feminine look: "As the masculine 'A.B.', secretary to the big boss, Leatrice gives a pleasing performance but she looks far more lovely in fussy frocks." Other critics panned the film for a variety of reasons. *Photoplay* found the story clichéd, while *Picture Play* objected to A.B.'s transformation into "a dumb Dora."[65] The critic lamented that "[o]ne of our most interesting and gracious actresses again is strangled by a story . . . unworthy of her talents."

As with *A Florida Enchantment* a decade earlier, only *Variety* found something unsettling about A.B.'s mannishness. Critic Fred Schrader wrote that the film was "[r]ather pleasant entertainment that might have been a much better picture had there not been too much stress laid on the masculine side of the heroine early in the picture."[66] Schrader suggested that presenting such an unapologetically masculine woman interfered with the film's ability to entertain. Later he called A.B. "frightfully masculine appearing." He is the only critic I have found to criticize A.B.'s masculinity specifically. Schrader's biggest concern, however, was with Joy's performance of femininity: "An impression lingers as one views the picture that cannot be fought off, that a female impersonator is playing the girl. It persists in the mind as the picture unreels, despite [what] one knows to the contrary. . . . Miss Joy is charming enough at times, but one cannot, while looking at the picture, disassociate the idea that she is doing an 'Eltinge.'" The allusion is to Julian Eltinge, the most famous female impersonator of the early twentieth century. Eltinge had in fact just starred in a gender disguise comedy for DeMille's company the previous year, *Madame Behave* (1925).[67] Schrader was likely responding to the sense of artificiality in Joy's performance of femininity. I had the same feeling when watching the film, but Schrader found Joy's satirical performance of femaleness disconcerting, whereas I see it as a clever critique of feminine norms. Although Eltinge was praised for the naturalness and glamour of his performances, he was also occasionally suspected of sexual inversion, rumors he attempted to dispel by displaying his masculinity offstage.[68] If Eltinge was associated with male homosexuality, it is possible that Schrader was subtly pointing to potential sexual deviance. As A.B. eventually gets the boy, the "lingering impression" that she is a cross-dressed man queers the ostensibly

heterosexual resolution. Schrader's distaste for A.B.'s "masculine side" and reference to Eltinge may hint to readers that there was something going on, but this insinuation, if intended, was more oblique than others at the time.

The publicity around Joy's haircut, her flirtations with women while in disguise, and her performance in *The Clinging Vine* show just how far female masculinity could go in 1926, on the cusp of the nationwide discussion of lesbianism that began at the end of that year. After her five "haircut" films, Joy grew her hair out and resumed feminine roles, but her popularity declined. Perhaps the public punished her for her brief flirtation with androgyny or preferred her shorter style, or perhaps she simply got older or did not cope well with synchronized sound.

A.B.'s look was also the look of a young woman hired to direct at Famous Players–Lasky three months after *The Clinging Vine* premiered. Like A.B., Dorothy Arzner worked in a male-dominated profession and sported an Eton crop, thick eyebrows, and flat-heeled shoes. While today Arzner looks the picture of a butch lesbian, journalists of the 1920s called her "one of those modern college girl types" and praised her combination of masculine and feminine traits.[69] Only in the 1930s and beyond, when women's fashions changed but she did not, did commentators suggest that there was something odd about Arzner.[70] As film historian Judith Mayne points out, journalists described Arzner's appearance in contradictory ways that reveal their struggle to grasp her look (much as journalists would do with Garbo).[71] However, Mayne neglects the way these descriptions changed over time, as Arzner's look increasingly deviated from the norm.

Overall, *The Clinging Vine* and publicity about Joy and Arzner show just how mannish one could be in 1926 without being suspected of lesbianism or inversion. However, Hollywood's ability to portray such a mannish woman without worrying about censors was about to end.

LESBIANS TAKE CENTER STAGE:
THE CAPTIVE (1926–1928)

Édouard Bourdet's play *The Captive* brought lesbianism before the American public eye. Moralists and civil libertarians alike seized upon the play as a battleground in the fight over censorship. Two publicity hounds, newspaper publisher William Randolph Hearst and publisher-producer Horace B. Liveright, faced off over the play, generating a huge amount of coverage. Newspapers coast to coast followed the production from its New York opening in September 1926 to its forced shuttering in February 1927, and from February to August 1928, when it played in six American cities, inciting legal battles in three of them. All in all, *The Captive* generated far more publicity in the United States than the controversy over Radclyffe Hall's novel *The Well of Loneliness* in 1928. Producers of

The Captive lost almost every legal battle they faced, and opponents successfully enacted new, more restrictive censorship laws; but the play laid the groundwork for lesbianism to have a place in American popular culture.

The Captive's model of lesbianism does not involve masculinity or inversion. Instead, it represents lesbianism as a nervous condition, detectable through behavioral clues. Because of this play, anyone who could read a newspaper could become informed about women who loved women, learn terms for discussing them, and pick up codes for recognizing them. Though some critics continued to speculate that only the "sophisticated" could understand the play, the extensive coverage ensured that every adult had access to these ways of reading. The play's title even became a euphemism for lesbianism in the film press.

The Captive, originally called *La Prisonnière*, first opened in Paris on March 6, 1926. Max Reinhardt staged it in Berlin and Vienna that same season, where it broke attendance records, and it went on to play in Belgium, the Netherlands, and Switzerland.[72] In New York, producer-director Gilbert Miller announced that he would bring an English-language adaptation by Arthur Hornblow Jr. to Broadway that fall under the aegis of the Charles Frohman Company, which was owned and operated by the Famous Players–Lasky film company. Women's clubs and religious groups registered their disapproval. The ex-president of the Colonial Dames of America, for example, told Miller that she "intended to use all her influence . . . to prevent such an affront to American womanhood."[73] On September 26, 1926, *The Captive* opened at the Empire Theatre, with seats selling for five dollars, one of the most expensive tickets on Broadway. New York's playboy mayor Jimmy Walker attended the premiere, as did many film luminaries, including Adolf Zukor, Edgar Selwyn (co-founder of Goldwyn Pictures), screenwriter Anita Loos, writer-actor Ruth Gordon, director Malcolm St. Clair, director Herbert Brenon (*Peter Pan*), and actors Robert Ames, Billie Burke, Florence Vidor, Norma Talmadge, and Fannie Ward.[74] The film industry was thus well aware of the play from its opening night. The play's star, Helen Menken, had recently married the then-unknown actor Humphrey Bogart.

In the play's first act, a young society woman, Irene de Montecel (Menken), convinces her childhood friend, Jacques Virieu (Basil Rathbone), to pretend that they are engaged to each other so that she can stay in Paris when her family moves to Rome. Jacques agrees to help, but tries to discover who is really keeping her in the city. He suspects she is having an affair with the married Monsieur d'Aiguines (Arthur Wontner). But when confronted by Jacques at the end of the second act, d'Aiguines reveals that Irene is not in love with him but with his wife: "it is not only another man who can be dangerous to a woman . . . in some case it can be another woman." He warns Jacques that "she can never belong to you no matter how you try. They're not for us." Jacques confronts Irene, and she swears she will give up Madame d'Aiguines. They agree to marry. The third act starts a

year later. Jacques has grown tired of Irene's indifference and, in the end, despairs of reforming her. She leaves him for Madame d'Aiguines in a dramatic exit scene recalling the famous door slam concluding Ibsen's *A Doll's House*.

The Captive does not show same-sex desire to be a symptom of gender inversion, as in *Four Horsemen*, or the product of excessive desire, as in *Manslaughter*; rather, it is a mysterious nervous ailment that can strike even the most respectable young woman. In publicity photographs, Menken's Irene is pretty and feminine, with a finger-waved bob and an array of fashionable dresses and skirts (fig. 27). Likewise, although we never see Madame d'Aiguines, her husband tells Jacques that she possesses "all the feminine allurements, every one."[75] Attraction between women is described as a kind of feminine narcissism, not complementary opposition. Monsieur d'Aiguines characterizes desire between women as "a secret alliance of two beings who understand one another because they're alike, because they're of the same sex, because they're of a different planet than he, the stranger, the enemy!"[76] Thus, the play presents a different model of lesbian desire than the ones we have seen so far.

According to the reviews, Menken portrayed Irene as a nervous wreck—sobbing, hysterical, with constantly twisting hands. One critic wrote that Menken "brooded through the play, a jerky puppet, dangled on taut nerves upon the very verge of madness, a hunted, terror-eyed puppet, fearful of prying and strung to the last limits of endurance."[77] Heavy white makeup made her face resemble a death mask. The play thus presented same-sex desire as a neurosis aligned with hysteria. This model was indebted to sexology and Freudian psychology, though it rejected inversion theory. At the same time, critics also drew upon older models of lesbianism as unnatural, or even supernatural, seduction. These critics described Madame d'Aiguines as a "mysterious sorceress" who holds Irene in thrall through some dark power.[78] (Pushing even further in this direction due to censorship, the San Francisco production rewrote d'Aiguine's monologue so that he claimed a "mystic power," rather than "another woman," had Irene in thrall.)[79] Another critic described Irene as a shadow.[80] There is a long tradition of aligning female same-sex desire with witchcraft or ghostliness.[81] This older model coexists in the play with the newer, medical model. Where d'Aiguines cast the women's attraction to each other as narcissistic, critics emphasized the differences of age and power between the two women, shifting the model from mirroring to seduction.

Rather than using mannish clothing as in *Four Horsemen* or *What's the World Coming To?*, the play presents lesbianism through behavioral clues: anxiety, frigidity, secrecy, late-night visits between women, and the exchange of violets. In the first two acts, Irene is unreasonably secretive and mysteriously unhappy. She caresses a corsage of violets while talking to her sister and becomes angry when asked about the flowers. Monsieur d'Auguines provides the key to unlock her

FIGURE 27. Irene de Montecel (Helen Menken) presses violets to her cheek in the New York production of *The Captive*. Photo by Vandamm Studio © Billy Rose Theatre Division, The New York Public Library for the Performing Arts.

behavior when he explains to Jacques that Irene has been coming to his house late at night to visit his wife. He warns Jacques (and the audience) to view close friendships between women with suspicion:

> Don't say "Oh, it's nothing but a sort of ardent friendship—an affectionate intimacy . . . nothing very serious . . . we know all about that sort of thing!" No! We don't know *anything* about it! . . . Friendship, yes—that's the mask. Under

cover of friendship a woman can enter any household, whenever and however she pleases—at any hour of the day—she can poison and pillage everything before the man whose home she destroys is even aware of what's happening to him. [italics in original][82]

D'Aiguines's warning recasts as pathological the intimacy between women that was considered normal in the nineteenth century. In a sense, he "outs" the homosocial relations of the Victorian era. Not everyone was willing to go along with this resignification of women's friendship, though. Eleanor Barnes, a Los Angeles critic, complained that the play "has a tendency to discourage healthy friendships between persons of the same sex through fear of public opinion."[83] In the third act, Irene's behavior confirms D'Aiguines's allegations. Despite her best efforts, she continues to be indifferent toward Jacques. A bouquet of violets delivered to the house provides her with the impetus to leave him.

The violets given by Madame d'Aiguines to Irene in the first and third acts become a key signifier of lesbian desire. Using flowers to convey particular messages was popular in the nineteenth century, and blue violets generally meant faithfulness or that the giver's thoughts were occupied with love.[84] However, by the end of the nineteenth century, violets had become a special code for women who loved women because fragments of Sappho's poems describe violets in the hair, bosoms, and laps of beautiful women believed to be Sappho's lovers.[85] While violets initially served as a secret code for insiders, the play introduced their meaning to the general public, and those who could not attend the play could learn the code from newspapers. The *New York World*'s review was subtitled "The Message of the Violets," and the *Brooklyn Citizen*'s "They Say It with Violets."[86] Another review noted that violets were "a symbol of Lesbianism, they say."[87] Journalists even observed that the play had caused a drop in the sale of violets.[88] Five year later, New York columnist O. O. McIntyre reminded readers, "Florists believe the continued slump in the sale of violets is due solely to Helen Menken's play with a Lesbian theme 'The Captive.' Violets symbolized perversion throughout the drama."[89] At its height, McIntyre's "New York Day by Day" column appeared in 22 million individual papers per week, so anyone who had failed to catch "the message of violets" in 1926 would have been reminded in 1931.[90]

Some New York critics doubted that playgoers would understand the nature of Irene's affliction. The reviewer in the *Brooklyn Citizen*, for example, believed that "a good percentage of the audience will fail to ascertain what it is all about."[91] These critics maintained the distinction between sophisticated and unsophisticated audiences elaborated by 1890s critics in their response to *A Florida Enchantment*. Most people, they assumed, had never heard of lesbianism. For example, the critic at *Variety* wrote, "There are millions of women, sedate in nature, who never heard of a Lesbian, much less believing that such people

exist. And many men, too."[92] In a review published in the *Kansas City Star*, New York critic Percy Hammond assumed that his Midwestern readers would not be familiar with Irene's condition: "[*The Captive*] will disclose to you in a skillful manner considerable light upon a phase of woman's life of which, no doubt, you are in the dark."[93] Hammond refers to a "phase" because it was common to consider passionate attachments between women as a developmental stage.

While many Americans may not have been aware of lesbianism, no critic seems to have found an actual playgoer who did not understand the play. In fact, although Hammond assumed that his Midwestern readers would be "in the dark," a playgoer from Kansas City named Ann Peppard White saw the production in New York and wrote forthrightly in the same paper that *The Captive* represented "Lesbian love." She even proposed that "the part [of Irene] is played with a heightened abnormality in deference to the censors,"[94] suggesting that New York censors were more easily offended than she and that she was well aware of how "normal" lesbians acted. Likewise, Gilbert Gabriel of the *New York Sun* remarked that he had "overheard two sweet young things in the lobby deciding that few persons would really get what it is all about. 'Well, my mother wouldn't,' said one of them."[95] These "sweet young things" are precisely the type of playgoer that critics might assume to be innocent. Not only do they comprehend the play's subject, but they repeat the critics' projection of ignorance onto someone else.

Some reviewers tried not to name the play's subject directly, in order to preserve the innocence of readers unacquainted with lesbianism. British literary critics had long employed this strategy when reviewing French novels with Sapphic themes, as Sharon Marcus has shown.[96] Hammond, for example, was relatively forthcoming when he reviewed *The Captive* in the *New York Herald Tribune*, but much more discreet when he discussed it two weeks later for the *Kansas City Star*: "All that [the reviewer] can do is to hint, and by the sly winking of his wicked eye, convey the news that 'The Captive' treats of a dilemma suitable only to the consideration of sex post-graduates. . . . It may be whispered, however, to those who are on the inside, that 'The Captive' deals with a class of women whose joys and sorrows are both to be pitied and censured."[97] While Hammond announced his inability to name what *The Captive* was about, he simultaneously invited Kansas City readers into his in-group. Gabriel, the *New York Sun* critic, also claimed to be conflicted about how much to say, but decided to come out with it after observing the "wise" girls in the lobby: "This is a late paragraph in which to specify the problem of the plot of 'The Captive.' It is a paragraph I have rewritten and crossed out ten times over for the tender benefit of those who know enough—and not too much—about Sappho, Havelock Ellis, et al. And I give it up with the satisfaction of having overheard two sweet young things in the lobby deciding that few persons would really get what it is all

about."⁹⁸ Gabriel did not directly name the "problem" at the heart of *The Captive*. Instead, he used code words—the poet Sappho and the British sexologist Havelock Ellis—that would be recognizable to those who already knew something of the subject. However, by suggesting that these names hid a secret knowledge, he helped to circulate them.

Most of the time, journalists were explicit about the play's subject. Their extensive coverage of the play's productions and legal battles likely alerted many readers to the concept and gave them terminology to name it and codes for detecting it. Articles in New York publications (for example, *New York Morning Telegraph, New Republic, Theatre Magazine, New Yorker*) and publications outside New York (for example, *Kansas City Star, Charleston Gazette, Oakland Tribune*) named the play's theme as "Lesbian" or "Lesbian love." *Variety* even undertook to explain the term to its readers: "'The Captive' is a homosexual story, and in this instance the abnormal sex attraction of one woman for another. 'Ladies' of this character are commonly referred to as Lesbians. Greenwich Village is full of them."⁹⁹ Cultural historian Chad Heap argues that press comments like this one alerted readers not only to the existence of lesbians but also to the Greenwich Village speakeasies where lesbians performed, jump-starting New York's "pansy and lesbian craze."¹⁰⁰

Despite his disapproval of the play, O. O. McIntyre played an important role in publicizing its theme. In a column printed in the *Charleston Gazette* (and probably elsewhere), he declared *The Captive* to be "a morbid play of sexual abnormality [that] deals with a congenitally Lesbian French girl."¹⁰¹ The next week, he complained in his widely syndicated column that "a Lesbian theme dominated" a new play on Broadway.¹⁰² Even outside New York, journalists described the relationship between Irene and Madame d'Aiguines in a variety of fairly explicit ways: "the attraction of woman for woman" (*Wilmington Morning News*), "a woman's unfortunate entanglement with one of those strange creatures of her own sex" (*Detroit Free Press*), "complicated and suggestive psychopathic relations between women" (*Boston Herald*), and "a twisted relationship with another woman" (*Davenport Democrat*).¹⁰³ Reviews of *The Captive* also circulated the names not only of Sappho and Havelock Ellis, but also of Richard von Krafft-Ebing, Cesare Lombroso, and Sigmund Freud.¹⁰⁴ In the middle of a plot synopsis, one review noted, "The case of a married woman leaving her husband for another woman is recorded in Kraft Ebbing's [*sic*] book 'Psychopathia Sexualis.' There are other recorded instances."¹⁰⁵ McIntyre grumbled in one of his syndicated columns that the "circumlocutions of Lombroso and Freud were not enough—the dregs of psychological depths are revealed."¹⁰⁶ While the Associated Press's coverage avoided the play's subject, one of its widely reprinted stories noted that the theme of *The Captive* was similar to the "psychopathic theme" of *The Drag*, Mae West's controversial transvestite comedy.¹⁰⁷ Overall, *The*

Captive inspired a flood of writing on lesbianism in the daily press, likely introducing terms and concepts to readers who were either unfamiliar with them or had never talked about them in public.

"Sophisticated" New York theater critics were divided over whether lesbianism was a fit subject for the stage. Unlike the critics who decried *A Florida Enchantment* in 1896, many now sided with *The Captive*. J. Brooks Atkinson of the *New York Times* called it "a genuine achievement in dramatic producing," and Frank Vreeland of the *New York Telegraph* wrote that it "exudes an aura of pity and terror that comes close to the Greek ideal."[108] The production played into the cultural clash between sophisticates and traditionalists. It was associated with European cosmopolitanism and the modernist movement's determination to represent contemporary social problems. Some reviewers likened the play to Ibsen's *Ghosts* and Georges Brieux's *Damaged Goods,* two social problem plays dealing with syphilis.[109] *The Captive*'s defenders argued that it should be judged on aesthetic grounds, while detractors countered that it should be judged on moral grounds, given the damage it could do to vulnerable theatergoers, particularly young women. Detractors maintained that lesbianism was a subject fit only for medical studies and definitely not for art or entertainment, falling back on earlier reasoning to restrict the knowledge of lesbianism to elite professional circles.

Responses to the play also shed light onto the cultural debate over sexual identity. Even those who championed the play called Irene's condition horrific. Some argued that it delivered an important warning to young women.[110] Other defenders claimed that evolution would naturally rid the world of "defectives" like Irene: "The most charitable view one can take of such persons is that they have a defective nervous organization. One thing evolutionary theory makes plain—that species which survive always rid themselves of defectives, of abnormal beings who do not carry on the species. After all, the instincts of the race are right. Whatever you or I may think of such arrested persons, history will dispose of them in the immemorial fashion. Life has a way of taking care of its own."[111] Likely this critic, Frank Vreeland of the *New York Telegram*, considered his view to be very modern—based on science rather than religious judgment—so we should not conflate modernity with acceptance of homosexuality; rather, modernity ushered in a willingness (even a compulsion, as Foucault argues) to talk about homosexuality. William A. White of the *New York Herald Tribune* took a scientific approach to homosexuality that was more sympathetic than Vreeland's, but still called for the eradication of this pathological condition.[112]

However, other critics found the play's treatment of lesbianism decidedly old-fashioned. Like Kansas City play enthusiast Ann Peppard White, Stark Young of the *New Republic*, a progressive monthly, argued that Menken played Irene as far more "insane, neurotic, [and] strange" than the "average instance" of

lesbianism.[113] The *New Yorker*'s critic went further: "I resented . . . the hypothesis that the intimate circle of a worldly French diplomat would regard [Irene's] idiosyncrasy as so unique and dumbfounding. For all its virtues 'The Captive' uses the abracadabra of an hitherto forbidden theme to create an atmosphere more stifling than that of life. Now that the field has been opened I should like to wager that in five years 'The Captive' will sound as old-fashioned as 'Mrs. Dane's Defence.'"[114] (*Mrs. Dane's Defence* was a 1900 play in which a woman is exiled from her village when she reveals that she once had an affair with a married man.) For this critic, modern sophistication entails a blasé tolerance of sexual deviance. Reviews of *The Captive* not only spread awareness of lesbianism and terms to discuss it, but also a wide range of attitudes toward it.

The circulation of knowledge about lesbianism was helped along by attempts to shut down the play. *The Captive* became a rallying point for both pro- and anti-censorship forces. It opened in New York in the midst of a broader crisis over "sex plays," aggravated by Mae West's risqué productions.[115] Hearst led the charge against immoral plays in part to damage the progressive governor of New York, Al Smith, who had lambasted Hearst in a 1919 speech and was preparing to run for president.[116] Though Smith opposed censorship, he could not afford to veto censorship legislation for fear of alienating some of his constituents. The debate over controversial New York plays sometimes intertwined with the similar debate over censoring moving pictures, particularly since *The Captive* was being produced by a film company.

The Captive was challenged several times throughout its five-month run in New York. A month and a half after it opened, New York District Attorney Joab H. Banton charged the play with being "salacious and objectionable to civic morals," but on November 15, a "Play Jury" of twelve citizens acquitted it.[117] Worried that West would bring *The Drag* to New York, Mayor Walker warned Broadway producers on December 28 not to open any more "sex plays."[118] Two days later, Hearst published an editorial in his *New York American*, "The Best Treatment For Unclean Spoken Plays Is to Apply the Methods Which Protected Motion Pictures."[119] Hearst pointed out that the very same firm that "produces many of the best and cleanest and highest class of moving pictures in the United States is responsible for one of the most vicious and obscene plays that has disgraced the stage." "Without the influence of censorship," he warned, "this firm might have produced moving pictures as demoralizing as its stage play."[120] It is ironic that Hearst held up Hollywood, which was busy defending itself against charges of immorality, as a model for cleaning up the stage. In fact, Hearst was looking to the six state moving picture censorship boards that had legally binding decision-making powers at this time; he hoped to wield this state power on Broadway. Broadway plays had more leeway in their treatment of taboo subjects

than moving pictures, because they were more closely aligned with "Art" and attended primarily by upper- and middle-class adults, whereas cinema was commerce and available to all. Arguing that moving picture censorship standards be applied to plays implied that they were commerce, too, and that they had influence beyond the metropolitan elite.

Despite Walker's warning, another sex play, *The Virgin Man*, opened on January 20, 1927. On January 26, State Senator Abraham Greenberg wrote a theater censorship bill, and Hearst ran another editorial urging the mayor to "Wipe Out Those Evil Plays."[121] When Mae West announced that she would bring *The Drag* to New York, top Broadway producers met on January 28 to establish a system of self-censorship and keep West's play out of the city. However, their efforts were too little, too late. Governor Smith encouraged the mayor and D.A. to use existing laws to close objectionable plays, in order to forestall additional censorship legislation. On the evening of February 9, the D.A. and his officers raided *The Captive*, Mae West's *Sex*, and *The Virgin Man*. They arrested forty producers, stage managers, and actors, including Menken and West. (Mayor Walker, who had attended *The Captive*'s premiere, chose this moment to take a vacation in Cuba, leaving Acting Mayor Joseph McKee in charge.) The Associated Press's report of the raid appeared on the front pages of newspapers throughout the county. However, Miller secured an injunction against future raids, and *The Captive* played five more very successful days, until Zukor and Lasky decided to shut it down to avoid going to trial. On the condition that Miller close the show and the actors agree not to play in it, the judge let them off with a warning.

However, Horace Liveright, a firebrand publisher of modernist literature with the firm Boni & Liveright, bought the rights to the play and vowed to reopen it in New York. He retained ACLU attorney Arthur Garfield Hays, a member of the defense team for John Scopes in the Scopes Monkey Trial, to defend his case and sue the authorities for an injunction against future raids. Hays told reporters, "This is another Scopes case. . . . Exactly the same issue is involved— the belief that if you keep people ignorant you would save their souls. Here in New York some people think that if you keep people ignorant you will save their morals."[122] However, the case failed to ignite broad public support, and the New York Supreme Court denied the appeal.[123] Liveright gave up his plans to reopen the play in New York, but announced that he would publish a book on the subject of *The Captive* by Warner Fabian, author of *Flaming Youth*.[124] Hays, for his part, described the persecution of *The Captive* as a major encroachment upon American civil liberties, similar to the Scopes and the Sacco and Vanzetti trials, in a book called *Let Freedom Ring*, published by Boni & Liveright the next year.[125] In the meantime, the New York legislature amended the obscenity code to prohibit plays "depicting or dealing with, the subject of sex degeneracy, or sex

perversion."[126] State lawmakers also passed the "Wales Padlock Law," so that a theater could be padlocked for an entire year if a jury found one of its plays to be immoral.

Hollywood, too, was fighting a reputation for immorality during this period, following the sensational trials of Roscoe "Fatty" Arbuckle and complaints about "sex pictures." The industry was determined to avoid legally binding national censorship. Because the National Board of Review of Moving Pictures had little sway over the industry, the Motion Picture Producers and Distributors of America (MPPDA) had appointed former U.S. Postmaster Will Hays in 1922 to lead a new effort at self-censorship. Throughout the second half of the 1920s, Hays and his colleagues tried to clean up moving pictures and convince community groups of the industry's sincere intentions. The moving picture industry took a more conservative approach to representing lesbianism than the Broadway stage and American book publishers. This conservatism extended, as some New Yorkers noted with disgust, to the Famous Players–Lasky Company's decision not to fight the charges against The Captive in 1927. Liveright, for example, told a reporter, "Mr. Lasky and Mr. Zukor brought pressure to bear on Mr. Miller and forced him to close the play because they were afraid of what their small town public might think of their producing a play like 'The Captive' in New York. I don't like to think the legitimate stage is dominated by motion picture interests."[127] The New Yorker, too, took umbrage that Broadway theater had to adhere to Midwestern standards: "It seems that the [theater] industry is quailing before women's clubs of Dubuque and other places in the hinterlands, and it was Mr. Adolph Zukor whose inverted thumbs brought 'The Captive' to a close. . . . When the police descended on the play Mr. Miller announced his intention of fighting the case out . . . [but] Mr. Zukor, fearing the effect that court action in defense of so peculiar a story might have upon the provinces, would have none of the defiance."[128] These sentiments outline a perceived clash between urban and rural values and show how some observers aligned the willingness to represent lesbianism with urban cosmopolitanism.

On the flip side, the editor of Photoplay, James Quirk, applauded the movie industry's uprightness compared to the excesses of Broadway. He argued that the two industries had switched places in terms of cultural legitimacy: "It is significant that while the theater mogul of a decade ago turned up his nose at the motion picture producer, we now see Adolph Zukor force the closing of 'The Captive' because the motion picture cannot be contaminated by any suspicion that it has the slightest connection with the legitimate producer of that perfume sprayed piece of parlor filth."[129] Reversing the accusations aimed at Hollywood, Quirk framed Zukor and the movies as moral crusaders against the decadent theater industry.

That Hollywood would never adapt a story as explicit as *The Captive* to screen, despite the play's economic success, was plain. In 1928, Ralph Wilk of *Film Daily* noted the unlikelihood that an actress playing Irene in a regional production of *The Captive* would ever repeat her part on screen "for the good and sufficient reason that Will Hays will never allow the piece to be picturized."[130] At the same time, several of the people involved in the New York production also worked in Hollywood. Norman Trevor played in several films before accepting the role of Irene's father in *The Captive*. After only a month, however, he returned to Hollywood to appear in several new Paramount films.[131] After the play closed, Samuel Goldwyn hired its translator, Arthur Hornblow Jr., to be his general production executive. *Film Daily* noted that Hornblow "will have complete charge of production under Goldwyn's direction."[132] Hornblow had a long and successful career in Hollywood, during which he produced films for Paramount, MGM, and independently, including *The Asphalt Jungle* (MGM, 1950), *Oklahoma!* (Magna Theatre Corp., 1955), and *Witness for the Prosecution* (Edward Small Prod., 1957). In 1959, Hornblow announced his intention to revive *The Captive* on Broadway and produce a film adaptation starring Kim Novak with Columbia Pictures, but neither project materialized.[133]

MOVIES IN THE WAKE OF *THE CAPTIVE*'S NEW YORK RUN

Hollywood reacted almost immediately to the increased awareness of lesbianism spread by *The Captive*. The MPPDA included "sex perversion" on its list of "Don'ts and Be Carefuls," the biggest film of the year featured a lesbian couple in a Parisian dancehall, and, for the first time, critics wrote that an actress's masculine clothing could have "pathological suggestions."

In 1927, the MPPDA stepped up its self-policing. At the beginning of the year, Hays sent Jason Joy to Hollywood to form a Studio Relations Committee that would work directly with producers to prevent objectionable films from being made.[134] Joy and his team drafted guidelines for the studios called "Don'ts and Be Carefuls," which listed eleven subjects to avoid and twenty-five subjects to handle with care.[135] "Any inference of sex perversion" appeared as the fourth subject to avoid. The Association of Motion Picture Producers adopted Joy's resolution on June 8, 1927. Although the National Board of Review had warned producers in 1916 against "the comedy presentation of the sexual pervert," state moving picture censorship codes, which were intentionally vague, never mentioned perversion directly. Neither did the industry's previous self-censorship guidelines, the "Thirteen Points" put out by the National Association of the Motion Picture Industry in 1921.[136] Producers were well aware that sex perversion was taboo, but Joy may have felt that the proscription needed to be spelled

out because of *The Captive*. However, the resolution did not prevent Hollywood films from including plenty of inferences of sex perversion in the coming years.

The most notable lesbian cameo appeared in *Wings* (Paramount, 1927), one of the top-grossing films of the 1920s. The film, which won the first ever Academy Award for "Outstanding Picture,"[137] premiered at the Criterion Theatre in New York on August 12, 1927, and roadshowed around the country with a twenty-five-piece touring orchestra for more than a year.[138] The lesbian cameo in *Wings* is similar to the one in *Four Horsemen*, but suggests a greater familiarity with real-life lesbians. In both films, wartime and a Parisian nightclub are the key factors that allow (or even demand) the representation of a lesbian couple. In *Wings*, American aviators "on furlough from Death" go to Paris to drink champagne and flirt with showgirls. The Folies Bergère nightclub is a Dionysian orgy of frantic pleasure—something like DeMille's Feast of Bacchus—justified by the men's perilous service to their nation. The film establishes the nightclub as a space of gender disorder from the moment we enter. A low camera follows two pairs of legs walking in sync—one in a plaid skirt and the other in a satin dress. The camera then tilts up to reveal that the plaid skirt belongs to a Scottish solider and the satin dress to a sexy French girl. Later on, the bleary-eyed young protagonist, Jack Powell (Buddy Rogers), mistakes his friend Mary Preston (Clara Bow) for a male officer due to her military uniform.

Although the nightclub is a space of exuberant heterosexual desire, a dazzling track forward exhibits the odd couples of the war at a series of cabaret tables, including one lesbian couple (fig. 28). We first see an officer and society woman toasting each other, then a rich older woman handing cash to a young "kept" man, then a woman caressing the cheek of a woman across from her. Next is a young couple who look back at the two women with wary surprise, then a woman who throws her drink in the face of an officer, and finally, a table of American servicemen and French showgirls, including a very drunk Jack Powell. As in *Four Horsemen*, positioning the two women analogously to heterosexual couples makes it clear that they are a romantic couple. The surprise of the young male-female couple marks them as unsophisticated country folk and the lesbian couple as the most odd of the couples portrayed. The American servicemen, on the other hand, act like true cosmopolitans and pay little attention to the sexual disorder around them. The trauma of war, the film suggests, justifies this amoral, pleasure-seeking attitude.

Unlike the female couple in *Four Horsemen*, the female couple in *Wings* does not wear gender-opposed clothing. Instead, both women appear in masculine-styled women's clothing: loose jackets, white collared shirts, and neckties. The one on the left wears a white felt hat, and the one on the right a black bolero hat. These women do not fit the masculine/feminine model of sexology. Instead, they resemble the styles adopted by European lesbian

FIGURE 28. In *Wings*, a track forward reveals a
rich woman with a young man; a female couple; a
shocked male-female couple; a woman throwing
a drink into her date's face; and a close-up of Jack
(Buddy Rodgers) mesmerized by his champagne.
Courtesy of UCLA Film & Television Archive.

writers and artists.[139] Although Laura Doan has shown that the bolero hat was popular with a range of British women at this time,[140] the posture and clothing of the woman on the right strongly resembles a photograph of Radclyffe Hall taken the year before (fig. 29). Either the filmmakers consciously modeled the woman on this portrait, or this particular style and pose already signified lesbianism to some. The shift in clothing style between *Four Horsemen* and *Wings* suggests that the increasing visibility of these transnational lesbian networks had put pressure on what a lesbian was imagined to look like. Lesbian couples could thus be made visible without gender polarization. Although Doan has argued that these clothing styles would not necessarily have connoted female same-sex desire in England, it is clear that they could function as markers of this "Parisian" sexual identity in American film.

Like *Four Horsemen*, *Wings* gets away with representing lesbians not only because of the setting but also because of the brevity of the shot. We see the female couple for only three seconds. An inattentive viewer could easily miss them. However, attentive viewers had the opportunity to encounter a lesbian couple, learn the dress codes of some European lesbians, and see characters model a blasé attitude toward lesbianism.

FIGURE 29. One member of the female couple in *Wings* resembles a portrait of Radclyffe Hall. Frame enlargement courtesy of UCLA Film & Television Archive; portrait courtesy of Getty Images.

Although no critics mentioned the lesbian couple in *Wings*, several mused on the mannish man-hater at the center of First National's *The Crystal Cup*, which opened two months later. For the first time, film critics suggested that masculine dress could be a sign of sexual deviance. California author Gertrude Atherton had published her novel with Boni & Liveright in 1925, and First National acquired the screen rights in May 1926. *Moving Picture News* described the novel as "a searching, analytical study of sex psychology."[141] The film itself is unfortunately lost, and descriptions of its plot are contradictory. Due either to her father's mistreatment of her mother or her own experience of brutal seduction, the wealthy heiress Gita Carteret (Dorothy Mackaill) develops an enmity toward men and adopts an extreme masculine style to prevent any amorous advances (fig. 30). She eventually agrees to marry a novelist, John Blake (Rockliffe Fellowes), in name only, but then falls in love with his friend, Dr. Geoffrey Pelham (Jack Mulhall). When the frustrated John enters Gita's room at night, she mistakes him for a burglar and shoots him. Dying, John "realizes that Dr. Pelham is the only man who can awaken the feminine in her nature," and he instructs his friend to marry her after his death.[142]

FIGURE 30. The man-hating Gita Carteret (Dorothy Mackaill) ignores the advice of her grandmother (Edythe Chapman) in *The Crystal Cup*. Courtesy of Photofest.

Gita's childhood trauma, hatred of men, and adoption of an ultra-mannish style fit an armchair etiology of lesbianism, even though the film never suggests that Gita is interested in women. This fact was not lost on critics. *Photoplay* noted, "There are spots in the picture where one's memory might hark back to 'The Captive' through the suggestion of Dorothy's clothes."[143] Several aspects of this comment deserve attention. First, for this reviewer, Dorothy's masculine clothes are the sign that points to lesbianism, not her hatred of men. Second, the title of *The Captive* is already being used as a euphemism for lesbianism. Third, it does not seem to matter that neither woman in *The Captive* wears masculine clothes. The play has made Gita's masculine style newly suspect and emboldened journalists to talk about their suspicions. In its capsule review published in subsequent issues, *Photoplay* was less specific about the film's deviance: "Dorothy Mackaill in the drama of a man-hater that sometimes approaches the weird. Only for the sophisticated."[144] Rather than using the title of *The Captive*, this synopsis relies on the code words "man-hater," "weird," and "sophisticated." This comment also demonstrates the connection between being "sophisticated" and being interested in watching representations of lesbianism. *Moving Picture News* argued that the filmmakers had played down the pathology of the original story in order to appeal to a broad audience, but that there was no way of eliding it completely: "Had [the story] been treated honestly it might have stirred up some agitation. But the idea was developed with half an eye on the box-office, consequently its pathological suggestions are but faintly indicated."[145] To these reviewers, the film suggested with one wink that Gita was a lesbian, but denied it with another.

Remarkably, critics around the country praised the film and Mackaill's performance of female masculinity. *Film Daily* wrote, "Dorothy Mackaill handles the role of a swaggering man hater in fine style" and admired her manner of igniting a cigarette lighter with "one flick of her nail."[146] Even *Educational Screen* praised Mackaill: "Fairly original story but chief interest is Dorothy Mackaill's fine portrayal of the would-be 'mannish' girl."[147] It deemed the film unsuitable for children and youth but "interesting" for "intelligent adults." Suitability for children is a useful gauge of whether critics associated female masculinity with sexual deviance; in this case, it seems they did. Critics' appreciation of Mackaill's masculinity contrasts with their preference for the hyper-feminine Leatrice Joy in *The Clinging Vine*.

One New Orleans exhibitor noticed that "[b]usiness was good during shopping hours but not so after dark," suggesting that middle-class married women were the film's primary demographic.[148] The eventual romance between Gita and Dr. Pelham likely helped the film. Mackaill had played opposite Mulhall in four romantic comedies by this point, so audiences expected them to get together, thereby dampening the suggestion that Gita was actually a lesbian. (The actors

went on to co-star in seven more films after this one.) Just before mentioning *The Captive*, the *Photoplay* review welcomed "that admirable co-starring combination of Dorothy Mackaill and Jack Mulhall."[149] Framing the film as a Mackaill-Mulhall picture diminishes the suggestion of lesbianism. The review continued, "Dorothy plays the role of a man hater with all the touches of the masculine in her attire, but you are going to love her just the same." This sentence balances the potentially unsettling fact that the protagonist is a masculine-looking "man hater" with the assertion that she is still charming and empathetic. This strategy—balancing out a protagonist's early, lesbian-like behavior with a later heterosexual romance—would be repeated in Greta Garbo's *Queen Christina* six years later, as I discuss in the next chapter. *The Crystal Cup* was evidently considered a success, as Mackaill cross-dressed in another film the next year, *Ladies' Night in a Turkish Bath* (Asher-Small-Rogers, 1928), and wore men's-style pajamas while comforting a female friend in *The Barker* (First National, 1928).

With *The Crystal Cup*, film critics stated for the first time that masculine clothing could suggest lesbianism. Perhaps to our surprise, they did not therefore condemn Mackaill's performance, even with its "pathological suggestions," but praised her swagger and skill. Even so, the number of actresses cross-dressing in American movies declined dramatically over the next several years and never returned to the heights of the 1910s and 1920s. It seems likely that new public awareness of "pathological suggestions" was part of the reason.

In the months after *The Captive* was shut down in New York, Hollywood paradoxically condemned inferences of "sex perversion" and yet released films featuring a lesbian couple and a masculine man-hater. The play had raised the profile of lesbianism to the extent that Mackaill's masculine clothes became suspect—even though *The Captive* never connected lesbianism with female masculinity. But that connection grew stronger over the next year.

THE CAPTIVE BEYOND NEW YORK

The Captive's reputation continued to spread in 1928, when Liveright sold the rights to regional producers across the United States. Historian Daniel Hurewitz has shown that audiences around the country were much more open to the play than moralizing entrepreneurs like William Randolph Hearst, whose disapproval dominated public discussion.[150] Critics in industrial cities like Baltimore and Cleveland saw the production as a way to prove that their communities were culturally on par with European metropoles. As in the past, a particular attitude toward the representation of lesbianism demonstrated one's cultural standing; but now, it was blasé unconcern that signaled one's sophistication. In February 1928, Edwin Knopf Jr. (brother to book publisher Alfred Knopf) co-produced *The Captive* in Baltimore, with Ann Davis as Irene. It ran for two sold-out weeks.

Knopf argued that the production "is not only affording Baltimoreans an opportunity to see one of the really remarkable plays of our time" but also "is definitely ranking Baltimore with New York, Paris, Vienna and other great centers of dramatic art."[151] A Baltimore critic scoffed at the play's New York detractors, positing Baltimoreans as more sophisticated than New Yorkers: "Just what the pure Prunellas of New York objected to, unless it be the theatre's recognition—certainly not new—of matters so taboo, is not clear. If they ask in horror can such things be, they need only open their eyes."[152] In March, producer S. W. Manheim launched a production at the Little Theater in Cleveland that ran for six weeks and broke the city's theater attendance records.[153] Critics praised the play and noted with satisfaction that Clevelanders seemed to know more about lesbianism than Hollywood executives.[154]

The real showdown came when theatrical producers Ed Rowland and A. Leslie Pearce brought the play to Los Angeles. Its fate there suggests that Hollywood producers, directors, and actors were already well aware of the production. Six months previously, Hearst had declared in *Variety* that "he would not stand for them staging 'The Captive' in Los Angeles," but Rowland and Pearce were not cowed.[155] The *Los Angeles Times* printed daily updates during the ten days prior to the play's opening on Wednesday, March 21, 1928, at the Mayan Theater, with Ann Davis again playing the lead role. Goaded by Hearst, city prosecutor Ernest Lickey sent two vice officers (and two Hearst reporters) to raid the play and arrest the producers on Thursday evening. However, the producers paid their bail, returned to work, and got an injunction against further interference on Friday. Lickey immediately overturned the injunction, and his men arrested the producers and cast two more times on Saturday.[156] The producers agreed to stop the show until they could have their day in court. Two thousand Angelenos signed a petition declaring that they "could see nothing lewd, obscene or indecent in the play."[157] A week later, as the jury was being selected for the trial, the producers arranged a private performance of the play, ostensibly for the benefit of Lickey, who had never seen it. Although Lickey did not show up, "such screen celebrities as Dolores del Rio, Edmond [*sic*] Carewe and others" attended.[158] The jury found Rowland and Pearce not guilty of obscenity; but before the producers could reopen the show, Hearst and Lickey convinced the city council to ban portrayals of "sex degeneracy or sex perversion."[159] Once more, fights about *The Captive* led to stricter censorship laws, despite largely positive responses from critics and audiences.

Another civil liberties skirmish occurred when Manheim, the play's Cleveland producer, tried to stage the play in Detroit. In May 1928, Manheim booked the Schubert Theatre for a three-month engagement, but Detroit's mayor threatened to revoke the theater's license the day after the play opened. Rather than

risk its license, the Schubert kicked the show out. Civil liberties attorney Clarence Darrow, who had defended Leopold and Loeb as well as John T. Scopes, contacted Manheim to offer his support: "We believe that the fight for 'The Captive' is a showdown on the whole censorship problem."[160] Darrow's support was not enough to reverse the Schubert's decision, but Manheim brought the play to Pittsburgh in July, where it ran for two weeks without interference.[161] Another production opened in San Francisco in July, again starring Ann Davis, but the police closed the show on opening night. The *San Francisco News* reported that "even the ridiculous spectacle of a squad of decidedly unaesthetic looking policemen trampling about the stage, trying to prevent people from saying things couldn't lessen the tremendous dramatic effect of Edouard Bourdet's fascinating drama."[162]

The more emphatically moralists tried to shut down *The Captive*, the more widely its reputation spread. While detractors managed to enact stricter censorship laws in New York and Los Angeles, they inadvertently helped spread the "message of violets" far and wide. Sophisticates and defenders of civil liberties defined themselves, in part, through their support of artists' right to represent lesbianism. The film industry was well aware of the play, as many Hollywood luminaries attended the New York and Los Angeles productions, and debates over the play both praised and denigrated Zukor's decision to shut it down in New York. Although movies could not be as explicit as the stage, the play provided a set of codes to journalists, filmmakers, and readers that could insinuate lesbianism without stating it outright. Film journalists seized upon the play's name as one of these euphemisms for lesbianism and began to discuss the potentially lesbian implications of movies from 1927 onward. Although the play never associates lesbianism with masculinity, actresses in ultra-mannish clothing came under new suspicion.

THE WELL OF LONELINESS AND THE LESBIAN BOOKS OF 1928

At the same time that *The Captive* was playing around the country, a host of novels treating lesbianism and inversion were published in the United States and England. These included Warner Fabian's *Unforbidden Fruit*, Wanda Fraiken Neff's *We Sing Diana*, Compton Mackenzie's *Extraordinary Women*, Virginia Woolf's *Orlando*, Djuna Barnes's *Ladies Almanack*, and Radclyffe Hall's *The Well of Loneliness*. Some were intended for a small circle of readers already in the know, but others aimed to reach the general public. The books ensured that lesbianism and inversion stayed in the public consciousness even as *The Captive* disappeared from American stages. By far the most discussed of the bunch,

Radclyffe Hall's *Well of Loneliness* promoted a model of the invert that would have important repercussions for cross-dressing in moving pictures, as we will see in the next chapter.

Before *Well* came the trashy *Unforbidden Fruit* and sedate *We Sing Diana*, both about life in women's colleges. The two books were aimed at a mass market: *Unforbidden Fruit* cost $2.00 and *We Sing Diana* $2.50. Educators had begun to view relationships between girls at women's colleges as potentially pathological, rather than a normal part of female development.[163] When it became clear in February 1927 that Liveright would not be able to remount *The Captive* in New York, he announced that a "study of attachments between girls at Radcliffe, Vassar, Wellesley and other women's colleges has been made by Warner Fabian, who wrote 'Flaming Youth' four years ago. . . . It deals with the same theme in a novel as 'The Captive' does on the stage."[164] *Smart Set* printed the first five chapters of Fabian's novel between February and June 1928, and in July, Boni & Liveright published the book. Fabian's novels were famed for capturing the devil-may-care attitude of modern girls, and *Unforbidden Fruit* was no different. However, despite Liveright's declaration, the *Captive* theme was only peripheral. On three brief occasions, the protagonists mention a girl who takes men's roles in campus plays, sings double-alto in the glee club, and shows untoward interest in a freshman girl.[165] However, we never see this girl directly, nor does anything happen between her and another girl.

Houghton Mifflin published Wanda Fraiken Neff's *We Sing Diana* in February 1928. In contrast to the nonstop partying in Fabian's novel, *We Sing Diana* shows women's communities as sterile and stifling, but the book takes a similar attitude toward lesbian activity. The narrator, a student at an East Coast women's college, observes, "Intimacies between girls were watched with keen, distrustful eyes. Among one's classmates, one looked for the bisexual type, the masculine girl searching for a feminine counterpart, and one ridiculed their devotions."[166] (At this time, "bisexual" usually meant possessing two sexes, as mentioned in chapter 3.) These intimacies remained firmly at the margins of the story, and one female book critic even complained that "Mrs. Neff touches only superficially the inescapable problem of perversion."[167] Both novels adhered to a model of gender inversion.

The summer and fall of 1928 witnessed a small boom of British lesbian fiction. In July, Mackenzie's *Extraordinary Women* and Hall's *The Well of Loneliness* were published in London. *Extraordinary Women* was a satirical look at Natalie Barney's coterie in Capri after the First World War, whereas *Well* was a serious depiction of an upper-class congenital invert, inspired by Hall's own experiences. Mackenzie's book was published in the United States that September and Hall's in December. In October, Woolf's *Orlando* came out in England and the United States simultaneously. *Orlando* is a novel about an androgynous boy who

becomes a woman and lives for centuries. The character was allegedly inspired by Woolf's lover, Vita Sackville-West.[168] Sometime that same year, Djuna Barnes privately printed 1,050 copies of *Ladies Almanack*, a parody of Barney's social circle, including Hall and her partner Una Troubridge.[169] Most of these British books were written by insiders for insiders, with little attempt to make them accessible to broad audiences. Readers could best appreciate Mackenzie's and Barnes's books only if they were already familiar with Barney's coterie. However, while Barnes's book was known to only a few, Mackenzie's was published by the left-wing Vanguard Press for $2.00 and became a New York bestseller the week it came out.[170] Still, it generated few reviews and was judged inferior to Mackenzie's previous novels.[171] *Orlando* was exclusive in another way. While the basic narrative is easy enough to understand, it uses an enigmatic, modernist style and numerous references to historical people, places, and events. It was published by the respected Harcourt, Brace & Company for $3.00 (with a limited first edition going for $15.00). As literary critic Fanny Butcher wrote in the *Chicago Daily Tribune*, "'Orlando' is the most cerebral novel of the year. That it is, therefore, the most alluring to some and the least to others is also true beyond a doubt."[172] "What idea Orlando actually is, no one, of course, can say," she went on. "You can read into it anything that you want." *Orlando* is not specifically about lesbians or inverts, but the protagonist's gender and sexual fluidity generate a nebulous eroticism that exceeds heterosexuality. No critic explicitly linked Woolf's book with the discussions about lesbianism at the time.

The Well of Loneliness, on the other hand, uses a straightforward, sentimental narrative and elements of tragedy to educate the public about inverts and build sympathy for them. It was written by an insider for outsiders. As Laura Doan has analyzed, the novel translates sexology, activist writings, and Hall's own experience into an accessible, compelling narrative.[173] Hall even secured an endorsement from British sexologist Havelock Ellis that was printed in the book's preface. *Well* is far more sympathetic to its protagonist than *The Captive*. Though many models of same-sex desire circulated at the time, Hall primarily articulates one: the female invert. In the book, masculinity of mind, body, and dress become key symptoms of an inverted identity. The early sections read like a case study from a sexological report. The parents of the protagonist, Stephen Gordon, yearn for a boy. The baby is born female but "narrow-hipped [and] wide-shouldered."[174] Stephen develops a crush on the family's working-class maid, dresses up like British imperial heroes, and declares herself to be a boy ("I must be a boy, 'cause I feel exactly like one").[175] Her father notices "the curious suggestion of strength in her movements, the long line of her limbs . . . and the pose of her head on her over-broad shoulders."[176] When Stephen grows up and falls in love with a married American actress, she becomes particularly fastidious about her male clothing: "The suit should be grey with a little white pin

stripe, and the jacket, she decided, must have a breast pocket. She would wear a black tie—no, better a grey one to match the little white pin stripe."[177] Stephen is kicked off her ancestral property, serves in an ambulance corps in the First World War, has a loving relationship with a young Welsh woman, Mary, meets other inverts in Paris (another take on Barney's social circle), and tricks Mary into marrying a man so that she can lead a "normal" life. While Mary and some of the Paris inverts are quite feminine, the masculine Stephen is the novel's primary case study, and her masculine habits and clothing indicate her condition. At the end of the novel, a dying Stephen is surrounded by a throng of ghostly, sad-eyed inverts. They possess her and she cries out, "Acknowledge us, oh God, before the whole world. Give us also the right to our existence!"[178]

Hall's novel became well known because of the furor over its publication in London. Although British literary critics largely praised the novel, journalist James Douglas wrote a scathing editorial in the *Sunday Express*, declaring, "I would rather give a healthy boy or a healthy girl a phial of prussic acid than this novel."[179] The British Home Secretary, Sir William Joynson-Hicks, agreed and instructed the director of public prosecutions to bring action against the novel. Despite the protests of acclaimed authors such as Virginia Woolf, E. M. Forster, and T. S. Eliot, the court ruled *Well* obscene in November 1928, and an appellate court affirmed the decision the next month. British authorities destroyed as many copies as they could lay their hands on. Laura Doan argues that the extensive circulation of photos of Hall during the trial established her look as a recognizable uniform of lesbianism in England.[180] While Hall's look was already associated with lesbianism in *What's the World Coming To?* and *Wings*, the publicity undoubtedly solidified this interpretation.[181]

In the United States, the *New York Times* and *Publisher's Weekly* reported on the British trial and the book's U.S. prospects. Historian Leslie A. Taylor has traced the book's complex publication history in the United States.[182] Although Hall originally signed a contract with Alfred A. Knopf, the company balked when British courts declared the book obscene. A bidding war then broke out among less reputable U.S. publishers. In the end, Covici-Friede won the rights to the book. The firm was managed by Pascal Covici, a Romanian Jewish immigrant, and Donald Friede, the well-off son of a Russian immigrant and former vice president of Boni & Liveright. Covici and Friede published the book on December 15, 1928, for $5.00, twice the price of a usual novel. A $10.00 limited edition sold out overnight. Within the first month, the firm had sold 20,000 copies.[183] U.S. literary critics greeted *Well* warmly, only occasionally taking issue with its unrelenting seriousness and loose structure. Although the book was expensive, book rental companies in small towns like Hutchinson, Kansas, and cities like Chicago offered it to readers by January 1929.[184] By the end of the first year, more than 100,000 copies had been sold in the United States.

Covici and Friede counted on efforts to suppress the book to boost sales.[185] On the advice of their lawyer, they notified John Sumner, president of the New York Society for the Suppression of Vice, of their intent to publish the book and sold Sumner one of the first copies.[186] Friede also traveled to Boston to give a copy to the Watch and Ward Society, which had banned hundreds of books in Boston.[187] Although Watch and Ward did not take the bait, Sumner did. On January 11, 1929, he delivered a court summons to Friede for selling an "obscene, lewd, lascivious, filthy, indecent, or disgusting book," and the police seized 865 copies.[188] The *New York Times* noted that, at this point, the book was already at the top of the bestseller list, with 20,000 copies sold. On January 22, District Attorney Joab H. Banton (of *The Captive* fame) brought the case against Friede. On February 21, after reading the book, the magistrate recommended the case to the Court of Special Sessions, arguing that, given the recent addition of "sex perversion" to the code governing theater, community mores were united against the representation of lesbianism.[189] Two months later, on April 19, the court gave its decision: "the book in question is not in violation of the law."[190] The U.S. Customs Court declared the book obscene a month later, but that decision was overturned in July.[191] The constant legal wrangling kept *The Well of Loneliness* in the papers well into the 1930s—surely Covici and Friede's intention.

A sea change had taken place since the coverage of *The Captive*. In discussing *Well*, journalists around the country did not hesitate to name the book's subject. They used a range of terms, including "urning," "intermediate sex," "inversion," "homosexuality," and "lesbianism."[192] The word "invert" seems to have been least familiar. A critic in Decatur, Illinois, called it "a baffling word," and literary critic Mary Ross defined it for readers of the *New York Herald Tribune*.[193] Many journalists assumed that the existence of inverts was common knowledge. "Of course there are inverts," the Decatur critic wrote. "It is true that coteries of them gather in every acknowledged rendezvous in Paris, New York, Chicago."[194] Overall, literary critics were far more sympathetic to the novel's protagonist and inverts in general than theater critics had been to *The Captive*'s protagonist. This acceptance was not limited to metropolitan papers. A reviewer for Mississippi's *Hattiesburg American* wondered why the book had been suppressed: "Genuine homosexuality is not a vice, but an endowment. About three out of every hundred are abnormal in this fashion."[195] A critic for Iowa's *Cedar Rapids Tribune* agreed: "The Radclyffe Hall book deals with inversion, which is perhaps commoner than most folks realize, and which is by most folks little understood. The subject is neither obscene nor abstruse. It ought to be as possible to read an authentic work on this subject as on ingrowing toenails."[196] Reviews published in Galveston, Texas, Charleston, West Virginia, and Appleton, Wisconsin, similarly praised the book and criticized the efforts against it.[197] Unlike earlier journalists, the reviewers of *Well* did not seem concerned that their articles

might inform young women of a vice they had never thought of. Inversion had gone mainstream.

Many communities hosted discussions and lectures relating to the book. In Baltimore, two different African American women's clubs read the book and organized events around it.[198] One club scheduled a lecture by Dr. Carla Thompson, a well-known Johns Hopkins psychoanalyst, on "Homosexuality, what it is and its causes." The *Baltimore Afro-American* presented the topic as entirely respectable: "The club sent Dr. Thompson a plant as a token of appreciation for the address."[199] In Chicago, a progressive Jewish community center invited a psychiatrist to discuss the book.[200] At a bookstore in San Francisco, Dr. Clement H. Arnold considered the book "from the medical standpoint" and offered "suggestions as to how such situations may be met in everyday life."[201] English professors at two Midwestern universities assigned the book to their composition classes.[202] These communities evidently received the book as the serious undertaking it was intended to be.

However, not everyone approved. Three weeks after Dr. Thompson's address to black women in Baltimore, a commentator in the *Baltimore Afro-American* objected:

> In the old days effeminate men were shunned as degenerates. Not so today, since psychoanalysts have had their say, and books like the "Well of Loneliness" have built up toleration for the men who wish they were women and the women who long to be men. . . . As expected, tolerance for the persons of twisted sex has resulted in the establishment of a fad, and an openly defiant attempt to draw recruits from the ranks of normal young people. . . . There is nothing more dangerous to the growth of a race and nothing more disgusting than this group of atypical men, whose minds should be centered on wholesome exercise and recreation, clean living and hard work, instead of devoting their time and their talent to the use of the skirt, the lipstick and the powder puff as a means of physically attracting others of the same sex.[203]

It is interesting that the commentator complained that books like *Well* were increasing the numbers of effeminate men rather than masculine women. Effeminate men were evidently considered more threatening, particularly to reformers hoping to establish the black community's respectability. It is clear that *The Well of Loneliness* prompted public discussions of inversion in diverse communities throughout the country.[204]

By the 1930s, the book was used as a sign of not-quite-achieved sophistication. It was simultaneously middlebrow and scandalous, but not too scandalous. For example, *The Living Age*, a weekly general-interest magazine, reported that an Italian journalist had observed:

[Upper-class American women] are not satisfied with having imposed on their husband the terrible task of keeping up with the Joneses; they have also had the leisure to acquire a culture that is of course superficial yet is sufficient to enable them to cut a figure in the world. . . . When a big executive returns in the evening . . . they assail him on all sides with a shower of questions . . . :

"What do you think, Mr. Jones, of Dr. Bunk's new system of psychoanalysis to cure girls of the Œdipus complex?" . . .

"What do you think of the Well of Loneliness? Don't you agree that it's one of the greatest novels of the century?"[205]

For this writer, familiarity with Freud and *The Well of Loneliness* was an empty signifier of class distinction. Knowledge of and a blasé attitude toward inversion were again used to establish oneself as worldly and cosmopolitan. The notion that the book was only slightly titillating was also reflected in a September 1930 article: a forthcoming $2.00 edition will "make it available to those countless suburban matrons who have been whispering about it for the last eight months or so."[206] The book is scandalous enough that middle-class women talk about it in whispers, but not so scandalous that they will not buy it.

In Hollywood discourse, *Well* was used to indicate a certain cosmopolitanism. In one anecdote, a young woman proved to be more sophisticated than the book's anticipated readers. Jim Tully, who reported to *New Movie Magazine* about his experience acting in the movie *Way for a Sailor*, encountered a young woman on the set reading *Well*. When asked whether she liked the book, she replied, "fairly well," but qualified her answer: "A person has to wade through a whole book to get what Havelock Ellis would give in a chapter."[207] The young woman's familiarity with inversion exceeded Tully's and the reader's expectations. The anecdote is similar to that of the "sweet young things" who were sure that their mothers would not understand *The Captive*. On the other hand, the Columbia Pictures detective film *The Secret Witness* (1931) offers a comic example of someone who is not quite up to the book's sophistication. Zasu Pitts plays a flustered telephone operator. While talking to her boyfriend on the phone, she mentions that she is reading "something about a well . . . I don't really understand it." The film cuts to the book's cover—*The Well of Loneliness*. As Richard Barrios points out, the gag suggests that producers expected audiences to be sufficiently familiar with the title to know what the book is about.[208] These anecdotes show how the novel was incorporated into structures of social distinction and that it had become broadly recognizable to general audiences.

Overall, the reception to *The Well of Loneliness* helped spread a broader range of terminology to American readers and publicized a model of same-sex desire as gender inversion. It also suggested a different set of codes than *The Captive*

for detecting inversion: mannish physiology, men's tastes in furniture and leisure activities, and, in particular, men's clothing. Publicly connecting masculine styles of clothing to inversion added another dimension to the reception of cross-dressing women.

In the midst of a second wave of cross-dressed women in American movies, lesbians and inverts entered popular consciousness through a series of movies, plays, and novels. The widespread coverage of *The Captive* and *The Well of Loneliness* did the most to circulate terms and concepts of same-sex desire, but they were accompanied by a range of lesser-known works. Even though movies could not be as explicit as plays or novels, they still managed to include a surprising amount of lesbian content, either in brief cameos (as in *Four Horsemen of the Apocalypse, Manslaughter,* and *Wings*) or through intertextual insinuations (as in *What's the World Coming To?* and *The Crystal Cup*). The growing familiarity with lesbianism and inversion over the course of the 1920s is evident, as journalists moved from vague words like "obscene" or "indecent" to specific words like "lesbian," "invert," and "homosexual." A knowing, blasé attitude toward lesbianism became a signifier of worldly cosmopolitanism. Codes established by *The Captive* and *The Well of Loneliness* in the 1920s would be picked up by fan magazine writers and moviemakers in the 1930s. Although masculinity was not necessary for signifying lesbianism in the 1920s, it became more tightly connected to same-sex desire in the late 1920s, as the model of inversion was popularly embraced. This connection had a significant impact on cross-dressed women in the movies.

5 ▸ THE LESBIAN VOGUE AND BACKLASH AGAINST CROSS-DRESSED WOMEN IN THE 1930S

If you want to dress like Garbo or Dietrich . . . you can this year, because their type of tailored femininity is the last word in chic.
—"THE MODE GOES MANNISH,"
New York Times, December 13, 1931

We believe the current trend toward mannish attire for women is a freakish fad and our fashion experts agree with us. . . . We have refrained all along from showing any women dressed as a man in our pictures and we will continue to do it. The order becomes effective immediately and our feminine stars have been warned that they must stay feminine.
—JACK L. WARNER, quoted in "Warners Ban Mannish Garb for Women Stars," *Los Angeles Times*, February 17, 1933

THE MOST ICONIC images of cross-dressed women in early Hollywood—Dietrich in a tailcoat in *Morocco* and Garbo in king's regalia in *Queen Christina*—are from the early 1930s. This is the cross-dressing that has stuck in our cultural memory, long after Marguerite Clark's twin princes and Gene Gauntier's girl spy have been forgotten. Counterintuitively, fewer films

featuring cross-dressed women were produced per year between 1929 and 1934 than in any period since 1909. The strong memory of the relatively few cross-dressed women from this time is not actually a contradiction, but the result of the convergence of cross-dressing and lesbianism. Capitalizing on the interest generated by *The Captive*, *The Well of Loneliness*, and other works of the late 1920s, American movie culture engaged more actively with lesbianism than ever before. A new, more sexualized strain of cross-dressing was conceptualized as a European import and aligned with the cosmopolitan nightlife of Paris and Berlin. Fan magazine writers used codes popularized in the previous decade to suggest that imported stars like Garbo were lesbian or inverted. Film journalists even sometimes used cross-dressing as a euphemism for lesbianism. Cross-dressed performances came under new suspicion from censors. At the same time, women around the country emulated the masculine styles of Garbo and Dietrich, prompting vigorous debates in the popular press over women's trousers. Though increasingly associated with sexual deviance, trousers and other masculine styles continued to symbolize modernity, autonomy, and disregard for convention. Whereas cross-dressed women had helped legitimize cinema in the 1910s by associating it with theater and the frontier, in the 1930s they became potentially deviant. So when Hollywood was pressured to clean up its act, cross-dressed women became part of the problem rather than the solution.

The number of cross-dressed women declined abruptly in American film in 1929. During the second wave of cross-dressed women (1922–1928), American companies had released an average of ten films per year featuring cross-dressed women, but during the third wave (1929–1934), they released an average of only five per year, only half as many. This decline coincided with the industry's transition to synchronized sound (1926–1931) and the onset of the Great Depression (October 1929). The higher costs of producing synchronized sound films and the lower profits due to the Depression caused film production to fall by a fifth after 1928 (from roughly 650 films per year to roughly 525).[1] Thus, while part of the decline in films featuring cross-dressed women can be attributed to the industry's overall contraction, some other factor was also at work.

One could imagine that the disruptiveness of adding a voice to the cross-dressed body might contribute to the decline, but there was no reason synchronized sound would have this effect. Cross-dressed women in musical theater, vaudeville, and nightclubs sang and spoke; in fact, they were precisely the type of act that synchronized sound films started importing from the stage. Indeed, in about 20 percent of this wave's films, cross-dressing is motivated by a musical number. Synchronization would therefore seem to provide the opportunity for more, not fewer, cross-dressed women. One might also argue that the female voice "outed" the cross-dressed woman's female body or generated an unpleasant disjunction between voice and body. But this argument does not make sense

either; by this point, cross-dressed women in cinema were always visibly female, and the intermix of masculine and feminine aspects of their performances was already noticeable. As scholars have pointed out, there was a lot of concern that actors' voices "fit" their bodies and that their voices conform to gender, class, and racial ideals.[2] However, women with low-pitched voices never generated the concern that men with high-pitched voices did. On the contrary, the lower voices of Garbo, Dietrich, and later Lauren Bacall were characterized as seductive rather than mannish.[3] Moreover, Hepburn's voice was not low, so there does not seem to have been any necessary connection between sartorial and vocal masculinity during this period.

The main reason for fewer cross-dressed women after 1928, I argue, is that women dressing like men had become more publicly linked to lesbianism. The newspaper coverage of *The Captive* had introduced the subject to households throughout the country and contributed to a lesbian and pansy craze in America's metropolises. All forms of gender deviance came under new suspicion. If synchronized sound and the Depression contributed to the decline in cross-dressed women, they did so in a roundabout way. Film scholar David Lugowski argues that "[synchronized] sound gave queerness a new voice" because it provided American movies new ways of communicating queerness via "innuendo in dialogue and vocal intonation."[4] While intonation was more important for identifying pansies than lesbians (even Lugowski spots lesbians via their tailoring), synchronized sound did allow cinema to import the verbal innuendo and "sophisticated" milieu of the Broadway stage, which resulted in more references to sexual deviance. And the Depression made producers more eager to exploit transgressive subjects than they had been, in order to win audiences back to cinemas.

In this chapter, I investigate the ways that Hollywood engaged with lesbianism between 1930 and 1934 and how cross-dressing played into this effort. I will also explore the 1933 backlash against women in trousers and how it fit into campaigns against Hollywood immorality and efforts by the Motion Picture Producers and Distributors of America (MPPDA) to police movie content. Women continued to cross-dress, now off-screen as well as on, but the practice had to be managed more carefully. Cross-dressing changed from a practice in which almost all actresses engaged to one for only a select few. Film companies exploited the practice's new sense of transgression and European cosmopolitanism, which continued to popularize new concepts of deviance and sexual identity; but cross-dressing was no longer the common practice that it had been. The early 1930s established the way we now look at cross-dressed women in Hollywood cinema, but the process was piecemeal and contested.

SOPHISTICATED SUBJECTS, SOPHISTICATED VIEWERS

In the early 1930s, American cities like New York and Chicago experienced a "lesbian and pansy craze," as historians like George Chauncey and Chad Heap have documented.[5] In the wake of Prohibition, Americans ventured into urban underworlds to drink in speakeasies and nightclubs otherwise inhabited by bohemians and sexual deviants. According to Heap, Greenwich Village club owners began marketing their pansy and lesbian entertainers to heterosexual patrons in autumn 1928. When popular pansy performer Jean Malin moved from the Village to a club on West Fifty-Fourth Street in 1930, he inspired so many imitators that a columnist quipped, "before the main stem knew what had happened, there was a hand on a hip for every light on Broadway."[6] Pansies and lesbians performed at venues ranging from high-class nightclubs to underground speakeasies, in white and African American entertainment districts alike. Attending these shows was a way to demonstrate one's worldliness. As *Vanity Fair* observed in 1931, patrons of Malin's shows "smirk[ed] with self-conscious sophistication at the delicate antics of their host."[7] Hollywood luminaries regularly attended these shows, and Malin moved to Hollywood in 1932 to be master of ceremonies at Club New York, which was patronized by the film colony.[8] Hollywood glamorized the newfound popularity of pansies and lesbians, spreading familiarity with these sexual types throughout the country and modeling a blasé attitude toward sexual nonconformity. At the same time, moralists warned that Greenwich Village had become a "Lesbians' Paradise," where "Lesbos, filthy with erotomania," went "on the make for sweet high school kiddies down for a thrill."[9]

During the Depression, movie producers turned to transgressive subjects like adultery and gangland violence to draw audiences back to the movies. "Sex perversion" was one of the many vices featured in films of the period, though it was far less common than heterosexual misbehavior. As film historian Ruth Vasey has discussed, the addition of sound made it more difficult for censors to cut films without destroying their synchronization and continuity. Recognizing censorship's growing threat to talking pictures, the MDDPA ratified a longer set of guidelines, called the "Production Code," in 1930. While the "Don'ts and Be Carefuls" of 1927 merely listed dangerous topics, the Code put forth general principles and a much longer set of topics to avoid. However, the attitude it took toward homosexuality was exactly the same: "Sex perversion or any inference to it" was forbidden.[10]

MPPDA leaders encouraged producers to represent controversial subjects in such a way that "sophisticated" viewers could understand the meaning, but unsophisticated viewers could not.[11] This strategy allowed producers to deny tabooed meanings, claiming *honi soit qui mal y pense.* Filmmakers used cuts, pans, and other codes to suggest extramarital sex, prostitution, rape, and abortion.[12] As I

discussed in the last two chapters, elites had long used these sorts of strategies to confine subjects like lesbianism to a limited group of sophisticates. However, the portion of the audience that the MPPDA considered "sophisticated" was much larger than the upper-class elite who could catch references to Roman poetry and French literature. By this time, as we saw in chapter 4, journalists expected the American public to understand references to Freud, Krafft-Ebing, Ellis, *The Captive*, and *The Well of Loneliness*. Since movies and articles about movie stars could not refer to lesbianism directly, they relied on codes that had been spread in the publicity over *The Captive* and *The Well of Loneliness* during the previous few years. This coverage had circulated so widely that "sophisticated" readers could likely be found all over the country, not only in the elite corners of major urban centers.

In late 1929, two new works presenting inverted women showed up in New York, but neither was widely seen or got much publicity. On November 12, 1929, the Provincetown Players, the company that had produced *The God of Vengeance*, opened *Winter Bound*, a play about a masculine and a feminine woman living together in an isolated Connecticut farmhouse. Though the *New York Times* critic noted that the play "wandered vaguely along the path of 'The Captive,'" the police did not intervene.[13] The reason may have had to do with the author, Thomas H. Dickinson, a professor of English and former member of the Hoover administration.[14] Most likely, it was because the play closed so quickly, after only thirty-nine performances.

On December 1, 1929, Georg Wilhelm Pabst's film *Die Büschse der Pandora* (*Pandora's Box*) opened at New York's Fifty-Fifth Street Playhouse. The film follows careless, beautiful Lulu (Louise Brooks), who destroys the life of each man she meets, until she is murdered by Jack the Ripper. Along with the men, the masculine-styled Countess Anna Geschwitz (Alice Roberts) falls for Lulu's charms. Gay film historian Vito Russo calls Geschwitz "probably the first explicitly drawn lesbian character" in cinema.[15] Though Geschwitz was preceded by the lesbian cameos I discussed in the last chapter, she may have been cinema's first *central* female character to express explicit desire for a woman. However, it is not clear what American viewers were able to see of her. The New York Board of Censors cut the film considerably before allowing it to play in the city. According to *Billboard*, "This feature spent several weeks in the censor board's cutting room, and the result of its stay is a badly contorted drama. . . . Every sequence has been cut, so heavy was the sex idea of the picture. Bathroom, bedroom and chaise-lounge scenes are cut in the middle and deleted to the point where what little continuity the picture had is destroyed."[16] Russo claims that British censors cut Geschwitz out of the film entirely and that this expurgated print was sent to the United States.[17] This assertion cannot be true, because the *Billboard* critic wrote that the actress who played Geschwitz "has the most attractive role

of the picture. This lady has the looks and a certain appeal that is hard to deny."[18] What's more, the *New Yorker* critic observed that the film had "a subdued Krafft-Ebing undertone."[19] So it seems that *some* of Geschwitz's desire for Lulu survived the censors' shears. *Pandora's Box* closed shortly after opening and did not seem to have traveled much. However, it did play at least one night in 1931 at the Little Theatre in Newark, New Jersey, where it was marketed as an exploitation film for "adults only."[20] Neither *Winter Bound* nor *Pandora's Box* made much of an impact on the American public. But at this moment, the Hollywood star system was on the verge of creating one of the world's most enduring lesbian stars.

THE MYSTERY OF GRETA GARBO

In the 1920s, a variety of media began sharing codes for detecting lesbianism. In the early 1930s, when fan magazines and daily newspapers promised readers insight into the secret lives of the stars, journalists put these codes to work in constructing Greta Garbo's star persona. Film historian Richard deCordova has argued that a "play of surface and depth characterized all discourse on the stars" and that, in a culture that "equates identity with the private and . . . accords the sexuality the status of the most private," the sexual was figured as "the ultimate secret."[21] Far from being inconsequential gossip, rumors about a star's illicit sexual activities were key to the operation of stardom.

Perhaps more than any other star, Garbo was defined by secrets. Journalists described her as a "sphinx," "Mona Lisa," and "the riddle of Hollywood."[22] The drive to reveal Garbo's secrets motivated hundreds if not thousands of articles and endless tell-all biographies, which continue to be published with regularity.[23] For a star like Garbo, rumors of lesbianism did not merely circulate among insiders; they were constructed by the mass-circulation press with MGM's tacit approval. MGM had promoted gay film star William Haines similarly in the 1920s, as film scholar Ronald Gregg has shown.[24]

Although Garbo arrived in Hollywood in 1925, media accounts did not begin to characterize her as lesbian until five years later. At first, MGM seemed uncertain of how to type her. Perhaps due to the tomboy roles of fellow Swede Anna Q. Nilsson, MGM took publicity photos of Garbo posing with the USC swim coach and sitting beside the MGM lion. Abandoning this tactic, the studio cast her as a Latin vamp in her first three films, reprising her breakout performance in the Swedish film *Gösta Berlings saga* (*The Saga of Gösta Berling*, 1924; U.S., 1928). Garbo wrote to a friend in Sweden, "They don't have a type like me out here," and a 1926 *New York Times* article agreed: "No one seems quite to understand Greta—her type or her personality."[25] Journalists characterized her as a timid Swedish immigrant adrift in fast-paced America.[26] On-screen, she played

aristocratic European femme fatales; off-screen, she had a highly publicized romance with costar John Gilbert. Soon, though, journalists began to describe her as "the Hollywood hermit" and noted that she wore dowdy sweaters, trench coats, and flat-heeled shoes, declared no interest in marriage, and rarely socialized with her peers.[27] Journalists proffered many explanations for her eccentricities: Was she "an introvert and a neurotic"? Anemic? Mourning the death of Mauritz Stiller, the Finnish-Swedish director who had mentored her? Was she merely a Swedish peasant ill equipped for modern city life? A melancholy Nordic? Or perhaps she was just a clever publicist?[28] Journalists regularly rehashed these speculations. However, between 1925 and 1930, Garbo was not described as particularly masculine, nor was she ever photographed in trousers. She continued to play the Continental vamp on-screen—beautiful, feminine, and irresistible. Her ability to communicate ineffable suffering while luring men to their destruction endeared her to women and men alike.[29]

In 1930, journalists began to suggest a new explanation for Garbo's oddities: lesbianism. The timing coincided with Hollywood's turn toward illicit sexuality and with Garbo's relationship with flamboyant playwright Mercedes de Acosta, a woman well connected to international lesbian social networks. However, reports about Garbo never used the words "lesbian" or "invert." Film studios were less willing than theater managers and book publishers to risk alienating large parts of the country. In order to suggest that Garbo might be lesbian, journalists mobilized codes from *The Captive* (such as close female friends visiting at all hours, the exchange of violets, and references to Sappho) and *The Well of Loneliness* (such as masculine clothing, behavior, and physiology, melancholy, and a preference for solitude). Photographs of Garbo in pants, as well as her trademark sweater and trench coat, became meaningful when they were aggregated with other bits of data, as film scholar Patricia White has described.[30] Garbo's lesbianism could be suggested so long as it remained deniable.

In *The Captive*, Monsieur d'Aiguines urged husbands to be suspicious of close friendships and late-night visits between women. Around 1930, the press likewise began to comment on Garbo's friendships with women—particularly Lilyan Tashman and Fifi d'Orsay. Tashman was a Broadway actress who had married gay actor Edmund Lowe in 1925. Her lesbianism was an open secret, and she was known for throwing "sophisticated" parties. A 1929 profile of Garbo called Tashman "one of Greta's few friends" and noted that she had been helping Garbo buy clothes.[31] Others contended that Tashman taught Garbo the art of hostessing.[32] D'Orsay was a French Canadian vaudeville performer who had invented a Parisian past in the Folies Bergère. In February 1930, one newspaper reported: "Greta Garbo and Fifi Dorsay [*sic*] have become inseparable friends. Everywhere that Greta goes, Fifi is sure to tag along and vice versa. . . . Fifi is Greta's first pal

since Lilyan Tashman and Greta parted company. . . . Just how long it will last no one knows, but the two 'gals' are certainly a colorful pair—so different and both so foreign."[33] Though labeled a friendship, Garbo and d'Orsay's relationship is described in terms used for romantic pairs: Tashman and Garbo "parted company" like a couple breaking up; people wonder "how long" the next one "will last." The women are described as "colorful," "different," and "foreign." We have already seen how some American films characterized same-sex eroticism as an attribute of Parisian nightlife. Describing the two women as "so foreign" suggests that their relationship may play by a different set of more cosmopolitan rules.[34] The fact that d'Orsay was believed to be Parisian rather than French Canadian contributes to this insinuation.

Later that year, a *New York Times* interview with d'Orsay illustrated the intimacy of their friendship. One night, d'Orsay related, Garbo called her and said, "Baby, I mus' come over and see you for dinnaire tonight." When d'Orsay explained that she already had guests, "Geegee," d'Orsay's "pet name for Miss Garbo," demanded, "T'row them out," which is exactly what d'Orsay did.[35] This story, reported neutrally, recalls Monsieur d'Aiguines's warning that a woman can enter another's household "whenever and however she pleases—at any hour of the day." This kind of reporting played upon the suspicion *The Captive* had cast on close female friendships.

Garbo's most famous "friends" were Mercedes de Acosta and Salka Viertel. Both women were aligned with foreignness and international artistic circles. De Acosta, a poet and playwright, was born in New York City, but identified as Spanish like her mother. Viertel, an actress, theater producer, and later screenwriter, was born in Galicia, Austria-Hungary. She performed around Eastern Europe and started an Expressionist theater troupe in Berlin with her husband, Viennese writer and director Berthold Viertel. In 1928, when Berthold was recruited to Hollywood, Salka went with him.[36] Journalists began discussing Garbo's relationships with de Acosta and Viertel in 1931 and 1932. Gossip columnists were the first step in expanding the circle of insiders; they could say more than other journalists because they relied on codes, frequently omitted names, and had a lower standard of evidence. In August 1931, shortly after Garbo and de Acosta first met, the *Hollywood Reporter*'s "Rambling Reporter" noted that "Greta Garbo has a new love."[37] In December, another source observed, "Maybe Mercedes de Acosta is giving Greta good advice. The two girls are inseparable companions."[38] Like the phrase "inseparable friends," "inseparable companions" suggests that the two women were some kind of couple. A month later, the Rambling Reporter caught Garbo out with d'Orsay at a "pansy" speakeasy: "Despite the 'law' against nance entertainers, the hottest speakeasy spot in N.Y. is on Sixth Avenue, with fifty lavender boys serving the likker—Greta Garbo, Fifi Dorsay

[*sic*] and Joe Schenck amongst its patrons."³⁹ The allegation associated Garbo with the illicit activities of the New York nightlife and a space (like the Parisian dancehall) where normal rules of sexual propriety were not observed.

In January 1932, the Rambling Reporter implied a rivalry between Viertel and de Acosta for the position of Garbo's sole companion and suggested that the two women were visually indistinguishable: "This is supposed to have happened when Mrs. Berthold Viertel went to the Pasadena station to meet Greta Garbo who was arriving from New York a few weeks ago. Mrs. V. came into the station in a very tailored attire, flat-heeled shoes, etc., and was immediately swamped with reporters. . . . When it was all over the reporters said, 'Thank you very much, Miss D'Acosta.'(!)"⁴⁰ The anecdote pays particular attention to the mannishness of Viertel's attire and suggests that on this basis the two women could be mistaken for each other. In fact, de Acosta was noted for her extravagant costumes, while Viertel was far more understated.⁴¹

Along with the *Hollywood Reporter*'s gossip for film industry insiders, newspapers and fan magazines also linked Garbo and de Acosta. In May 1932, *Photoplay*'s gossip columnist Cal York called de Acosta "Garbo's dearest girl friend."⁴² That same month the *Los Angeles Times* referred to de Acosta as the "fond friend of Greta Garbo," and in July the paper noted that Garbo was accompanied to New York by "her close friend, Mrs. Mercedes De Acosta Poole, poet, playwright and traveling companion."⁴³ A profile of Garbo in the *Chicago Tribune* in August described de Acosta as "the great Garbo's chum."⁴⁴ "Chum," like "pal" or "companion," suggests a singular relationship between the two women.

The savviest alignment of Garbo with codes of lesbianism came from fan magazine writer Rilla Page Palmborg, who claimed to have intimate access to Garbo because her husband was Swedish.⁴⁵ She published two articles in *Photoplay* in 1930 and an unauthorized biography in 1931, all entitled "The Private Life of Greta Garbo."⁴⁶ Selections from the biography were printed in newspapers like the *Milwaukee Journal*.⁴⁷ Palmborg at first suggested that Garbo had male lovers and then rejected this possibility. The "tall, blond, handsome young Swede" with whom she had been seen around town in fact "knows that here is not a chance for him."⁴⁸ Like other reporters, Palmborg observed that Garbo's only exclusive relationships were with women: "Lilyan Tashman was reported to be Garbo's pal. Then Fifi Dorsay [*sic*] was supposed to be her chum. Others declared that Nils Asther was the only person she invited to her house."⁴⁹ Palmborg implied that these relationships were exclusive and singular. However, she hastily dispelled the suggestion that Garbo and Asther, a Danish-born Swedish actor, were a couple: "Hollywood never has taken the friendship between Nils Asther and Greta Garbo the way Hollywood usually takes friendship."⁵⁰ (In fact, Asther was the former lover of Mauritz Stiller, Garbo's mentor.) Indeed, according to Palmborg,

"Garbo did not seem to be devoted to any particular man" in the summer of 1929.[51] Palmborg thus dismissed rumors of Garbo's relationships with men and confirmed instead her intimate, exclusive friendships with women.

Palmborg also used one of *The Captive*'s most famous codes for lesbianism. In the second *Photoplay* article and the book, she claimed that "Garbo has always been fond of flowers. Her favorites are pansies and violets. . . . A bunch of violets was almost always to be found at the head of her bed."[52] Palmborg did not say whether the violets were a gift, but positioning the flowers at the "head of her bed" is particularly suggestive. Columnist O. O. McIntyre noted only a month later that sales of violets continued to sag because the flower "symbolized perversion" in *The Captive*.[53] While violets were associated with lesbian desire, pansies were associated with gay men. If this were not enough, Palmborg mentioned at the end of the book that "Garbo's next picture was to be *Sappho*."[54] Although Garbo did indeed star in an adaptation of Alphonse Daudet's novel *Sapho*, retitled *Inspiration*—an entirely heterosexual love story between a male painter and Parisian courtesan—the name Sappho was also a code for lesbianism. The connection between violets, Sappho, and same-sex desire had long circulated in coverage of *The Captive*, and it seems likely that interested readers would have recognized these codes.

Even more common than stories about Garbo's female friendships and affinity for violets were descriptions of her masculinity and obsessive privacy. These signifiers were less stable. Though some films of the 1920s and *The Well of Loneliness* provided audiences with the framework to interpret these traits as signifiers of lesbianism, alternate meanings continued to exist. Journalists described Garbo as "a tall, lanky, mannishly attired woman" and reported, "She wears a mannish walking-suit of brown, with leather jacket."[55] Palmborg's description of Garbo's attire resembles that of Stephen Gordon in *The Well of Loneliness*: "[Garbo] always wore heavy, low-heeled slippers. Oftenest these were the smallest size obtainable in men's low shoes. . . . She wore men's tailored shirts. She owned dozens of men's silk ties, in all colors. At night she wore men's pajamas, in soft shades of silk and in stripes. Her hats were of soft felt in mannish style. When her manservant brought her shoes, she would laugh and say, 'Just the kind for us bachelors, eh?'"[56] Palmborg's repetition of the word "men's" in describing Garbo's clothing pushes beyond androgynous women's fashion to suggest that Garbo was obsessed with masculinity. Garbo referred to herself as a "bachelor" in several interviews, and this claim even infiltrated the dialogue of her film *Queen Christina*. Her declaration, interest in upper-class men's fashion, and decision to have a manservant rather than a maid characterize Garbo as a male dandy—a persona common to artistic European lesbians like Romaine Brooks, Gluck, and Bryher.[57]

Garbo's physicality was also described as masculine. "Garbo strides along like a man and fairly races across the ground. . . . She plays tennis like a man, too," attested two of her friends.[58] Another journalist reported that Garbo "swings a stick with masculine effort."[59] Descriptions of Garbo behaving "like a man" align her with conceptions of the invert. These kinds of behaviors have become so much a part of Garbo's persona that we no longer find them surprising, but they were an important intervention into her persona at the time. Garbo's on-screen performances were considered quintessentially feminine; there, her heterosexual desire exceeded all boundaries (particularly the bounds of marriage). Only in her private life—and thus, only in print sources—was Garbo constructed as being man-like. At this point, there were not many photographs illustrating this masculinity, and so for several years her masculinity was primarily constructed through written discourse.

Journalists frequently elaborated on the furnishings and décor of celebrity homes as clues to a star's inner life. Coverage of female stars often insisted that even these ambitious career women were suitably domestic at home.[60] Not so Garbo. Her home revealed only a deeper level of mannishness. A *Photoplay* reporter, Katherine Albert, wrote that Garbo "likes solid substantial furniture and hates feminine geegaws," and the *Detroit Free Press* asserted that her home "contains no feminine appointments. The furnishings are solid and mannish."[61]

Garbo's masculinity could be freely discussed because it did not have any singular meaning. Although audiences could triangulate her masculinity with the accounts of her intense friendships with women and fondness for violets to read her as lesbian, journalists just as often presented alternative explanations. One of the most common was that her masculinity was a result of her working-class background. She was packaged into the stereotype of both the timid immigrant girl and the mannish Swedish peasant.[62] Whereas masculine styles might signify lesbianism in the sophisticated setting of the Parisian dancehall, in a Swedish peasant girl they might indicate a country bumpkin or nature-loving tomboy.

In these years, journalists' proliferating explanations for the swirl of signs around Garbo were contradictory and at odds with her glamorous on-screen persona. Only later, with *Queen Christina*, did Garbo's public and private personae come together on-screen. But this film was not the only platform for representing lesbianism during this period.

ENTER MARLENE

In 1930, Paramount recruited the German actress Marlene Dietrich as an answer to Greta Garbo. Though journalists often pitted Dietrich and Garbo against each other, they had quite different personae. Where Garbo was ostensibly a

melancholy peasant, Dietrich was a cosmopolitan sophisticate straight out of Berlin's exotic cabaret scene. Where Garbo was a loner who shunned marriage, Dietrich was a wife and mother. Adela Rodgers St. Johns's 1931 profile of Dietrich, for example, described the actress's maternal devotion at length.[63] In fact, at the same time that insinuations about Garbo's lesbianism began appearing in the press, Dietrich's most famous on-screen lesbian moment passed by without comment. In *Morocco* (Paramount), released in New York on November 14, 1930, and nationwide on December 6, Dietrich plays a showgirl, Amy Jolly, who performs a musical number in a black tailcoat and kisses a female audience member on the lips, as described earlier in the introduction. The on-screen cabaret audience applauds, the woman fans herself in delighted embarrassment, and Jolly flicks the brim of her hat. She walks back onstage and throws the flower to a surprised Legionnaire (Gary Cooper). No reviews at the time mentioned the kiss. The cross-dressed number evidently gave the character license to play-act "masculine" desire for a woman. Furthermore, the kiss expressed the unruly desire that allegedly characterized North Africa, something like the Parisian nightclub and Roman bacchanalia in films of the 1920s.

The image of Dietrich in the black tuxedo she wore in this scene is probably the most reproduced likeness of the star today (fig. 31). However, this image did

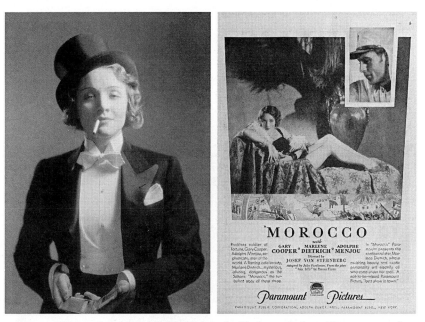

FIGURE 31. The now-iconic image of Dietrich in the black tuxedo from *Morocco* versus the contemporary ad for the film, which shows off Dietrich's bare legs. Photograph courtesy of Getty Images; ad from *Picture Play Magazine* (January 1931).

not circulate much at the time.[64] Advertisements for the film featured photographs of Dietrich in an ostrich-feather boa and short black slip, showing off long, bare legs.[65] The film was "little more than the visualization of a very delicate idea," Edwin Schallert wrote in the *Los Angeles Times*, but he seemed to be referring exclusively to Jolly's affair with the male Legionnaire.[66]

In 1931, Dietrich began wearing trousers in public. Although de Acosta later claimed to have persuaded Dietrich to wear pants, the choice also coincided with the fashion world's embrace of masculine-styled women's leisurewear.[67] *Vogue* profiled mannish women's coats in April 1931 and in December declared, "Biarritz has gone mannish again."[68] The fashion spread urged readers, "Borrow from the men—if you want to be chic—their flannel shorts, their shirts, their tight-fitted, double-breasted jackets, [and] pyjama trousers cut like men's pyjama trousers."[69] The *New York Times* endorsed the fad for mannish styles that same month: "More than ever this season men are going to accuse women of stealing their clothes. The charge will be entirely true, but the women probably will not listen; they will be too busy assembling gay and very new-looking resort costumes of the stolen goods."[70] The *Times* associated this theft with Garbo and Dietrich's influence: "If you want to dress like Garbo or Dietrich (off screen) you can this year, because their type of tailored femininity is the last word in chic."[71] In this context, mannish clothing was not a secret code for lesbianism or inversion, but a modern fashion statement associated with wealth and leisure.

But the trend was also about more than fashion. In the spring of 1932, the Hollywood press reported that Garbo, Dietrich, and de Acosta were all patronizing the same tailor shop, Watson and Sons.[72] Gossip columnist Cal York wrote in *Photoplay*: "And it gets more topsy-turvy than ever when you see Marlene Dietrich going into the swankiest tailoring shop in Hollywood to order a man's full dress suit in white. . . . That same shop creates Garbo's mannish looking clothes—the ones she wears on the street, and the other day Mercedes De Acosta, Garbo's dearest girl friend, was in the place trying on a pair of white flannel trousers."[73] Dietrich's white dress suit was undoubtedly the one she wore in *Blonde Venus* (Paramount, 1932). York draws attention to the special intimacy of Garbo's relationship with de Acosta and triangulates the three women via their patronage of the same men's shop, perhaps raising the suspicion that Dietrich shared the other women's predilections as well. However, Dietrich's clothing did not generate much press until later.

THE "MANNISH FEMMES" OF *MAEDCHEN IN UNIFORM*

While *Pandora's Box* came and went with little fanfare in 1929, the German talkie *Maedchen in Uniform* became the movie equivalent of *The Captive* when it opened in the United States in 1932. It generated an enormous amount of

press, and its name became synonymous with lesbianism—even though journalists could not agree on whether or not the film actually depicted lesbianism. Directed by Leontine Sagan and based on a play by Christa Winsloe, the film is set in a girls' boarding school and has an all-female cast. It follows a young woman, Manuela von Meinhardis (Herthe Thiele), as she enters a school run by the authoritarian Frau Oberin (Emilia Unda). Manuela and her schoolmates gravitate toward a kind young teacher, Fraulein von Bernburg (Dorothea Wieck). But when Manuela, exhilarated by her performance as a young swain in a school play, announces to her classmates that von Bernburg loves only her, Frau Oberin isolates Manuela and disciplines von Bernburg. Devastated, Manuela runs up a spiral staircase to leap to her death; at the last minute, her classmates and von Bernburg stop her. In the film's last image, Frau Oberin retreats down a dark hallway.

The film premiered in Berlin in November 1931 and played in France, England, Sweden, Spain, and Switzerland. When two young artists, John Krimsky and Gifford Cochran, tried to bring the film to New York in June 1932, the New York Board of Censors rejected the film on the basis that it treated the same theme as *The Captive*.[74] Krimsky and Cochran resubmitted the film, arguing, as Krimsky told the *New York Herald Tribune*, "If you say it has a 'Captive' angle then you're saying that in every girls' school all over the world the 'Captive' theme is prevalent, because young girls in every school adore the teacher who's the nicest; which is, of course, an absurd statement. . . . Of course, people who are going to look for something unpleasant may find it. They usually do. But the story is a fine psychological study of a student—a student with a mother complex—and her teacher."[75] Like the author of *A Florida Enchantment* years before, Krimsky accused those who found lesbianism in the film of projecting their own perversions into it. Krimsky may have made this argument earnestly or merely strategically. The New York Board of Censors relented in August 1932 and passed the film on the condition of significant cuts:

- "[A]ll views of Manuela's face as she looks at Miss von Bernburg in the classroom";
- Manuela's confession to von Bernburg that she wants to come to her at night;
- Manuela's declaration to her classmates after the play;
- Von Bernburg's defense of her affectionate attitude toward the schoolgirls;
- Frau Oberin's command forbidding von Bernburg to speak to Manuela;
- A scene in which Manuela clings to von Bernburg's skirt;
- Von Bernburg's admonishment to Manuela, "You should not like me so much";
- And, finally, "views of Manuela's face registering unseemly desire."[76]

It is hard to imagine how the film could have remained coherent after these cuts, particularly if the distributors omitted Manuela's declaration to her classmates after the play, which is the major narrative turning point. The New York reviews suggest that this scene, at least, was left in. Interestingly, the board did not ask the distributors to cut a scene in which von Bernburg kisses Manuela on the lips before bed. Critics complained that the film's English subtitles did not translate all the dialogue; it is possible that some exchanges that the board wanted excised were left untranslated rather than cut out. It is not clear whether the distributors actually made the cuts the board requested, but there were no further official interventions, as there had been with *The Captive*.

The distributors gave *Maedchen in Uniform* lavish treatment to demonstrate its status as high-quality art film. On September 21, 1932, it premiered at New York's Criterion Theatre, a 900-seat movie palace on Broadway. (Incidentally, *A Florida Enchantment* had premiered here eighteen years earlier, when the venue was called the Vitagraph Theatre.) The film played twice daily at top prices, between $1.50 and $1.65 per ticket. Critics lauded the film's artistry. The National Board of Review even named it the best film playing that month in New York.[77] After three weeks, it beat the earnings records that *The Covered Wagon* (Famous Players–Lasky, 1923), *Beau Geste* (Paramount, 1926), and *Wings* (Paramount, 1927) had previously set in that theater.[78] MGM entered negotiations to distribute the film, but the deal fell through because the studio refused to roadshow it (that is, send the film on a national tour with a team of musicians and higher ticket prices).[79] Instead, Krimsky and Cochran worked with independent regional distributors. By the time the film began its national run, a reviewer in the *New York Sun* asserted that the film's "fame has already reached to many large cities of the country. Likewise, the touch of scandal inherent in it has also been blown nationwide."[80] On October 31, 1932, a "complete and unabridged" version opened in Baltimore at the 850-seat Auditorium Theatre.[81] The film went on to play in Chicago, St. Louis, Cincinnati, Boston, and Philadelphia, and probably other cities, too.[82] It is not clear whether cut or uncut versions played in these cities, but presumably Krimsky and Cochran encouraged exhibitors to use the unabridged print when possible.

Maedchen in Uniform paints a complex picture of attachments between women in the hothouse environment of the all-girls school. Unlike the intimacies of the student couples in *Unforbidden Fruit* and *We Sing Diana*, longing in *Maedchen* is structured around differences of age and authority. As film scholar B. Ruby Rich points out, the film presents two different kinds of affection: collective (the students' longing for von Bernburg and her undifferentiated affection for them) and exclusive (Manuela's insistence that von Bernburg love only her).[83] These desires are presented as an intensification of mother-child

relations, offering a counterpoint to the models of the congenital invert and libertine that we have seen before. *Maedchen* is closer to Freud's theory of homosexual desire as arrested emotional development, in which a daughter fails to extricate herself from her originary connection to her mother. Though this longing was figured in familial terms, it was not devoid of the eroticism that was a key component of Freud's account of childhood development. What's more, older women who were in sexual relationships with younger women sometimes described themselves as mother and daughter, as Martha Vicinus has shown.[84] *Maedchen* also frames the students' affection for von Bernburg as a schoolgirl crush—an intense but also fleeting adolescent experience. The film sparked debate over whether Manuela's deep devotion to von Bernburg was part of normal (that is, heterosexual) female development, or whether it was an unnatural deviation.

As Rich points out, the film communicates Manuela and von Bernburg's feelings through lingering shots of each looking at the other, superimpositions of the women's faces on each other, and a series of emotionally charged encounters.[85] Though the New York censors may have cut several glances and superimpositions, they left one of the women's crucial encounters: a goodnight kiss. In a dimly lit dormitory, von Bernburg kisses each student goodnight on the forehead. When she comes to Manuela, the girl throws her arms around her teacher and looks up adoringly. Von Bernburg leans slowly in, takes Manuela's chin in her hands, and kisses the girl full on the mouth. Rich writes, "The kiss is permitted, to each alike, but it is at once the given and the boundary. . . . The entire equilibrium is founded upon this extreme tension, which is snapped when Manuela, overwhelmed by the atmosphere and her feelings, breaks the rules."[86] I agree that the kiss, as distributed equally to each girl, ritualizes and contains the girls' affection for von Bernburg, and that Manuela disrupts this equilibrium by wanting more intense, more exclusive, erotic contact with her teacher. Yet I want to look more closely at what this kiss might have communicated to audiences by comparing it to film scholar Linda Williams's study of heterosexual movie kisses.

In many ways, Manuela and von Bernburg's kiss looks like a classic Hollywood kiss. The room is dim and the lighting sensuous. The edges of each partner glow with rim lighting. The moment starts with a tight framing on two faces close together. One, in shadow, looks down solemnly. The other, lit somewhat brighter, beams upward. The taller figure places a hand on the other's neck and leans down to deliver a tender, closed-mouth kiss. At this point, the film cuts to a three-quarters shot. The couple's touching lips are obscured in shadow. A stark, white, rim light separates them from the shadowy background. Thus far, the shot is formally similar to Hollywood kisses between male-female couples. Williams writes that in pre-1960s Hollywood—when the kiss was the limit of what could be represented in terms of sex—the act could be understand as simultaneously

infantile and adolescent. The kisses are infantile in that they recall "the earlier act of maternal breast-feeding in which one erotogenic zone—the mother's nipple, her milk—excites another—the infant's mouth."[87] They are adolescent when understood as poised on the brink of "a more advanced, adult stage of genital sex." Manuela and von Bernburg's kiss is certainly infantile: the film has already framed the women as mother and child. But is it also adolescent? Does it anticipate the later "joining of other body parts," in Williams's words?

Williams notes that in Hollywood films, the camera often looks away in the middle of a kiss, suggesting that the kiss continues longer than the audience is permitted to see. The look away can also suggest more intimate sexual contact. In *Maedchen*, in contrast, the camera records the kiss's conclusion and von Bernburg's exit. The kiss only lasts a moment. It functions as a full stop, the limit of what can occur between these women. However, it is precisely this full stop to which Manuela objects. She later tells von Bernburg: "When you say goodnight and leave, and shut the door to your room . . . I stare at the door in the darkness. I want to get up and come to you . . . but I know I can't." Manuela longs for the kiss to be a prelude to something else, something perhaps less specific than genital stimulation, but nonetheless more satisfying than a kiss. In a sense, Manuela wants the kiss to be more "adolescent" than its formal representation has permitted. Yet that possibility evidently worried the New York censors, as they demanded that the distributors cut Manuela's confession to von Bernburg.

Williams argues that heterosexual movie kisses are anatomized sex acts. Visually, Manuela and von Bernburg's kiss imitates a heterosexual Hollywood kiss, contributing to the impression that their feelings for each other are erotic. This framing is similar to the way the female pairs in *Four Horsemen* and *Wings* become "couples" through visual parallels with the male-female pairs around them. Yet this kiss is more precisely ended than most, cutting it off from a trajectory leading to "the joining of other body parts." But Manuela's desire to go to von Bernburg's bedroom and the press's lively debate over their relationship suggests that many viewers recognized that the kiss could indeed lead to sex acts.

Male clothing also plays a role in the expression of female same-sex desire in this movie, but in a different way than the inversion model. Temporarily assuming a male persona in a school play provides Manuela the opportunity to declare her desire for von Bernburg publicly, first within the fictional framework of the play and then offstage. Manuela plays the title role in a performance of Friedrich Schiller's *Don Carlos*. In the scene we see performed, Don Carlos declares his forbidden love to Elisabeth, a woman his father, the king, has recently married. Whereas the girl playing Elisabeth requires the prompter's help, Manuela declares her lines with conviction. She falls to her knees and kisses the queen's hand, who reproves her: "Know you, it is the Queen, your mother, whom you address in such presumptuous strain?" Don Carlos/Manuela replies

passionately: "Let them come here, and drag me to the scaffold! A moment spent in paradise like this is not too dearly purchased by a life." A play within a play (or in this case, within a film) often authorizes characters to speak truths that cannot otherwise be spoken. Don Carlos/Manuela declares forbidden love to a woman who protests by reasserting her ostensibly maternal position. Von Bernburg watches the performance from the front row, leaning forward intently. As Rich notes, the queen and von Bernburg even share the name Elizabeth.[88] The film thus uses a trouser role as a vehicle for a woman to express desire for another woman, a device that had been used to communicate lesbian desire at least since Charlotte Brontë's *Villette* (1853), notes literature scholar Terry Castle.[89] However, *Maedchen* goes a step further.

After the performance, still in costume, Manuela drinks spiked punch. All the schoolgirls dance with each other in an explosion of happy emotion, something like the freewheeling eroticism of *Wings*' Parisian dancehall. But when Manuela notices that the girl she is dancing with has tattooed a heart with the initials "E.v.B." on her arm, Manuela stops the festivities and gathers all the girls around her. She announces that von Bernburg has given her one of her petticoats and proclaims, "Now I know for sure—she loves me! . . . Nothing else matters. She is there. She loves me! I'm not afraid of anything" (fig. 32). When Frau Oberin advances upon Manuela, the girl shouts, "Yes, everyone should know about it!" Although Manuela does not precisely declare her feelings toward von Bernburg, she asserts that their relationship is intimate and exclusive. It is the headmistress's reaction, however—isolating Manuela in the infirmary and threatening von Bernburg—that confirms the significance of Manuela's declaration. (These are also the actions that the New York censors tried to cut out.) The film uses the playful performance of masculinity as a conduit for the public expression of same-sex desire.

Almost all of *Maedchen*'s initial New York reviews repeated the refrain that, despite rumors, the film did not explore the same subject as *The Captive*. For example, Al Sherman at the *New York Telegraph* wrote, "There are some who profess to see, in the picture's compelling story, a hint of that neuroticism which forms the basis of 'The Captive.' If that is true, then every adoring friendship of a youth for his elder becomes perversion while the frantic crushes of adolescent schoolgirls prove no more nor less than a Freudian descent into Lesbianism."[90] This kind of defense was typical.[91] Bland Johaneson at the *Daily Mirror* likewise defended the film from "whisperings" that it was a "celluloid 'Well of Loneliness.'"[92] Even *Educational Screen* recommended the film, calling the "Industry's hint of Freudian motif mere dirty publicity."[93] Unlike critics of the 1920s, journalists in the early 1930s assumed their readers would already be familiar with *The Captive, The Well of Loneliness*, Freudian theory, and lesbianism.

FIGURE 32. Still in costume, Manuela (Herta Thiele) declares "She loves me!" in *Maedchen in Uniform.*

The review in *Variety* suggests that some writers had begun to use the word "mannish" as a code word for "lesbian." Noting the "whispering campaign that managed to get started to the effect that the picture has to do with the subject of mannish femmes," the critic asserted that the film "really has to do with no such subject, but . . . it will undoubtedly help sell a few tickets."[94] Though "mannish femmes" sounds contradictory, *Variety* referred to all women as "femmes," regardless of gender presentation. Neither von Bernburg nor Manuela is very masculine, suggesting that this reviewer used "mannish" not as a synonym for masculine (as fashion advertisements of the 1920s had done) but rather for "lesbian." In 1932, the term "mannish" was acquiring the suggestion of sexual deviance with which we are familiar today.

Many critics argued that *Maedchen* represented a lonely child's longing for a substitute mother or else an innocent adolescent crush. While passionate relationships between girls had been considered a normal part of adolescent development, these relationships were increasingly viewed with suspicion in the decades after the turn of the century.[95] The debates over Manuela and von Bernburg's feelings for each other landed in the midst of this shift. According to most reviewers, the rumors that preceded the film—"the whispered words that

'Maedchen in Uniform' was 'just full of Lesbianism and all that sort of thing, old chap'"—were merely a publicity stunt.[96] Of course, the censors had probably removed the most explicit signs of Manuela and von Bernburg's attraction to each other. However, by continuously countering rumors of lesbianism, critics kept the subject in the public eye and suggested that this reading was the prevalent one.

Contrary to the reception of A Florida Enchantment, critics suggested that the *least* sophisticated viewers were the ones who found lesbianism in the film. They were either sensation seekers or moralists "peering, with fanatic eyes, for a hint of perversion."[97] Some reviews described the two ways of reading the film as equally valid, as indicated by the title of an article in the Baltimore Sun: "Film Made in Germany Meets Two Schools of Thought, One Seeing It as Tender Story, Other as Pathological Study."[98] Lesbian meanings were not assumed to be restricted to "sophisticated" readers but available to all.

A few critics argued that Maedchen was indeed about lesbianism but treated the subject with such taste and dignity that it qualified as art and should therefore transcend moral judgment. For example, Richard Watts Jr. of the New York Herald-Tribune saw "no use denying that 'Maedchen in Uniform' does hint at pathological matters," but he insisted that the film "is that rare and surprising thing, a motion picture so distinguished in its manner that . . . you are forced to end by describing it as a Work of Art."[99] Many reviewers hailed the film as one of the best of the year, an example of the cinematic artistry possible in Europe and unexpected proof that the medium of film could produce something of worth. "Nothing has ever been done like it in the movies," according to the New Yorker reviewer, "and I do not expect that it will ever be duplicated . . . this picture is, in fact, that 'step forward' in the movies so often heralded."[100] Although defenders of Maedchen dismissed The Captive as sensationalist, they vindicated Maedchen on the same terms employed by supporters of the play five years earlier, that is, as a subtle work of art that should not be bound to the moral requirements of lower forms of cultural production.

As explicitly lesbian as Maedchen seems to us now, kisses and crushes between women were considered perfectly normal in the nineteenth and beginning of the twentieth century.[101] So the critical debate over the meaning of these women's affection for each other should be considered genuine. And yet this very debate put the subject of lesbianism before thousands of readers. It also demonstrated that the ability to see lesbianism in a film was not limited to a small cadre of sophisticated viewers. Maedchen in Uniform blurs the distinction between maternal affection, schoolgirl crushes, and lesbian desire. It displays Manuela and von Bernburg's kiss in the style of a heterosexual Hollywood kiss, suggests visually that nothing more was possible, then reveals through dialogue Manuela's longing for more. While the film eschews the model of inversion, Manuela uses male

masquerade to declare her own feelings. Even though the film was indepen-
dently distributed, it apparently played in a thousand U.S. cinemas in the three
years following its New York debut.[102]

The film's title became a euphemism for lesbianism in much the way that
The Captive had. "The title *Maedchen in Uniform* and the story associated with it
have thus become symbolic, as it were, of Lesbianism, as far as motion pictures
are concerned," stated a memo by the Production Code Administration (PCA)
when the film's distributors applied to rerelease it in 1936.[103] Furthermore, the
film's critical success is likely to have encouraged MGM to adopt new strategies
to elaborate Garbo's previously off-screen lesbian persona.

THE SIGN OF THE CROSS (1932), CAVALCADE (1933), AND THE PANSY CRAZE

Lesbianism was all around in the winter of 1932–1933. In addition to *Maedchen's*
national tour, *The Captive* was revived in Baltimore with nary a peep from the
police.[104] In a women's prison film released in February, *Ladies They Talk About*
(Warner, 1933), one inmate warns another about a muscular inmate with short
hair, cigar, tailored outfit, and bowtie: "Watch out for her, she likes to wrestle!"
More significantly, the two biggest films of the season, Cecil B. DeMille's *The
Sign of the Cross* (Paramount, 1932) and the Noel Coward adaptation *Cavalcade*
(Fox, 1933), both featured lesbian cameos. Formally, the cameos harkened back
to the 1920s; one was set in ancient Rome, the other in a London nightclub,
and they were brief and peripheral to the plot. However, unlike their reception
in the 1920s, these scenes provoked critics and censors to describe them as les-
bian, perverse, and even pornographic. They became flashpoints for critics of
Hollywood and an impetus for stronger censorship. Lesbianism had become
well enough known that anyone could recognize it, so it was more dangerous
to include explicit scenes in mass-market Hollywood films. At the same time,
lesbian moments were also good box office.

The season's most provocative lesbian sequence was in Cecil B. DeMille's *The
Sign of the Cross*. The film, adapted from an 1895 British stage play, depicts
the conflict between a Christian community and the powerful Roman state,
headed by Nero (Charles Laughton). Nero's right-hand man, Marcus Superbus
(Fredric March), falls in love with a young Christian woman, Mercia (Elissa
Landi). Though he tries to bring her around to the Roman way of life, her faith
eventually inspires him to face the lions with her. Despite the film's Christian
message, it was packed with eroticized, violent spectacle, including gorillas and
alligators attacking nearly nude women in chains, a battle between Amazons
and Little People, and packs of lions attacking and eating Christians. Repris-
ing the bacchanalia in *Manslaughter*, female same-sex desire is embedded in the

sexual excess of ancient Rome. There are no female inverts, although some of the men are sissyish, particularly Nero. The first potentially lesbian moment occurs when Nero's wife, Empress Poppaea (Claudette Colbert), bathes in a pool of ass's milk. After slipping off her robe and lowering herself into the milk, Poppaea invites a female slave to join her. The camera modestly looks away, panning to two cats lapping milk from the edge of the pool. This look away suggests that a sexual encounter might occur; the lapping cats intimate oral sex. The scene is a perfect illustration of the strategy encouraged by the MPPDA's Studio Relations Committee (SRC): simultaneously making available a sophisticated meaning to the wise and a benign meaning to the innocent. Despite the scene's suggestiveness and Colbert's apparent nudity, neither critics nor censors took offense, perhaps because Poppaea's heterosexuality is affirmed through her obsession with Marcus.

Trouble, instead, came from another scene, which Richard Barrios has called "the most homoerotically forward scene in the first seven decades of American cinema."[105] Marcus throws an orgy at the royal palace to seduce Mercia. When she rebuffs his advances, he introduces her to Ancaria (Joyzelle Joyner), "the wickedest and, uh, most *talented* woman in Rome." Ancaria dances seductively around Mercia, running her hands over the girl's hair and body, swaying her hips, and thrusting her pelvis into the girl. Midway through, we hear Christians singing from the street. Mercia's resolve hardens, and she rejects Ancaria.

The scene, which lasts more than three minutes, was transgressive enough that considerable wrangling was required to keep it in the film. James Wingate of the SRC objected to the dance, but DeMille ignored him. DeMille later recounted that when Will Hays called him up personally and asked, "What are you going to do about that dance?" DeMille answered, "Will, listen carefully to my words because you may want to quote them. Not a damn thing."[106] At this point, DeMille had the clout to defy Hays. DeMille defended his decision to Paramount's general manager in New York: "As to the dance, I should only advise cutting this if you believe that it will hurt box office value. It would seem to me to have the opposite effect. Are there many people who will stay away from a theater today because of a sensational dance?"[107] Paramount evidently agreed with DeMille and kept the entire sequence. (After the New York premiere, DeMille agreed to cut a scene in which an Amazon skewers a Little Person and another in which a gorilla attacks a chained woman.)

Paramount marketed *The Sign of the Cross* as a spectacular super production. It opened with an exclusive run at the magnificent 1,960-seat Rialto Theatre on Broadway on November 30, 1932. Tickets for reserved seating ranged from fifty cents to a dollar fifty and could be purchased by mail four weeks in advance. The film opened nationwide two months later, around the same time as *Maedchen*'s roadshows. In fact, in Los Angeles, *Maedchen* opened on January 19 at the

600-seat Cameo Theatre, and *Sign of the Cross* the next day at the 1,654-seat Bilt-more Theatre. A critic at the Catholic journal *Commonweal* compared the two films, praising *Maedchen's* delicacy while declaring *Sign of the Cross* "nauseat-ing."[108] Most critics, however, lauded DeMille's film as a thrilling spectacle and artistic triumph.[109] Most reviews of the film did not mention the lesbian dance at all, but some Catholics critics were outraged by it. *Commonweal* and *Our Sunday Visitor* called Ancaria's dance pornographic.[110] Catholic writer Daniel Lord, who had helped draft the Production Code, called the scene "sex perversion."[111] Priests in several cities encouraged their parishioners to boycott the film, a harbinger of the larger Catholic boycotts to come. However, Catholics were not the only viewers who were offended. Film critic and historian Terry Ramsaye wrote in the *Moving Picture Herald*: "We are required to see Marcia [*sic*] . . . made to stand the immobile focus of a bombardment of Lesbian wiles offered by a dancing wanton through some three or four minutes of screen time. This amazing inter-lude is dragged into the plot by its tail. . . . But as to the picture—they will shud-der, they will gasp, they will cry, and they will love it, provided their sensibilities survive the odors of Lesbos and de Sade. It's that kind of picture and they are that kind of people."[112] Unlike critics of the 1920s, Ramsaye was not afraid to write the word "Lesbian" and assumed his readers would be familiar with the mean-ing of "Lesbos" and "de Sade." Despite his own distaste, he, like DeMille, knew his audience and acknowledged that a brief representation of female same-sex desire, along with sadism, was a box office draw. Strangely enough, the trade journal *Harrison's Reports* argued that "the average adult will not understand that it is a Lesbian dance, and hardly any of the adolescents will know what is happening."[113]

The Sign of the Cross exploited a Roman setting to display taboo sexuality, including two beautiful women bathing together and a woman trying to seduce another on behalf of a man. Neither sequence suggested that female same-sex desire was associated with masculinity; instead, both relied on the model of lesbian behavior as a form of libertinism. Although the choice to retain these sequences proved to be good box office, it angered many Catholics who worked to keep subsequent examples off the screen.

The season's most acclaimed film, *Cavalcade*, was adapted from a Noel Cow-ard play that ran the previous year at London's Drury Lane Theatre. It was the film industry's biggest all-sound production up to that point, with a budget of one million dollars.[114] Epic in scope, the film told the story of Britain from 1899 to the present day via the fortunes of a middle-class British family. It followed in the tradition of ambitious film treatments of the First World War, many of which had been rewarded by box office success and Academy Awards, such as *The Four Horsemen of the Apocalypse, The Big Parade* (MGM, 1925), and *Wings*. Like *Four Horsemen* and *Wings*, it includes a seconds-long glance at a lesbian

couple in a metropolitan nightclub. In fact, the cameo is so similar to the one in *Four Horsemen* twelve years earlier that it may have been modeled on that sequence. Whereas *Four Horsemen* and *Wings* portrayed same-sex couples just before and in the midst of war, *Cavalcade* presents them as a consequence of war. The film cuts from mass celebrations of the Armistice to blind soldiers learning to weave baskets, priests delivering sermons to empty pews, and newspaper headlines declaring "DIVORCE! DIVORCE! DIVORCE!" "SEX MURDER DRAMAS!" and "VICE ORGIES INCREASING!" The film then moves to an upscale London club, as if to illustrate these "vice orgies." According to a surviving description (this footage was lost when the scene was removed for the film's rerelease in 1935), two blond women sit together, the one on the left in a black, tuxedo-styled dress, and the one on the right in a frilly white dress, the same framing as in *Four Horsemen*.[115] The woman in black takes the other's hand in hers, again similar to the earlier action. The next part of the sequence survives. The camera pans right to a pair of men who exchange a bracelet, then pans quickly back to the left. We see the female couple for a split second before the scene dissolves to a wide shot of the dance floor. This female couple harkens back to the gender-differentiated model of *Four Horsemen* and *Well of Loneliness*, although it is unclear whether the woman in black is inverted or merely a libertine. The narrative argues that these same-sex couples were created by the trauma of war. Significantly, the film connects the stylish tuxedo dress, which was designed by Earl Luick, not with fashionable modernity but with sexual deviance.

Cavalcade premiered at the 800-seat Gaiety Theatre on Broadway on January 5, 1933, and at Grauman's 2,200-seat Chinese Theatre in Los Angeles a week later. In February, it opened in various cities across the country. Critics everywhere waxed poetic. For example, Ralph T. Jones at the *Atlanta Constitution* described it as "an achievement that should live forever. It should be stored in the archives of the world, to be shown again and again to future generations."[116] Likewise, the normally staid *Wall Street Journal* critic believed it brought a "new beauty and a new dignity" to the screen: "In most respects this film is so superior to all others of its type that no comparison is possible."[117] The film won the 1933 Academy Award for Best Picture. Most critics did not mention the nightclub scene at all. The *Wall Street Journal* critic brought it up only to reiterate the film's argument that same-sex couples were a side effect of the war: "After effects of the War, with its jazz era, are shown by swiftly alternating scenes of debauched parties, blind and maimed soldiers in veterans' hospitals, wild and unrestrained dances, empty church pews, womanish men, mannish women, aged youth and youthful grandparents."[118] This critic evidently did not feel that these "womanish men" or "mannish women" detracted from the film's "beauty" or "dignity."

However, Norbert Lusk, New York film correspondent for the *Los Angeles Times*, drew his readers' attention to "the slight and fleeting moment that mars the tastefulness of the whole," even though "it will pass unnoticed by many": "To some spectators, however, it came as a shock to find the high idealistic tone of the work marred by two lapses into the sordid and the morbid in the sequence depicting post-war licentiousness. Flashes involving two women and a male couple seem unnecessarily embarrassing, especially when it is realized that the idea could have been projected quite as forcibly without touching on degradation."[119] Lusk makes an argument common to critics of literary and dramatic realism: just because offensive behavior exists does not mean it should be represented.[120] These few seconds out of an almost two-hour-long film weighed so heavily on Lusk's mind that he began his review with them. (Curiously, he had only praise for *Sign of the Cross* a month earlier.)[121] Like commentators on lesbian works before him, he argued that only a select few will notice these "flashes." But unlike them, he was not worried that by pointing them out, he would alert innocents to their existence.

The lesbian moments in *Ladies They Talk About*, *The Sign of the Cross*, and *Cavalcade* coincided with Hollywood's short-lived but frenzied pansy craze. Film studios, many on the brink of receivership, capitalized on taboo subjects to sell tickets. Best known were tales of unregulated heterosexual desire, like *She Done Him Wrong* (Paramount, 1933) and *Baby Face* (Warner, 1933). But studios also exploited the popularity of the pansy performers and female impersonators found in nightclubs. Fox included two female impersonators in a Greenwich Village nightclub in *Call Her Savage* (1932), and by early 1933 the studio was working simultaneously on *Sailor's Luck*, a comedy featuring a pansy lifeguard, *The Warrior's Husband*, a comedy about a gender-inverted Amazon society, and *Arizona to Broadway*, featuring Jean Malin impersonating Mae West. Paramount also tested (and rejected) Malin for a role in *I Love That Man*, and MGM announced Malin's participation in its forthcoming comedy *Dancing Lady*.[122] At the same time, according to *Variety*, RKO's *Our Betters* featured "a pansy dancing teacher . . . with rouged lips and all."[123] In a February 1933 article, *Variety* indicated that *Cavalcade* had encouraged Hollywood studios to feature more gays and lesbians: "Producers are going heavy on the panz stuff in current pix, despite the watchful eyes of the Hays office, which is attempting to keep the dual-sex boys and lesbos out of films. With a 'queer' flash in 'Cavalcade,' attitude is that if a picture of that type can get away with it why not in the programmers."[124] As examples of the new boldness, the article listed the "mauve" characters in *Our Betters* and *Sailor's Luck*, Malin's "violetty part" in *I Love That Man*, and the casting of the BBB Cellar Revue in *The Warrior's Husband*. The writer assumed that these performers not only

played pansy roles but *were* pansies, and framed their employment as some kind of invasion. "Hiring Pansies in Hollywood Has Its Drawbacks," according to the article's sub-headline, noting that the BBB Cellar Revue players demanded frilly dressing rooms, but also implying that the complications were not confined to backstage. Lesbians and mannish women were not as dangerous as sissies, the writer asserted, but they served as an advance guard. Many of the films that featured pansies and lesbians were adaptations of stage plays and variety acts. This transposition was enabled by synchronized sound, but the greater reach of film worried many commentators.

As in the 1920s, lesbian cameos in the early 1930s were part of ambitious, big-budget adaptations of theatrical works, which were produced alongside many minor films featuring pansy performers. By this time, viewers were fairly familiar with lesbians and inverts from the newspapers. The cameos that had gone by without a word became a problem. Some of them connected sexual deviance with fashionable, masculine-styled women's clothing.

DIETRICH'S TROUSERS TAKE CENTER STAGE

Even as some films associated mannish dress with lesbianism, masculine-styled women's clothing jumped in popularity when Dietrich wore a tuxedo to the Los Angeles premieres of *Maedchen in Uniform* and *The Sign of the Cross* in January 1933. While *Vogue* was already endorsing mannish styles for women's leisure-wear and Garbo had been photographed in trousers, Dietrich shockingly wore men's clothing to a *formal* event. As Hollywood columnist Ted Cook wrote, "Historians, with an eye cocked toward Hollywood—i.e. cock-eyed historians—will always remember 1933 as the year of the international breach over Marlene Dietrich's breeches."[125] The suit Dietrich wore to the premiere of *Maedchen* on January 19 attracted relatively little publicity. However, when she wore "that faultlessly cut tuxedo of strictly masculine genre" to *The Sign of the Cross* premiere at the Biltmore the next day, "well, something rather epoch-making was obviously in the air."[126] Dorothy Calhoun described the scene with even more hyperbole:

> Before radio announcers and goggle-eyed spectators stuttering with amazement, Marlene coolly and challengingly wore the tux, which may yet become as much a symbol of liberty as Betsy Ross's flag and posed obligingly for the newspaper photographers. Every newspaper in America carried a picture of Marlene in trousers. Telegraph wires clicked, cables carried the news to far countries, and dress-designers cursed and tore their hair. Department stores blossomed out in pantaloons for every size, from junior miss to stylish stout. Advertisements blared the new "Marlene Mannish Styles." Editorials discussed the Dietrich

vogue, pulpits denounced it, Broadway caught up the new fad and put it behind footlights.[127]

While many journalists connected Dietrich's penchant for pants to her European background, Calhoun suggested that pants were aligned with an inherently American yearning for freedom. She also framed Dietrich's appearance as a national and even global media event. Calhoun charted a complex relay among spheres of cultural production—from cinema to the news media, dress designers, department stores, advertisements, pulpits, and, lastly, Broadway. The writers of *Vogue*, in contrast, questioned whether Hollywood ever came up with any really new fashions or merely followed trends set by European designers.[128] Still, Calhoun's description shows that, even accounting for hyperbole, Hollywood observers felt that something important had happened.

The dominant story in the press was Dietrich's open defiance of Paramount's proscription against wearing trousers to the premiere and the studio's decision to take advantage of the publicity opportunity.[129] It is more likely, however, that Paramount participated in Dietrich's decision to wear men's formalwear to premieres and interviews and only feigned shock to make a better story. After all, Dietrich was essentially reappearing in outfits she had worn in her Paramount films, reminding the public of her performances. She claimed to have been wearing trousers for a long time before coming to the United States, thus associating the practice with cosmopolitan Berlin.[130] Dietrich's tuxedoes and trousers, then, were understood paradoxically as both a sign of foreignness and an American cry of liberty, just as they were alternately read as a sign of the star's headstrong independence from the Hollywood machine and a calculated publicity stunt.

The next month, newspapers observed that ordinary women were taking up pants in Dietrich's wake (fig. 33). "Chicago Girls Copy Marlene," the *Chicago Daily Tribune* noted: "Trousered women strolling along Michigan avenue may be a familiar sight before the spring is well advanced, merchandisers point out. A department store at Madison and State streets recently showed a wax model wearing trousers and fitted man's coat to match, with one of the mannish brimmed felts now in vogue."[131] Likewise, in an article titled "Pants and the Woman," the *New York Times* asked, "Will women wear the pants? Overwhelmingly 'Yes!' came the answer from scores of that sex when a leading Fifth Avenue store introduced a sale of ladies' trouser suits in the *Times*."[132]

Journalists were divided over whether Dietrich had ignited the vogue for trousers or merely publicized an already popular practice. In a February 1933 article in the *Los Angeles Times*, Alma Whitaker reminded readers that "girls have been trousering for lo, these many seasons":

FIGURE 33. "Ethel Carpenter and Kay Pettingill, wearing the new Marlene Dietrich trouser suits as they go for a stroll in Michigan Avenue." "Chicago Girls Copy Marlene," *Chicago Daily Tribune*, February 26, 1933.

One Hollywood store alone claims to have sold more than 5000 pairs of slacks in 1932. A department store man casually estimated that at least a million pairs of pants for women were sold in this territory last year, and that during the past three or four years the total for just this coast would reach a billion! As for this

season, oh boy how the stores are stocking up on 'em all over the country—not just feminized slacks either, but honest-to-goodness trousers of masculine cut, together with coats and shirts.[133]

Even if Whitaker's estimates were exaggerated, her article suggests that women's trousers were more widespread in day-to-day life in the early 1930s than has been previously thought. Whitaker gave Dietrich credit, though, for introducing trousers as formal attire.

Dietrich's tuxedoed appearances in January 1933 prompted a backlash. The anonymous gossip columnist in the *Hollywood Reporter* ridiculed the way "the newspaper boys and girls" were falling for "the Dietrich trousers, as though they were an innovation here—or anywhere else":

> Marlene must be relying heavily on their poor memories to think that they would swallow more than her exhibitionism as something NEW. Garbo, among others, wore trousers around this town for years. . . . The difference is only in the fact that Greta obviously wore them for comfort, and never stood or paraded around in them, making herself cheaply conspicuous just for the sake of being photographed—or laughed at.[134]

The writer seems offended that any woman would invite a public gaze on her trousered body or wear trousers for anything but practical reasons. If trousers made Dietrich "cheaply conspicuous" to this columnist, other journalists would complain in the coming months that Dietrich's trousers hid her foremost gift to mankind: her shapely legs.[135] In *New Movie Magazine*, Ted Cook put his pique into verse: "It doesn't seem right and it doesn't seem fair / For a woman whose legs are beyond all compare, / To hide them in pants from the critical stare / Of her nature-loving public."[136] Cook suggested cellophane trousers as a compromise. Negative and positive responses to Dietrich's trousers intensified in the coming months.

Already in January, journalists differentiated between Garbo's and Dietrich's relationship to trousers. It was perfectly acceptable for Garbo to wear trousers in her everyday life, so long as she hid from journalists and photographers. Dietrich, on the other hand, actively sought publicity for her trousers and tuxedos, wearing them to interviews, photo shoots, and film premieres. According to journalists, this determination to show off is why Dietrich's trousers had a bigger impact on the media and women's fashion than Garbo's. Another reason for the discrepancy could be that trousers were considered essential to Garbo's ontology as a melancholy invert, whereas they were one of the many costumes donned by Dietrich, the playful bisexual, as Patricia White has argued.[137] Dietrich wore men's clothing more often than Garbo; but at the same time, she

looked more insistently feminine in it than Garbo. Dietrich wore tuxedos as a fashion statement—and it was precisely as a fashion statement that they were picked up by department stores, not as a way of expressing innate feelings of masculinity (though, of course, masculine women and inverts were undoubtedly buying these clothes, too).

BACKLASHES AGAINST PANTS AND PERVERSION

In February 1933, separate but intertwined backlashes occurred within the film industry against women in pants and against sex perversion. For the first time in the United States, female-to-male cross-dressing was singled out as a dangerous practice. This reaction shows how much the meanings of cross-dressed women had changed since the 1910s. On February 17, 1933, the *Los Angeles Times* reported that "sixteen feminine stars and feature players of the cinema yesterday received an edict banning public appearances or photographs in mannish attire":

> The edict went out to contract players at the Warner Brothers–First National studios and came from Jack L. Warner, vice-president of the studio. . . . "We believe the current trend toward mannish attire for women is a freakish fad and our fashion experts agree with us," said Warner. "We have refrained all along from showing any women dressed as a man in our pictures and we will continue to do it.
>
> "The order becomes effective immediately and our feminine stars have been warned that they must stay feminine."[138]

Retailers had long advertised "mannish" styles, as I discussed in chapter 3, but Warner now associated "mannish attire" with the adjective "freakish." This connection likely arose from the link to lesbianism apparent in *Variety*'s use of the word "mannish" four months earlier. Warner also tried to relegate mannish clothing to an extremely limited time period—a one-time fad, never to return, even more temporary than either the frontier or girlhood, as described in chapter 2. He implicitly refuted the idea expressed by some journalists that women were moving inexorably along a "path to masculinity."[139]

Warner's announcement was undoubtedly a publicity stunt meant to establish his actresses' respectability without actually changing production practices. After all, it was not true that Warner Brothers and First National had "refrained all along from showing any woman dressed as a man." Only five years earlier, Warner Brothers had produced a historical drama in which a betrayed woman becomes a man-hating, jodhpur-wearing plantation owner (*The Climbers*, 1927) and a contemporary drama in which a girl disguises herself as boy to visit her brother's side of their orphanage (*What Every Girl Should Know*, 1927). Three years later, *The Office Wife* (1930) included a female novelist who wears tweed,

a monocle, and a fedora, and puffs on a cigar.[140] Moreover, First National had produced two of Anna Q. Nilsson's cross-dressing dramas, *Miss Nobody* (1926) and *Easy Pickings* (1927). One of the actresses to whom Warner served notice was Bebe Daniels, who had worn mannish attire in at least seven films by that point.[141] These examples demonstrate not only that Jack Warner had a selective memory, but also that a practice completely acceptable in the 1920s had now become suspect.

Warner's demand that actresses wear feminine clothing in public shows the extent to which mannish clothing had migrated from on- to off-screen. When actresses donned men's clothing on-screen, there was almost always some kind of practical justification; the same choice in everyday life could only mean personal enjoyment of the clothing. The explanatory frameworks were therefore more narrow and included gender inversion and lesbianism. Warner's edict may have influenced how his own actresses dressed, but it did little to stem the vogue for mannish women's clothing. Instead, wearing men's or mannish clothing became a practice limited to a smaller number of actresses who incorporated it into their star personae; it was no longer the universal phenomena it had been in the 1910s and 1920s.

Ten days after Warner's edict, "the men and women regularly employed as screen writers" declared a "War on Filth." They were not concerned with risqué films like *She Done Him Wrong*, as many were, but rather with "the growing tendency to depict perversion on the screen." The *Hollywood Reporter* announced:

> Both the Screen Writers' Guild and the Writers' Branch of the Academy are expected to take formal action this week, demanding that the production of stories based on perversion, or containing sequences showing it, be barred. They have no hope that the Hays organization will or can do anything to stop it, and feel that they must effect the cure themselves. One of the most prominent screen writers said yesterday:
>
> "If you want to get a job today in pictures at big money, all you have to do is write a dirty book. . . .
>
> "The great majority of men and women in the Guild and in the Academy resent such cesspool stuff and will use every bit of influence they possess . . . to eliminate it from the screen."[142]

The organizations complained about the lesbian seduction in *The Sign of the Cross* and the pansy characters in low-budget comedies. However, they did not object to cross-dressed women or films with less salacious representations of lesbian desire, like *Morocco* or *Maedchen*. Effeminate men who might desire other men were more threatening than mannish women and lesbians, despite the comedic mode in which these men appeared.

These industry reactions were part of a broader backlash against lesbian and pansy performers that was rooted in the fear that knowledge of lesbianism and homosexuality had spread too far and that the film industry was partially responsible. As typically happens in moral panics, children were deemed most at risk. Broadway actress Evelyn Nesbit (famous for inspiring the Harry Thaw–Stanford White murder in 1906) observed in the early 1930s, "Twenty years ago 'queers' were a rarity—today they are quite the fashion.... As for the Lesbian—a decade ago one had to dash for the nearest book of reference to learn the term's meaning. Today they are accepted with a cynical shoulder-shrug and the casual remark that many of them are to be found in the best social circles and that many stars of the theatre and screen are 'that way.'"[143] Nesbit suggested not only that more people were aware of lesbianism than ever before, but also that it had become widespread in Hollywood. In 1933, a physician named La Forest Potter warned that homosexuality had become "as common as lying" in single-sex boarding schools and noted, like Nesbit, that "the theatrical and the motion picture profession has gone 'queer' to an almost unbelievable extent."[144]

Just as Jack Warner worked to legitimize his actresses by distancing them from Dietrich, the writers' organizations demonstrated their upright morality by calling out greedy producers and the ineffective MPPDA. The complaint may also have been a way for established employees to defend themselves against writers newly imported from New York, who were unafraid of presenting more "sophisticated" subjects. Only four days after the writers declared their war on filth, *Film Daily* reported that "Lasky Bans Fem Trousers": "Declaring that the romantic structure of the screen is threatened by the actions of feminine players wearing trousers and getting wide publicity, Jesse L. Lasky, producer for Fox, says he will engage for his pictures only those actresses who retain their feminine charm. Immeasurable harm is being done to the industry by actresses who spoil their attractiveness with men's garb."[145] The contention that trousers threaten "the romantic structure of the screen" implies that masculine-styled clothing is at odds with heterosexual romance. Given that two-thirds of the films featuring cross-dressed women in the 1920s were organized around heterosexual romance, Lasky's reasoning seems absurd. Also, tight-fitting men's clothing had long been used to display women's figures. At least since the mid-1910s, cross-dressing movie actresses wore menswear designed to make their femininity highly apparent. Trousers may have produced a different kind of sexual spectacle, but they were definitely not a refusal to engage in image culture. Garbo is perhaps the only actress who could be accused of using mannish clothing deliberately to disguise her figure, but this ploy was hardly effective.

Finally, Lasky's edict was both hypocritical and hyperbolic. Lasky's companies had produced at least ten films featuring cross-dressed women,[146] and he had even hired the pants-wearing Dorothy Arzner to direct films at Paramount

in 1926. The film industry was indeed in crisis, but surely the decimated banking system, record unemployment, and declining box office receipts had done more "harm" than women in pants. The fact that Lasky's announcement came so quickly after the writers' declaration suggests that these two campaigns were related, although no one said so in print at the time. The shrill tenor of Lasky's announcement hints that more was at stake than a misguided fashion trend. *Film Daily*, which was aimed at industry professionals who were mostly men, echoed Lasky's tenor in its report on the ban. In contrast, when journalist Dorothy Calhoun described Lasky's edict in a fan magazine marketed to women, she dismissed his concerns. Not only was Lasky mistaken in what fans do or do not like, she implied, but women's trousers were no passing fad: "Mr. Lasky is an influential man, but his position is somewhat like that of the legendary Norse gentleman who stood on the seashore and bade the tides turn back."[147] In this same article, she likened trousers to the American flag, a symbol of liberty. Although the article reported negative reactions to trousers from several female stars, it also included photographs of five stars in stylish trouser suits, including Dietrich and Fay Wray (fig. 34). For fan magazines, trousers were merely a new fashion trend, one that did not change an actress's imperative to display herself attractively. This attitude contrasted with the battle cries of producers uncritically reprinted in industry papers like the *Hollywood Reporter* and *Film Daily*.

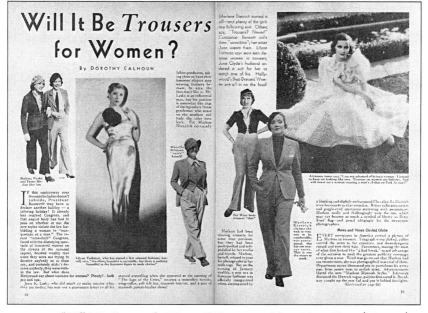

FIGURE 34. "Will It Be Trousers for Women?" Photo spread from *Movie Classic* (May 1933).

March 1933 was a time of tremendous uncertainty for the film industry. Franklin D. Roosevelt was sworn into office on March 4 and in his inaugural address promised Americans a "New Deal" and declared a four-day bank holiday from March 6 to 10, during which new fiscal policies would be implemented. During the closure, film studios temporarily lost their lines of credit and were unable to make payroll. On March 5, Hays called an emergency meeting of the MPPDA in New York, during which the members reaffirmed their commitment to the Production Code. Hays made clear that his office was intensifying its scrutiny of film content.[148] Two days later, the Association of Motion Picture Producers (AMPP) met in Hollywood and proposed an industry-wide, eight-week, 50 percent pay cut.[149] After a daylong work stoppage, the pay cut was applied, unevenly, to most film workers. Studio bosses' inconsistency in lifting the pay cut and their unwillingness to trim executive salaries prompted writers, actors, and directors to form guilds to protect their interests. The industry was tense and wary.

FAN MAGAZINES EMBRACE THE TROUSER CRAZE

Despite the backlash, the vogue for women's trousers expanded throughout 1933. Fan magazines ran long articles on women in pants, accompanied by extensive photo spreads of attractive young women in trouser suits. Disregarding Warner's and Lasky's edicts, several stars were regularly photographed in trousers. One up-and-coming actress, Katharine Hepburn, established pants as part of her trademark style.[150] The most consistently negative voice against women's trousers came from the *Hollywood Reporter*. While the paper's Rambling Reporter had stated neutrally in 1931 that Garbo "buys men's suits for herself," the "Lowdown" columnist derided Dietrich for making herself "cheaply conspicuous" and lamented, "The sad part of it is that a million morons who were on the verge of going tres feminine with the current fashions, will now probably become 'self-made men' instead."[151] In March, the Rambling Reporter observed that Dietrich looked like "a ghastly-pale Julian Eltinge" at the Brown Derby restaurant, invoking the name of the then fading female impersonator. Even more spitefully, the paper asserted, "Inasmuch as miss Dietrich continues to break social customs here in the matter of her dress, on the Boulevard in full mannish attire, it's our guess that Paramount and the entire industry will not be losers if she returns to Germany and stays there."[152] The *Hollywood Reporter* framed female trousers as a contagious, un-American disease introduced by an immigrant who needed to be expelled.

Just as vehement were some of the actresses Calhoun interviewed, who argued that trousers defiled feminine aesthetics. Constance Bennett declared, "Trousers for women are incredible, ridiculous and absurd! I can't imagine wearing such

atrocities." Gwili Andre, a New York model-turned-actress, explained, "After all, women are not made like men. Why try to look like them? The result is grotesque." Surprisingly, Lilyan Tashman, a prominent force in international lesbian circles and Garbo's close friend, criticized mannish styles and even used her (secretly gay) husband to make her point. Tashman told Calhoun, "Most men despise women in trousers, and my husband, Edmund Lowe, is one of those who are most vehement against the pants-for-women vogue. . . . Anything beautiful is excusable, but there is nothing beautiful in the feminine figure in male clothes." Interestingly, many of these women admitted that *some* masculine-styled women's clothing could be attractive, but not pants or other "extreme" masculine attire. Some even framed the question in terms of labor: if women began wearing longer-lasting and less varied clothes, "think how many thousands of textile workers and lace makers, and silkworms would be out of work!"[153]

At the same time, fan magazines championed the vogue for pants and noted that it had spread far beyond Dietrich. "Marlene Wins!" declared *New Movie Magazine*. "Hollywood Has at Last Succumbed to the Trousers Craze."[154] The magazine displayed photographs of Dietrich and four other actresses in trousers, including Hepburn (fig. 35). In Calhoun's "Will It Be Trousers for Women?" aviatrix Amelia Earhart was quoted as telling Dietrich, "I like the new style you so courageously started. . . . Trousers are a practical and comfortable garment for the modern woman who leads an active life."[155] The text was accompanied by photographs of women in dapper trouser suits and two in traditional dresses. A photo layout before the article shows two blond actresses, one in a loose trouser suit and the other in a scanty slip, with the headline, "One Stays Feminine— One Goes Masculine—And Both Have Glamour!"[156] The next month, an article called "Intimate Facts about Marlene's Attire" noted that "Dietrich, Garbo, Bankhead, Hepburn, Joan Crawford, Sally Eilers, Barbara Stanwyck and many other stars" were all buying suits at Watson and Sons.[157] (Stanwyck was evidently defying Warner's prohibition.) While Warner and Lasky saw trousers as antithetical to the attractive display of women's bodies, fan magazines asserted that trousers were chic and appealing. Actresses cited trousers as a comfortable, practical choice, but photo spreads also displayed them as cutting-edge fashion. The major difference between these and earlier photographs of actresses in men's clothing is that the women are ostensibly shown in their everyday lives. Actresses in the 1910s and 1920s were photographed in tuxedos, Fauntleroy suits, overalls, and cowboy outfits, but it was always clear that they were playing a role.

Fashion columns also registered the trend, but advised women to embrace a softer mannish style. In a column in the *Washington Post* called "How to Be Beautiful," Elsie Pierce wrote, "Tailored suits are simple and charming; some with . . . feminine touches, others designed on masculine lines that make father and brother shake their heads woefully."[158] Pierce advised that the "mannish

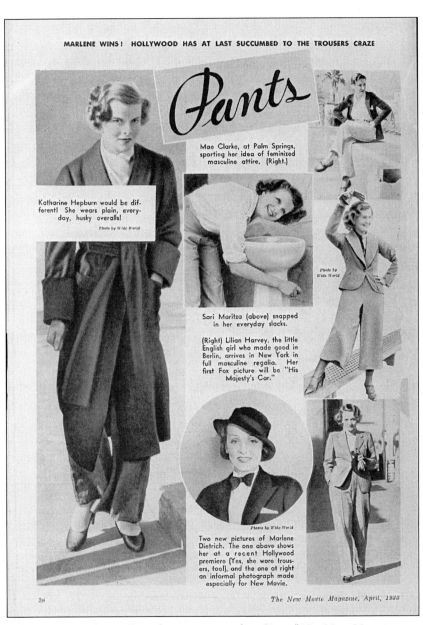

Pants

Mae Clarke, at Palm Springs, sporting her idea of feminized masculine attire. (Right.)

Katharine Hepburn would be different! She wears plain, every-day, husky overalls!

Photo by Wide World

Sari Maritza (above) snapped in her everyday slacks.

(Right) Lilian Harvey, the little English girl who made good in Berlin, arrives in New York in full masculine regalia. Her first Fox picture will be "His Majesty's Car."

Photo by Wide World

Two new pictures of Marlene Dietrich. The one above shows her at a recent Hollywood premiere (Yes, she wore trousers, too!), and the one at right an informal photograph made especially for New Movie.

Photo by Wide World

FIGURE 35. Triumphant collage of women in pants from "Pants," *New Movie Magazine* (April 1933).

trouser style" is "not for the average woman." Likewise, in *New Movie Magazine*'s "Hollywood Fashion Letter," Janet Rice declared that "Marlene's trousers for street wear and her man's tuxedo for evening are starting a decided vogue," but added that most Hollywood women "have compromised by wearing mannish sports suits and feminized mess jackets for evening."[159] Department store managers around the country likewise indicated that their shoppers preferred masculine-styled suit jackets to "extreme things" like trousers, but that they were open to "slacks for week-end cruises and sports."[160] In June, *Vogue* weighed in. A fashion spread called "Mannish for Play Clothes" declared, "It's fun to play two roles—mannish for sports and feminine for dancing. On this page, you see the new mannish trend in clothes for the beach or for strenuous activities" (fig. 36).[161] The top photo shows one woman in loose slacks and a blouse and another "Dietrich-like young person" in a dark fitted jacket, slacks, and fedora. Just so the women's sexual orientation would not be in doubt, a bare-chested man rests an arm over each woman's shoulders.

As judged by letters to the editor, the public response to mannish styles was mixed and not so neatly polarized along gendered lines as journalists were. One Hollywood man was irritated that all "the public is falling for this Dietrich male attire fad" and insisted, "The average woman has no excuse for this." Likewise, a woman from San Francisco asserted, "Marlene should be sued for disrupting home life, parading in masculine attire!" She associated these new styles with her "old maid aunt," which could be a euphemism for lesbianism or for hopelessly unattractive womanhood. In contrast, a Los Angeles woman approved: "The trousers worn outside of work by [Garbo,] Dietrich and Hepburn are as comfortable, not to say as charming and logical, as the drapes with which they are gowned for the public eye. If young girls and women who follow the styles . . . of the best dressed actresses, will observe the simple, sensible togs these three personalities wear, they will be saved many a pang of hopeless envy."[162] Like the dress reformers of the previous generation, this woman regarded trousers as a sensible, economic choice; the actresses who chose to wear them were not home wreckers or even trendsetters but practical-minded models. Thus, trousers were sometimes seen as a threat to normal heterosexual relations, but not a straightforward sign of lesbianism, even though this hint now lingered in the air.

Journalists breathed a sigh of relief when Dietrich returned from a summer trip to Europe in September 1933 wearing more feminine garb.[163] The *Chicago Daily Tribune* reported, "Marlene Dietrich, exuding femininity at its fluffiest, came back to America today. The mannish trousers were missing—left behind in Europe—as she tripped off the French liner Paris in true womanly fashion."[164] Europe, once the source of the sexual decadence infecting America, was now the place that reasserted traditionally gendered fashions. The actress declared her continued interest in comfortable, mannish clothing during the

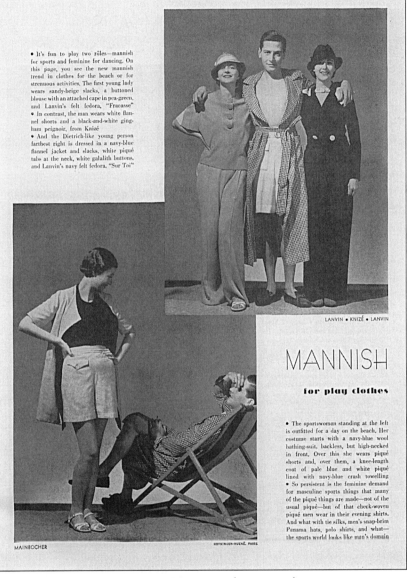

• It's fun to play two rôles—mannish for sports and feminine for dancing. On this page, you see the new mannish trend in clothes for the beach or for strenuous activities. The first young lady wears sandy-beige slacks, a buttoned blouse with an attached cape in pea-green, and Lanvin's felt fedora, "Fracasse"
• In contrast, the man wears white flannel shorts and a black-and-white gingham peignoir, from Knizé
• And the Dietrich-like young person farthest right is dressed in a navy-blue flannel jacket and slacks, white piqué tabs at the neck, white galalith buttons, and Lanvin's navy felt fedora, "Sur Toi"

LANVIN • KNIZÉ • LANVIN

MANNISH

for play clothes

• The sportswoman standing at the left is outfitted for a day on the beach. Her costume starts with a navy-blue wool bathing-suit, backless, but high-necked in front. Over this she wears piqué shorts and, over them, a knee-length coat of pale blue and white piqué lined with navy-blue crash towelling
• So persistent is the feminine demand for masculine sports things that many of the piqué things are made—not of the usual piqué—but of that check-woven piqué men wear in their evening shirts. And what with tie silks, men's snap-brim Panama hats, polo shirts, and what—the sports world looks like man's domain

MAINBOCHER

HOYNINGEN-HUENÉ, PARIS

FIGURE 36. "Mannish for Play Clothes," from *Vogue* (June 15, 1933).

day, but championed gowns for the evening.[165] Journalists also suggested that Dietrich's influence over American fashion had waned with the advent of Paramount's new star, the curvaceous Mae West, newly imported from the stage. *Picture Play*, for example, was relieved that "Mae West's hourglass figure saved the day" and quelled "the Dietrich pantaloon revolution."[166] Fan magazines pitted Dietrich and West's opposing feminine types against each other in a faux civil war.[167] Though journalists framed West as a reassuring return to femininity, the actress had developed her persona in collaboration with gay men and female impersonators, and her ultra-feminine persona could be seen as a "drag" version of femininity.[168] The civil war invented by publicists was thus fought between an androgynous soft butch and a female drag queen. In any case, despite the competing fashions of Mae West, the vogue for female trousers expanded throughout 1933. Fan magazines and fashion journals embraced the trend with photo spreads, presenting trousers as a fun fashion statement and somewhat neutralizing their growing association with deviant sexual cultures.

HAYS ON HOMOSEXUALITY

Concern about representations of homosexuality continued to resonate in Hollywood even as the trouser trend expanded. In April and May 1933, Will Hays told executives that they must stand by their reaffirmed commitment to the Code. At the annual meeting on April 20, he warned that the industry faced an onslaught of proposed censorship legislation at national, state, and regional levels, which threatened to "place irresponsible and responsible producers alike under the thumb of incompetent dictatorship."[169] He listed forty-eight troublesome films, most of which had overly explicit references to heterosexual sex. However, he also mentioned *The Sign of the Cross* (for its "lascivious dance"), *Cavalcade* (for "sex perversion"), and five comedies featuring pansy characters (for "sex perversion," "pansy," "effeminate man emphasized," and "homosexuality"). After listing the films, he exclaimed, "This slant they have taken out there on homosexuality and Lesbianism has about ruined us." Although the number of films representing "sex perversion" was small, they weighed on him more heavily than the others. Hollywood's allegedly more liberal attitude toward homosexuality (that is, admitting that its existed) was a threat to the motion picture industry, in Hays's view. When he expanded on the "problem pictures" in a May 19 memo, one of the five types he singled out was the film that included representations of homosexuality.[170] "Attempts have been made to introduce homosexuality into pictures and constant vigilance is necessary to see that this does not happen," Hays warned. In his opinion, it was "a downright shame" that *Cavalcade* and *The Sign of the Cross* chose to show sequences that "tended to express Lesbianism." The sadistic violence in *The Sign of the Cross* did not bother Hays in the lingering

way that the lesbian dance did. He also griped about the casting call for effeminate extras for *The Warrior's Husband*, the hiring of Jean Malin, and the convention of portraying couturiers as homosexual. For Hays, homosexuality was so taboo that even a handful of films with brief moments of caricature were as dangerous as the many films with long and fairly explicit representations of rape, prostitution, extramarital sex, and near incest.

In a June 1933 article in *Vanity Fair*, Pare Lorenz, a film critic and director who fought against censorship, expressed astonishment at what he called "our changing and somewhat shocking Hollywood morals."[171] According to Lorenz, "An educated foreigner, strange to the land, might well conclude from the general moral precepts of ordinary movies that the country at large was engaging in a final, orgiastic, razzle-dazzle dash to the devil." Lorenz mostly complained about poorly written stories of adultery, but he also noted that this foreigner would "find pictures especially created for ladies who admittedly prefer pants to petticoats, and he would find in almost every movie comedy some allusion to homosexuality." Strikingly, Lorenz equated pants-wearing with lesbianism. The reason these kinds of pictures get made is not "a general moral hardening of the arteries on the part of audiences," but rather "the fact that they are moviewise; that they don't believe what they see, any more than the manufacturers believe what they produce." In Lorenz's opinion, American audiences had become so blasé that they could not be shocked any more. However, when it came to lesbian cameos, critics were more easily shocked in the early 1930s than they had been in the 1920s because they assumed that general audiences could now catch these innuendoes. The masses had become sophisticated. Of course, there continued to be differences in the extent to which viewers would read a woman in pants as lesbian, but the basic ability to do so was now believed to be widely shared, not restricted to the cultural elite.

QUEEN CHRISTINA (1933/34)

A mere six months after Hays's warnings, MGM released *Queen Christina*. The film marked a high point in lesbian visibility and the consolidation of female masculinity as a publicly recognizable code for lesbianism. Unlike *Maedchen*, *Queen Christina* was a big-budget, prestige picture by a major Hollywood studio. Moreover, in contrast to the lesbian cameos in previous super-productions, the lesbian character was at its center. The film used both female masculinity and intimacy between women to suggest the protagonist's deviant gender and sexual identity, even though the narrative eventually recuperates her as feminine and heterosexual. The film also reconciled contradictory explanations of Garbo's persona and put her formerly off-screen attributes on-screen. All of these breakthroughs were made possible by the earlier works that had established a public

vocabulary for lesbianism and generated public interest in the subject. *Maedchen*, in particular, had shown that lesbianism could be addressed explicitly if it was handled artfully. Indeed, *Queen Christina* borrowed narrative and formal strategies from the German film.

In July 1933, *Photoplay* noted that Garbo was taking a "gamble" by appearing in men's attire in her next film, but asserted that "not a few people are speculating with the idea that when the public sees Garbo in masculine attire in 'Queen Christina' a new vogue will spring up, a vogue more sweeping than that which Dietrich inspired."[172] The *New Movie Magazine* observed that the trousers versus skirts debate had been "rekindled by Garbo wearing dietrichs in 'Queen Christina.'"[173] In fact, *Queen Christina* seems to have been the first time that Garbo consented to be photographed in trousers; previously her attire had only been described by journalists.

Queen Christina purports to tell the life story of Kristina Vasa, the woman who ruled Sweden from 1626 until 1654, when she abdicated the throne, converted to Catholicism, and moved to Rome. She was famous for wearing men's clothing, refusing to marry, and bringing artists and scholars to court. As author and literary historian Sarah Waters has shown, biographers had long debated the nature of Christina's intimate relationships with women.[174] However, the film frames Christina's life as a tragic love story revolving around her relationship with a fictional Spanish ambassador, Don Antonio (John Gilbert). It opens with the death of Christina's father and the six-year-old girl's coronation. At the ceremony, her counselor, Axel Oxenstierna (Lewis Stone), announces to the court, "Our king is dead, but his spirit still lives, in us, and in his child, Christina. Her father, our king, brought up this child as a boy, accustomed her ears to the sound of cannon fire and sought to mold her spirit after his own." The film then introduces the adult Christina (Greta Garbo), who dresses in elegant menswear and complains about her duties as monarch of a nation eternally at war, preferring to hunt and go on retreats with her lady-in-waiting, Countess Ebba Sparre (Elizabeth Young). While disguised as a man, Christina encounters Don Antonio in a village inn. They become friends, and Don Antonio suggests that they share a room. They maintain this arrangement even after Don Antonio discovers Christina's true sex. A love affair begins. Afterward, Christina is torn between her duties to her country (which include marrying a Swedish military hero, Prince Charles Gustavus) and her desire for Don Antonio and a life of peace. She abdicates the throne to follow Don Antonio to Spain, but at the last minute her former lover, Count Magnus (Ian Keith), kills Antonio in a duel. Christina sails away from Sweden alone.

Maedchen informed the way the film conceptualized and visually presented Christina's relationship with Ebba Sparre. Salka Viertel, Garbo's intimate friend and one of the film's screenwriters, recalled a conversation with MGM

vice president Irving Thalberg that makes this connection clear: "[A]bruptly he asked if I had seen the German film *Mädchen in Uniform*, a great success in Europe and New York. It had been directed by a woman, my former colleague at the *Neue Wiener Bühne*, Leontine Sagan, and dealt with a lesbian relationship. Thalberg asked: 'Does not Christina's affection for her lady-in-waiting indicate something like that?' He wanted me to 'keep it in mind,' and perhaps if 'handled with taste it would give us very interesting scenes.'"[175] This account shows that *Maedchen* had become part of the vocabulary not only of a European actress and writer but also of an American studio executive. Just as *The Captive* had been the preferred euphemism for lesbianism five years earlier, *Maedchen* now served as shorthand.

However, the "something like that" to which Thalberg referred is not merely lesbianism, but a particular model of same-sex eroticism: the adoration of a young woman for a female authority figure. Initially, Ebba's admiration for Christina is similar to Manuela's devotion to von Bernburg. We are introduced to Ebba when she runs into the queen's chamber in the early morning. She curtsies, approaches the queen, kneels, and kisses the queen's hand. When she stands, the queen takes Ebba's head in her hands and kisses her on the lips. Ebba proposes that they take a sleigh ride together, but Christina has work to do. Their dynamic—Ebba's bubbly enthusiasm and the queen's more measured display of interest—seems close to *Maedchen* thus far. Additionally, the way the film stages these physical interactions, and particularly the kissing scene, is strikingly similar to *Maedchen*, as a comparison of the sequences makes clear. In the first set of shots—the genuflection—the queens in both films stand on the left side of the frame and look down at the girls in front of them (fig. 37). Manuela and Ebba kneel and tenderly kiss the left hands of their monarchs. The camera is at virtually the same distance in both shots, revealing the women's full bodies. The curtains around Christina's bed resemble the curtains of the stage in *Maedchen*. In *Queen Christina*, however, the gender of the costuming is reversed: the queen wears a man's tunic and the girl wears a dress. *Maedchen* draws from the German Expressionist tradition of expressive lighting and uses the darkened stage and glowing spotlight to emphasize the encounter visually, whereas in *Queen Christina*, the women do not stand out from the bright bedchamber, evenly lit in typical MGM/Hollywood style.

In the next set of images, the full-mouthed kiss, we again see the older women positioned on the left, tilting their heads down and holding the faces of the younger women, who tilt their heads up to receive the kiss (fig. 38). Again the camera is at the same distance—in this case, a medium shot—and again we see the contrasting lighting styles. In *Maedchen* we know that Manuela is kneeling on her bed, which is out of frame, and in *Queen Christina* we see the queen's bed in the background.

FIGURE 37. Manuela (Herta Thiele) kissing the queen's hand in *Maedchen in Uniform*, compared to Ebba (Elizabeth Young) kissing the queen's hand in *Queen Christina*.

FIGURE 38. Von Bernburg (Dorothea Wieck) and Manuela (Herta Thiele) kissing in *Maedchen in Uniform,* compared to Christina (Greta Garbo) and Ebba (Elizabeth Young) kissing in *Queen Christina.*

Despite these marked similarities, there are important differences. In *Maedchen*, the genuflection and full-mouth kiss are separated by time and space and occur in the opposite order. A medium close-up of Manuela and von Bernburg precedes the full-mouth kiss, producing a sense of enhanced intimacy. Von Bernburg kisses Manuela in that scene, whereas in the later genuflection, Manuela kisses the hand of a fellow schoolgirl. In *Queen Christina*, the genuflection leads directly to the kiss (there is a cut as Ebba stands); the staging takes the two scenes from *Maedchen* and melds them. Also, we never get a closer shot of the two women together. Although *Queen Christina* replicates the visual presentation of the *Maedchen* kiss in many ways, the bright lighting and camera distance dampen the erotic effect of the earlier film.

Furthermore, in *Queen Christina*, we soon discover that the dynamic of the women is not the same as in *Maedchen*. When Christina proposes that she and Ebba spend several nights together at an isolated inn, the girl flinches. Christina and the audience soon discover why: Ebba is engaged to a guardsman and is afraid to tell Christina. When Christina overhears the couple's conversation about this issue, she confronts Ebba and breaks off her relationship with the girl. James Wingate of the MPPDA's Studio Relations Committee worried that this scene would be "interpreted as indicating that there is a tinge of lesbianism in the relationship between Christina and Ebba."[176] (Wingate never expressed worry about Christina and Ebba's kiss, though.) In a letter to MGM's general manager, Wingate recommended that the phrase "and leave Stockholm" be added to the end of the guardsman's complaint that Ebba is afraid to the tell the queen "that you love me and that you want to marry me." According to Wingate, this addition would "change the implication of this speech so that it could be interpreted to mean that Christina opposes Ebba's marriage because it would take her away from the city." MGM did not add the line. Additionally, Wingate recommended that MGM delete several lines from Christina's angry speech to Ebba, such as her declaration that "[y]our smiles, and your cooing voice and your sympathy" were "all lies!" MGM rewrote and shortened the queen's accusations, but her jealousy remained. After these specific recommendations, Wingate emphasized: "Even with these changes we assume that you will be careful to avoid anything in the portrayal of this scene which might be construed as lesbianism." Despite Wingate's admonition, the film's portrayal of Christina and Ebba's relationship—from the kiss presented in the style of *Maedchen* to Christina's jealousy—is clearly meant to be "construed as lesbianism." When the completed film was submitted to the SRC, it was initially rejected, ironically for the depiction of Christina and Antonio's affair, not the lesbian content.[177] The film did manage to get a seal of approval by appealing to the SRC's Hollywood Jury, a committee that was dissolved shortly afterward.

These scenes show how *Queen Christina*, a big-budget MGM film, borrowed the visual vocabulary of *Maedchen*, a film with more limited distribution but a national reputation, to depict an erotic relationship between two women. *Maedchen's* critical success likely encouraged MGM to include this aspect of Christina's life without too much fear of reprisal. Even though *Queen Christina* narratively recuperated Christina's sexuality, the nature of her relationship with Ebba seems clear.

That relationship also invites audiences to read Christina's masculinity as a sign of her sexual identity. Her masculinity and her kiss with Ebba rebound upon each other to signify the character's possible inversion or lesbianism. As in *The Clinging Vine*, we are introduced to the adult Christina through a series of shots that suggest the figure of a man. We first see two people on horseback from a high overhead shot, then cut increasingly closer to the backside of a figure in an elegant tunic, trousers, and wide-brimmed black hat, and finally we cut to a close-up of the black hat, which is lifted to reveal Garbo's face. Just as Manuela's playful donning of historical menswear in *Maedchen* allows her to declare her desire for another woman, Garbo's assumption of similar garb gives her the freedom to express homoerotic desire more candidly.

The Well of Loneliness, discussed in the previous chapter, also seems to inform the film's representation of Christina, as Patricia White argues. According to White, "Both heroines [Stephen Gordon and Christina] are raised as boys amid wealth and social prominence and dogs, horses, and books; they experience strong identifications with dead fathers and are fastidious about the men's clothing they favor. After their first female lovers jilt them, the two protagonists find great love, which causes them to be exiled from their birthright. They each end up as solitary expatriates who strongly resemble Christian martyrs."[178] While the film was also informed by historical accounts of Christina, Garbo's star persona, and *Maedchen in Uniform*, the parallels between *Queen Christina* and *Well of Loneliness* are significant.

Written discourses external to the film also invited audiences to view Christina as lesbian. Rumors concerning Christina's affairs with women dated back to the 1660s, when a series of pamphlets appeared in Paris and called her "one of the most ribald tribades ever heard of," writes Sarah Waters.[179] Although nineteenth-century biographers downplayed Christina's sexuality, sexologist Edward Carpenter offered her as an example of the "intermediate sex" in a footnote of his book *Love's Coming-of-Age* (1906).[180] In the years that followed, Christina's biographers tussled over how to categorize the queen.[181] Viertel and de Acosta based the script for *Queen Christina* on Faith Compton Mackenzie's *The Sibyl of the North*, published in 1931, which was discreet about Christina's affairs.

However, Margaret Goldsmith's *Christina of Sweden: A Psychological Biography*, published the same week that Garbo's film debuted in New York, was much more frank. Goldsmith asserted that "many contemporary documents, and Christina's

own letters, make it quite clear that she was attracted by her own sex."[182] According to Waters, Goldsmith told Christina's story through the framework of Stephen Gordon's life. The near-simultaneous release of the film and Goldsmith's biography was not lost on reviewers. When Lewis Gannett reviewed Goldsmith's book for the *New York Herald-Tribune*, he found the evidence for Christina's "persistent love" of Ebba "overwhelming," but wondered, "will Miss Garbo play such a Christina?"[183] After seeing the film, Gannett sighed: "What do facts and theories matter? Christina, to all those who see Garbo's film, will always be the lovely girl who fell in love with the Spanish Ambassador in the snow, and no amount of professional research will ever change her."[184] Though Gannett was disappointed by the film's formulaic romance (as Garbo herself was), the film does not entirely disguise Christina's desire for Ebba, despite the SRC's efforts.

The film was marketed as an exposition on Garbo herself. The *New York Journal* wrote that "Queen Christina is entirely Garbo, and Garbo is entirely Queen Christina."[185] This kind of claim was typical. Press coverage described the historical figure of Christina as an astonishing double of Garbo. In a *Photoplay* article called "Two Queens Were Born in Sweden," Helen Dale used the same language to describe both the actress and her character: "moody," "headstrong," "distinctly masculine taste in clothes," "refuses to marry," "strong and virile" hands, "eyes might have belonged to either sex," and so on (fig. 39).[186] Each time she

FIGURE 39. "Two Queens Were Born in Sweden," from *Photoplay* (October 1933).

characterized Christina, Dale would write something like: "You could substitute the name of Garbo anywhere in this paragraph." Of course, as Marcia Landy and Amy Villarejo remind us, the apparent coincidence of Garbo resembling Christina is "not a coincidence at all" but "selected and painstakingly constructed."[187] Garbo's reference to herself as a "bachelor" in Palmborg's 1930 *Photoplay* article, for example, returns in the film as Christina's assertion that "I shall die a bachelor!"

The project was developed specifically as a vehicle for Garbo and shaped to elaborate Garbo's existing persona. That persona had been marked by a sharp dichotomy between the glamorous femme fatale on-screen and the mannish introvert off-screen, but the film reconciled both aspects of the star. For example, the queen glides effortlessly between men's hunting gear in private and glittering gowns in public—just like Garbo. While some journalists had attributed Garbo's masculinity to her Swedish background, the film's version of Christina showed that one could be both Swedish and lesbian. Rather than being a singular oddity, Garbo was fit into a historical lineage marked as Swedish. Furthermore, by aligning Garbo so closely with Christina, the film argued against understanding Garbo's oddities as attributes of her class status.

Lesbian viewers are often disappointed that the film undoes Christina's lesbianism by focusing on her romance with Don Antonio and clothing her in increasingly feminine garb.[188] It is true that Christina's affair with Ebba is framed as a prelude to the real love story, a stage on the way to "normal" adult sexuality. And yet, several factors prevent us from merely writing off Christina's lesbianism as a phase. Although the ending may provide heterosexual viewers some reassurance, it does not negate the pleasures that both hetero- and homosexual viewers may have experienced watching the earlier scenes. Furthermore, the visual spectacle of watching a kiss between two women operates independently of a narrative that tries to contain it, as film scholar Chris Straayer has pointed out. Of *Queen Christina*, Straayer writes, "Although the film's narrative later assigns heterosexuality to both women, it never really 'corrects' the kiss."[189] In other words, the strong visual and narrative signs of Christina's lesbianism early in the film linger beyond the narrative's attempt to redirect them.

Additionally, although Christina and Don Antonio's relationship is "really" heterosexual, it comes about in a decidedly homoerotic way. Don Antonio imagines that he is asking a boy to share his bed. The sexual tension between them heightens as the Spaniard undresses. The next morning, when Don Antonio and Christina refuse to exit their curtained bed, Don Antonio's servant assumes that his master is refusing to leave the bed of another man. Thus, Christina becomes "heterosexual" by emulating a male homosexual encounter. Furthermore, the film steadfastly avoids kisses between Christina and Don Antonio. While censorship concerns likely played a part, this choice also diverted the film's erotic

display from heterosexuality to a sensuous auto-eroticism. This aspect is most evident in a scene in which Christina roams around the room she shares with Don Antonio, touching a series of objects. Eventually, she pauses in front of a mirror. While the narrative frames the scene as a meditation on her romance with Don Antonio, the image highlights the eroticism of Garbo alone.

Discourses about Garbo worked against the recuperation of Christina as heterosexual and feminine. Articles about Garbo repeatedly argued that the masculine, solitary Garbo was the real one and that the feminine woman in love with a man was merely a performance. Thus viewers could read the film as enacting a progression from the real Garbo (who wears men's clothes, kisses girls, and so on) to the fictional Garbo (the suffering diva). Garbo herself pointed out both the conventionality and the fictionality of the film's focus on the Don Antonio romance. In a letter to a friend she mocked, "Just imagine *Christina* abdicating for the sake of a little Spaniard."[190] Viewers could also read the film as an inversion of Garbo's own biography. The actress had started out in Hollywood with a more feminine style and a publicized romance with Gilbert and then progressed to an increasingly masculine style and rumors of romance with female friends. Thus, while the film itself moves from "adolescent" lesbian androgyny to "adult" heterosexual femininity, viewers could reflect that Garbo herself was going in the opposite direction. Press accounts of Gilbert's participation in the film make clear his peripheral role in her current life. In a *Photoplay* article, "'Now I Help You,' Says Garbo to Gilbert," Martin Stevers noted that Garbo and "her friend, Mrs. Berthol Viertel, had worked on the story—had, in fact, a well-organized scenario to present—before Jack was even mentioned for the part."[191] This description positions Viertel as Garbo's primary companion and Gilbert as an afterthought. *Queen Christina* created a more coherent and more recognizably lesbian star persona for Greta Garbo, whose homosexuality was therefore in no way undone by the film's stock romance plot.

Most critics praised the film and particularly Garbo's performance.[192] Audiences, too, responded positively. One male engineer told the *Chicago Tribune* that the film had converted him to "the view that that Garbo woman is the nearest thing to perfection the screen can hope to find."[193] A North Carolina woman likewise wrote to a fan magazine that "after witnessing that marvelous portrayal of Queen Christina, I want to shout from the housetops that Garbo is still Queen of the Screen. Long may she reign."[194] Going against the grain, journalist Frederic F. Van de Water wrote in *New Movie Magazine* that the movie "is about one-half as good as all the advance whoop-de-doo said it was going to be" and that Garbo "moves through this film with the smoldering grace of a sulky cat."[195] Of the reviews I could find, only the *Wall Street Journal* critic made reference to the queen's same-sex desire: "the glamour of Greta Garbo as she lives out the life of a brilliant, perhaps perverse young queen, suffers nothing; it is augmented."[196]

According to this critic, the opportunity to portray this type of character only added to Garbo's appeal.

Queen Christina is an unusual example of positive lesbian visibility. It was made possible by the series of works in the preceding decade that raised the subject of lesbianism and established masculinity as a sign of sexual inversion and a strategic conduit for the expression of same-sex desire. These works provided audiences with the intertexts they would need to read Christina as potentially lesbian and thus to read Garbo's own off-screen oddities as signs of lesbianism as well. The fact that this film was made and the shape it ultimately took were the result of Garbo and Viertel's activism in combination with MGM's desire to elaborate the persona already constructed by the fan and industry press.[197]

THE PRODUCTION CODE GETS STRONGER

Only a few years after lesbians entered American popular culture, the MPPDA banished them once more through more robust enforcement of the Production Code. Even though trousers had become fashion items for ordinary women, mannish clothing had also become a recognized signifier of lesbianism in the movies and, as such, part of the industry's morality problem. Beginning in 1934, female-to-male cross-dressing was scrutinized by the Production Code Administration in a way it never had been before.

Despite the reaffirmation of the Code that Hays had demanded in the wake of the new Roosevelt administration, many observers still felt that the movies were insufficiently regulated. Joseph Breen, a Catholic newspaperman in charge of the MPPDA's publicity in Los Angeles, worked with Catholic leaders to put pressure on the industry by boycotting films that did not meet the Code and blacklisting theaters that played them. According to Ruth Vasey, Breen essentially ran the SRC from November 1933 onward.[198] He also convinced Catholic bishops to establish a committee on motion pictures, which in April 1934 created a "Legion of Decency," whose adherents swore to boycott all films "except those which do not offend decency and Christian morality."[199] Millions of Catholics signed on within a few months, and Jewish and Protestant leaders lent their support.[200] Responding to the agitation concocted by Breen, the MPPDA board met in June 1934, changed the name of the SRC to the Production Code Administration (PCA), and put Breen at the helm. Appeal to the Hollywood Jury was eliminated. Most important, every company in the MPPDA agreed not to distribute or release a film without a PCA seal.

The MPPDA played up the establishment of the PCA as a dramatic change, and many film histories have taken these claims at face value. However, film historians like Richard Maltby, Lea Jacobs, and Ruth Vasey have shown that Breen mainly extended the practices established by his predecessors and state

censorship boards.[201] Nevertheless, the PCA did regulate homosexuality much more strictly than previous censorship bodies had done. The new attitude was evident when companies applied to rerelease older films. The PCA consistently eliminated the brief lesbian and pansy cameos of previous years. For example, when Fox applied in 1935 to rerelease *Cavalcade*, the PCA required the studio to remove the shot of the female couple in the nightclub before it would pass the film.[202] When Paramount considered rereleasing *The Sign of the Cross* that same year, Breen told the studio it would have to cut "Anacaria's [*sic*] dance."[203] When the film was finally rereleased in 1938 and again in 1944, the dance was gone.

Likewise, the PCA repeatedly denied a seal to *Maedchen in Uniform*, but the film nonetheless managed to find audiences outside mainstream cinemas. In January 1934, the *Film Daily*'s annual poll of film critics named *Maedchen* one of the ten best films of 1933.[204] Less than a week later, Krimsky and Cochran announced that they would release an English-dubbed version called *Girls in Uniform*.[205] (It was likely the expurgated version the New York censor board had cut up.) *Girls in Uniform* played at the Criterion Theatre in New York from January 24 to February 4, 1934. That summer, at the same time that Hays was establishing PCA's stricter rules, *Girls in Uniform* played in Pittsburgh, Chicago, and perhaps elsewhere.[206] *The Educational Screen* gave the dubbed version high praise, again recommending the film to both youth and adults.[207] A New York pastor even declared his ambition to exhibit *Maedchen in Uniform* and other quality films in thousands of churches across the country (though he does not seem to have achieved this goal).[208] In the short term, Krimsky and Cochran steered clear of the PCA. In February 1935, they announced that German and English versions of the film were available for nontheatrical showings, and in March they released a 16mm sound-on-film version for amateur projectionists, distributed through New York's Mogull Brothers.[209] In July 1935, the film showed in Los Angeles at the magnificent 2,812-seat Pantages Theatre, which probably alerted the PCA to the fact that the film was being shown without its approval.

When Krimsky and Cochran applied for a seal that summer, the film was rejected. In the PCA's judgment, Breen wrote, "the picture is a violation of the production code and unacceptable for public exhibition in theatres before mixed audiences."[210] Krimsky and Cochran appealed the decision, and Breen wrote back on October 4, 1934: "You will recall that the German version . . . was definitely tagged as a picture with the definite flavor of sexual perversion (lesbianism)."[211] This was one of the few times the PCA used the word lesbian, according to Patricia White.[212] The next day, Krimsky announced that he would appeal to Hays personally in New York.[213] He pointed to the "universal acclaim" the film had received "from educators, clergymen, social workers and the general public."[214] The PCA acknowledged the film's artistry, but still refused to award a seal. Nonetheless, the film continued to be shown at alternative venues, such as Berkeley's

Campus Theater and New York's New School for Social Research.[215] Critic Wood Soanes of the *Oakland Tribune* declared the film "the hardy perennial of the intelligenzia group of cinemas."[216] On February 12, 1936, the PCA generated a memo on the film, which recognized that "[t]he title Maedchen in Uniform and the story associated with it have thus become symbolic, as it were, of Lesbianism, as far as motion pictures are concerned."[217] The memo continued, "The inference of Lesbianism is painfully apparent even in the expurgated English version. It cannot be explained away." Despite the censorship to which the film was subjected and the robust debates on the nature of Manuela's and von Bernburg's feelings, public opinion had decided by 1936 that these feelings were lesbian.

Maedchen would never be granted a PCA seal. Nonetheless, it continued to play both publicly and privately. In May 1936, the leftist Garrison Film Distributors took over the film's 35mm and 16mm distribution in North and South America. The film had entered critical discourse to the extent that *Variety* used the title as a stand-in for lesbianism in its 1937 review of the French film *Club de Femmes*: "A third [girl], a la 'Maedchen in uniform,' is attracted to a girl friend."[218] The fate of *Cavalcade, The Sign of the Cross*, and *Maedchen in Uniform* shows how much more strictly the PCA policed lesbianism than had previous forms of censorship.

The PCA was also suspicious of cross-dressed women, and particularly of the gender disguise romantic comedies that had been a mainstay of American cinema since the 1910s. This new suspicion is evident in its negotiations with RKO over the Katharine Hepburn vehicle *Sylvia Scarlett*. The film was adapted from a novella by Compton Mackenzie, author of *Extraordinary Women*, and includes many innuendoes around accidental same-sex desire. It was nonetheless a fairly typical "temporary transvestite" comedy in the long theatrical tradition of *Twelfth Night*.

As in earlier cross-dressing comedies, an intertwining series of love triangles unfolds around the cross-dressed woman (fig. 40). The film follows Sylvia Snow (Hepburn), a young French woman who disguises herself as Sylvester to flee to England with her embezzler father, Henry (Edmund Gwenn). In London, a charming grifter, Jimmy Monkley (Cary Grant), scams and then adopts Sylvester and Henry. They do the same to a ditzy blond maid, Maudie (Dennie Moore), and all four head to the seaside as a traveling variety show. Jimmy and Maudie both try to cozy up to the charming youth, but Sylvester falls for an aristocratic bohemian, Michael Fane (Brian Aherne), who loves a temperamental Russian princess. Like Florida in *A Florida Enchantment*, the English seaside becomes a lush, exotic space where sexual desire exceeds boundaries of class, age, marital status, and gender. While customs officers, policemen, and angry mobs haunt the group's every step in London, the seaside offers a wide-open space in which entertainment, desire, and masquerade rule.

FIGURE 40. Sylvester (Katharine Hepburn) tries out a "Ronald Coleman" moustache in *Sylvia Scarlett*.

"This play on the fact that Sylvia is mistaken for a man is open to some question," Breen wrote to RKO studio head B. B. Kahane on August 12, 1935, after reviewing the script.[219] Breen continued, "We . . . respectfully suggest that thought be given to the danger of over-emphasizing or playing upon any possible relationship between Sylvia and another woman based upon the fact that she is masquerading as a boy. In any case, here and elsewhere in the script, there should be no physical contact, and such matters should be treated for light comedy, and nothing suggestively emphasized by any horrified reaction on the part of Sylvia." Breen particularly objected to a scene in which Maudie kisses Sylvester, thinking her to be a boy. Breen worried that the disguised woman incited female same-sex eroticism and that another scene, in which a drunk bystander sees Michael profess his desire to Sylvester, gave the impression of male same-sex eroticism. Breen advised, "There should be no reaction from the drunk to the fact that Michael is speaking intimately and tenderly about a person who, to him, is apparently a man. In other words, there should be no play on the fact that Sylvia is disguised." While RKO retained the kiss between women in a much-abbreviated form, the studio cut the scene in which Michael is observed by the drunk.

Breen's objections reveal the considerable distance between the cross-dressed women of the first wave and those of the third. Whereas cross-dressed women had contributed to the medium's legitimacy during the 1910s by referencing established, genteel representational traditions and fixing non-bourgeois, single-sex spaces, in the mid-1930s the cross-dressed woman suggested deviant sexual identities. In *Sylvia Scarlett*, long-established innocent and newly circulating sophisticated interpretations collided. *Sylvia Scarlett* was similar to earlier cross-dressing films in many ways. It was adapted from a literary source and opened with an exclusive run at Radio City Music Hall.²²⁰ Hepburn's performance evokes the vitality of frontier and battlefield heroines, as well as the Fairbanksian boyhood of Mary Pickford's Fauntleroy and Betty Bronson's Peter Pan. Like many cross-dressing frontier films, *Sylvia Scarlett* frames Sylvia's boyhood as an adolescent stage, to be abandoned when she reaches sexual maturity. While Jimmy offers Sylvia a way to linger in this unsettled stage—Sylvia could remain Sylvester as she and Jimmy drift around conning people—she instead chooses Michael, the man who will make a woman out of her. Marriage to him would mean financial security and a radical rise in class status. Like *A Range Romance*, *Sylvia Scarlett* proposes that the partnership of Michael and Sylvia will remedy the dysfunctional, anti-bourgeois sociality of both partners: Michael's dissipated, pleasure-seeking lifestyle and Sylvia's homosocial trio with a lascivious, lower-class conman and infantile father.

Breen's objections demonstrate that the same-sex eroticism aroused by the cross-dressed woman, which had received no censure in earlier films, was now read within the framework of deviant sexual identity. And yet, despite the circulation of these potential readings and the film's present-day reputation as a failure, many critics praised Hepburn's cross-dressed performance and did read it within older traditions. Philip K. Scheuer at the *Los Angeles Times*, for example, wrote that the film "affords Miss Hepburn opportunity to take on the habiliments and, to a really astonishing degree, the physical attributes of a boy."²²¹ Scheuer framed gender disguise as an opportunity for a female actress to demonstrate her skill, as it had been in films of the 1910s and early 1920s. While critics agreed that the structure of film was sprawling and unsatisfying, they did not complain that it was immoral or that there was anything unsavory about Hepburn's masculinity. This reception suggests that the innocent readings of cross-dressed women cultivated during the first wave did not disappear when sophisticated readings began to circulate more widely, but rather that both readings continued to operate alongside each other.

Female-to-male cross-dressing had been one of the ways of making American movies wholesome and legitimate, but in the 1930s it came under suspicion as one of Hollywood's many improprieties. The relatively overt representation of lesbians was part of the industry's overall fascination with vice, but also

capitalized on the publicity over *The Captive* and *The Well of Loneliness*. By the early 1930s, the American public was apprised of a range of codes for lesbianism and inversion, and censors became much more sensitive to this topic. The lesbian cameos that had gone unnoticed in the 1920s were no longer permissible because the ability to spot lesbians was no longer limited to the educated elite. The general public had become sophisticated. The relationship between men's clothing and a lesbian identity continued to be complex, though. On the one hand, a journalist could use the phrase "ladies who prefer pants to petticoats" to mean lesbians. On the other, fan magazines could endorse trousers as a charming fashion statement available to all woman.

After 1934, cross-dressed women in American film became more narratively contained, homogenous, and visibly female. Synchronized sound allowed films to include the types of singing and dancing male impersonation that had been popular in variety and music hall entertainments. Female-to-male cross-dressing often occurred within the confines of a musical number. Shirley Temple impersonated an old man in *Curly Top* (Fox, 1935), for example, and Judy Garland a boy in *Babes on Broadway* (MGM, 1941) and a tramp in *Easter Parade* (MGM, 1948). Films also sometimes presented historical women who wore men's clothing, like George Sand in *A Song to Remember* (Columbia, 1944) and Martha Jane Cannary Burke in *Calamity Jane* (Warner Bros., 1953), but invariably feminized them and emphasized their ostensible heterosexuality. American studios occasionally released gender disguise romantic comedies, like *Sullivan's Travels* (Paramount, 1941) and *How to Be Very, Very Popular* (Twentieth Century Fox, 1955), and stories of heroic disguised women, like *Zorro's Black Whip* (Republic, 1944) and *National Velvet* (MGM, 1944). Except for infants and the character Peter Pan, studios never cast girls or women in male roles: for mainstream filmmaking, that practice ended for good in the mid-1920s.

Moving from the brief moments highlighting female couples in *Four Horsemen of the Apocalypse* and *Manslaughter* through popular cultural texts both large and small, the last two chapters demonstrate the key role that film and media played in shifting the codes for recognizing lesbianism from elite spheres to mass audiences during the 1920s and early 1930s. Although female masculinity and other traits remained ambiguous by themselves, particular texts invited viewers to see them as signifiers of lesbianism through triangulation with signs inside and outside the text. Whereas these intertexts had long been restricted discourses like sexology or Roman history, in the 1920s the texts offering spectators the lens through which to see lesbianism became popular novels, plays, and films. These texts articulated various models of same-sex desire, from sexual inversion to the intensification of homosocial bonds, which implied differing sets of codes to detect. Nonetheless, in a visual medium like film, female masculinity became an important tool for rendering deviant sexuality visible.

CONCLUSION

Today new forms of female masculinity are exploding, ranging from butches, dykes, and studs to transmen, FTMs, ags, genderqueers, individuals masculine-of-center, and many more. Transgender men and masculine women can make their own movies now, from feature films to documentaries, avant-garde works, and YouTube videos. At the same time, mainstream media culture has considerably less room for female masculinity than it did in the early twentieth century. Considering the work butch women, trans men, and others have had to do to make themselves recognized, it is worth remembering that assigned-female bodies in men's clothes were not always ignored or reviled, but played a significant role in America's idealized conception of itself and in the growth of a new mass medium.

What counts as cross-dressing has changed dramatically. Outside of some orthodox religious communities, trousers have become standard female apparel. Today there are very few types of clothing that are exclusive to men, so the way to tell if a woman is wearing "men's clothes" is through style and cut. And yet, there continues to be a fascination with women in "men's" clothing. Female fashion models like Elliott Sailors, Casey Legler, and Erika Linder have all been signed to model men's clothing lines.[1] Their looks play on trans male and butch aesthetics, as well as the longstanding appeal of the androgynous boy. At the same time, Nike has sponsored the black American basketball player Brittney Griner to wear its line of men's clothing.[2] Since women of color were almost always excluded from cross-dressing and lesbian roles in cinema's first decades, Griner's contract represents an important expansion of the female masculinities that American popular culture is willing to celebrate.

Moving back to the early twentieth century, I still hope to find the voices of lesbian, inverted, and female-bodied male viewers and film personnel. Undoubtedly, these sorts of people went to the movies, talked about movies, wrote about

movies, and perhaps even made movies. They must have had their own assess-
ments of the cross-dressed and lesbian women they saw there. In the adjacent
realm of live theater, Martha Vicinus has shown that lesbians like Natalie Bar-
ney willfully read theatrical performers like Sarah Bernhardt and Vesta Tilley
as contributing to their own identity projects.[3] While famous queer moviego-
ers like Gertrude Stein and Colette engaged with silent cinema in their work, I
have found no mention of their responses to cross-dressed movie women. Per-
haps some lesbian, inverted, and female-bodied male viewers kept diaries, made
scrapbooks, or wrote letters about their experiences of the movies during these
years. These traces have yet to be found, but I very much hope they will be dis-
covered. For now, we can only imagine how they may have made sense of the
cross-dressed women they saw on-screen, living in the context of mainstream
discourses, but with their own sense of what mannish clothing could mean.

During the silent era, cross-dressed women were more prevalent, more popu-
lar, and more heterogeneous in American cinema than at any time since. Imagine,
for a moment, if Hollywood produced an average of twenty-six films featuring
cross-dressed women every year. At this earlier historical moment, when many
commentators felt that women were becoming increasingly like men, moving
pictures seized upon cross-dressed women as a way to acknowledge and render
pleasurable these profound social changes. Female-to-male cross-dressing can-
not be reduced to any one effect—even now—and particularly not during this
earlier period when the rules of gender and desire were so much in flux. Cross-
dressed women were intricately woven into longstanding cultural narratives of
heroism and vulnerability, of desire and confusion, of comedy and tragedy. In
this moment of social and industrial transition, the cross-dressed woman—
seemingly a figure of instability—helped the American moving picture industry
legitimate its social standing and become one of the world's first mass entertain-
ment industries.

APPENDIX
U.S. Films Featuring Cross-Dressed Women, 1904–1934

This list has been compiled from the trade press, publicity bulletins, photographs, secondary literature, Jaye Kaye's Transgender Movie Site, and suggestions from archivists, scholars, and collectors. Errors and omissions certainly remain. An asterisk marks films about which I am uncertain—either because reviews of a lost film suggest the presence of cross-dressing but do not confirm it or because the female character wears masculine-styled clothes, but I am not sure whether it would have been considered cross-dressing at the time.

Where film prints are known to be extant, I have indicated where to find them. (Films with no suggestions are currently believed to be lost.) Prints that are incomplete are noted as "inc." The highest quality sources are archives, which I have listed according to International Federation of Film Archives (FIAF) abbreviations (see key below). When films are available on DVD, I have listed the company from which they can be purchased. The best quality DVDs are produced by Criterion, Flicker Alley, Image Entertainment, Kino Lorber, the Library of Congress, Milestone, the National Film Preservation Foundation (NFPF), and Warner Archive. DVDs from other companies are likely made from lower-resolution scans of 16mm reduction prints. The website SilentEra.com provides helpful reviews of DVD releases. While I indicate when films can be viewed on YouTube, this status is in flux, and the versions available there are extremely low quality. I recommend using YouTube to preview films before buying the DVD or contacting an archive. I hope that new attention to these films will inspire archives and distributors to make more of them available to the public.

Release Date	Title	Cross-Dressing Performer	Where to Find
October 1904	_Girls in Overalls_	?	
24 November 1906	_The Female Highwayman_	?	
09 March 1907	_The Spy, a Romantic Story of the Civil War_	?	

(continued)

Release Date	Title	Cross-Dressing Performer	Where to Find
11 March 1908	The Boy Detective; or, The Abductors Foiled	?	USL, USM, USW
14 March 1908	The French Spy	?	
20 May 1908	When Knights Were Bold	Linda Arvidson	USM, USW
25 July 1908	Lady Jane's Flight	Florence Lawrence	
20 October 1908	The Planter's Wife	Florence Lawrence	USW
22 December 1908	The Merchant of Venice*	Florence Turner	USW
14 January 1909	A Rural Elopement	Linda Arvidson	USW
04 March 1909	A Fool's Revenge	Marion Leonard	USM, USW
15 March 1909	A Cowboy Argument	?	
21 March 1909	The Girl Spy: An Incident of the Civil War	Gene Gauntier	CAO
02 April 1909	On the Western Frontier	?	AUC
10 July 1909	For Her Sweetheart's Sake	?	
20 July 1909	The Adventures of Fifine	?	
03 August 1909	The Prince and the Pauper	Cecil Spooner	
30 August 1909	Pranks	Marion Leonard	USM, USW
06 September 1909	1776; or, The Hessian Renegades	?	FRB, GBB, USF, USL, USM, USR, USW
15 October 1909	Hansel and Gretel	Cecil Spooner	
29 October 1909	The Girl Scout	?	
22 November 1909	When Women Win	?	
25 December 1909	A Midsummer Night's Dream	Gladys Hulette	DVD-Milestone; YouTube; GBB, USR, USW
24 January 1910	The Ranch King's Daughter*	?	
05 February 1910	Twelfth Night	Edith Storey and Florence Turner	DVD-Milestone; YouTube; GBB, USW
10 February 1910	The Duke's Plan	Marion Leonard	GBB, USM, USW
17 February 1910	The Girls of the Range	?	
24 February 1910	Taming a Husband	Dorothy Bernard	USM, USW
01 April 1910	The Further Adventures of the Girl Spy	Gene Gauntier	GBB
22 April 1910	The Bravest Girl in the South*	Gene Gauntier	

Release Date	Title	Cross-Dressing Performer	Where to Find
29 April 1910	The Love Romance of the Girl Spy*	Gene Gauntier	
02 May 1910	The Cow Boy Girls*	?	
07 June 1910	The Two Roses	Marie Eline	Thanhouser.org, Vimeo; DEK
17 June 1910	The Little Hero of Holland	Marie Eline	
12 July 1910	The Lucky Shot	Marie Eline	
25 July 1910	The Call to Arms	Mary Pickford	FRB, USW
08 August 1910	The House with Closed Shutters	Dorothy West	DVD-Kino; DEI, USF, USL, USM, USW
12 August 1910	The Red Girl and the Child	Lillian St. Cyr	USM
22 August 1910	The Taming of Jane*	Florence Lawrence	USW
25 August 1910	Wilful Peggy	Mary Pickford	USL, USW
27 August 1910	The Deputy's Love	Clara Williams	
28 September 1910	A Western Girl's Sacrifice	?	
08 November 1910	The Little Fire Chief	Marie Eline	
27 December 1910	The Vicar of Wakefield	Marie Eline	Thanhouser.org, Vimeo; FRL, GBB, NLA, USW
27 December 1910	Girls Will Be Boys	?	
28 December 1910	The Girl Spy Before Vicksburg	Gene Gauntier	NLA
02 January 1911	The Argonauts	?	
14 January 1911	A Girl of the West	Gladys Field?	
16 February 1911	Billy and His Pal	Edith Storey	Filmpreservation.org; NZW
28 February 1911	Captain Barnacle's Courtship	Florence Turner	
18 March 1911	The Sheriff's Daughter	?	
07 April 1911	The Girl Stowaway's Heroism	?	
11 April 1911	Velvet and Rags	Marie Eline	
17 April 1911	With Stonewall Jackson	?	
16 May 1911	The Colonel and the King	Marie Eline	
02 June 1911	A Circus Stowaway	Marie Eline	GBB
03 June 1911	Little Soldier of '64	Gene Gauntier	GBB
10 June 1911	The Subduing of Mrs. Nag	Mabel Normand	
21 June 1911	Cupid and the Comet	?	DEI, GBB

(continued)

Release Date	Title	Cross-Dressing Performer	Where to Find
13 July 1911	*Bobby the Coward*	Edna Foster	ARF, ROB, USM, USR
24 July 1911	*A Country Cupid*	Edna Foster	DVD-Unknown Video; YouTube; DEI, USF, USL, USM
01 August 1911	*The Pied Piper of Hamelin*	Marie Eline	
04 August 1911	*The Judge's Story*	Marie Eline	
07 August 1911	*The Ruling Passion*	Edna Foster	USM
11 August 1911	*Cupid the Conquerer*	Marie Eline	
15 August 1911	*Captain Barnacle's Baby*	Gladys Hulette	
15 August 1914	*The Winds of Fate*	Gladys Hulette	
16 August 1911	*Special Messenger*	Gene Gauntier	GBB
28 August 1911	*Swords and Hearts*	Dorothy West	DVD-Kino; Archive .org; YouTube; GBB, USF, USM
07 September 1911	*The Old Confectioner's Mistake*	Edna Foster	USM
11 September 1911	*Billy the Kid*	Edith Storey	
13 October 1911	*The Tempter and Dan Cupid*	Marie Eline	
17 October 1911	*The Early Life of David Copperfield*	Flora Foster	DVD-Thanhouser; ITT
19 October 1911	*The Adventures of Billy*	Edna Foster	DVD-Unknown Video; YouTube; USF, USL, USM
21 October 1911	*Wages of War*	Edith Storey?	
26 October 1911	*The Long Road*	Edna Foster	USF, USL, USM
06 November 1911	*The Battle*	Edna Foster	DVD-Kino; Fandor .com; CAQ, DEK, ESM, FRB, GBB, ITB, ITG, USF, USL, USM, USR, USW
13 November 1911	*In the Days of Gold*	Betty Harte	
20 November 1911	*My Brother Agostino*	Ormi Hawley	GBB
01 December 1911	*A Range Romance*	?	USW
05 December 1911	*The Newsy and the Tramp*	Marie Eline	
14 December 1911	*The Substitute*	?	GBB
18 December 1911	*As in a Looking Glass*	Edna Foster	USF, USM, USW
21 December 1911	*A Terrible Discovery*	Edna Foster	USM, USF, USR, FRC
24 December 1911	*Before Yorktown*	Grace Cunard	

Release Date	Title	Cross-Dressing Performer	Where to Find
26 December 1911	*She*	Marie Eline	Thanhouser.org, Vimeo; GBB, USW
01 January 1912	*The Baby and the Stork*	Edna Foster	USF, USM, USR, USW
09 January 1912	*Just a Bad Kid*	Marie Eline	
22 January 1912	*For His Son*	Edna Foster	DVD-Image; You-Tube; FRL, USM, USR
23 January 1912	*Her Ladyship's Page*	Marie Eline	
28 January 1912	*Defender of the Name**	Marion Leonard	
29 January 1912	*A Blot in the 'Scutcheon*	Edna Foster and ?	USM, USR
01 February 1912	*The Transformation of Mike*	Edna Foster	USF, USL, USM
01 February 1912	*The Little Stowaway*	Betty Harte	
09 February 1912	*A Mysterious Gallant*	Iva Shepard	
12 February 1912	*Billy's Stratagem*	Edna Foster	NLA, USW
20 February 1912	*Washington in Danger*	Marie Eline	
26 February 1912	*When Women Rule**	Myrtle Stedman	
26 February 1912	*The Sunbeam*	Edna Foster	DVD-Kino; You-Tube; USM
07 March 1912	*A String of Pearls*	Edna Foster	USM
15 March 1912	*The Poacher*	Marie Eline	
19 March 1912	*Nicholas Nickleby*	Marie Eline	Thanhouser.org, Vimeo; GBB, USW, USF
02 April 1912	*The Mine on the Yukon*	Mrs. William Bechtel	
16 April 1912	*The Baby Bride*	Marie Eline	USW
01 May 1912	*The Post Telegrapher*	Edith Black	DEK, NLA, USW (inc.)
02 May 1912	*Jack and Jingles*	Maud Potter	
15 May 1912	*Prince Charming*	Edna Foster	GBB (inc.)
20 May 1912	*Oliver Twist*	Vinnie Burns	USW
22 May 1912	*The District Attorney's Conscience*	Edna Foster	NLA, USW
24 May 1912	*Diamond Cut Diamond*	Flora Finch	GBB, NLA
03 June 1912	*Tomboy Bessie**	Mabel Normand	FRL, ITG, USM, USW
05 June 1912	*The Drummer Girl of Vicksburg*	Miriam Cooper	
13 June 1912	*Katchem Kate*	Mabel Normand	DVD-Classic Video Streams; YouTube; FRL, ITG, USM, USW *(continued)*

Release Date	Title	Cross-Dressing Performer	Where to Find
25 June 1912	The Queen of May	?	GBB
30 June 1912	Doggie's Debut	Marie Eline	
19 July 1912	The Ranchman and the Hungry Bird	Marie Eline	
30 July 1912	Treasure Trove	Marie Eline	GBB, USW
19 August 1912	With the Enemy's Help	Edna Foster	GBB, USW
07 September 1912	The Darling of the C.S.A.	Anna Q. Nilsson	Filmpreservation.org; NLA
08 September 1912	Don't Pinch My Pup	Marie Eline	
16 September 1912	The Cowboy's Best Girl	Myrtle Stedman	
04 October 1912	The Warning	Marie Eline	
07 October 1912	As You Like It	Rose Coghlan	USW
09 October 1912	A Sister's Devotion	Geraldine Gill	
01 November 1912	Making a Man of Her	Louise Glaum	NLA, USW
01 November 1912	On Secret Service	Anna Little	NLA
06 November 1912	Her Education*	Betty Harte	
15 November 1912	In Time of Peril	Marie Eline	
24 November 1912	The Truant's Doom	Marie Eline	
16 December 1912	Mabel's Adventures	Mabel Normand	
30 December 1912	Mabel's Strategem	Mabel Normand	Archive.org; YouTube; ITG
04 January 1913	The Tiniest of Stars	Marie Eline	Thanhouser.org, Vimeo; GBB, USW
10 January 1913	The Evidence of the Film	Marie Eline	Thanhouser.org, Vimeo; GBB, USW
17 January 1913	The Little Turncoat	?	
21 January 1913	Her Fireman	Marie Eline	
27 January 1913	A Misappropriated Turkey	Edna Foster	USM, USW
28 January 1913	When Mary Grew Up	Clara Kimball Young	GBB, NLA
01 February 1913	A Girl Worth Having	?	
23 February 1913	The Ghost in Uniform	Marie Eline	
24 February 1913	A Daughter of the Confederacy	Gene Gauntier	
24 March 1913	Pauline Cushman, the Federal Spy	Winifred Greenwood	
11 April 1913	The Changeling	Marie Eline	
16 April 1913	Dick Whittington and His Cat	Vinnie Burns	GBB
17 May 1913	Belle Boyd, a Confederate Spy	Winifred Greenwood	USL

Release Date	Title	Cross-Dressing Performer	Where to Find
06 June 1913	*The Runaway*	Marie Eline and Helen Badgley	
07 June 1913	*When Women Are Police**	Ruth Roland	
04 July 1913	*Her Two Jewels*	Marie Eline	
15 July 1913	*A Sister to Carmen*	Helen Gardner	GBC
05 August 1913	*The Protectory's Oldest Boy*	Marie Eline	
10 October 1913	*Cutey's Waterloo*	Lillian Walker and Ada Gifford	
15 October 1913	*The Coast Guard's Sister*	Miriam Nesbitt	USM
24 October 1913	*The Rogues of Paris*	Vinnie Burns	
04 November 1913	*Girls Will Be Boys*	Pearl White and ?	
08 November 1913	*Old Coupons*	Edna Foster	USM
17 November 1913	*A Cure for Suffragettes**		USM
12 December 1913	*Uncle's Namesakes*	Marion Fairbanks and Madeline Fairbanks	Thanhouser.org, Vimeo; GBB
23 December 1913	*A Vagabond Cupid*	Eleanor Kahn	
26 December 1913	*Cupid's Lieutenant*	Marie Eline	
27 December 1913	*The Pride of the Force*	Carrie Ward	
01 January 1914	*Frou Frou*	Helen Badgley	CAO
01 January 1914	*A Lady of Quality*	Cecilia Loftus	
06 January 1914	*Shadowed*	Pearl White	
17 January 1914	*The Mystery of a Taxicab**	Louise Fazenda	
19 January 1914	*What Came to Bar Q*	Lillian Christy	
30 January 1914	*The Purse and the Girl*	Marie Eline	
31 January 1914	*In the Year 2014**	Louise Fazenda	
31 January 1914	*It May Come To This**	Pearl White	
01 February 1914	*The Merchant of Venice*	Lois Weber	
03 February 1914	*In the Fall of '64*	Grace Cunard	
14 February 1914	*A Nest Unfeathered*	Edna Foster	
21 May 1914	*A Fair Rebel*	Linda Arvidson	USM, USW
01 June 1914	*The Escape*	Edna Foster	
11 June 1914	*The Knockout*	Minta Durfee	DVD-Flicker Alley, Delta; YouTube; USW
30 June 1914	*The Girl in Pants**	Pearl White	

(continued)

Release Date	Title	Cross-Dressing Performer	Where to Find
03 July 1914	Those College Days*	Victoria Forde	
04 July 1914	Molly the Drummer Boy	Viola Dana	
11 July 1914	Lillian's Dilemma	Lillian Walker	USW
August 1914	The Boundary Rider	Elsie Moors	
04 August 1914	The Trey O' Hearts*	Cleo Madison	
10 August 1914	A Florida Enchantment	Edith Storey and Ethel Lloyd	DVD-Library of Congress, Harpodeon; YouTube; USW
28 August 1914	When Men Wear Skirts	Ruth Roland	
04 September 1914	A Lively Affair	Mabel Van Buren and Lucie K. Villa	DVD-National Film Preservation Fnd.; YouTube; USW
05 September 1914	The Return of the Twins' Double	Grace Cunard	
12 September 1914	Mabel's Blunder	Mabel Normand	DVD-Unknown Video, Grapevine; YouTube; USF, USW
25 September 1914	The Death Mask	Tsuru Aoki	USW
28 September 1914	The Magic Cloak of Oz	Violet MacMillan	DVD-Warner; Archive.org; USL, USW
28 September 1914	The Patchwork Girl of Oz	Violet MacMillan	DVD-Library of Congress; YouTube; USL, USW
29 September 1914	Jealous James	Eva Bell?	
October 1914	The Adventures of Miss Tomboy	?	
12 October 1914	The Ragged Earl	Ormi Hawley	
19 October 1914	The Mystery of Edwin Drood	Margaret Prussing	
03 November 1914	Little Jack	Jackie Saunders	
08 November 1914	Should a Wife Forgive?	Marie Osborne	USW
04 December 1914	His Majesty the Scarecrow of Oz	Mildred Harris	DVD-Warner; YouTube; USR, USW
14 December 1914	The Crucible	Marguerite Clark	
17 December 1914	A Question of Clothes	Norma Talmadge	USM
ca. 1915	The Spider (?)	?	USW
02 January 1915	Putting It Over	?	
09 January 1915	The Girl of the Pines	Edna Maison	
11 January 1915	My Lady High and Mighty	Mary Fuller	

Release Date	Title	Cross-Dressing Performer	Where to Find
23 January 1915	Old Peg-Leg's Will	Grace Cunard	
29 January 1915	How She Fooled Aunty	Irene Hunt	
01 February 1915	Mistress Nell	Mary Pickford	USM
02 February 1915	The Girl of the Secret Service	Grace Cunard	
23 February 1915	Tomboys	May Durham, Edna Hayes, Lillian Frayne, and Muriel Kane	
23 February 1915	She Would Be a Cowboy	Ruth Roland	
March 1915	The Bridge of Sighs	Dorothy Welsh	
05 March 1915	The Tragedy of the Rails	Gertrude McCoy	
08 March 1915	The Caprices of Kitty	Elsie Janis	USW (inc.)
10 March 1915	The Girl Detective, Ep. 7: Following a Clue	Ruth Roland	
13 March 1915	All for Peggy	Pauline Bush	
14 March 1915	Little Bobby	Helen Badgley	
14 March 1915	Outside the Gates	Pauline Bush	
02 May 1915	Almost a King*	Billie Rhodes	
02 May 1915	Ethel's Disguise	Fay Tincher	
05 May 1915	The Baby	Violet Radcliffe	
17 May 1915	Betty in Search of a Thrill	Elsie Janis	
23 May 1915	The Rivals	Violet Radcliffe	
28 May 1915	Little Dick's First Case	Violet Radcliffe	
29 May 1915	The Amber Vase	Doris Pawn	
02 June 1915	Hearts and the Highway	Lillian Walker	
14 June–30 August 1915	The Romance of Elaine, Ep.?	Pearl White	
18 June 1915	The Little Deceiver	Edna Mayo	
21 June 1915	The Ashcan; or, Little Dick's First Adventure	Violet Radcliffe	
21 June–15 November 1915	The Broken Coin, Ep.?	Grace Cunard	
22 June 1915	Which Shall It Be?	Helen Badgley	USR
13 July 1915	A Ten-Cent Adventure	Violet Radcliffe	
20 July 1915	The Runaways	Violet Radcliffe	
27 July 1915	The Straw Man	Violet Radcliffe	

(continued)

Release Date	Title	Cross-Dressing Performer	Where to Find
02 August 1915	*Rags*	Mary Pickford	USR, USW
03 August 1915	*Billie's Goat*	Violet Radcliffe	
11 August 1915	*Comrades Three*	Winifred Greenwood	
12 August 1915	*Nearly a Lady*	Elsie Janis	
16 August 1915	*A Bunch of Keys*	June Keith and William Castelet	
24 August 1915	*The Little Cupids*	Violet Radcliffe	
25 August 1915	*When a Woman Loves*	Emmy Wehlen	
September 1915	*The Barefoot Boy*	Marguerite Courtot	
14 September 1915	*The Little Life Guard*	Violet Radcliffe	
13 October 1915	*Under New Management*	Gertrude Selby	GBB
29 November 1915	*The Prince and the Pauper*	Marguerite Clark	
06 January 1916	*The Red Circle*, Ep. 4: *In Strange Attire*	Ruth Roland	
15 January 1916	*Peggy*	Billie Burke	USF, USR
16 January 1916	*The Beckoning Flame*	Tsuru Aoki	
05 February 1916	*The White Rosette*	Helen Rosson	GBB (inc.)
20 February 1916	*Poor Little Peppina*	Mary Pickford	USR, USW
03 April 1916	*The Dumb Girl of Portici*	?	GBB
08 May 1916	*Snowbird*	Mabel Taliaferro	USR
29 May 1916	*Gloria's Romance*, Ep. 2: *Caught by the Seminoles*	Billie Burke	
05 June 1916	*Never Again, Eddie*	Billie Rhodes	GBB
16 June 1916	*The Matrimonial Martyr**	Ruth Roland	FRC
25 June 1916	*The World's Great Snare*	Pauline Frederick	
24 July 1916	*Pastures Green*	Vivian Rich	
30 July 1916	*A La Cabaret*	Ora Carew	
13 August 1916	*Daughter of the Don*	Marie McKeen	
21 August 1916	*Little Eve Edgarton*	Ella Hall	FRB
25 August 1916	*The Danger Girl*	Gloria Swanson	DVD-Alpha Video, Harpodeon, Passport; YouTube; CAQ, FRL, ITG, USF, USL, USR, USW

Release Date	Title	Cross-Dressing Performer	Where to Find
10 September 1916	*Dollars and Sense*	Ora Carew	DVD-Harpodeon, Sunrise Silents; CAO, CAQ, FRL, USB, USF, USR, USW
21 September 1916	*Land O' Lizards*	Anna Little	
12 October 1916	*Her Father's Son*	Vivian Martin	USW
16 October 1916	*The Ragged Princess*	June Caprice	
17 October 1916	*Daughter of the Gods*	Jane Lee	GBC
29 October 1916	*A Sister of Six*	Violet Radcliffe	GBB, ITN
12 November 1916	*Jim Grimsby's Boy*	Enid Markey	
13 November 1916	*Behind the Screen*	Edna Purviance	DVD-Image, Delta; YouTube; CAO, CAQ, DEI, DEK, DKK, ESB, ESM, ESV, FRB, FRL, GBB, GBC, HUB, ILA, ITB, ITC, ITG, ITT, NOO, ROB, SES, USB, USF, USI, USL, USM, USR, USW
30 November 1916	*Miss Jackie of the Navy*	Margarita Fischer	
09 December 1916	*The Wharf Rat*	Mae Marsh	
10 December 1916	*Oliver Twist*	Marie Doro	
24 December 1916	*20,0000 Leagues Under the Sea*	Jane Gail	DVD-Image, Alpha, Grapevine; You-Tube; BEB, DKK, FRL, GBB, MXU, USF, USL, USM
25 December 1916	*Joan the Woman**	Geraldine Farrar	DVD-Image, Passport, eOne; YouTube; FRB, FRL, GBB, USF, USR
07 January 1917	*Pearl of the Army, Ep. 6: Major Brent's Perfidy**	Pearl White	CAO, FRC, USR, USW (inc.)
28 January 1917	*Pearl of the Army, Ep. 9: The Monroe Doctrine**	Pearl White	CAO, FRC, USR, USW (inc.)
29 January 1917	*Love Aflame*	Ruth Stonehouse	USW (inc.)
09 February 1917	*Grant, Police Reporter, Ep. 17: The Trap*	Ollie Kirby	

(continued)

Release Date	Title	Cross-Dressing Performer	Where to Find
19 February 1917	Sloth	Shirley Mason	USW (inc.)
05 March 1917	The Boy Girl	Violet Mersereau	USW (inc.)
05 March 1917	Poor Little Rich Girl	Mary Pickford	ITG, USF, USM, USR, USW
10 March 1917	The Drifter	Claire Du Bray	
11 March 1917	The Little Brother	Enid Bennett	
12 March 1917	The Dancer's Peril	Alice Brady	DVD-Grapevine; ITG, USF, USR
17 March 1917	A Matrimonial Shock	Lillian Hamilton	
18 March–24 June 1917	The Mystery of the Double Cross, Ep. 1–15	Mollie King	DVD-Finders Keepers, A1, Sunrise Silents; AUC, USL, USW
26 March 1917	Sunny Jane*	Jackie Saunders	
22 April 1917	Cheerful Givers	Bessie Love	
18 May 1917	Caught in the End	Lillian Hamilton	USW
03 June 1917	Cactus Nell	Polly Moran	USL
03 June 1917	The Girl and the Ring	Claire Anderson	Private collection
04 June 1917	Lady Barnacle	Viola Dana	
04 June 1917	The Fight That Failed	?	
17 June 1917	Fires of Youth	Helen Badgley	Thanhouser.org, Vimeo; GBB, USL, USW
18 June 1917	Jilted in Jail	Edith Roberts	
July 1917	Alma, Where Do You Live?	Ruth MacTammany	
01 July 1917	Patsy*	June Caprice	
09 July 1917	Peggy, the Will o' the Wisp	Mabel Taliaferro	
28 July 1917	The Little Boy Scout	Ann Pennington	
30 July 1917	Jack and the Beanstalk	Violet Radcliffe	USR
05 August 1917	The Amazons	Marguerite Clark, Elsie Lawson, and Helen Greene	
09 August 1917	The Jury of Fate	Mabel Taliaferro	
11 August 1917	The Little Chevalier	Shirley Mason	USW
20 August 1917	The Lair of the Wolf	Dionna Drew	
20 August 1917	The Little Duchess	Madge Evans	USR, USW
September 1917	The Wild Girl	Eva Tanguay	USM
10 September 1917	Pants	Mary McAlister	
24 September 1917	The Edge of the Law	Ruth Stonehouse	
01 October 1917	The Lady Drummer	Fay Tincher	

Release Date	Title	Cross-Dressing Performer	Where to Find
08 October 1917	The Girl Who Won Out	Violet MacMillan	
08 October 1917	The Trouble Buster	Vivian Martin	
14 October 1917	Aladdin and the Wonderful Lamp	Violet Radcliffe	BRR, FRL, USR, USW
17 November 1917	Jerry's Running Fight	Claire Alexander	
02 December 1917	The Babes in the Woods	Violet Radcliffe	CAO, USR
10 December 1917	Miss Jackie of the Army	Margarita Fischer	
11 December 1917	Putting One Over	Billie Rhodes	
23 December 1917	Runaway Romany	Marion Davies	
01 January 1918	Madame Who	Bessie Barriscale	
27 January 1918	Treasure Island	Violet Radcliffe	
17 February 1918	Revelation	Alla Nazimova	
18 March 1918	Wanted, a Mother	Madge Evans	
01 April 1918	A Bit of Jade	Mary Miles Minter	
01 July 1918	Opportunity	Viola Dana	USR
08 July 1918	The Good-Bye Kiss	Sally Eilers	
29 July 1918	The Dream Lady	Kathleen Emerson	FRB
August 1918	Mickey	Mabel Normand	DVD-Alpha, Unknown, Grapevine; YouTube; BEB, GBB, ITG, ROB, USL, USM, USW
02 September 1918	The Silent Woman	Baby Ivy Ward	
07 October 1918	Whatever the Cost	Anita King	
13 October 1918	The Daredevil	Gail Kane	
14 October 1918	Together	Violet Mercereau	
17 November 1918	Fan Fan	Violet Radcliffe	
16 December 1918	Danger, Go Slow	Mae Murray	
16 December 1918	Two-Gun Betty	Bessie Barriscale	
30 December 1918	Know Thy Wife	Dorothy Devore	DVD-Image, Madacy; CAO, USF
06 January 1919	The Gold Cure	Viola Dana	
02 February 1919	The Bondage of Barbara	Mae Marsh	
15 February 1919	The Imp	Elsie Janis	USW
24 February 1919	Peggy Does Her Darndest*	May Allison	
24 March 1919	The Lamb and the Lion	Billie Rhodes	
30 March 1919	Toton	Olive Thomas	
20 April 1919	As a Man Thinks	Baby Ivy Ward	
27 April 1919	A House Divided	Baby Ivy Ward	
05 May 1919	Ginger	Violet Palmer	USW

(continued)

Release Date	Title	Cross-Dressing Performer	Where to Find
25 May 1919	Rowdy Ann	Fay Tincher	DVD-Image; Archive.org, YouTube; ITG, USF, USM, USW
02 June 1919	Phil-for-Short	Evelyn Greeley	USW
08 June 1919	Love's Prisoner	Olive Thomas	
22 June 1919	Hearts and Flowers	Phyllis Haver	DVD-Image; Fandor.com; USF, USL, USM
22 June 1919	Bare-Fisted Gallagher	Agnes Vernon	
13 July 1919	Muggsy	Jackie Saunders	
21 July 1919	The Microbe	Viola Dana	
21 July 1919	The Spitfire of Seville	Hedda Nova	
03 August 1919	Upstairs	Mabel Normand	
18 August 1919	The Girl Alaska	Lottie Kruse	USW
21 August 1919	Checkers	Jean Acker	
01 September 1919	The Hoodlum	Mary Pickford	RUR, USL, USR
21 September 1919	La Belle Russe	Marian Stewart	
29 September 1919	Miss Crusoe	Virginia Hammond and Nora Cecil?	
06 October 1919	The Oakdale Affair	Evelyn Greeley	
November 1919	Human Desire	Anita Stewart	USF, USW
December 1919	My Lady Robin Hood	Texas Guinan	USF, USL, USR
28 December 1919–4 April 1920	The Adventures of Ruth, Ep. ?	Ruth Roland	
29 February 1920	The Flame of Hellgate	Beatriz Michelena	
01 March 1920	The Fighting Shepherdess*	Anita Stewart	
04 April 1920	Treasure Island	Shirley Mason	
25 April 1920	Rio Grande	Rosemary Theby	
May 1920	Bubbles	Mary Anderson	RUR
17 May 1920	The Cradle of Courage	Ann Little	BEB, USB, USF, USL, USM, USW
29 May 1920	Her First Flame	Gale Henry	DVD-Alpha, Classic Video; USF, USR, USW
August 1920	The Little Wanderer	Shirley Mason	
August 1920	Lunatics in Politics	Alice Howell	
November 1920	The Mystery Mind, Ep. ?	Peggy Shanor	
08 November 1920	Are All Men Alike?*	May Allison	
December 1920	What Happened to Rosa	Mabel Normand	DVD-Grapevine, Unknown, Classic Video; YouTube; ITG, USW

Release Date	Title	Cross-Dressing Performer	Where to Find
January 1921	The Girl Montana	Blanche Sweet	
23 January 1921	The Mountain Woman	Pearl White	
06 March 1921	Four Horsemen of the Apocalypse		DVD-CD Baby, Hollywood's Attic, Nostalgia; YouTube; BEB, DEK, ESM, ESV, FRB, FRL, GBB, ITC, ITN, USF, USM, USR, USW, YUB
June 1921	Thunder Island	Edith Roberts	
11 September 1921	Little Lord Fauntleroy	Mary Pickford	DVD-Milestone; YouTube; FRC, RUR, USR, USW
25 September 1921	Rough Seas	Beatrice La Plante	USL
28 November 1921	Hail the Woman	Muriel Frances Dana	BEB, USM, USW
12 February 1922	Moran of the Lady Letty	Dorothy Dalton	DVD-Flicker Alley; Fandor.com; BEB, CZP, USL, USR, USW
10 March 1922	What Next?	Vera Reynolds	
30 October 1922	Married to Order	Rosemary Theby	USL
07 January 1923	Three Who Paid	Bessie Love	
21 January 1923	Man's Size	Alma Bennett	
04 February 1923	When Knighthood Was in Flower	Marion Davies	USW
04 March 1923	Down to the Sea in Ships	Clara Bow	DVD-Kino; You-Tube; NLA, USF, USL, USR
30 May 1923	The Kid Reporter	Baby Peggy	GBB
10 September 1923	The Fighting Blade	Dorothy Mackaill	USL, USM
16 September 1923	Navy Blues	Dorothy Devore	YouTube (inc.); CAO, FRL, USL
29 October 1923	Ponjola	Anna Q. Nilsson	Private collection
04 November 1923	Little Old New York	Marion Davies	DVD-Grapevine; YouTube; RUR, USR, USW
05 November 1922	Our Gang, aka Donkey Delivery Company		DVD-Grapevine; YouTube; ITB, USW
19 November 1923	Dangerous Maid	Constance Talmadge	RUR, USW
December 1923	The Trail of the Law	Norma Shearer	GBB

(continued)

Release Date	Title	Cross-Dressing Performer	Where to Find
01 January 1924	*Thief of Bagdad*	Mathilde Comont	DVD-Criterion, Kino; YouTube; AUC, BEB, BRR, CAQ, DEK, DEW, DKK, ESM, GBB, ITG, ROB, RUR, USF, USI, USL, USM, USW
06 January 1924	*The Love Bandit*	?	
13 January 1924	*The Humming Bird*	Gloria Swanson	NLA, USW
14 January 1924	*A Lady of Quality**	Virginia Valli	
30 March 1924	*Shanghaied Lovers*	Alice Day	USM
16 April 1924	*Mademoiselle Midnight*	Mae Murray	RUR, USL
05 June 1924	*Grandpa's Girl*	Kathleen Clifford	CAO, ITN
03 November 1924	*Merton of the Movies*	Viola Dana	
17 November 1924	*The Silent Accuser**	Eleanor Boardman	FRB
29 December 1924	*Peter Pan*	Betty Bronson	DVD-Kino; BEB, USL, USM, USR, USW
18 January 1925	*Fear-Bound**	Marjorie Daw	
01–15 March 1925	*Idaho*, Ep. 1–3	Vivian Rich	
07 April 1925	*Wasted Lives**	Edith Roberts	USW
17 July 1925	*The Lawful Cheater*	Clara Bow	
26 July 1925	*Lady Robinhood*	Evelyn Brent	
01 August 1925	*Parisian Love*	Clara Bow	DVD-Kino; You-Tube; USL, USW
30 August 1925	*Pursued*	Dorothy Drew	
18 October 1925	*The Keeper of the Bees*	Gene Stratton	
15 November 1925	*The Road to Yesterday*	Vera Reynolds and Trixie Friganza	DVD-Sunrise Silents, Passport, Alpha; AUC, USF, USL, USR, USW
01 December 1925	*Handsome Brute*	Virginia Lee Corbin	
06 December 1925	*The Fighting Dude*	Virginia Vance	DVD-Alpha; You-Tube; GBC, ROB, USM, USL
13 December 1925	*A Peaceful Riot*	Alice Ardell	USL
27 January 1926	*What's the World Coming To?*		DVD-Looser Than Loose, A-1 (inc.); YouTube (inc.); USL (inc.)
22 March 1926	*Beverly of Graustark*	Marion Davies	USW
April 1926	*Mike*	Sally O'Neill	USW (trailer only)
02 May 1926	*She's a Prince*	Alice Ardell	USM, USW

Release Date	Title	Cross-Dressing Performer	Where to Find
17 May 1926	The Palm Beach Girl*	Bebe Daniels	
13 June 1926	Eve's Leaves	Leatrice Joy	DVD-Grapevine; USL
27 June 1926	Miss Nobody	Anna Q. Nilsson	
06 September 1926	The Clinging Vine	Leatrice Joy	DVD-Image; USF, USL, USW
27 September 1926	Almost a Lady	Marie Prevost	FRB, USL
31 October 1926	King of the Kitchen	Della Peterson	
08 November 1926	For Alimony Only	Leatrice Joy	
14 November 1926	Exit Smiling	Beatrice Lillie	BEB, GBB, USL, USR
28 November 1926	Madame Dynamite	Alice Howell	USL, USR
12 December 1926	Going Crooked	Bessie Love	USM, USR
19 February 1927	Don Juan	Yvonne Day	DVD-Warner; ESM, FRL, GBB, ITC, ITG, USB, USI, USL, USR, USW
20 February 1927	Easy Pickings	Anna Q. Nilsson	
26 February 1927	The Understanding Heart*	Joan Crawford	
27 February 1927	One Hour Married	Mabel Normand	
12 March 1927	What Every Girl Should Know	Patsy Ruth Miller	
15 March 1927	The Enchanted Island	Charlotte Stevens	
30 April 1927	Señorita	Bebe Daniels	BEB, LUM
14 May 1927	The Climbers*	Irene Rich	
12 August 1927	Wings*		DVD-Warner; AUC, BEB, ESB, FRC, GBB, ITG, USF, USI, USL, USM, USR, USW
11 September 1927	Two Girls Wanted	Janet Gaynor	
24 September 1927	A Sailor's Sweetheart*	Louise Fazenda	GBB
16 October 1927	The Crystal Cup	Dorothy Mackaill	
12 November 1927	She's a Sheik	Bebe Daniels	
03 March 1928	Tillie's Punctured Romance	Louise Fazenda	
11 March 1928	Finders Keepers	Laura La Plante	USW (trailer only)
25 March 1928	Circus Days	Dorothy Devore	
01 April 1928	Ladies' Night in a Turkish Bath	Dorothy Mackaill	USL
25 August 1928	The Cardboard Lover	Marion Davies	USW
September 1928	Kitty Doner in "A Bit of Scotch" (Vitaphone #2668)	Kitty Doner	

(continued)

Release Date	Title	Cross-Dressing Performer	Where to Find
September 1928	Kitty Doner, A Famous Male Impersonator (Vitaphone #2669)	Kitty Doner	
22 September 1928	Beggars of Life	Louise Brooks	DVD-Grapevine, Classic Video Streams; AUC, BEB, DKK, GBB, USR
23 September 1928	Hit of the Show	Gertrude Olmstead	FRB
28 October 1928	Mother Knows Best	Madge Bellamy	
02 June 1929	Battling Sisters	Betty Boyd and Marjorie Jennings?	USM
13 July 1929	She Goes to War	Eleanor Boardman	DVD-Alpha Video, Grapevine; YouTube
24 August 1929	Marianne	Marion Davies	USL
11 May 1930	The Flirting Widow	Dorothy Mackaill	DVD-Lost and Found
01 August 1930	Dixiana	Bebe Daniels	DVD-Alpha Video; YouTube
23 August 1930	The Office Wife*	Faith Baldwin	DVD-Warner Archive
21 September 1930	Bright Lights	Dorothy Mackaill	DVD-Warner Archive
03 December 1930	Morocco	Marlene Dietrich	DVD-Universal
12 January 1931	Red Fork Range	Ruth Mix	
15 January 1931	West of Cheyenne	Josephine Hill	DVD-Sinister Cinema
14 March 1931	Kiki	Mary Pickford	
04 April 1931	Dishonored*	Marlene Dietrich	DVD-Universal
03 May 1931	Are You There	Bea Lillie	
30 May 1931	Laughing Sinners	Joan Crawford	DVD-Warner Archive
16 September 1932	Blonde Venus	Marlene Dietrich	DVD-Universal
20 October 1932	The Old Dark House	Elspeth Dudgeon	DVD-Kino
21 May 1933	The Warrior's Husband*	Elissa Landi and Marjorie Rambeau	USM
15 July 1933	The Fugitive	Cecelia Parker	
07 October 1933	Wild Boys of the Road	Dorothy Coonan	DVD-Warner
27 October 1933	Broadway Through a Keyhole	Constance Cummings and Blossom Seeley	DVD-Film Collectors Society; YouTube
16 November 1933	Little Women	Katharine Hepburn	DVD-Warner
17 November 1933	Blood Money	Kathlyn Williams and Sandra Shaw	DVD-Zeus

Release Date	Title	Cross-Dressing Performer	Where to Find
01 December 1933	*What's Your Racket*	Noel Francis	
26 December 1933	*Queen Christina*	Greta Garbo	DVD-Warner
29 June 1934	*Cockeyed Cavaliers*	Dorothy Lee	DVD-Roberts Videos
31 August 1934	*She Loves Me Not*	Mariam Hopkins	DVD-Classic Movie Love
15 September 1934	*The Scarlet Empress*	Marlene Dietrich	DVD-Criterion, Universal

KEY

Major Archives
GBB: BFI/National Film and Television Archive (London)
NLA: EYE Filmmuseum (Amsterdam)
USF: Academy Film Archive (Beverly Hills)
USL: UCLA Film and Television Archive (Los Angeles)
USM: Museum of Modern Art (New York)
USR: George Eastman House (Rochester)
USW: Library of Congress (Washington, D.C.)

Other Archives
ARF: Fundacion Cinemateca Argentina (Buenos Aires)
AUC: National Film and Sound Archive, Australia (Canberra)
BEB: Cinémathèque Royale (Brussels)
BRR: Cinemateca do Museu de Arte Moderna (Rio de Janeiro)
CAO: National Archives of Canada (Ottawa)
CAQ: Cinémathèque Québécoise (Montreal)
DEI: Filmmuseum/Münchner Stadtmuseum (Munich)
DEK: Deutsche Kinemathek (Berlin)
DEW: Deutsches Filminstitut-DIF (Wiesbaden)
DKK: Danish Film Institute (Copenhagen)
ESM: Filmoteca Española (Madrid)
ESV: Instituto Valenciano de Cinematografia (Valencia)
FRB: Archives du Film du CNC (Bois d'Arcy)
FRC: Cinémathèque Française (Paris)
GBC: Cinema Museum (London)
HUB: Hungarian National Film Archive (Budapest)
ILA: Israel Film Archive (Jerusalem)
ITB: Cineteca del Comune di Bologna (Bologna)
ITG: Cineteca del Friuli (Gemona)

ITN: Cineteca Nazionale (Rome)
ITT: Museo Nazionale del Cinema (Torino)
MXU: Filmoteca de la UNAM (Mexico)
FRL: Lobster Films (Paris)
NZW: New Zealand Film Archive (Wellington)
NOO: Norsk Filminstitutt (Oslo)
ROB: Arhiva Nationala de Filme (Bucharest)
RUR: Gosfilmofond of Russia (Moscow)
SES: Cinemateket-Svenska Filminstitutet (Stockholm)
USB: Pacific Film Archive (Berkeley)
USI: Harvard Film Archive (Cambridge)
YUB: Jugoslovenska Kinoteka (Belgrade)

NOTES

ABBREVIATIONS

BRTC Billy Rose Theatre Collection, New York Public Library for the Performing Arts, New York City

MHL Margaret Herrick Library, Academy of Motion Picture Arts and Sciences, Los Angeles

PASC Performing Arts Special Collections, Library Special Collections, University of California, Los Angeles

INTRODUCTION

1. For example: Edith Becker et al., "Lesbians and Film," *Jump Cut* 24–25 (March 1981): 17–21; Judith Mayne, *Directed by Dorothy Arzner* (Bloomington: Indiana University Press, 1994), 103.

2. Homer Dickens, *What a Drag: Men as Women and Women as Men in the Movies* (New York: Quill, 1984). Rebecca Bell-Metereau lists only seven silent films featuring cross-dressed women in her *Hollywood Androgyny*, 2nd ed. (New York: Columbia University Press, 1993).

3. Dianne Dugaw, *Warrior Women and Popular Balladry, 1650–1850* (Cambridge and New York: Cambridge University Press, 1989); Julie Wheelwright, *Amazons and Military Maids: Women Who Dressed as Men in the Pursuit of Life, Liberty and Happiness* (London: Pandora, 1989); Susan Gubar, "Blessings in Disguise: Cross-Dressing as Re-Dressing for Female Modernists," *Massachusetts Review* 22, no. 3 (1981): 477–508.

4. San Francisco Lesbian and Gay History Project, "'She Even Chewed Tobacco': A Pictorial Narrative of Passing Women in America," in *Hidden from History*, ed. Martin Duberman, Martha Vicinus, and George Chauncey (New York: Meridian Books, 1990), 183–94; Esther Newton, "The Mythic Mannish Lesbian: Radclyffe Hall and the New Woman," *Signs* 9, no. 4 (1984): 557–75; Lisa Duggan, *Sapphic Slashers: Sex, Violence, and American Modernity* (Durham, NC: Duke University Press, 2000).

5. Susan M. Gilbert, "Costumes of the Mind: Transvestism as Metaphor in Modern Literature," *Critical Inquiry* 7, no. 2 (1980): 391–417; Marjorie Garber, *Vested Interests: Cross-Dressing and Cultural Anxiety* (New York: Routledge, 1992).

6. Louis Sullivan, *From Female to Male: The Life of Jack Bee Garland* (Boston: Alyson Publications, 1990); Judith Halberstam, *Female Masculinity* (Durham, NC: Duke University Press, 1998); Nan Alamilla Boyd, "The Materiality of Gender: Looking for Lesbian Bodies in Transgender History," *Journal of Lesbian Studies* 3 (1999): 73–82; Clare Sears, "All That Glitters: Trans-ing California's Gold Rush Migrations," *GLQ: A Journal of Lesbian and Gay Studies* 14, nos. 2–3 (2008): 383; Peter Boag, *Re-Dressing America's Frontier Past* (Berkeley: University of California Press, 2011).

7. Michel Foucault, *The History of Sexuality*, vol. 1, *An Introduction*, trans. Robert Hurley (New York: Vintage Books, 1978), 43; George Chauncey, *Gay New York: Gender, Urban Culture, and the Makings of the Gay Male World, 1890–1940* (New York: Basic Books, 1994).

8. Duggan, *Sapphic Slashers*.

9. Vito Russo, *The Celluloid Closet: Homosexuality in the Movies* (New York: Harper & Row, 1981); Andrea Weiss, *Vampires and Violets: Lesbians in Film* (New York: Penguin Books, 1993); Richard Barrios, *Screened Out: Playing Gay in Hollywood from Edison to Stonewall* (New York: Routledge, 2003).

10. Sharon Marcus, *Between Women: Friendship, Desire, and Marriage in Victorian England* (Princeton: Princeton University Press, 2007).

11. Elizabeth Freeman, *Time Binds: Queer Temporalities, Queer Histories* (Durham, NC: Duke University Press, 2010). See also Carolyn Dinshaw, *Getting Medieval: Sexualities and Communities, Pre- and Postmodern* (Durham, NC: Duke University Press, 1999). Susan Potter's dissertation on lesbianism in early cinema takes this approach, privileging the author's response to selected films to imagine the desires these moving images may have elicited in female spectators of an earlier age. Susan Margaret Potter, "Queer Timing: The Emergence of Lesbian Representation in Early Cinema" (Ph.D. diss., University of Auckland, 2012).

12. David Halperin makes a similar defense of historicism in *How to Do the History of Homosexuality* (Chicago: University of Chicago Press, 2002), 14–17.

13. See, for example, Laura L. Behling, *The Masculine Woman in America, 1890–1935* (Urbana: University of Illinois Press, 2001).

14. Examples in: Kristen Anderson Wagner, "'Comic Venus': Women and Comedy in American Silent Film" (Ph.D. diss., University of Southern California, 2009), 307–11.

15. See, for, example, William Henry Milburn, *The Pioneer Preacher; or, Rifle, Axe, and Saddle-Bags, and Other Lectures* (New York: Derby & Jackson, 1858), 42; "Women's Rights," *Logansport Democratic Pharos*, March 17, 1858; "Letter from an Indian to His Friends in the Rocky Mountains," *Manitoba Free Press*, November 27, 1880; "I Believe, Said a Soap-Box Man . . . ," *Davenport Gazette*, January 21, 1884; "Chronicle Cullings," *San Francisco Chronicle*, March 10, 1885; "The Only Female Mayor," *Decatur Republican*, August 18, 1887.

16. Robert E. Riegel, "Women's Clothes and Women's Rights," *American Quarterly* 15, no. 3 (1963): 394, doi:10.2307/2711370.

17. Richard von Krafft-Ebing, *Psychopathia Sexualis, with Especial Reference to the Antipathic Sexual Instinct, a Medico-Forensic Study*, 12th ed., trans. Francis Joseph Rehman (New York: Rebman, 1903), 399.

18. Ibid., 398; Havelock Ellis and John Addington Symonds, *Sexual Inversion* (London: Wilson and Macmillan, 1897), 94–95.

19. In their important work, Carroll Smith-Rosenberg and Esther Newton fall into the trap of declaring inverts to be mannish lesbians, but they are far from alone. Smith-Rosenberg, "The New Woman as Androgyne: Social Disorder and Gender Crisis, 1870–1936," in Smith-Rosenberg, *Disorderly Conduct: Visions of Gender in Victorian America* (New York: Alfred A. Knopf, 1985), 245–96; Newton, "Mythic Mannish Lesbian."

20. Jay Prosser, *Second Skins: The Body Narratives of Transsexuality* (New York: Columbia University Press, 1998), 135–70. See also Stephen Cromwell, "Passing Women and Female-Bodied Men: (Re)claiming FTM History," in *Reclaiming Genders: Transsexual Grammars at the Fin de Siècle*, ed. Kate More and Stephen Whittle (London and New York: Cassell, 1999), 34–82.

21. Smith-Rosenberg, "New Woman as Androgyne."

22. Smith-Rosenberg, *Disorderly Conduct*, 280.

23. Quoted in Martha H. Patterson, ed., *The American New Woman Revisited: A Reader, 1894–1930* (New Brunswick: Rutgers University Press, 2008), 279.

24. Leila Rupp, *Sapphistries: A Global History of Love between Women* (New York: NYU Press, 2009).

25. Martha Vicinus, *Intimate Friends: Women Who Loved Women, 1778–1928* (Chicago and London: University of Chicago Press, 2004).

26. "When Stage Beauties Have Donned Manly Attire," *Baltimore Post*, July 26, 1903, box MWEZ+n.c. 26.791, Robinson Locke Collection, BRTC.

27. Ibid.

28. Gillian M. Rodger, "Male Impersonation on the North American Variety and Vaudeville Stage, 1868–1930" (Ph.D. diss., University of Pittsburgh, 1998), 156–62.

29. Patrick B. Tuite, "'Shadow of [a] Girl': An Examination of Peter Pan in Performance," in *Second Star to the Right: Peter Pan in the Popular Imagination*, ed. Allison Kavey and Lester D. Friedman (New Brunswick, NJ: Rutgers University Press, 2009), 117.

30. Grace R. Clarke, "Girl Boys of the Stage; Actresses Love to Play Them," *Chicago Daily Tribune*, March 14, 1909.

31. Lisa Merrill, *When Romeo Was a Woman: Charlotte Cushman and Her Circle of Female Spectators* (Ann Arbor: University of Michigan Press, 1999); Tuite, "Shadow of [a] Girl," 121.

32. "The Woman Who Won Fame in Trousers and Who Will Never Wear Them Again, Believes Every Woman Should Wear Them," *The World*(?), August 30, 1903, box MWEZ+n.c. 26.791, Robinson Locke Collection, BRTC.

33. "Kathleen Clifford At All Interested in Suffrage?" clipping in Robinson Locke Scrapbook, ser. 3, vol. 355, p. 4, BRTC, as quoted in Elizabeth Reitz Mullenix, *Wearing the Breeches: Gender on the Antebellum Stage* (New York: St. Martin's Press, 2000), 271.

34. Vesta Tilley, "The Mannish Woman," *Pittsburgh Gazette Home Journal*, April 3, 1904.

35. See, for example, "Amazing Double Life of Girl Who Lived for Years as a Man," *The Day Book*, May 13, 1914, Noon edition.

36. "Trouble That Clothes Make: Strange Adventures of Women Who Have Masqueraded as Men," *Washington Post*, October 25, 1908.

37. Boag, *Re-Dressing America's Frontier Past*.

38. Patricia A. Cunningham, *Reforming Women's Fashion, 1850–1920: Politics, Health, and Art* (Kent, Ohio: Kent State University Press, 2003), 48.

39. Michelle Ann Abate, *Tomboys: A Literary and Cultural History* (Philadelphia: Temple University Press, 2008), xv.

40. Ibid., xix–xx.

41. Examples of early tomboys appear in *The Tomboys* (Selig, 1906) and *Tomboy Bessie* (Biograph, 1912).

42. "They Love Acting in Boys' Clothing," *Manitowoc Daily Herald*, August 24, 1917.

43. Richard Abel, *Americanizing the Movies and "Movie-Mad" Audiences, 1910–1914* (Berkeley: University of California Press, 2006), 119; Nanna Verhoeff, *The West in Early Cinema: After the Beginning* (Amsterdam: Amsterdam University Press, 2006), 401.

44. Patterson, *American New Woman Revisited*, 25.

45. "Woman Who Won Fame in Trousers." See also a 1915 Wild West show program quoted in Nancy Floyd, *She's Got a Gun* (Philadelphia: Temple University Press, 2008), 97.

46. Tom Gunning, "The Cinema of Attraction: Early Film, Its Spectator and the Avant-Garde," *Wide Angle* 3, no. 4 (1986): 63–71; Charlie Keil and Shelley Stamp, *American Cinema's Transitional Era: Audiences, Institutions, Practices* (Berkeley: University of California Press, 2004).

47. It is not accurate to call years 1930–1934 "pre-Code." The Production Code was put in place in 1930, but not rigorously enforced until 1934.

48. Around 70 percent were shorts (that is, two reels or less) and 30 percent were features (three reels or longer).

49. Chris Straayer, "Redressing the 'Natural': The Temporary Transvestite Film," in Straayer, *Deviant Eyes, Deviant Bodies: Sexual Re-Orientations in Film and Video* (New York: Columbia University Press, 1996), 42–78.

50. Ibid., 74–78.

51. Edna/Billy Foster is the one case I've found in which the performer's gender identity is unclear. See chapter 2.

52. Cromwell, "Passing Women and Female-Bodied Men"; Peter Boag, "Go West Young Man, Go East Young Woman: Searching for the Trans in Western Gender History," *Western Historical Quarterly* 36, no. 4 (2005): 477–97, doi:10.2307/25443237; Erica Rand, *The Ellis Island Snow Globe* (Durham, NC: Duke University Press, 2005), 82–85.

53. Rand, *Ellis Island Snow Globe*, 83.

54. Key works include: Kaier Curtin, *We Can Always Call Them Bulgarians: The Emergence of Lesbians and Gay Men on the American Stage* (Boston: Alyson Publications, 1987); Martha Vicinus, "Turn-of-the-Century Male Impersonation: Rewriting the Romance Plot," in *Sexualities in Victorian Britain*, ed. Andrew H. Miller and James Eli Adams (Indianapolis: Indiana University Press, 1996), 187–213; Lawrence Senelick, "The Evolution of the Male Impersonator on the Nineteenth-Century Popular Stage," *Essays in Theatre* 1, no. 1 (1982): 29–44; Shari Benstock, *Women of the Left Bank: Paris, 1900–1940*, 1st ed. (Austin: University of Texas Press, 1986); Sandra Gilbert and Susan Gubar, *No Man's Land: The Place of the Woman Writer in the Twentieth Century*, vol. 2, *Sexchanges* (New Haven: Yale University Press, 1988).

55. Katie Sutton, *The Masculine Woman in Weimar Germany* (New York: Berghahn Books, 2011), 126–50; Weihong Bao, "From Pearl White to White Rose Woo: Tracing the Vernacular Body of Nuxia in Chinese Silent Cinema, 1927–1931," *Camera Obscura* 20, no. 3 60 (2005): 193.

CHAPTER 1 MOVING PICTURE UPLIFT AND THE FEMALE BOY

1. "Motion Pictures—Amusements," *New York Day*, December 11, 1915. Other positive reviews of Clark's performance include: Kitty Kelly, "Marguerite Clark in Double Role," *Chicago Daily Tribune*, October 29, 1915; "Mark Twain Story Filmed," *Philadelphia Ledger*, November 30, 1915, Robinson Locke Scrapbook, NAFR+, ser. 1, vol. 118, p. 85, BRTC (hereafter Locke Scrapbook); "The Prince and the Pauper," *Variety*, December 3, 1915.

2. "Washington—The Prince and the Pauper," *Detroit News*, December 6, 1915, Locke Scrapbook, NAFR+, ser. 1, vol. 118, p.89.

3. See, for example: Russell Merritt, "Nickelodeon Theatres, 1905–1914: Building an Audience for the Movies," in *The American Film Industry*, ed. Tino Balio (Madison: University of Wisconsin Press, 1985), 83–102; Tom Gunning, *D.W. Griffith and the Origins of American Narrative Film: The Early Years at Biograph* (Urbana: University of Illinois Press, 1991); William Uricchio and Roberta Pearson, *Reframing Culture: The Case of the Vitagraph Quality Films* (Princeton: Princeton University Press, 1993); Eileen Bowser, *The Transformation of Cinema, 1907–1915* (Berkeley: University of California Press, 1994); Shelley Stamp, *Movie-Struck Girls: Women and Motion Picture Culture after the Nickelodeon* (Princeton: Princeton University Press, 2000); Lee Grieveson, *Policing Cinema: Movies and Censorship in Early-Twentieth-Century America* (Berkeley: University of California Press, 2004).

4. Merritt, "Nickelodeon Theatres"; Bowser, *Transformation of Cinema*, 37–47; Miriam Hansen, *Babel and Babylon: Spectatorship in American Silent Film* (Cambridge, MA: Harvard University Press, 1991), 114–20; Stamp, *Movie-Struck Girls*, chap. 1.

5. I have found only three cases of actresses playing non-white male characters, and they all involve white actresses in blackface. Marie Eline played black boys in *The Judge's Story* (Thanhouser, 1911) and *Washington in Danger* (Thanhouser, 1912), and Ethel Lloyd played a "mulatto" valet in *A Florida Enchantment*, which I discuss in chapter 3. I have not found any films in which women of color played male roles.

6. See, for example, Grace R. Clarke, "Girl Boys of the Stage; Actresses Love to Play Them," *Chicago Daily Tribune*, March 14, 1909.

7. An earlier, all-child film version of *Treasure Island* (Fox, 1918) featured nine-year-old Violet Radcliffe as Long John Silver.

8. Straayer, *Deviant Eyes, Deviant Bodies*, 74–78.

9. Mullenix, *Wearing the Breeches*, chap. 3; Sutton, *Masculine Woman in Weimar Germany*, chap. 4.

10. Halberstam, *Female Masculinity*, 46.

11. Alan Dale, "Why an Actress Cannot Wear Trousers Like a Man," *New York Journal*, February 13, 1898, box MWEZ+n.c. 26.791, BRTC.

12. See, for example, William Lee Howard, "Effeminate Men and Masculine Women," *New York Medical Journal* 71 (1900): 687; "New Woman a Freak, Says Bishop Doane," *New York Times*, June 8, 1909.

13. "Actors Not Needed?" *American Journal Examiner*, 1904, box MWEZ+n.c. 26.791, BRTC.

14. "Fascination of Masculine Garb for Ambitious Actresses," *Morning Telegraph*, July 5, 1903, box MWEZ+n.c. 26.791, BRTC.

15. Even in European film, the practice was quite limited. Though Bernhardt made her moving picture debut as Hamlet in a scene filmed for the 1900 Paris Exposition, she played only female roles in subsequent films. Likely inspired by Bernhardt, the Danish superstar Asta Nielsen cast herself as Hamlet in a 1920 German film that she financed and produced with her husband. However, Nielsen changed the story so that Hamlet was a girl disguised as a boy, thus motivating the cross-gender casting. The film was well reviewed by New York critics but did not receive wide release in the United States.

16. William Dean Howells, "The New Taste in Theatricals," *Atlantic Monthly*, May 1869, 642–43. Robert C. Allen discusses the reception of Thompson's burlesque troupe in *Horrible Prettiness: Burlesque and American Culture* (Chapel Hill: University of North Carolina Press, 1991).

17. Dale, "Why an Actress Cannot Wear Trousers Like a Man."

18. "Stage Art's Adamless Eden. Are Men Actors Really Needed?" *New York Herald*, July 10, 1904, box MWEZ+n.c. 26.792, BRTC.

19. Twenty-nine-year-old Violet MacMillan played Ojo the Munchkin Boy in *The Patchwork Girl of Oz* (Oz Film Manufacturing, 1914) and Timothy Noland in *The Magic Cloak of Oz* (Oz Film Manufacturing, 1914). Thirteen-year-old Mildred Harris played Button Bright in *His Majesty the Scarecrow of Oz* (Oz Film Manufacturing, 1914).

20. Richard Abel, *The Red Rooster Scare: Making Cinema American, 1900–1910* (Berkeley: University of California Press, 1999).

21. Mullenix, *Wearing the Breeches*, 130.

22. Laurence Senelick, *The Changing Room: Sex, Drag, and Theatre* (London and New York: Routledge, 2000), 267.

23. "Richmond Hill Theatre," *Spirit of the Times*, April 7, 1832; as quoted in Mullenix, *Wearing the Breeches*, 128.

24. Alan Richardson, "Reluctant Lords and Lame Princes: Engendering the Male Child in Nineteenth-Century Juvenile Fiction," *Children's Literature* 21 (1993): 3–19; Anna Wilson,

"Little Lord Fauntleroy: The Darling of Mothers and the Abomination of a Generation," *American Literary History* 8, no. 2 (1996): 232.

25. Gail Bederman, *Manliness and Civilization: A Cultural History of Gender and Race in the United States, 1880–1917* (Chicago: University of Chicago Press, 1995).

26. Angelica Shirley Carpenter and Jean Shirley, *Frances Hodgson Burnett: Beyond the Secret Garden* (Minneapolis: Lerner Publications, 1990), 67.

27. Wilson, "Little Lord Fauntleroy," 235.

28. "The Prince and the Pauper," *Life*, January 30, 1890.

29. "Amusements," *New York Times*, January 26, 1890.

30. "Elsie Leslie in 'The Prince and the Pauper' at the National," *Washington Post*, January 20, 1891.

31. The Playgoer, "Little Lord Fauntleroy at the Casino," unknown publication, 1903, MWEZ+nc27, 581, Vivian Martin Scrapbook, BRTC.

32. Uricchio and Pearson, *Reframing Culture.*

33. *The Edison Kinetogram*, August 14, 1909, and *Moving Picture World*, August 28, 1909; as quoted in Richard deCordova, *Picture Personalities: The Emergence of the Star System in America* (Urbana: University of Illinois Press, 1990), 42.

34. "Spooner, a Small Cyclone in Knickerbockers, Gives Creditable Performance in New Peggy Play in an Unfamiliar Atmosphere," *New York Telegraph*, May 5, 1903, Cecil Spooner clipping file, BRTC.

35. "The Prince and the Pauper," *Moving Picture World*, August 14, 1909.

36. "The Prince and the Pauper," *New York Dramatic Mirror*, August 14, 1909.

37. "Hansel and Gretel," *New York Dramatic Mirror*, October 23, 1909.

38. "The Thanhouser Kid," *Moving Picture World*, June 4, 1910.

39. *Photoplay*, November 1912; as quoted in "Marie Eline (The Thanhouser Kid)," *Thanhouser Company Film Preservation, Inc.*, accessed June 3, 2011, http://www.thanhouser.org/people/elinem.htm.

40. "Advertisement: The Boy Detective," *New York Clipper*, March 14, 1908; "The Boy Detective," *Moving Picture World*, March 14, 1908.

41. For an extended analysis of Foster's career and performance style, see Laura Horak, "Cross-Dressing in D. W. Griffith's Biograph Films: Humor, Heroics, and Good Bad Boys," in *The Blackwell Companion to D. W. Griffith*, ed. Charlie Keil (West Sussex, U.K.: Wiley-Blackwell, forthcoming).

42. "Comments on the Films," *Moving Picture World*, July 29, 1911.

43. Leslie A. Fiedler, *Love and Death in the American Novel* (New York: Criterion Books, 1960), 270.

44. "Biograph Kids Are Wonderful Girls," *Motography* 12, no. 1 (July 4, 1914): 3–4.

45. In a slight deviation, she also played a "Bobby" in *As in a Looking Glass* and *The Baby and the Stork.*

46. In the *Motography* interview, Edna says that her sister Flora played in *The District Attorney's Conscience*, but *Moving Picture World* credits the part of "Little Billie" to Edna. "Biograph Kids Are Wonderful Girls"; "The District Attorney's Conscience," *Moving Picture World* 12, no. 5 (May 4, 1912): 433.

47. *New York Dramatic Mirror*; as cited by Ben Brewster, "The Baby and the Stork," in *The Griffith Project*, vol. 5, ed. Paolo Cherchi Usai (London: British Film Institute, 2001), 166–68.

48. H.F.H., "Prince Charming," *Moving Picture World*, April 27, 1912; "Letter to the Editor from 'the Quakers,'" *New York Dramatic Mirror*, October 30, 1912, Edna Foster clipping file, BRTC.

49. "Biograph Kids Are Wonderful Girls."

50. "Superb Acting in Dickens Revival," *New York Times*, February 27, 1912.

51. "Nat C. Goodwin as Fagin," *Moving Picture World*, June 1, 1912.

52. Ibid.

53. "Advertisement: Oliver Twist," *Moving Picture World*, June 1, 1912.

54. "Mark Twain Story Filmed."

55. "Prince, Born Here, Back in Hartford," unknown publication, December 1915, Locke Scrapbook, NAFR+, ser. 1, vol. 118, p. 89.

56. G.F.W., "The Prince and the Pauper," *New York Evening Mail*, December 4, 1915, ibid., p. 88.

57. "Washington—The Prince and the Pauper."

58. Kelly, "Marguerite Clark in Double Role."

59. "Mark Twain Story a Movie Thriller," *New York Times*, October 29, 1915.

60. G.F.W., "The Prince and the Pauper."

61. Grace Kingsley, "'Oliver Twist' Vivid," *Los Angeles Times*, December 27, 1916. See also "Oliver Twist," *Motion Picture News*, December 23, 1916; as quoted in Anthony Slide, *Selected Film Criticism, 1912–1920* (Metuchen, NJ: Scarecrow Press, 1982), 188.

62. "Oliver Twist," *Evening Wisconsin*, 1916, NAFR+, ser. 3, vol. 421, p. 95, BRTC.

63. George Blaisdell, "Oliver Twist," *Moving Picture World*, December 23, 1916.

64. "Another Star in Trousers; It's Marie Doro This Time," *Cleveland Leader*, December 16, 1916.

65. Edward Weitzel, "'Treasure Island' Is Finely Produced by Maurice Tourneur for Paramount," *Moving Picture World*, April 24, 1920.

66. "The Screen," *New York Times*, September 16, 1921.

67. Edwin Schallert, "Right from the Front," *Los Angeles Times*, March 30, 1924; Robert E. Sherwood, "The Silent Drama," *Life*, June 26, 1924, 26.

68. Michael Monahan, "The American Peril," *The Forum* 51 (June 1914): 878–79; as quoted in Gaylyn Studlar, *This Mad Masquerade: Stardom and Masculinity in the Jazz Age* (New York: Columbia University Press, 1996), 56.

69. Lenard R. Berlanstein, "Breeches and Breaches: Cross-Dress Theater and the Culture of Gender Ambiguity in Modern France," *Comparative Studies in Society and History* 38, no. 2 (1996): 338–69.

70. Studlar, *This Mad Masquerade*, 41.

71. George Creel, "A 'Close-Up' on Douglas Fairbanks," *Everybody's Magazine*, December 1916, 728; as quoted in Scott Curtis, "Douglas Fairbanks: Icon of Americanism," in *Flickers of Desire: Movie Stars of the 1910s*, ed. Jennifer M. Bean (New Brunswick, NJ: Rutgers University Press, 2011), 230.

72. *Little Lord Fauntleroy* was not adapted to film until 1921 because Burnett refused to sell the rights until then. Carpenter and Shirley, *Frances Hodgson Burnett*, 111.

73. Pickford cross-dressed in *The Call to Arms* (Biograph, 1910), *Wilful Peggy* (Biograph, 1910), *Mistress Nell* (Famous Players, 1915), *Poor Little Peppina* (Famous Players–Mary Pickford Co., 1916), and *Kiki* (Feature Productions, 1931). Her characters both cross-dress and start fights in *Rags* (Famous Players, 1915), *Poor Little Rich Girl* (Mary Pickford Co., 1917), and *The Hoodlum* (Mary Pickford Co., 1919).

74. "Little Lord Fauntleroy," *Exceptional Photoplays*, October 1921.

75. Grace Kingsley, "Flashes," *Los Angeles Times*, November 3, 1921.

76. "Little Lord Fauntleroy," *Variety*, September 23, 1921.

77. George Blaisdell, "Oliver Twist," *Moving Picture World*, December 23, 1916.

78. "The Screen," *New York Times*, September 25, 1921.

79. Charles S. Sewell, "Newest Reviews and Comments," *Moving Picture World*, January 10, 1925.

80. Shelley Stamp, *Lois Weber in Early Hollywood* (Berkeley: University of California Press, 2015), 269–85.

81. "Treasure Island—pressbook," January–April 1920, Paramount Pictures press sheets, MHL.

82. "Shirley Mason," *McClure's*, May 1917, Locke Scrapbook, NAFR+ ser. 2, vol. 275, p. 45.

83. "Girls Will Be Boys!" *Los Angeles Times*, August 27, 1924.

84. Rob King, "The Kid from *The Kid*: Jackie Coogan and the Consolidation of Child Consumerism," *Velvet Light Trap*, no. 48 (Fall 2001): 7.

85. Ibid.

86. Grace Kingsley, "Flashes," *Los Angeles Times*, December 26, 1921.

87. "Lesser Will Destroy Old 'Twist' Film," *Los Angeles Times*, May 21, 1922.

88. Clayton Hamilton, "The Screen," *Theatre Magazine*, January 1923, Betty Bronson Papers (collection 158), box 12, PASC.

89. Sherwood, "The Silent Drama."

90. Schallert, "Right from the Front."

91. Grace Kingsley, "With Jackie on a Holiday," *Los Angeles Times*, March 6, 1921.

92. "Jackie Coogan Coming for $300,000 Contract," *New York Times*, April 9, 1921. See also "Infant Film Star Dotes on Casino," *New York Times*, April 10, 1921.

93. "Jackie Coogan Gives Tips on Keeping Neat," *Sacramento Union*, May 2, 1922, Jackie Coogan Papers, scrapbook 3, MHL; quoted in King, "The Kid from *The Kid*," 12.

94. "Infant Film Star Dotes on Casino." See also "My Girl, Patsy," *Santa Ana Register*, July 29, 1922; quoted in King, "The Kid from *The Kid*," 11.

95. Lea Jacobs, *The Decline of Sentiment: American Film in the 1920s* (Berkeley: University of California Press, 2008); Anke Brouwers, "Feeling Through the Eyes: The Legacy of Sentimentalism in Silent Hollywood—The Films of Mary Pickford and Frances Marion" (Ph.D. diss., Universitiet Antwerpen, 2011).

CHAPTER 2 COWBOY GIRLS AND GIRL SPIES

1. Louis Reeves Harrison, "The 'Bison-101' Headliners," *Moving Picture World*, April 27, 1912.

2. Boag, *Re-Dressing America's Frontier Past*. See also: Sullivan, *From Female to Male*; San Francisco Lesbian and Gay History Project, "She Even Chewed Tobacco"; Boag, "Go West Young Man, Go East Young Woman"; Sears, "All That Glitters"; Clare Sears, *Arresting Dress: Cross-Dressing, Law, and Fascination in Nineteenth-Century San Francisco* (Durham, NC: Duke University Press, 2014).

3. For an in-depth analysis of the American frontier myth, see: Richard Slotkin, *Gunfighter Nation: The Myth of the Frontier in Twentieth-Century America* (New York: Atheneum, 1992); Richard Slotkin, *Regeneration Through Violence: The Mythology of the American Frontier, 1600–1860* (New York: HarperPerennial, 1996).

4. On the contribution of female bodies to American masculinity, see Halberstam, *Female Masculinity*. The most comprehensive of the many books on female soldiers in the Civil War is Richard Hall, *Women on the Civil War Battlefront* (Lawrence: University Press of Kansas, 2006). On the Revolutionary War, see Linda Grant De Pauw, "Women in Combat: The Revolutionary War Experience," *Armed Forces and Society* 7 (Winter 1981): 209–26.

5. Bederman, *Manliness and Civilization*, 186.

6. Abel, *Americanizing the Movies*, 142.

7. "A Western Girl's Sacrifice," *Moving Picture World*, October 22, 1910.

8. Abel, *Red Rooster Scare*; Abel, *Americanizing the Movies*.

9. Abel, *Americanizing the Movies*, 119.

10. Ibid., 118.

11. "The 101 Ranch Cowgirls, Bless 'Em," in Miller Brothers and Arlington 101 Ranch Real Wild West (Wild West show program), August 8–9, 1915; as quoted in Floyd, *She's Got a Gun*, 97. In 1912, the New York Motion Picture Company hired the Miller Brothers 101 Ranch and Wild West Show to appear in its westerns under the brand name Bison 101.

12. Verhoeff, *The West in Early Cinema*, 391.

13. Garber, *Vested Interests*, 17.

14. Verhoeff also counts as cross-dressing those cases in which women assume male roles but not male clothing, such as *The Craven* (Vitagraph, 1912) and *How States Are Made* (Vitagraph, 1912).

15. Verhoeff, *The West in Early Cinema*, 401.

16. Abel, *Americanizing the Movies*, 143, 163.

17. Clarke, "War and the Sexes."

18. Straayer, *Deviant Eyes, Deviant Bodies*, 43–44.

19. Alexandra Stern, "California's Eugenic Landscapes," in Stern, *Eugenic Nation: Faults and Frontiers of Better Breeding in Modern America* (Berkeley: University of California Press, 2005), 120.

20. Matthew Basso, Laura McCall, and Dee Garceau, eds., *Across the Great Divide: Cultures of Manhood in the American West* (New York: Routledge, 2001), 1.

21. Stern, "California's Eugenic Landscapes," 131.

22. As quoted in Abel, *Americanizing the Movies*, 64.

23. Bowser, *Transformation of Cinema*, 162.

24. "Girls in Overalls," *Selig Polyscope Bulletin*, 1904, William Selig Papers, Subject files–General, 25.f-552, Releases 1903–1907, MHL.

25. *The Female Highwayman* may have been inspired by reports of real-life female highway-men: *Daily Bulletin* (Brownwood, TX), February 11, 1907; "Female Highwayman," *New State Tribune* (Muskogee, OK), October 24, 1907. Peter Boag also recounts several reports about women disguising themselves as men to rob stagecoaches or steal horses in *Re-Dressing America's Frontier Past*, 37–38.

26. Bederman, *Manliness and Civilization*, chap. 1.

27. Gauntier claims that she also made a film titled *The Hitherto Unrelated Adventures of the Girl Spy*, but either this film was never released or it came out under a different title. Gene Gauntier, "Blazing the Trail," *Woman's Home Companion*, November 1928, 170.

28. David Mayer, *Stagestruck Filmmaker: D. W. Griffith and the American Theatre* (Iowa City: University of Iowa Press, 2009), 133.

29. Helen M. Greenwald, "Realism on the Opera Stage: Belasco, Puccini, and the California Sunset," in *Opera in Context: Essays on Historical Staging from the Late Renaissance to the Time of Puccini*, ed. Mark A. Radice (Portland, Ore.: Amadeus Press, 1998), 288.

30. On *The Lonely Villa* chase, see Rick Altman, "*The Lonely Villa* and Griffith's Paradigmatic Style," *Quarterly Review of Film Studies* 6, no. 2 (1981): 123–34, doi:10.1080/10509208109361084; Tom Gunning, "Heard Over the Phone: *The Lonely Villa* and the De Lorde Tradition of the Terrors of Technology," *Screen* 32, no. 2 (1991): 184–96, doi:10.1093/screen/32.2.184.

31. Ben Singer, *Melodrama and Modernity: Early Sensational Cinema and Its Contexts* (New York: Columbia University Press, 2001), chap. 8.

32. Gunning, "*The House with Closed Shutters*," 144.

33. Of the surviving films, the only exceptions to this structure are *The Post Telegrapher*, in which the racing girl rides with the cavalry, and *Swords and Hearts*, which cuts back and forth more dynamically between the girl and her pursuers.

34. "The Girl Spy," *Moving Picture World*, May 22, 1909; "A Girl Spy Before Vicksburg," *Moving Picture World*, January 14, 1911.

35. Courtney, *Hollywood Fantasies of Miscegenation*, 46.

36. Ibid., 40–49.

37. "The House with Closed Shutters," *Moving Picture World*, August 20, 1910.

38. "Pauline Cushman, the Federal Spy," *Moving Picture World*, March 22, 1913.

39. Gaylyn Studlar, "Building Mr. Pep: Boy Culture and the Construction of Douglas Fairbanks," in Studlar, *This Mad Masquerade*, 48–65.

40. "Cowboy Argument," *New York Dramatic Mirror*, March 27, 1909.

41. *Girls Will Be Boys* (Essanay, 1910) has a similar structure but does not take place on the frontier. The film seems to be loosely adapted from Arthur Wing Pinero's *The Amazons* (1895). Verhoeff mistakenly identifies this film as a western in *The West in Early Cinema*, 398–99.

42. "When women rule" films include: *When Women Win* (Lubin, 1908), *When Women Rule* (Selig, 1912), and *Her First Flame* (Model Comedy Co., 1919).

43. "The Cow Boy Girls," *Selig Polyscope Bulletin*, 1910, William Selig Papers, Subject files–General, 26.f-554, Releases 1910, MHL.

44. "The Cowboys and the Bachelor Girls," *Moving Picture World*, November 26, 1910.

45. Interestingly, a later comedy, *Rowdy Ann* (Christie, 1919), shows a frontier girl remaking a women's boarding school along the lines of a Western ranch.

46. Charlotte Perkins Gilman, "Bee Wise (1913)," in Gilman, *Herland, The Yellow Wall-Paper, and Selected Writings* (New York: Penguin Books, 1999), 263–71.

47. "The Cow Boy Girls," *Selig Releases*, vol. 1, no. 4, April 29, 1910, William Selig Papers, folder 554, MHL.

48. "The Cow Boy Girls," *Moving Picture World*, May 14, 1910.

49. Mark, "The Cowboys and the Bachelor Girls," *Variety*, December 3, 1910.

50. Jennifer Lynn Peterson, "'The Nation's First Playground': Travel Films and the American West, 1895–1920," in *Virtual Voyages: Cinema and Travel*, ed. Jeffrey Ruoff (Durham, NC: Duke University Press, 2006), 79–98; Jennifer Peterson, *Education in the School of Dreams: Travelogues and Early Nonfiction Film* (Durham, NC: Duke University Press, 2013), 235–67.

51. "The Suffragette; or, The Trials of a Tenderfoot," *Selig Polyscope Bulletin*, 1913, William Selig Papers, Subject files–General, 26-f.557, Releases 1913, MHL.

52. For more on white men appropriating Native American rituals, see Philip Joseph Deloria, *Playing Indian* (New Haven: Yale University Press, 1998).

53. Rebecca J. Mead, *How the Vote Was Won: Woman Suffrage in the Western United States, 1868–1914* (New York: NYU Press, 2006).

54. "Girls with Wild West Show to Help Women Gain Equal Suffrage," *Toledo Blade*, August 17, 1912; from Abel, *Americanizing the Movies*, 307n106. See also Gertrude Price, "Western Girl You Love in the 'Movies' Is a Sure Enough Suffrager," *Des Moines News*, February 11, 1913; as quoted in ibid., 307n104.

55. Singer, *Melodrama and Modernity*; Stamp, *Movie-Struck Girls*; Jennifer M. Bean, "Technologies of Early Stardom and the Extraordinary Body," in *A Feminist Reader in Early Cinema*, ed. Jennifer M. Bean and Diane Negra (Durham, NC: Duke University Press, 2002), 404–43.

56. With the exception of *The Mystery of the Double Cross*, none of these episodes is known to survive.

57. Clarke, "War and the Sexes," 136.

58. Examples include: *Navy Blues* (Christie Film Co., 1923), *A Peaceful Riot* (Standard, 1925), *One Hour Married* (Hal Roach Studios, 1927), *Finders Keepers* (Universal, 1928), *Marianne* (Cosmopolitan, 1929), and *She Goes to War* (Inspiration, 1929).

59. "Make Way for Male Attire," *Los Angeles Times*, September 6, 1914.

60. Richard Willis, "Kathlyn the Intrepid," *Photoplay*, April 1914; as quoted in Bean, "Technologies of Early Stardom," 426.

61. "A Daughter of the Sunlands," *Cosmopolitan*, January 1915.

62. Stamp, *Movie-Struck Girls*, 144.

63. "A Daughter of the Sunlands." Roland capitalized upon her association with the frontier in many serials produced by her own company, Ruth Roland Serials, such as *The Adventures of Ruth* (1919), *Ruth of the Rockies* (1920), *The Timber Queen* (1922), and *White Eagle* (1922).

64. Hilary A. Hallett, "Based on a True Story: New Western Women and the Birth of Hollywood," *Pacific Historical Review* 80, no. 2 (2011): 194. See also Hilary A. Hallett, *Go West, Young Women! The Rise of Early Hollywood* (Berkeley: University of California Press, 2013).

65. Singer, *Melodrama and Modernity*, 223.

66. DeCordova, *Picture Personalities*, 98.

67. Abel, *Americanizing the Movies*, 250–51.

68. Singer, *Melodrama and Modernity*, 224.

69. As cited in Boag, "Go West Young Man," 33.

70. Sears, "All That Glitters"; Dee Garceau, "Nomads, Bunkies, Cross-Dressers, and Family Men: Cowboy Identity and the Gendering of Ranch Work," in Basso, McCall, and Garceau, eds., *Across the Great Divide*, 149–68.

71. Geoffrey Bateman, "The Queer Frontier: Placing the Sexual Imaginary in California, 1868–1915" (PhD diss., University of Colorado at Boulder, 2010), chap. 2; quotation at 132.

72. Boag, *Re-Dressing America's Frontier Past*, chap. 3.

73. "Put Girls In Overalls," *Chicago Daily Tribune*, May 12, 1904.

74. Charlotte Perkins Gilman, *Women and Economics: A Study of the Economic Relation between Men and Women as a Factor in Social Evolution* (Boston: Small, Maynard, & Company, 1898), 56.

75. These include the novels *What Diantha Did* (1910) and *The Crux* (1910) and short stories "Bee Wise" (1913), "Dr. Claire's Place" (1915), and "Joan's Defender" (1916). Bateman, "The Queer Frontier," chap. 4.

76. Vitagraph Company, "Advertisement for Billy the Kid," *New York Dramatic Mirror*, August 9, 1911.

77. See, for example, *Sunny Jane* (Balboa, 1917), *Patsy* (Fox, 1917), *The Sunset Trail* (Lasky, 1917), *Mickey*, and *Rowdy Ann*.

78. Sears, "All That Glitters," 383.

79. Garceau, "Nomads, Bunkies, Cross-Dressers, and Family Men," 154.

80. Sears, "All That Glitters," 385.

81. Theodore Roosevelt, *The Life of Thomas Hart Benton* (Boston: Houghton Mifflin, 1887), 21, as quoted in Bederman, *Manliness and Civilization*, 180–81.

82. Straayer, *Deviant Eyes, Deviant Bodies*, 54.

83. *Fort Wayne Journal-Gazette*, December 8, 1911; *Mansfield News*, December 15, 1911; *Sydney Morning Herald*, March 14, 1912; *Evening Post* (Wellington, New Zealand), March 29, 1912; *Lethbridge Herald*, July 26, 1913; *Daily Courier* (Connellsville, PA), July 25, 1914.

84. "A Range Romance," *Moving Picture World*, December 16, 1911.

85. Siobhan Somerville also makes this point in *Queering the Color Line: Race and the Invention of Homosexuality in American Culture* (Durham, NC: Duke University Press, 2000), chap. 2.

86. Karen J. Leong, "'A Distinct and Antagonistic Race': Constructions of Chinese Manhood in the Exclusionist Debates, 1869–1878," in Basso, McCall, and Garceau, eds., *Across the Great Divide*, 131–48; Sears, "All That Glitters"; Bateman, "The Queer Frontier," chap. 4.

87. *Reno Evening Gazette*, October 22, 1919.

88. "Masonic Auditorium—'The Snow Bird,'" *Washington Post*, June 11, 1916.

89. George T. Pardy, "'The Girl Alaska' Is Unique Production," *Exhibitor's Trade Review*, August 23, 1919. See also *Twin Falls Daily News*, January 22, 1920.

90. "The Screen," *Daily Globe*, January 23, 1920.

91. Woody Register, *The Kid of Coney Island: Fred Thompson and the Rise of American Amusements* (Oxford: Oxford University Press, 2001), 216–27. According to Register, Taliaferro had a romantic friendship with a woman, author Clara Laughlin (226–27).

92. Joshua Lowe, "The Snowbird," *Variety*, June 16, 1916.

93. Harvey F. Thew, "The Snowbird," *Motion Picture News*, June 17, 1916.

94. "The Girl Alaska," *Morning Telegraph*, August 17, 1919. See also "Current Releases Reviewed," *Motography*, June 17, 1916.

95. Leopold Von Sacher-Masoch, *Venus in Furs*, translated by Joachim Neugroschel (1870; repr. London: Penguin Classics, 2010); Anne McClintock, *Imperial Leather: Race, Gender, and Sexuality in the Colonial Contest* (New York: Routledge, 1995), chap. 3.

96. *Daily Mail* (Maryland), May 12, 1916.

97. Allan R. Ellenberger, "Director Edwin Carewe's Grave Is Marked after More than 69 Years," *Hollywoodland: A Site about Hollywood and Its History*, September 12, 2009, http://allanellenberger.com/book-flm-news/edwin-carewe-marked-at-hollywood-forever/; "Miss Del Rio Is Sole Star of 'Ramona,'" *New York Times*, February 19, 1928.

98. On men's last-minute conversion through recognition of a woman's innocence, see Peter Brooks, *The Melodramatic Imagination: Balzac, Henry James, Melodrama, and the Mode of Excess*, 2nd ed. (New Haven: Yale University Press, 1995), 25.

99. "Current Releases Reviewed"; "The Snowbird," *Lowell Sun*, May 15, 1916.

100. "Current Releases Reviewed."

101. "The Snowbird," *Moving Picture World*, June 17, 1916.

102. "Why Players Come from California," *Stage Pictorial*, not dated, Scrapbook *ZAN-T213, reel 56, Billie Burke, BRTC. I believe the article was published in 1911 because it describes the Vitagraph Company as being located in Santa Monica, and the company was located there for only that year.

103. Julius Johnson, "The Girl on the Cover," *Photoplay*, April 1920.

CHAPTER 3 THE DETECTION OF SEXUAL DEVIANCE

1. "A Silly and Vulgar Play," *New York Times*, October 13, 1896.

2. "*A Florida Enchantment*," source unknown, 1896. From *A Florida Enchantment* (play) clipping file, BRTC.

3. "At the Bijou," *Racine Journal-News*, August 16, 1916.

4. See, for example, Lillian Faderman, *Surpassing the Love of Men: Romantic Friendship and Love between Women from the Renaissance to the Present* (New York: Morrow, 1981); Newton, "The Mythic Mannish Lesbian"; Smith-Rosenberg, *Disorderly Conduct*; Lillian Faderman,

Odd Girls and Twilight Lovers: A History of Lesbian Life in Twentieth-Century America (New York: Columbia University Press, 1991); Duggan, *Sapphic Slashers*.

5. Newton, "The Mythic Mannish Lesbian"; Smith-Rosenberg, *Disorderly Conduct*; Faderman, *Odd Girls and Twilight Lovers*.

6. Foucault, *History of Sexuality*, vol.1, *An Introduction*, 42–43.

7. Ibid., 44.

8. Ibid., 43.

9. Ibid., 45.

10. Halperin, *How to Do the History of Homosexuality*, 27–33.

11. Mark Lynn Anderson, *Twilight of the Idols: Hollywood and the Human Sciences in 1920s America* (Berkeley: University of California Press, 2011), 3, 6.

12. Potter, "Queer Timing."

13. Archibald Clavering Gunter and Fergus Redmond, *A Florida Enchantment* (New York: Home Publishing Company, 1892). Though the book's title page credits Fergus Redmond as coauthor, his name is not included in the copyright or contemporary reviews.

14. Ibid., 46.

15. "Theatrical Notes," *San Francisco Chronicle*, December 13, 1896; "Masks and Faces," *National Police Gazette*, December 19, 1896.

16. Sidney Drew's first wife, Gladys Rankin, died on January 9, 1914. Drew and Morrow apparently fell in love on the set of *A Florida Enchantment* and married in July 1915.

17. Siobhan Somerville discusses the differences between the book and the film in *Queering the Color Line*, 39–76.

18. Daniel J. Leab, "The Gamut from A to B: The Image of the Black in Pre-1915 Movies," *Political Science Quarterly* 88, no. 1 (1973): 53–70; Daniel J. Leab, *From Sambo to Superspade: The Black Experience in Motion Pictures* (Boston: Houghton Mifflin, 1975); Thomas Cripps, *Slow Fade to Black: The Negro in American Film, 1900–1942* (New York: Oxford University Press, 1977).

19. Russo, *Celluloid Closet*, 11–13. Laurence Senelick was perhaps the first scholar to write about the play in "Evolution of the Male Impersonator," 38.

20. R. Bruce Brasell, "A Seed for Change: The Engenderment of 'A Florida Enchantment,'" *Cinema Journal* 36, no. 4 (1997): 3–21; Somerville, *Queering the Color Line*, 39–76. Somerville also presented parts of her chapter at the American Studies Association in 1994 and the Society of Cinema and Media Studies in 1995.

21. Somerville, *Queering the Color Line*, 66.

22. On the contradictory codes of representing blackness in transitional-era American cinema, see Jacqueline Stewart, *Migrating to the Movies: Cinema and Black Urban Modernity* (Berkeley: University of California Press, 2005), chap. 2.

23. Somerville, *Queering the Color Line*, 54–55. To support this claim, Somerville cites Lisa Duggan, "The Trials of Alice Mitchell: Sensationalism, Sexology, and the Lesbian Subject in Turn-of-the-Century America," *Signs* 18, no. 4 (1993): 791–814; Sharon Ullman, "'The Twentieth Century Way': Female Impersonation and Sexual Practice in Turn-of-the-Century America," *Journal of the History of Sexuality* 5, no. 4 (1995): 578n9, 587; and Newton, "The Mythic Mannish Lesbian." However, Duggan's research concerns only the years around 1892, and Ullman generalizes based on her analysis of cross-dressed men, who were associated with homosexuality much earlier than cross-dressed women.

24. Somerville, *Queering the Color Line*, 58.

25. Lawrence Levine, *Highbrow/Lowbrow: The Emergence of Cultural Hierarchy in America* (Cambridge, MA: Harvard University Press, 1988).

26. Ibid., 176–77.

27. For arguments that the elites had less power than Levine ascribes to them, see Michael Fellman's review in *American Historical Review* 95, no. 2 (1990): 569–70; and Rob King, "'Made for the Masses with an Appeal to the Classes': The Triangle Film Corporation and the Failure of Highbrow Film Culture," *Cinema Journal* 44, no. 2 (2005): 3–33.

28. Richard Butsch, *The Making of American Audiences: From Stage to Television, 1750–1990* (Cambridge and New York: Cambridge University Press, 2000), 66–80.

29. Gunter biography from James David Hart, *The Popular Book: A History of America's Literary Taste* (Berkeley: University of California Press, 1950), 188; Donald T. Blume, *Ambrose Bierce's Civilians and Soldiers in Context: A Critical Study* (Kent, Ohio: Kent State University Press, 2004), 284; John T. Soister and Henry Nicolella, *American Silent Horror, Science Fiction and Fantasy Feature Films, 1913–1929* (Jefferson, NC: McFarland, 2012), 204.

30. Although a 1938 profile of Gunter claims that *Mr. Barnes* sold more than a million copies in the United States, recent scholarship suggests this number was inflated. Nonetheless, all of Gunter's novels combined probably reached more than a million readers. Hart, *Popular Book,* 188.

31. "Mr. Gunter Playfully Wrestles with a Question of Sex," *The World,* October 18, 1896.

32. "Authors Club Rejects Mr. Gunter," *Chicago Daily Tribune,* May 6, 1894.

33. "*A Florida Enchantment,*" *Rocky Mountain News,* February 7, 1892.

34. "Fresh Literature," *Los Angeles Times,* February 22, 1892.

35. "*A Florida Enchantment,*" 1896; "A Silly and Vulgar Play"; "An Ill-Advised Effort. Gunter's Dramatization of 'A Florida Enchantment' a Mistake," *The World,* October 13, 1896, *A Florida Enchantment* (play) clipping file, BRTC; also "*A Florida Enchantment,*" *The Critic* (New York), October 17, 1896.

36. Michael C. Emery, Edwin Emery, and Nancy L. Roberts, *The Press and America: An Interpretive History of the Mass Media,* 9th ed. (Boston: Allyn and Bacon, 2000), 169.

37. "Broadway Theatre," *New York Times,* October 16, 1888.

38. Paul DiMaggio, "Cultural Entrepreneurship in Nineteenth-Century Boston," in *Rethinking Popular Culture: Contemporary Perspectives in Cultural Studies,* ed. Chandra Mukerji and Michael Schudson (Berkeley: University of California Press, 1991), 377.

39. Allen, *Horrible Prettiness,* 195–240.

40. Senelick, *The Changing Room,* 332.

41. "A Silly and Vulgar Play." See also "*A Florida Enchantment,*" October 17, 1896.

42. "A Silly and Vulgar Play."

43. Ibid.

44. "An Ill-Advised Effort."

45. Edward Gibbon, *The History of the Decline and Fall of the Roman Empire,* 6 vols. (London: Electric Book Co., 2001), originally published between 1776 and 1789. On the ostensible relationship between the decline of the Roman Empire and deviant sexuality, see Norman Vance, "Decadence and the Subversion of Empire," in *Roman Presences: Receptions of Rome in European Culture, 1789–1945,* ed. Catharine Edwards (Cambridge: Cambridge University Press, 1999).

46. "*A Florida Enchantment,*" 1896.

47. "Bisexual, Adj. and N.," *OED Online* (Oxford University Press, December 2012), http://www.oed.com/view/Entry/19448.

48. Sharon Marcus, "Comparative Sapphisms," in *The Literary Channel: The Inter-National Invention of the Novel,* ed. Margaret Cohen and Carolyn Dever (Princeton: Princeton University Press, 2002), 255–56, 259.

49. "Sophistication, N.," *OED Online* (Oxford University Press, September 2013), http://www.oed.com/view/Entry/184765.

50. "Mr. Gunter Can't See It," *New York Herald*, October 14, 1896. See also "An Ill-Advised Effort."

51. "Mr. Gunter Can't See It."

52. "*A Florida Enchantment*," *San Francisco Call*, November 1, 1896.

53. "*A Florida Enchantment*," *Galveston Daily News*, November 1, 1896.

54. "Coming to the Theaters," *Washington Post*, November 26, 1896; "The Stage," *Washington Post*, November 29, 1896; "At the Theaters," *Washington Post*, December 1, 1896.

55. "The Stage."

56. "Hoyt's. —*A Florida Enchantment*," *New York Dramatic Mirror*, October 17, 1896.

57. See, for example, Tom Gunning, "From the Opium Den to the Theatre of Morality: Moral Discourse and Film Process in Early American Cinema," *Art and Text* 30 (September–November 1988); Janet Staiger, *Bad Women: Regulating Sexuality in Early American Cinema* (Minneapolis: University of Minnesota Press, 1995); Stamp, *Movie-Struck Girls*; Grieveson, *Policing Cinema*.

58. The board changed its name to the National Board of Review of Moving Pictures in early 1916. Grieveson, *Policing Cinema*, 25, 194.

59. Policies of the National Board of Review of Motion Pictures Concerning Sex Motion Pictures, box 171, National Board of Review of Motion Pictures Records, 1907–1971, Manuscripts and Archives Division, New York Public Library (hereafter cited as NBRMP Records).

60. "Bulletin 10," October 1, 1914, box 171, NBRMP Records.

61. "Special Bulletin on Motion Picture Comedies," n.d., box 171, NBRMP Records.

62. "Special Bulletin to Motion Picture Producers," n.d., box 171, NBRMP Records.

63. Reviews and Reports of Correspondents, boxes 155–58, NBRMP Records.

64. The board recommended cutting instances of male effeminacy in *Film Exposure* (Triangle, 1917) and *Maggie's First False Step* (Keystone, 1917), and instances of male-to-female cross-dressing in *A Gambler's Gambol* (L-KO, 1916), *Turks and Troubles* (Vitagraph, 1917), and *Fares and Fair Ones* (Vitagraph, 1919). Boxes 155–58, NBRMP Records.

65. The film was *A Trip to Chinatown* (Selig, 1917). Box 158, NBRMP Records.

66. Box 155, NBRMP Records.

67. "*Little Old New York*," *Exceptional Photoplays*, November 1923, and "*Peter Pan*," *Exceptional Photoplays*, December 1924–January 1925, box 161, NBRMP Records.

68. Carroll Smith-Rosenberg, "The Female World of Love and Ritual: Relations between Women in Nineteenth-Century America," *Signs* 1, no. 1 (1975): 1–29; Sherrie A. Inness, "Mashes, Smashes, Crushes, and Raves: Woman-to-Woman Relationships in Popular Women's College Fiction, 1895–1915," *NWSA Journal* 6, no. 1 (1994): 48–68; Marcus, *Between Women*.

69. "*A Florida Enchantment*," *New York Dramatic Mirror*, August 19, 1914.

70. "Vitagraph Theatre Changes Bill. With 'The Painted World' and 'A Florida Enchantment' It Has Strong Program," *Moving Picture World*, August 22, 1914; "Pleasing Variety at Vita Theater," *Motography*, August 29, 1914.

71. "Final Week of *A Florida Enchantment*," *Dramatic News*, September 5, 1914.

72. See, for example, *Syracuse Herald*, October 18, 1914; *Atlanta Constitution*, November 1, 1914; *Oshkosh Daily Northwestern*, November 21, 1914; "Among the Movies," *Gazette & Bulletin* (Williamsport, PA), December 28, 1914; "Mrs. Wiggs at Clunes," *Los Angeles Times*, January 10, 1915; *Daily Republican* (Rushville, IN), January 22, 1915; *Warren Evening Times* (PA), February 3, 1915; "At the Bijou"; *Ogden Examiner*, December 9, 1916.

73. "*A Florida Enchantment*," August 19, 1914.

74. P. F. Leahy, "Letter to the Editor," *Motion Picture Magazine*, August 1915.

75. Brasell, "A Seed for Change," 12; Somerville, *Queering the Color Line*, 57.

76. Sime Silverman, "*A Florida Enchantment*," *Variety*, August 14, 1914.

77. "Slanguage Dictionary," *Variety*, September 2013, http://variety.com/static-pages/slanguage-dictionary/.

78. Quoted text from the Greater San Francisco and Oakland Cloak Companies, *San Francisco Chronicle*, August 9, 1914; Hecht and Company, *Washington Post*, August 9, 1914. See also: New York Racket Store, *Lock Haven Express*, July 14, 1914; Greene's, *Chicago Daily Tribune*, August 9, 1914; H. C. Capwell Co. Basement Store, *Oakland Tribune*, August 11, 1914; J. W. Robinson Co., *Los Angeles Times*, August 13, 1914; The Killian Co., *Cedar Rapids Republican*, September 10, 1914; Denecke's, the Big "Style" Store of Iowa, *Evening Gazette*, September 15, 1914; Hawisher-English Company, *Lima Daily News*, September 28, 1914.

79. "America's Leading Out-of-Doors Girl," *Chicago Daily Tribune*, August 16, 1914.

80. Ellis and Symonds, *Sexual Inversion*, 87–88.

81. Newton, "The Mythic Mannish Lesbian"; Smith-Rosenberg, *Disorderly Conduct*.

82. The first usage captured in Google Books Ngram Viewer is in 1943, but it does not seem to have become common until the 1980s and 1990s.

83. John Lyly, *Gallathea* (London: Printed by John Charlwoode for the widdow Broome, 1592); Ovid, *Metamorphoses*, trans. David Raeburn (London: Penguin, 2004), 372–79.

84. Gaddis, "He, She, or It," *Motion Picture Magazine*, July 1917.

85. Rodger, "Male Impersonation," 258.

86. Vitagraph Company of America, "*A Florida Enchantment*," *Vitagraph Bulletin of Life Portrayals*, September 1, 1914, 6; as quoted in Somerville, *Queering the Color Line*, 56.

87. Justus Dickinson, "Putting One's Best Face Forward," *The Green Book*, December 1914, 1016, Edith Storey clipping file, MHL.

88. Senelick, "Evolution of the Male Impersonator," 38.

89. Uricchio and Pearson, *Reframing Culture*.

90. Somerville, *Queering the Color Line*, 49–52.

91. Vitagraph Company, "Why Did We Open The Vitagraph Theatre," *Variety*, March 6, 1914; Vitagraph Company, "Why Did We Open The Vitagraph Theatre," *Moving Picture World*, March 7, 1914; Vitagraph Company, "Why Did We Open The Vitagraph Theatre," *Motography*, March 21, 1914.

92. Library Theatre, *Warren Evening Times*, February 3, 1915.

93. Rob King, *The Fun Factory: The Keystone Film Company and the Emergence of Mass Culture* (Berkeley: University of California Press, 2009), 106.

94. "This Is the Life," *Variety*, July 17, 1914.

95. Untitled memo, n.d., box 171, NBRMP Records.

96. "Edith Storey," *Motion Pictures*, December 1914, Robinson Locke Collection, ser. 4, envelope 2185, BRTC.

97. Dickinson, "Putting One's Best Face Forward," 1016.

98. Bowser, *Transformation of Cinema*, 162–65.

99. Somerville, *Queering the Color Line*, 47.

100. Thomas Graham, "Flagler's Magnificent Hotel Ponce de Leon," *Florida Historical Quarterly* 54, no. 1 (1975): 1–17, doi:10.2307/30155893.

101. "Among the Movies."

102. Somerville, *Queering the Color Line*, 51; Marguerite Bertsch, *How to Write for Moving Pictures: A Manual of Instruction and Information* (New York: George H. Doran Company, 1917), http://babel.hathitrust.org/cgi/pt?id=mdp.39015003765362.

103. Bertsch, *How to Write for Moving Pictures*, 264.

104. Ibid., 272–75.

CHAPTER 4 ENTER THE LESBIAN

1. Richard Dyer, "Seen to Be Believed: Some Problems in the Representation of Gay People as Typical," in Dyer, *The Matter of Images: Essays on Representation*, 2nd ed. (London and New York: Routledge, 2002); Harry M. Benshoff and Sean Griffin, *Queer Images: A History of Gay and Lesbian Film in America* (Lanham, MD: Rowman and Littlefield, 2006).

2. Barrios, *Screened Out*; Benshoff and Griffin, *Queer Images*.

3. This objection has also been raised by Judith Halberstam and Nan Boyd. See Halberstam, *Female Masculinity*; Boyd, "Materiality of Gender."

4. Laura Doan, *Fashioning Sapphism: The Origins of a Modern English Lesbian Culture* (New York: Columbia University Press, 2001). See also: Alison Oram, *Her Husband Was a Woman! Women's Gender-Crossing in Modern British Popular Culture* (London: Routledge, 2007); Deborah Cohler, *Citizen, Invert, Queer: Lesbianism and War in Early Twentieth-Century Britain* (Minneapolis: University of Minnesota Press, 2010).

5. Philip Meyer, *The Vanishing Newspaper: Saving Journalism in the Information Age* (Columbia: University of Missouri Press, 2009), 9.

6. "Adjusting for Ticket Price Inflation," *Box Office Mojo*, http://www.boxofficemojo.com/about/adjuster.htm (accessed May 25, 2014).

7. Chon Noriega also makes this point in "'Something's Missing Here!': Homosexuality and Film Reviews during the Production Code Era, 1934–1962," *Cinema Journal* 30, no. 1 (1990): 20–41.

8. Frederick Lewis Allen, *Only Yesterday: An Informal History of the 1920's* (1931; repr. New York: Wiley, 1997), 133.

9. On the rise of "sophistication," see Faye Hammill, *Sophistication: A Literary and Cultural History* (Liverpool: Liverpool University Press, 2010).

10. Though Paul Poiret introduced "harem pants" into Parisian haute couture in 1913, they did not become part of mainstream women's fashion.

11. The term "garçonne" was popularized by Victor Margueritte's 1922 novel of that name.

12. "Girls Will Be Boys," *Los Angeles Times*, July 21, 1925.

13. Laura Doan makes this point in the British context in *Fashioning Sapphism*.

14. This convenient coincidence was noted by journalists at the time; see Rose Pelswick, "New Films Find Feminine Stars in Male Garb," *New York City American*, September 9, 1923, *Little Old New York* scrapbook, MFL n.c. 1664, BRTC.

15. "Girls Will Be Boys!"

16. "Girls Will Be Boys," *Picture-Play Magazine*, July 1926.

17. Madeline Mahlon, "On with the Pants," *Photoplay*, July 1926.

18. Mahlon also forgot that Marion Davies had cross-dressed in *Runaway Romany* (Ardsley Art Film, 1917), six years before *Little Old New York*.

19. Pelswick, "New Films Find Feminine Stars in Male Garb."

20. "Girls Will Be Boys!"

21. Andrea Weiss, *Paris Was a Woman: Portraits from the Left Bank* (San Francisco: Harper San Francisco, 1995); Benstock, *Women of the Left Bank*; Tirza True Latimer, *Women Together/Women Apart: Portraits of Lesbian Paris* (New Brunswick, NJ: Rutgers University Press, 2005).

22. Eric Garber, "A Spectacle in Color: The Lesbian and Gay Subculture of Jazz Age Harlem," in *Hidden from History: Reclaiming the Gay and Lesbian Past*, ed. Martin Duberman, Martha Vicinus, and George Chauncey (New York: New American Library, 1989), 318–31.

23. Chauncey, *Gay New York*, 301–30; Chad C. Heap, *Slumming: Sexual and Racial Encounters in American Nightlife, 1885–1940* (Chicago: University of Chicago Press, 2009), 231–76.

24. F. Andrew Hanssen, "Revenue Sharing and the Coming of Sound," in *Economic History of Film*, ed. Michael Pokorny and John Sedgwick (New York: Routledge, 2004), 92.

25. George Chauncey, "From Sexual Inversion to Homosexuality: The Changing Medical Conceptualization of Female 'Deviance,'" in *Passion and Power: Sexuality in History*, ed. Kathy Peiss, Christina Simmons, and Robert Padgug (Philadelphia: Temple University Press, 1989).

26. Lisa Walker, *Looking Like What You Are: Sexual Style, Race, and Lesbian Identity* (New York: NYU Press, 2001).

27. Gavin Lambert, *Nazimova: A Biography* (New York: Alfred A. Knopf, 1997), 201; Thomas Slater, "Moving the Margins to the Mainstream: June Mathis's Work in American Silent Film," *International Journal of the Humanities* 4, no. 2 (2007): 82.

28. Katherine Lipke, "Most Responsible Job Ever Held by a Woman," *Los Angeles Times*, June 3, 1923.

29. Larry Billman, *Film Choreographers and Dance Directors: An Illustrated Biographical Encyclopedia, with a History and Filmographies, 1893 Through 1995* (Jefferson, NC: McFarland & Company, 1997), 554.

30. Alexandre Jean Baptiste Parent-Duchatelet, *De la prostitution dans la ville de Paris consideree sous la rapport de l'hygiene publique* (Brussels: Hauman, Cattoir, 1836); Ellis and Symonds, *Sexual Inversion*.

31. See, for example, *Cabiria* (Itala, 1914), *Intolerance* (Triangle, 1916), and *The Ten Commandments* (Paramount, 1923).

32. Curtin, *We Can Always Call Them Bulgarians*, 25.

33. Charles A. Madison, "Scholom Asch," *Poet Lore* (Winter 1923). On the play's European reception, see Curtin, *We Can Always Call Them Bulgarians*, 28–29.

34. As quoted in Curtin, *We Can Always Call Them Bulgarians*, 29.

35. Vicinus, *Intimate Friends*, 1–60.

36. Jay Leyda reports that this film, titled *Bog mesti* in Russian, was 835 meters long. Two other films titled *The God of Vengeance* (a British 1913 Duskes film and a U.S. 1914 Chariot film) do not seem to be related to Asch's play. Leyda, *Kino: A History of the Russian and Soviet Film* (London: Allen, 1960), 416.

37. Quoted in Curtin, *We Can Always Call Them Bulgarians*, 29–31.

38. Ibid., 33.

39. "'God of Vengeance' Players Convicted," *New York Times*, May 24, 1923.

40. Dawn B. Sova, *Banned Plays: Censorship Histories of 125 Stage Dramas* (New York: Facts on File, 2004), 103.

41. Metcalfe, "The Theatre. The Dissemination of Slime," *Wall Street Journal*, February 5, 1923.

42. Metcalfe, "The 'God of Vengeance' Verdict," *Wall Street Journal*, May 26, 1923.

43. Richard Polenberg, *Fighting Faiths: The Abrams Case, the Supreme Court, and Free Speech* (Ithaca, NY: Cornell University Press, 1999), 76.

44. Sime Silverman, "Most Offensive Line Ever Uttered on Stage Is Uttered by 'The God of Vengeance,'" *San Antonio Evening News*, February 24, 1923; "New York Play Called Obscene,"

Chicago Daily Tribune, March 7, 1923; "Arraign Producer and Cast," *Washington Post*, March 8, 1923; "Convicted for Playing in 'God of Vengeance,'" *Chicago Daily Tribune*, May 24, 1923; "Entire Cast Convicted," *Los Angeles Times*, May 24, 1923; "Players Guilty of Immorality in N.Y. Drama," *Chicago Daily Tribune*, May 24, 1923; "Show Production Is Held Immoral by New York Jury," *Atlanta Constitution*, May 24, 1923.

45. Metcalfe, "Doctors Disagree," *Wall Street Journal*, June 2, 1923.

46. Geoffrey F. Morgan, "Must the Theater Be Censored?" *The Billboard*, July 12, 1924.

47. Doan, *Fashioning Sapphism*, 102–10.

48. This photograph of Radclyffe Hall and Una Troubridge was taken *after* the film came out, so there could not have been a direct influence, but the similarity of the two images suggests that the connection between Hall's style and lesbianism was already at least partly established by 1926. Either Hall was known as an invert before *Well* or her style was already identified by some as a lesbian look.

49. Heather Addison, "'Do Go On!': Performing Gender in *The Clinging Vine* (1926)," *Quarterly Review of Film and Video* 25, no. 4 (2008): 338; Johanna Schmertz, "The Leatrice Joy Bob: *The Clinging Vine* and Gender's Cutting Edge," in *Researching Women in Silent Cinema: New Findings and Perspectives*, ed. Monica Dall'Asta, Victoria Harriet Duckett, and Lucia Tralli (Bologna: Dipartimento delle Arti—DAR, Alma Mater Studiorum Università di Bologna, 2013), 405.

50. Schmertz, "The Leatrice Joy Bob."

51. For example: "Leatrice Joy," *Photoplay*, August 1926.

52. *Made for Love* (1926), *Eve's Leaves* (1926), *The Clinging Vine* (1926), *For Alimony Only* (1926), and *Vanity* (1927)

53. Schmertz, "The Leatrice Joy Bob," 403.

54. "The Lark of the Month," *Photoplay*, July 1926. *Photoplay* had described short-haired actress Bessie Love having a similar experience six months earlier: "The Lark of the Month," *Photoplay*, January 1926.

55. "Going, Going, Gone!" *Photoplay*, August 1926.

56. "It's a Girl!" *Motion Picture Magazine*, September 1926.

57. Sears had also written the book and lyrics for a Broadway musical, *The Lady Billy* (1920), in which a woman singer passes herself off as a boy soprano. Schmertz, "The Leatrice Joy Bob," 403.

58. Joan Riviere, "Womanliness as a Masquerade," *International Journal of Psychoanalysis* 10 (1929): 303–13.

59. Johanna Schmertz, "'Who Dressed A.B. Like a Girl?': Leatrice Joy's Performances of Gender in *The Clinging Vine* (1926)" (paper presented at Women and the Silent Screen VI, Bologna, Italy, June 24, 2010).

60. "*The Clinging Vine*," *Photoplay*, September 1926.

61. Addison, "Do Go On!"; Karen Ward Mahar, "Working Girls: The Masculinization of American Business in Film and Advice Literature in the 1920s" (paper presented at Women and the Silent Screen V, Stockholm, June 13, 2008).

62. Barrios, *Screened Out*, 33. See also Benshoff and Griffin, *Queer Images*, 26.

63. "Film Estimates," *The Educational Screen*, November 1926.

64. "*The Clinging Vine*," *Film Daily*, August 8, 1926.

65. "*The Clinging Vine*," *Picture Play Magazine*, October 1926, http://www.silentsaregolden.com/clingingvinereview.html.

66. Fred Schrader, "*The Clinging Vine*," *Variety*, July 21, 1926.

67. Schmertz, "The Leatrice Joy Bob," 407–8.

68. Ullman, "The Twentieth Century Way."

69. Mayme Ober Peak, "Only Woman Movie Director," *Boston Sunday Globe*, December 2, 1928, Dorothy Arzner scrapbook, box 4, Dorothy Arzner Papers, PASC (hereafter cited as Arzner scrapbook). See also Ann Sylvester, "Make Way for the Ladies!" *Picture Play Magazine*, December 1927; Grace Kingsley, "Leave Sex Out, Says Director," *Los Angeles Times*, September 18, 1927, Arzner scrapbook.

70. For example, "Woman Among the Mighty," *New York World Telegram*, November 21, 1936, Arzner scrapbook; R. Ewart Williams, "Film for Women Made by Women," *Film Pictorial*, March 6, 1937.

71. Mayne, *Directed by Dorothy Arzner*.

72. Curtin, *We Can Always Call Them Bulgarians*, 50.

73. "Gilbert Miller Preparing to Defy Mrs. Loomis by Producing 'The Prisoner,'" *New York World*, August 20, 1926; as quoted in Curtin, *We Can Always Call Them Bulgarians*, 44.

74. "Notable Audience Hails 'Captive' at Premiere," *New York Herald Tribune*, September 30, 1926, *The Captive* clipping file, BRTC.

75. Édouard Bourdet, *The Captive*, trans. Arthur Hornblow Jr. (New York: Brentano's, 1926), 150.

76. Ibid., 149–50.

77. Source unknown, ca. September 1926, *The Captive* clipping file, BRTC.

78. "Winnowing Dirt from Cleanliness," *Pittsburgh Press*, February 27, 1927, see also Percy Hammond, "The Theaters. 'The Captive,' an Expert Play, Dealing with a Subject Too Odd for a Polite Reviewer," *New York Herald Tribune*, September 30, 1926, *The Captive* clipping file, BRTC.

79. Don Wiley, "Relentless and Absorbing Tragedy in 'The Captive,'" *San Francisco News*, 1928, MWEZ+ n.c. 18.866, Ann Davis collection, BRTC.

80. Alexander Woollcott, "The Stage," *New York World*, September 30, 1926, *The Captive* clipping file, BRTC.

81. Terry Castle, *The Apparitional Lesbian: Female Homosexuality and Modern Culture* (New York: Columbia University Press, 1993).

82. Bourdet, *The Captive*, 149.

83. Eleanor Barnes, "'The Captive' Good Play for Medical Student," *Los Angeles Illustrated Daily News,*" March 22, 1928, MWEZ+ n.c., Ann Davis collection, BRTC.

84. *The Language of Flowers: An Alphabet of Floral Emblems* (London, Edinburgh, and New York: T. Nelson and Sons, 1858), 16.

85. *The Sappho Companion*, ed. Margaret Reynolds (London: Chatto & Windus, 2000), 362.

86. Alexander Woollcott, "The Stage"; "The Premiere," *Brooklyn Citizen*, September 30, 1926.

87. Ibos, publication unknown, 1926, *The Captive* clipping file, BRTC.

88. Ibid.; Edwin Schallert, "Bourdet Play at the Egan," *Los Angeles Times*, February 1, 1928; Barnes, "'The Captive' Good Play for Medical Student."

89. This column appeared on November 4, 1931 in many newspapers, including *The Day* (New London, CT), the *Salt Lake Tribune*, and the *San Antonio Light*.

90. Charles B. Driscoll, *The Life of O. O. McIntyre* (New York: Greystone Press, 1938), 20.

91. Ray W. Harper, "Footlight Reflections," *Brooklyn Citizen*, October 3, 1926. See also "'The Captive' at Empire," *Brooklyn Standard*, September 30, 1926; as quoted in Curtin, *We Can Always Call Them Bulgarians*, 53.

92. "The Captive," *Variety*, October 8, 1926, *The Captive* clipping file, BRTC.

93. Percy Hammond, "Hammond and the Ladies," *Kansas City Star*, October 10, 1926.

94. Ann Peppard White, "Gotham Plays in Resume," *Kansas City Star*, January 9, 1927. The article introduces White as "a Kansas Citian who takes a deep interest in the theater," suggesting that she was not a professional critic.

95. Gilbert W. Gabriel, "'The Captive' from Paris," *New York Sun*, September 30, 1926.

96. Marcus, "Comparative Sapphisms."

97. Hammond, "Hammond and the Ladies."

98. Gabriel, "'The Captive' from Paris."

99. "*The Captive*," October 8, 1926. *Variety* also published an article in 1925 listing twenty Greenwich Village establishments that catered to "the temperamental set." *Greenwich Village: Culture and Counterculture*, ed. Rick Beard and Leslie Cohen Berlowitz (New Brunswick, NJ: Rutgers University Press in association with the Museum of the City of New York, 1993), 364.

100. Heap, *Slumming*, 235.

101. O. O. McIntyre, "Philosophy and Piffle!" *Charleston Gazette*, November 7, 1926.

102. O. O. McIntyre, "New York Day by Day," *Piqua Call*, November 16, 1926.

103. C.L.J., "Miss Davis Superb in Difficult Role," *Wilmington Morning News*, 1928, MWEZ+ n.c. 18.866, Ann Davis collection, BRTC; Len G. Shaw, "Shubert-Detroit. *The Captive*," *Detroit Free Press*, May 28, 1928, *The Captive* clipping file, BRTC; "New York Play Jury Acquits 'The Captive,'" *Boston Herald*, November 15, 1926, ibid.; Bradley W. Trent, "Sex Play Not among 'Flop' in Hard Year," *Davenport Democrat and Leader*, December 28, 1926.

104. Ibos; McIntyre, "New York Day by Day," November 16, 1926; publication unknown, 1926, *The Captive* clipping file, BRTC.

105. Ibos.

106. McIntyre, "New York Day by Day," November 16, 1926.

107. "Arrest 40 in N.Y. Stage Clean-Up," *The Bee* (Danville, VA), February 10, 1927.

108. J. Brooks Atkinson, "Tragedy from the French," *New York Times*, September 30, 1926, *The Captive* clipping file, BRTC; Frank Vreeland, "The Marble Bride," *New York Telegram*, September 30, 1926, ibid.

109. Stark Young, "Three Plays," *New Republic*, November 10, 1926, 323–24; publication unknown, 1926, *The Captive* clipping file, BRTC.

110. "Girls' Schools Upheld 'Captive' Says Shostac," *New York Herald Tribune*, February 21, 1927, *The Captive* clipping file, BRTC.

111. Vreeland, "Marble Bride."

112. William A. White, "To Fear—or to Understand," *New York Herald Tribune*, January 30, 1927, *The Captive* clipping file, BRTC.

113. Young, "Three Plays."

114. "*The Captive*," *New Yorker*, October 9, 1926, *The Captive* clipping file, BRTC.

115. Curtin, *We Can Always Call Them Bulgarians*, 91–102; Marybeth Hamilton, "Mae West Live: *SEX, The Drag*, and 1920s Broadway," *TDR* 36, no. 4 (1992): 82–100, doi:10.2307/1146217.

116. Curtin, *We Can Always Call Them Bulgarians*, 87; Daniel Hurewitz, "Banned on Broadway but Coming to a Theater Near You: *The Captive* and Rethinking the Breadth of American Anti-Lesbian Hostility in the 1920s and '30s," *Journal of Lesbian Studies* 17, no. 1 (2013): 47–51.

117. "Jury to Decide 'The Captive's' Future To-Day," *New York Herald Tribune*, November 15, 1926, *The Captive* clipping file, BRTC; "New York Play Jury Acquits 'The Captive'"; Percy Hammond, "'The Captive' Draws Not Guilty Verdict, and Rialto Rejoices," *Syracuse Herald*, November 21, 1926. Six of the twelve jurors found the play "objectionable to morals," but the jury required nine "no" votes to find a play guilty.

118. John H. Houchin, *Censorship of the American Theatre in the Twentieth Century* (Cambridge: Cambridge University Press, 2003), 98.

119. William Randolph Hearst, "The Best Treatment for Unclean Spoken Plays Is to Apply the Methods Which Protected Motion Pictures," *New York American*, December 30, 1926.

120. Ibid.; as quoted in Curtin, *We Can Always Call Them Bulgarians*, 61.

121. "Don't Relax Mayor! Wipe Out Those Evil Plays Now Menacing Future of Theatre," *New York American*, January 26, 1927.

122. "Liveright Decides to Hold Up 'Captive,'" *New York Times*, February 19, 1927.

123. Curtin, *We Can Always Call Them Bulgarians*, 99.

124. "Girls' Schools Upheld 'Captive' Says Shostac." Warner Fabian was a pseudonym adopted by journalist and author Samuel Hopkins Adams.

125. Arthur Garfield Hays, *Let Freedom Ring* (New York: Boni & Liveright, 1928).

126. As quoted in Curtin, *We Can Always Call Them Bulgarians*, 100.

127. "Horace Liveright Clatters Down B'Way on Rosintante," *New York Post*, February 17, 1927; as quoted in Curtin, *We Can Always Call Them Bulgarians*, 98.

128. "Movies and Morals," *The New Yorker*, March 5, 1927.

129. James R. Quirk, "Close-Ups and Long-Shots," *Photoplay*, April 1927.

130. Ralph Wilk, "A Little from the Lots," *Film Daily*, April 12, 1928.

131. "Trevor to Coast," *Film Daily*, November 28, 1926.

132. "Hornblow in Charge of Goldwyn Studio," *Film Daily*, October 19, 1927. See also "Hornblow Is Production Aide to Sam Goldwyn," *Motion Picture News*, March 18, 1927; "News and Gossip of All the Studios," *Photoplay*, June 1927.

133. Sam Zolotow, "Hornblow Plans Return to Stage," *New York Times*, January 9, 1959; "Hornblow Returning," *Monroe Morning World* (Louisiana), March 29, 1959; "Too Raw for B'way 1927, 'The Captive' Goes Film, Plus New Stage Version," *Variety*, September 9, 1959; "'The Captive' Will Try It Again," *Ukiah Daily Journal* (California), September 17, 1959.

134. Ruth Vasey, *The World According to Hollywood, 1918–1939* (Madison: University of Wisconsin Press, 1997), 47–49.

135. The text of the "Don'ts and Be Carefuls" is reprinted in Jon Lewis, *Hollywood v. Hard Core: How the Struggle Over Censorship Saved the Modern Film Industry* (New York: NYU Press, 2000), 301–2.

136. On state censorship codes, see Laura Wittern-Keller, *Freedom of the Screen: Legal Challenges to State Film Censorship, 1915–1981* (Lexington: University Press of Kentucky, 2008). The text of the "Thirteen Points" is reprinted in Garth Jowett, *Film, the Democratic Art* (Boston: Little, Brown, 1985), 465.

137. *Wings* won "Outstanding Picture" of 1927/1928 and *Sunrise* won "Unique and Artistic Production."

138. Thomas Gladysz, "*Wings*, 1927" (essay written for the San Francisco Silent Film Festival, July 2012), http://silentfilm.org/archive/wings-2012.

139. Benstock, *Women of the Left Bank*; Weiss, *Paris Was a Woman*.

140. Doan, *Fashioning Sapphism*, 113.

141. "'The Crystal Cup' with Mackaill," *Motion Picture News*, May 1, 1926.

142. American Film Institute, "*The Crystal Cup*," *AFI Catalog of Feature Films*, http://www.afi.com/members/catalog/DetailView.aspx?s=&Movie=3523.

143. "The Shadow Stage," *Photoplay*, October 1927.

144. "Brief Reviews of Current Pictures," *Photoplay*, December 1927.

145. *Motion Picture News*, November 25, 1927; as quoted in Barrios, *Screened Out*, 34.

146. *Film Daily*, October 9, 1927; Phil M. Daly, "And That's That," *Film Daily*, October 11, 1927.

147. "The Film Estimates," *The Educational Screen*, November 1927. See also "Newspaper Opinions on New Pictures," *Motion Picture News*, January 7, 1928; "Newspaper Opinions on New Pictures," *Motion Picture News*, January 14, 1928.

148. "Key City Reports," *Motion Picture News*, February 4, 1928.

149. "The Shadow Stage."

150. Hurewitz, "Banned on Broadway but Coming to a Theater Near You," 46.

151. *Baltimore American*, February 1928; as quoted in Hurewitz, "Banned on Broadway but Coming to a Theater Near You," 46.

152. *Baltimore News*, February 1928; as quoted in Hurewitz, "Banned on Broadway but Coming to a Theater Near You," 46.

153. Hurewitz, "Banned on Broadway but Coming to a Theater Near You," 46.

154. Ibid.

155. Ibid., 48.

156. Ibid.

157. Ibid., 50.

158. "'Captive' Given Private Exhibit," 1928, MWEZ+ n.c. 18.866, Ann Davis collection, BRTC.

159. Hurewitz, "Banned on Broadway but Coming to a Theater Near You," 51.

160. Ibid., 52.

161. Ibid., 52–53.

162. As quoted in Curtin, *We Can Always Call Them Bulgarians*, 112–13.

163. Nancy Sahli, "Smashing: Women's Relationships before the Fall," *Chrysalis* 8 (1979): 17–27; Lillian Faderman, "Love between Women in 1928: Why Progressivism Is Not Always Progress," *Lodestar Quarterly*, no. 13 (Spring 2005), http://lodestarquarterly.com/work/281/.

164. Unknown publication, 1928, *The Captive* clipping file, BRTC.

165. Warner Fabian, *Unforbidden Fruit* (New York: Boni and Liveright, 1928), 21, 63–65, 310–11.

166. Wanda Fraiken Neff, *We Sing Diana* (Boston and New York: Houghton Mifflin, 1928), 199.

167. Edith H. Walton, "Post-War Novels—and Others," *The Bookman*, May 1928.

168. Louise A. DeSalvo, "Lighting the Cave: The Relationship between Vita Sackville-West and Virginia Woolf," *Signs* 8, no. 2 (1982): 204.

169. Susan Sniader Lanser, "Introduction," in [Djuna Barnes], *Ladies Almanack* (New York: NYU Press, 1992), xviii. It seems that the book was not published publicly until 1972.

170. "Keeping Up in the World of Books," *Charleston Daily Mail*, September 30, 1928.

171. See, for example, "Title Deceiving in Mackenzie's Latest Offering," *Mansfield News*, September 13, 1928.

172. Fanny Butcher, "You Either Like 'Orlando' or It Stirs Your Ire," *Chicago Daily Tribune*, December 15, 1928.

173. Doan, *Fashioning Sapphism*, 144–63.

174. Radclyffe Hall, *The Well of Loneliness* (1928; repr., New York: Anchor Books, 1990), 13.

175. Ibid., 20.

176. Ibid., 26.

177. Ibid., 163.

178. Ibid., 437.

179. As quoted in Laura Doan and Jay Prosser, eds., *Palatable Poison: Critical Perspectives on "The Well of Loneliness"* (New York: Columbia University Press, 2001), 38.

180. Doan, *Fashioning Sapphism*, xiv–xv, 123–25.

181. It is not clear how widely Hall's photograph circulated in the United States. The only U.S. newspaper with a photograph of Hall I have found is the *Chicago Tribune*, which printed it at least three times: Frank Swinnerton, "New English Novel Is Writers' Picture of Publisher's Idea," *Chicago Daily Tribune*, August 11, 1928; Fanny Butcher, "Radclyffe Hall Book Written in Fine English," *Chicago Daily Tribune*, December 29, 1928; Fanny Butcher, "Another Book by Radclyffe Hall Out Today," *Chicago Daily Tribune*, April 25, 1932.

182. Leslie A. Taylor, "'I Made Up My Mind to Get It': The American Trial of 'The Well of Loneliness,' New York City, 1928–1929," *Journal of the History of Sexuality* 10, no. 2 (2001).

183. Ibid., 261.

184. *Hutchinson News*, January 25, 1929; *Southtown Economist*, April 24, 1929.

185. Taylor, "I Made Up My Mind to Get It," 269–70.

186. Ibid., 260–61.

187. Ibid., 269.

188. Ibid., 270.

189. Ibid., 281. As Taylor points out, the book was not actually ruled obscene at this point, contrary to the reporting in "Novel 'Loneliness' Is Ruled Obscene," *New York Times*, February 22, 1929.

190. "'Well of Loneliness' Cleared in Court Here," *New York Times*, April 20, 1929.

191. Taylor, "I Made Up My Mind to Get It," 284.

192. Butcher, "Radclyffe Hall Book Written in Fine English"; F.B., "Again Censor's Game Is Played to Tune of Greater Selling," *Chicago Daily Tribune*, January 19, 1929; C.M.W., "The Cherry Tree," *Cedar Rapids Tribune*, February 1, 1929; M.G.P., "Saturday Book Review: *The Well of Loneliness*," *Hattiesburg American*, April 29, 1929; D.S.O., "This Is Book That Baffles and Repulses," *Decatur Herald*, May 26, 1929; Stanley E. Babb, "Book News and Reviews: A Novel by Radclyffe Hall," *Galveston Daily News*, August 18, 1929; "Dr. Thompson Addresses Book Club," *Baltimore Afro-American*, March 1, 1930; Eugene Lohrke, "Book Treats of Homosexuality," *Charleston Gazette*, August 10, 1930; Palestine Wells, "Book-a-Month Clubs Becoming Popular," *Baltimore Afro-American*, March 29, 1930.

193. Mary Ross, "The Captive," *New York Herald Tribune*, December 16, 1928; as quoted in Taylor, "I Made Up My Mind to Get It," 267. See also D.S.O., "This Is Book That Baffles and Repulses."

194. D.S.O., "This Is Book That Baffles and Repulses."

195. M.G.P., "Saturday Book Review: *The Well of Loneliness*."

196. C.M.W., "The Cherry Tree."

197. Babb, "Book News and Reviews: A Novel by Radclyffe Hall"; Lohrke, "Book Treats of Homosexuality"; Eleanor Evans Wing, "Books and Bookmen: The Unlit Lamp," *Appleton Post-Crescent*, October 17, 1931.

198. "Dr. Thompson Addresses Book Club"; "Pat to Pansy," *Baltimore Afro-American*, March 29, 1930.

199. "Dr. Thompson Addresses Book Club."

200. "Meetings and Lectures," *Chicago Daily Tribune*, November 8, 1930.

201. "'Well of Loneliness' to Be Topic of Lecture," *Oakland Tribune*, September 22, 1929.

202. "Books and Authors," *New York Times*, October 13, 1929; Stanley E. Babb, "Book News and Reviews: Believe It or Not," *Galveston Daily News*, October 27, 1929.

203. "Effeminate Men," *Baltimore Afro-American*, March 22, 1930.

204. For more on homosexuality in communities of color in the 1920s, see Garber, "A Spectacle in Color"; Chauncey, "From Sexual Inversion to Homosexuality."

205. "Talkies Preferred," *The Living Age*, August 1931.

206. Bruce Catton, "Book Survey: *The Well of Loneliness*," *Olean Evening Times* (New York), August 29, 1930; Bruce Catton, "Book Survey: *The Well of Loneliness*," *Frederick Post* (Maryland), September 12, 1930.

207. Jim Tully, "Almost an Actor," *New Movie Magazine*, December 1930.

208. Barrios, *Screened Out*, 1–2.

CHAPTER 5 THE LESBIAN VOGUE AND BACKLASH

1. Tino Balio, *Grand Design: Hollywood as a Modern Business Enterprise, 1930–1939* (New York: Scribner; Toronto: Collier Macmillan Canada; New York: Maxwell Macmillan International, 1993), 13–14; F. Andrew Hanssen, "Revenue Sharing and the Coming of Sound," in *Economic History of Film*, ed. Michael Pokorny and John Sedgwick (New York: Routledge, 2004), 92.

2. Donald Crafton, *The Talkies: American Cinema's Transition to Sound, 1926–1931* (New York: Scribner, 1997); Alice Maurice, "'Cinema at Its Source': Synchronizing Race and Sound in the Early Talkies," *Camera Obscura* 17, no. 1 (2002): 31–62; Jessica Taylor, "'Speaking Shadows': A History of the Voice in the Transition from Silent to Sound Film in the United States," *Journal of Linguistic Anthropology* 19, no. 1 (2009): 1–20, doi:10.1111/j.1548-1395.2009.01016.x; Jennifer Fleeger, *Sounding American: Hollywood, Opera, and Jazz* (Oxford and New York: Oxford University Press, 2014).

3. Kaja Silverman, *The Acoustic Mirror: The Female Voice in Psychoanalysis and Cinema* (Bloomington: Indiana University Press, 1988), 61; Arne Lunde, "'Garbo Talks!': Scandinavians in Hollywood, the Talkie Revolution, and the Crisis of Foreign Voice," in *Screen Culture: History and Textuality*, ed. John Fullerton (Bloomington: Indiana University Press, 2004), 21–40.

4. David M. Lugowski, "Queering the (New) Deal: Lesbian and Gay Representation and the Depression-Era Cultural Politics of Hollywood's Production Code," *Cinema Journal* 38, no. 2 (1999): 5.

5. Chauncey, *Gay New York*; Heap, *Slumming*.

6. As quoted in Heap, *Slumming*, 236.

7. Ibid., 237–38.

8. Ibid., 237.

9. Ibid., 239.

10. The 1930 Production Code is reprinted in Balio, *Grand Design*, 13.

11. Vasey, *The World According to Hollywood*, 104–13.

12. Ibid., 206.

13. "'Winter Bound' Moves Along Devious Paths," *New York Times*, November 13, 1929.

14. "A Pair of Playwrights Who Are Not Exactly New," *New York Times*, November 10, 1929.

15. Russo, *Celluloid Closet*, 24.

16. J.F.L, "New Films Caught in New York: 'Pandora's Box,'" *Billboard*, December 14, 1929.

17. Russo, *Celluloid Closet*, 25.

18. J.F.L, "New Films Caught in New York."

19. J.C.M., "The Current Cinema," *The New Yorker*, December 7, 1929; as reprinted in Potter, "Queer Timing," 202.

20. Thomas Gladysz, "*Pandora's Box*, 1929" (essay written for the San Francisco Silent Film Festival, July 2012), http://www.silentfilm.org/archive/pandoras-box-2012.

21. DeCordova, *Picture Personalities*, 131, 140.

22. On Garbo as a sphinx, see Belle M. M., "The Voice of the Movie Fan," *Chicago Daily Tribune*, May 20, 1928, and George Shaffer, "Ann Harding Adopts Sphinx Role of Garbo," *Chicago*

Daily Tribune, July 1, 1932. On Garbo as Mona Lisa, see Edwin Schallert, "Greta Magnetic," *Los Angeles Times*, October 18, 1926. On Garbo as the riddle of Hollywood, see Harry D. Wilson, "Why Garbo Plays Dumb," *Motion Picture*, August 1931.

23. In addition to the works written during Garbo's career, an average of four Garbo biographies have been published every decade from the 1960s through today.

24. Ronald Gregg, "Gay Culture, Studio Publicity, and the Management of Star Discourse: The Homosexualization of William Haines in Pre-Code Hollywood," *Quarterly Review of Film and Video* 20, no. 2 (2003): 81–97.

25. Letter by Garbo cited in Alexander Walker, *Garbo: A Portrait* (New York: Macmillan, 1980), 42, and Barry Paris, *Garbo: A Biography* (New York: Alfred A. Knopf and Random House, 1995), 99. On Garbo's "type," see Katherine Lipke, "Greta Garbo Most Alluring," *New York Times*, October 17, 1926.

26. For example: Mordaunt Hall, "Hollywood Surprises New Swedish Actress," *New York Times*, February 28, 1926; Lipke, "Garbo Most Alluring"; M.H., "The Hollywood Hermit," *New York Times*, March 24, 1929.

27. Lipke, "Garbo Most Alluring"; M.H., "Hollywood Hermit"; Elza Schallert, "Famed of Europe Frolic in Cordial Party Circle," *Los Angeles Times*, November 22, 1931. See also "Greta, Incognito, Plays Tag with Reporters," unknown publication, December 28, 1931, Clipping File, MHL.

28. The following articles made each of these arguments in turn: Katherine Albert, "What Garbo Thinks of Hollywood," *Photoplay*, August 1930; Madame Sylvia, "Garbo's Glamour—Mystery or Misery?" *Photoplay*, December 1936; Adela Rogers St. Johns, "Great Love Stories of Hollywood, Part III. The Tragic Love of Greta Garbo," unknown publication, April 1931, Clipping File, MHL; "The Reason Why Greta Garbo Will Not Talk," *Los Angeles Times*, August 9, 1931; "Greta Garbo, The Woman Nobody Knows," *The Living Age*, June 1931; Wilson, "Why Garbo Plays Dumb."

29. Lipke, "Garbo Most Alluring."

30. Patricia White, "Black and White: Mercedes de Acosta's Glorious Enthusiasms," *Camera Obscura* 15, no. 3 (2000): 227.

31. Rilla Page Palmborg, "Greta Garbo Goes Home," *Motion Picture Classic*, February 1929.

32. Dorothy Calhoun, "Why Garbo's Friends Dare Not Talk," *Motion Picture*, July 1935.

33. Unknown publication, Feburary 16, 1930, Clipping File, MHL.

34. Vasey, *The World According to Hollywood*, 217–18.

35. "Young Star's Rapid Rise," *New York Times*, October 5, 1930.

36. Emily D. Bilski and Emily Braun, *Jewish Women and Their Salons: The Power of Conversation* (New York: Jewish Museum; New Haven: Yale University Press, 2005).

37. "Rambling Reporter," *Hollywood Reporter*, August 21, 1931.

38. Unknown publication, December 22, 1931, Clipping File, MHL.

39. "Rambling Reporter," *Hollywood Reporter*, January 7, 1932. Schenck was president of United Artists, but left to found Twentieth Century with Darryl F. Zanuck in 1933. The company merged with Fox Film Corporation in 1935.

40. "The Lowdown," *Hollywood Reporter*, January 27, 1932.

41. White, "Black and White."

42. Cal York, "The Monthly Broadcast of Hollywood Goings-On!" *Photoplay*, May 1932.

43. Alma Whitaker, "Celebrities Overflow Cinemaland's Rosters," *Los Angeles Times*, May 1, 1932; "Garbo, Going Home, Leads Wild Chase in New York," *Los Angeles Times*, July 26, 1932.

44. Nancy Randolph, "Debut Party on Eve of Race at Belmont Park," *Chicago Daily Tribune*, August 21, 1932.

45. Palmborg, "Garbo Goes Home," 21; Rilla Page Palmborg, "The Private Life of Greta Garbo," *Photoplay*, September 1930, 38.

46. Palmborg, "Private Life of Garbo"; Rilla Page Palmborg, "Chapter Two of The Private Life of Greta Garbo," *Photoplay*, October 1930; Rilla Palmborg, *The Private Life of Greta Garbo* (Garden City, NY: Doubleday, Doran and Company, 1931).

47. *Milwaukee Journal*, Green Sheet daily feature, October 26, 1931–November 1931.

48. Palmborg, "Private Life of Garbo," 38, 92.

49. Ibid., 39.

50. Palmborg, "Chapter Two," 102.

51. Ibid., 143.

52. Ibid., 142; Palmborg, *Private Life of Garbo*, 164.

53. O. O. McIntyre, "New York Day by Day," *The Day*, November 4, 1931; O. O. McIntyre, "Once Overs," *San Antonio Light*, November 4, 1931; McIntyre, "New York Day by Day," *The Day*, November 16, 1926.

54. Palmborg, *Private Life of Garbo*, 275.

55. "Greta, Incognito, Plays Tag with Reporters"; Wilson, "Why Garbo Plays Dumb," 27, 93.

56. Palmborg, "Chapter Two," 36–39, 142–43. Patricia White connects Stephen Gordon's and Garbo's fastidious interest in male clothing in "Black and White," 253.

57. Doan, *Fashioning Sapphism*; Latimer, *Women Together/Women Apart*.

58. Palmborg, "Private Life of Garbo," 40.

59. Wilson, "Why Garbo Plays Dumb."

60. Stamp, *Movie-Struck Girls*, chap. 3.

61. Albert, "What Garbo Thinks of Hollywood"; "Call Quiet Swedish Star 'Portrait of a Recluse,'" *Detroit Free Press*, May 4, 1930.

62. I explore the way Swedishness recuperated Garbo's gender deviations in "Queer Crossings: Greta Garbo, National Identity, and Gender Deviance," in *Silent Cinema and the Politics of Space*, ed. Jennifer M. Bean, Anupama Kapse, and Laura Horak (Bloomington: Indiana University Press, 2014), 270–94.

63. Adela Rogers St. Johns, "Mother," *New Movie Magazine*, January 1931.

64. One of the few exceptions is in "Reflections and News of the Screen World," *New York Times*, November 16, 1930.

65. *Motion Picture News*, November 22, 1930; *Picture Play Magazine*, January 1931.

66. "'Morocco' Subtle Visualization of Romance," *Los Angeles Times*, November 16, 1930.

67. Mercedes de Acosta, *Here Lies the Heart* (New York: Reynal, 1960), 234.

68. "Fashion: The Mannish Cut for Travelling," *Vogue* 77, no. 7 (April 1, 1931): 58, 59; "Fashion: Biarritz—A Foretaste of Palm Beach," *Vogue* 78, no. 11 (December 1, 1931): 48, 49.

69. "Fashion," December 1, 1931.

70. "The Mode Goes Mannish: Slacks, Shirts, Shorts among Beach Styles Borrowed from the Men; Skirts, Too, Adopt Masculine Lines," *New York Times*, December 13, 1931.

71. Ibid.

72. George Shaffer, "Dietrich Orders Full Dress Suit of White for Song Act," *Chicago Daily Tribune*, March 1, 1932; Cal York, "The Monthly Broadcast of Hollywood Goings-On!" *Photoplay*, May 1932; Herb Howe, "My Ten Favorite Thous," *New Movie Magazine*, June 1932.

73. York, "Monthly Broadcast of Hollywood Goings-On!" 99.

74. Marguerite Tazelaar, "Uncensoring 'Maedchen in Uniform,'" *New York Herald Tribune*, September 18, 1932; Martin Dickstein, "Slow Motion," *Brooklyn Eagle*, September 1932, MFLx n.c. 1836, BRTC; Mordaunt Hall, "The Screen: 'Girls in Uniform,' a

German-Language Picture Concerned with Life in a Potsdam Girls' School," *New York Times*, September 21, 1932; Wood Soanes, "'Maedchen' in English Shown in Berkeley," *Oakland Tribune*, November 1, 1935.

75. Tazelaar, "Uncensoring 'Maedchen in Uniform.'"

76. *What Shocked the Censors! A Complete Record of Cuts in Motion Picture Films Ordered by the New York State Censors from January, 1932 to March, 1933* (New York: National Council on Freedom from Censorship, 1933), 33–35.

77. "'Maedchen in Uniform' 1st Choice," *New York Herald Tribune*, 1932, *Maedchen in Uniform* clipping file, BRTC.

78. "M-G-M Drops Out of 'Maedchen' Picture," *Motion Picture Daily*, October 19, 1932.

79. Ibid.

80. John S. Cohen Jr., "The Talking Pictures: Europe Redivivus," *New York Sun*, October 1932, MFL x n.c. 1836, BRTC.

81. Eleanore Wilson, "'Maedchen in Uniform' Offers New Possibilities in Style and Form," *Washington News*, November 2, 1932.

82. "*Maedchen in Uniform* Still a Hit," *New York Herald Tribune*, November 9, 1932.

83. B. Ruby Rich, "From Repressive Tolerance to Erotic Liberation," in Rich, *Chick Flicks: Theories and Memories of the Feminist Film Movement* (Durham, NC: Duke University Press, 1998), 185.

84. Vicinus, *Intimate Friends*, 5–60.

85. Rich, "From Repressive Tolerance to Erotic Liberation," 186.

86. Ibid.

87. Linda Williams, *Screening Sex* (Durham, NC: Duke University Press, 2008), 46.

88. Rich, "From Repressive Tolerance to Erotic Liberation," 189.

89. Castle, *The Apparitional Lesbian*, 43.

90. Al Sherman, "*Maedchen in Uniform*," *New York Telegraph*, September 1932, MFL x n.c. 1836, BRTC. John S. Cohen at the *New York Sun* also mentioned *Well of Loneliness*, only to dismiss the comparison. Cohen, "The New Talkie," *New York Sun*, September 1932, MFL x n.c. 1836, BRTC.

91. Additional examples include Dickstein, "Slow Motion"; Bland Johaneson, "'Maids in Uniform' in Exquisite Diction Tells a Wistful Story," *New York Mirror*, September 21, 1932, MFL x n.c. 1836, BRTC; "New Films: *Maedchen in Uniform*," *New York Bronx Home News*, September 21, 1932, MFL x n.c. 1836, BRTC

92. Johaneson, "'Maids in Uniform.'"

93. "The Film Estimates," *Educational Screen*, December 1932.

94. Kauf., "*Maedchen in Uniform*," *Variety*, September 27, 1932.

95. Jeanette Marks, "Unwise College Friendships" (unpublished essay, South Hadley, Mass., 1908); Anne MacKay, *Wolf Girls at Vassar: Lesbian and Gay Experiences 1930–1990* (New York: St. Martin's Press, 1993); Faderman, *Surpassing the Love of Men*.

96. Al Sherman, "Unjust Whispering Campaign on 'Maedchen' Points a Needed Moral," *New York Telegraph*, ca. October 1932, MFL x n.c. 1836, BRTC.

97. Sherman, "*Maedchen in Uniform*."

98. "*Maedchen in Uniform* Still Brings Sharp Discussion," *Baltimore Sun*, October 1932, MFL x n.c. 1836, BRTC. See also Martin Dickstein, "The Screen: 'Maedchen in Uniform,' a Brilliant German Film, Makes Brooklyn Debut at the Majestic," *Brooklyn Daily Eagle*, November 22, 1932, *Maedchen in Uniform* clipping file, BRTC.

99. Richard Watts Jr., "On the Screen: *Maedchen in Uniform*," *New York Herald Tribune*, September 21, 1932, MFL x n.c. 1836, BRTC.

100. J.C.M., "The Current Cinema: The New German Picture," *The New Yorker*, September 17, 1932, MFL x n.c. 1836, BRTC.

101. Smith-Rosenberg, "Female World of Love and Ritual"; Marcus, *Between Women*.

102. Douglas W. Churchill, "Hollywood on the Wire," *New York Times*, September 1, 1935.

103. As quoted in White, *Uninvited*, 18.

104. Ward Morehouse, "Broadway After Dark," *New York Sun*, December 27, 1932, *The Captive* clipping file, BRTC.

105. Barrios, *Screened Out*, 89.

106. Scott Eyman, *Empire of Dreams: The Epic Life of Cecil B. DeMille* (New York: Simon and Schuster, 2010), 296.

107. As quoted in ibid.

108. As quoted in Barrios, *Screened Out*, 92.

109. "The Theatre: Roman Holiday," *Wall Street Journal*, December 3, 1932; Norbert Lusk, "De Mille Again the Old Master," *Los Angeles Times*, December 4, 1932; Frank Drake, "'The Sign of the Cross' Stupendous Production," *Atlanta Constitution*, February 13, 1933.

110. Eyman, *Empire of Dreams*, 296.

111. Ibid., 295.

112. Terry Ramsaye, "The Sign of the Cross," *Motion Picture Herald*, December 3, 1932; as quoted in Barrios, *Screened Out*, 93.

113. "'Sign of the Cross' with Frederic March, Elissa Landi and Claudette Colbert," *Harrison's Reports*, December 17, 1932.

114. Henry Wales, "'Cavalcade' Is Called Biggest Film in History," *Chicago Daily Tribune*, December 4, 1932.

115. Barrios describes this lost scene in *Screened Out*, 98.

116. Ralph T. Jones, "'Cavalcade,' Film of the Century, Holds Big Audience Spellbound," *Atlanta Constitution*, February 21, 1933.

117. H.V.H., "The Theatre: About Cavalcade," *Wall Street Journal*, January 20, 1933.

118. Ibid.

119. Norbert Lusk, "Stage and Screen: Praises Heaped on 'Cavalcade,'" *Los Angeles Times*, January 8, 1933.

120. Marcus, "Comparative Sapphisms," 253–54.

121. Lusk, "De Mille Again the Old Master."

122. According to Barrios, Malin's movies were released after the backlash to the pansy craze, and his name was removed from the credits.

123. As quoted in Barrios, *Screened Out*, 100.

124. "Tsk, Tsk, Such Goings On," *Variety*, February 8, 1933.

125. Ted Cook, "Hollywood Cook Coos," *New Movie Magazine*, April 1933.

126. Alma Whitaker, "Why All This Fuss about Men's Pants for Women?" *Los Angeles Times*, February 12, 1933.

127. Dorothy Calhoun, "Will It Be Trousers for Women?" *Movie Classic*, May 1933, 18–19. *The Sign of the Cross* premiere was on January 19, but Calhoun says January 12. I believe she is talking about the same event, because she mentions Maurice Chevalier, who emceed the premiere.

128. "Fashion: Does Hollywood Create?" *Vogue* 81, no. 3 (February 1, 1933): 59–61, 76–77.

129. Cook, "Hollywood Cook Coos," 43; Calhoun, "Will It Be Trousers for Women?" 19.

130. Franc Dillon, "Intimate Facts about Marlene's Wardrobe," *New Movie Magazine*, May 1933.

131. Virginia Gardner, "Chicago Girls Copy Marlene," *Chicago Daily Tribune*, February 26, 1933.

132. D. F. Beckham, "Pants and the Woman," *New York Times*, February 12, 1933.

133. Whitaker, "Why All This Fuss about Men's Pants for Women?"

134. "The Lowdown," *Hollywood Reporter*, January 30, 1933.

135. Ted Cook, "Hollywood Fashion Cook-Coos," *New Movie Magazine*, May 1933. See also Stacy Kent, "Our Hollywood Neighbors," *Movie Classic*, February 1933.

136. Cook, "Hollywood Fashion Cook-Coos."

137. White, "Black and White."

138. "Warners Ban Mannish Garb for Women Stars," *Los Angeles Times*, February 17, 1933.

139. Beckham, "Pants and the Woman."

140. Barrios, *Screened Out*, 61. According to Barrios, the novelist, played by Blanche Frederici, was meant to represent Faith Baldwin, who wrote the novel upon which the film was based.

141. Another was Barbara Stanwyck, who later made a career of playing butch frontier women.

142. "Writers War on Filth," *Hollywood Reporter*, February 27, 1933.

143. Comments by Evelyn Nesbit in the *Broadway Tattler*, as reprinted in La Forest Potter, *Strange Loves: A Study in Sexual Abnormalities* (New York: Robert Dodsley Co., 1933), 5–6, note 1, http://babel.hathitrust.org/cgi/pt?id=mdp.39015050141756.

144. Ibid., 7, 9.

145. "Lasky Bans Fem Trousers," *Film Daily*, March 3, 1933.

146. Lasky Feature Play Co.: *Oliver Twist* (1916). Famous Players–Lasky: *Moran of the Lady Letty* (1922), *Only 38* (1923), *Merton of the Movies* (1924), *The Humming Bird* (1924), *Peter Pan* (1924), *The Palm Beach Girl* (1926). Paramount Famous Lasky Corp.: *She's a Sheik* (1927), *Senorita* (1927), *Beggars of Life* (1928).

147. Calhoun, "Will It Be Trousers for Women?"

148. Vasey, *The World According to Hollywood*, 128–29.

149. Joseph McBride, *Frank Capra: The Catastrophe of Success* (Jackson: University Press of Mississippi, 2011), 285.

150. Photo spreads of Hepburn in trousers include "The Don't-Care Girl," *New Movie Magazine*, May 1933, and Sara Hamilton, "Well! Well! So This Is Hepburn!" *Photoplay*, August 1933.

151. "Rambling Reporter," *Hollywood Reporter*, November 21, 1931; "The Lowdown," *Hollywood Reporter*, January 30, 1933.

152. Cook, "Hollywood Cook Coos," 43.

153. Calhoun, "Will It Be Trousers for Women?" 62.

154. "Pants," *New Movie Magazine*, April 1933.

155. Calhoun, "Will It Be Trousers for Women?" 65.

156. Dorothy Calhoun, "One Stays Feminine—One Goes Masculine—And Both Have Glamour!" *Movie Classic*, May 1933.

157. Dillon, "Intimate Facts about Marlene's Wardrobe."

158. Elsie Pierce, "How to Be Beautiful," *Washington Post*, April 20, 1933.

159. Janet Rice, "Hollywood Fashion Letter," *New Movie Magazine*, April 1933.

160. "Here's What the Country Thinks of the Trousers Fad," *New Movie Magazine*, May 1933.

161. "Mannish for Play Clothes," *Vogue* 81, no. 12 (June 15, 1933): 22.

162. "The Audience Talks Back," *Photoplay*, April 1933. See also "Box Office Critics," *New Movie Magazine*, July 1933; "What the Fans Think," *Picture Play Magazine*, August 1933.

163. "Dietrich's Trousers Missing When She Returns from Europe," *Chicago Daily Tribune*, September 27, 1933; "Ship Brings Marlene in Paris Mode," *Los Angeles Times*, September 27, 1933; "What? No Trousers?" *Los Angeles Times*, September 29, 1933; "Miss Dietrich Returns," *Los Angeles Times*, October 2, 1933.

164. "Dietrich's Trousers Missing."

165. Ibid.

166. Karen Hollis, "They Say in New York," *Picture Play Magazine*, May 1933.

167. Kenneth Baker, "War Clouds in the West?" *Photoplay*, December 1933.

168. Pamela Robertson, "'The Kinda Comedy That Imitates Me': Mae West's Identification with the Feminist Camp," *Cinema Journal* 32, no. 2 (1993): 57–72, doi:10.2307/1225605.

169. Will H. Hays, speech on the Production Code, May 1, 1933, 5, MDDPA Digital Archive, http://mppda.flinders.edu.au/records/914.

170. Will H. Hays, memorandum on Production Code problems, May 19, 1933, MDDPA Digital Archive, http://mppda.flinders.edu.au/records/1932.

171. Pare Lorenz, "The Cinema in Review," *Vanity Fair*, June 1933.

172. Arline Hodgekins, "Garbo's Gamble," *Photoplay*, July 1933.

173. Hollywood Boulevardier, "The I'm-No-Angel Girl," *New Movie Magazine*, August 1933.

174. Sarah Waters, "'A Girton Girl on a Throne': Queen Christina and Versions of Lesbianism, 1906–1933," *Feminist Review* 46, no. 1 (1994): 41–60.

175. Salka Viertel, *The Kindness of Strangers* (New York: Holt, Rinehart and Winston, 1969), 175.

176. James Wingate to E. J. Mannix, "Queen Christina," August 7, 1933, *Queen Christina* file, Motion Picture Association of America, Production Code Administration Records (hereafter MPAA/PCA Records), MHL.

177. Marcia Landy and Amy Villarejo, *Queen Christina* (London: British Film Institute, 1995), 24.

178. Patricia White, *Uninvited: Classical Hollywood Cinema and Lesbian Representability* (Bloomington: Indiana University Press, 1999), 13.

179. Waters, "'A Girton Girl on a Throne,'" 43.

180. Ibid., 45–46.

181. Ibid., 47.

182. Margaret Goldsmith, *Christina of Sweden: A Psychological Biography* (London: Arthur Barker Ltd., 1933), 67.

183. Lewis Gannett, *New York Herald-Tribune*, as quoted in Russo, *Celluloid Closet*, 64.

184. As quoted in Russo, *Celluloid Closet*, 66. The *New York Times* book critic also referenced the movie in his review of the book. John Chamberlain, "Books of the Times," *New York Times*, December 27, 1933.

185. As quoted in Landy and Villarejo, *Queen Christina*, 21.

186. Helen Dale, "Two Queens Were Born in Sweden," *Photoplay*, October 1933.

187. Landy and Villarejo, *Queen Christina*, 73.

188. Waters, "'A Girton Girl on a Throne,'" 51.

189. Straayer, *Deviant Eyes, Deviant Bodies*, 60.

190. Greta Garbo to Hörke Wachtmesister, January 1934. As quoted in Sven Broman, *Conversations with Greta Garbo* (New York: Viking, 1992), 119.

191. Martin Stevers, "'Now I Help You,' Says Garbo to Gilbert," *Photoplay*, October 1933.

192. Mordaunt Hall, "Miss Garbo and Others," *New York Times*, January 7, 1934; Harry Evans, "The Movies," *Life*, February 1934; Edwin Schallert, "Swedish Star Monarch," *Los Angeles Times*, February 12, 1934; Larry Reid, "Be Sure to See 'Queen Christina'!" *Movie Classic*, March 1934; "The Shadow Stage: Queen Christina," *Photoplay*, March 1934; Norbert Lusk, "The Screen in Review: Queen Christina," *Picture Play Magazine*, April 1934.

193. "The Voice of the Movie Fan: Converted to Garbo Worship," *Chicago Daily Tribune*, March 4, 1934.

194. Mrs. Joe Miller, "Garbo Still Her Queen," *Hollywood*, May 1934.

195. Frederic F. Van de Water, "New Pictures You Should See and Why: Queen Christina," *New Movie Magazine*, March 1934.

196. R.P.C., "Garbo," *Wall Street Journal*, December 30, 1933.

197. Hall, "Miss Garbo and Others"; Evans, "The Movies"; Schallert, "Swedish Star Monarch"; Reid, "Be Sure to See 'Queen Christina'!"; "The Shadow Stage: Queen Christina"; Lusk, "The Screen in Review: *Queen Christina*."

198. Vasey, *The World According to Hollywood*, 131.

199. As quoted in Thomas Doherty, *Pre-Code Hollywood: Sex, Immorality, and Insurrection in American Cinema, 1930–1934* (New York: Columbia University Press, 1999), 321.

200. Vasey, *The World According to Hollywood*, 130.

201. Richard Maltby, "'Baby Face,' or How Joe Breen Made Barbara Stanwyck Atone for Causing the Wall Street Crash," *Screen* 27, no. 2 (1986): 22–46, doi:10.1093/screen/27.2.22; Lea Jacobs, *The Wages of Sin: Censorship and the Fallen Woman Film, 1928–1942* (Madison: University of Wisconsin Press, 1991); Vasey, *The World According to Hollywood*.

202. Barrios, *Screened Out*, 140.

203. Ibid., 141.

204. "'Cavalcade' Heads Ten Best Films," *Film Daily*, January 10, 1934.

205. Chas. Alicoate, "Short Shots from Eastern Studios," *Film Daily*, January 16, 1934; "Krimsky-Cochran to Make 2 or 3 Films Next Season," *Film Daily*, January 16, 1934.

206. "Krimsky to Produce," *Billboard*, July 28, 1934; "'Maedchen in Uniform,'" *Chicago Daily Tribune*, July 29, 1934.

207. "The Film Estimates," *Educational Screen*, September 1934.

208. "Movies Given in Church Is Pastor's Aim," *Washington Post*, July 12, 1934; "Church Plan to Exhibit Pictures," *Billboard*, July 21, 1934.

209. "'Maedchen' for Non-Theatricals," *Film Daily*, February 5, 1935; Russell C. Holslag, "News of the Industry," *Movie Makers: The Magazine of the Amateur Cinema League*, March 1935.

210. As quoted in Churchill, "Hollywood on the Wire."

211. As quoted in White, *Uninvited*, 19.

212. Ibid.

213. "John Krimsky to Launch New Independent Company," *Film Daily*, October 5, 1935.

214. As quoted in White, *Uninvited*, 20.

215. Soanes, "'Maedchen' in English Shown in Berkeley"; "Film Alliance Reviving 'Maedchen,'" *Film Daily*, February 4, 1936.

216. Soanes, "'Maedchen' in English Shown in Berkeley."

217. As quoted in White, *Uninvited*, 18.

218. "Club de Femmes," *Variety*, October 13, 1937.

219. Joseph I. Breen to B. B. Kahane, August 12, 1935, *Sylvia Scarlett* file, MPAA/PCA Records, MHL.

220. Andre Sennwald, "Katharine Hepburn and Edmund Gwenn in 'Sylvia Scarlett,' at the Radio City Music Hall," *New York Times*, January 10, 1936; Philip K. Scheuer, "New Hepburn Acting Feat Chronicled," *Los Angeles Times*, December 26, 1935.

221. Scheuer, "New Hepburn Acting Feat Chronicled." See also W. H. McG., "The Theatre: Gets Nowhere," *Wall Street Journal*, January 13, 1936.

CONCLUSION

1. Chris Spargo, "Casey Legler, Erika Linder & Elliott Sailors Are the Hottest New Female, and Male, Models," *NewNowNext*, October 21, 2013, http://www.newnownext.com/casey -legler-erika-linder-elliott-sailors-female-male-models/10/2013/; Kelsey Garcia, "Elliott Sail- ors Tells Us about Her Emotional Transition from Working as a Female to a Male Model," *Elle*, October 29, 2013, http://www.elle.com/news/culture/elliott-sailors-model-interview; Casey Legler, "I'm a Woman Who Models Men's Clothes. But This Isn't about Gender," *The Guardian*, November 1, 2013, http://www.theguardian.com/commentisfree/2013/nov/01/ woman-models-mens-clothes-casey-legler.

2. Laurie Abraham, "How Slam-Dunking, Gender-Bending WNBA Rookie Brittney Griner Is Changing the World of Sports," *Elle*, November 4, 2013, http://www.elle.com/life-love/ society-career/brittney-griner-profile.

3. Vicinus, "Turn-of-the-Century Male Impersonation"; Vicinus, *Intimate Friends*, 175–201.

BIBLIOGRAPHY

Abate, Michelle Ann. *Tomboys: A Literary and Cultural History.* Philadelphia: Temple University Press, 2008.

Abel, Richard. *Americanizing the Movies and "Movie-Mad" Audiences, 1910–1914.* Berkeley: University of California Press, 2006.

———. *The Red Rooster Scare: Making Cinema American, 1900–1910.* Berkeley: University of California Press, 1999.

Abraham, Laurie. "How Slam-Dunking, Gender-Bending WNBA Rookie Brittney Griner Is Changing the World of Sports." *Elle*, November 4, 2013. http://www.elle.com/life-love/society-career/brittney-griner-profile.

Acosta, Mercedes de. *Here Lies the Heart.* New York: Reynal, 1960.

Addison, Heather. "'Do Go On!': Performing Gender in *The Clinging Vine* (1926)." *Quarterly Review of Film and Video* 25, no. 4 (2008): 334–45.

Allen, Frederick Lewis. *Only Yesterday: An Informal History of the 1920's.* 1931. Reprint, New York: Wiley, 1997.

Allen, Robert C. *Horrible Prettiness: Burlesque and American Culture.* Chapel Hill: University of North Carolina Press, 1991.

Altman, Rick. "*The Lonely Villa* and Griffith's Paradigmatic Style." *Quarterly Review of Film Studies* 6, no. 2 (1981): 123–34. doi:10.1080/10509208109361084.

Anderson, Mark Lynn. *Twilight of the Idols: Hollywood and the Human Sciences in 1920s America.* Berkeley: University of California Press, 2011.

Balio, Tino. *Grand Design: Hollywood as a Modern Business Enterprise, 1930–1939.* New York: Scribner; Toronto: Collier Macmillan Canada; New York: Maxwell Macmillan International, 1993.

Barrios, Richard. *Screened Out: Playing Gay in Hollywood from Edison to Stonewall.* New York: Routledge, 2003.

Basso, Matthew, Laura McCall, and Dee Garceau, eds. *Across the Great Divide: Cultures of Manhood in the American West.* New York: Routledge, 2001.

Bateman, Geoffrey. "The Queer Frontier: Placing the Sexual Imaginary in California, 1868–1915." Ph.D. diss., University of Colorado at Boulder, 2010.

Bean, Jennifer M. "Technologies of Early Stardom and the Extraordinary Body." In *A Feminist Reader in Early Cinema*, edited by Jennifer M. Bean and Diane Negra, 404–43. Durham, NC: Duke University Press, 2002.

Beard, Rick, and Leslie Cohen Berlowitz, eds. *Greenwich Village: Culture and Counterculture.* New Brunswick, NJ: Rutgers University Press in association with the Museum of the City of New York, 1993.

Becker, Edith, Michelle Citron, Julia Lesage, and B. Ruby Rich. "Lesbians and Film." *Jump Cut* 24–25 (March 1981): 17–21.

Bederman, Gail. *Manliness and Civilization: A Cultural History of Gender and Race in the United States, 1880–1917.* Chicago: University of Chicago Press, 1995.

Behling, Laura L. *The Masculine Woman in America, 1890–1935.* Urbana: University of Illinois Press, 2001.

Bell-Metereau, Rebecca. *Hollywood Androgyny*. 2nd ed. New York: Columbia University Press, 1993.

Benshoff, Harry M., and Sean Griffin. *Queer Images: A History of Gay and Lesbian Film in America*. Lanham, MD: Rowman and Littlefield, 2006.

Benstock, Shari. *Women of the Left Bank: Paris, 1900–1940*. Austin: University of Texas Press, 1986.

Berlanstein, Lenard R. "Breeches and Breaches: Cross-Dress Theater and the Culture of Gender Ambiguity in Modern France." *Comparative Studies in Society and History* 38, no. 2 (1996): 338–69.

Billman, Larry. *Film Choreographers and Dance Directors: An Illustrated Biographical Encyclopedia, with a History and Filmographies, 1893 through 1995*. Jefferson, NC: McFarland & Company, 1997.

Bilski, Emily D., and Emily Braun. *Jewish Women and Their Salons: The Power of Conversation*. New York: Jewish Museum; New Haven: Yale University Press, 2005.

Blume, Donald T. *Ambrose Bierce's Civilians and Soldiers in Context: A Critical Study*. Kent, Ohio: Kent State University Press, 2004.

Boag, Peter. "Go West Young Man, Go East Young Woman: Searching for the Trans in Western Gender History." *Western Historical Quarterly* 36, no. 4 (2005): 477–97. doi:10.2307/25443237.

———. *Re-Dressing America's Frontier Past*. Berkeley: University of California Press, 2011.

Bowser, Eileen. *The Transformation of Cinema, 1907–1915*. Berkeley: University of California Press, 1994.

Boyd, Nan Alamilla. "The Materiality of Gender: Looking for Lesbian Bodies in Transgender History." *Journal of Lesbian Studies* 3 (1999): 73–82.

Brasell, R. Bruce. "A Seed for Change: The Engenderment of 'A Florida Enchantment.'" *Cinema Journal* 36, no. 4 (1997): 3–21.

Brewster, Ben. "*The Baby and the Stork*," In *The Griffith Project*, vol. 5, *Films Produced in 1911*, edited by Paolo Cherchi Usai, 166–68. London: British Film Institute, 2001.

Broman, Sven. *Conversations with Greta Garbo*. New York: Viking, 1992.

Brooks, Peter. *The Melodramatic Imagination: Balzac, Henry James, Melodrama, and the Mode of Excess*. 2nd ed. New Haven: Yale University Press, 1995.

Brouwers, Anke. "Feeling Through the Eyes: The Legacy of Sentimentalism in Silent Hollywood—The Films of Mary Pickford and Frances Marion." Ph.D. diss., Universitiet Antwerpen, 2011.

Butsch, Richard. *The Making of American Audiences: From Stage to Television, 1750–1990*. Cambridge and New York: Cambridge University Press, 2000.

Carpenter, Angelica Shirley, and Jean Shirley. *Frances Hodgson Burnett: Beyond the Secret Garden*. Minneapolis: Lerner Publications, 1990.

Castle, Terry. *The Apparitional Lesbian: Female Homosexuality and Modern Culture*. New York: Columbia University Press, 1993.

Chauncey, George. "From Sexual Inversion to Homosexuality: The Changing Medical Conceptualization of Female 'Deviance.'" In *Passion and Power: Sexuality in History*, edited by Kathy Peiss, Christina Simmons, and Robert Padgug. Philadelphia: Temple University Press, 1989.

———. *Gay New York: Gender, Urban Culture, and the Makings of the Gay Male World, 1890–1940*. New York: Basic Books, 1994.

Clarke, Elizabeth. "War and the Sexes: Gender and American Film, 1898–1927." Ph.D. diss., Wilfred Laurier University, 2013.

Cohler, Deborah. *Citizen, Invert, Queer: Lesbianism and War in Early Twentieth-Century Britain.* Minneapolis: University of Minnesota Press, 2010.

Courtney, Susan. *Hollywood Fantasies of Miscegenation: Spectacular Narratives of Gender and Race, 1903–1967.* Princeton: Princeton University Press, 2005.

Crafton, Donald. *The Talkies: American Cinema's Transition to Sound, 1926–1931.* New York: Scribner, 1997.

Cripps, Thomas. *Slow Fade to Black: The Negro in American Film, 1900–1942.* New York: Oxford University Press, 1977.

Cromwell, Stephen. "Passing Women and Female-Bodied Men: (Re)claiming FTM History." In *Reclaiming Genders: Transsexual Grammars at the Fin de Siècle,* edited by Kate More and Stephen Whittle, 34–82. London and New York: Cassell, 1999.

Cunningham, Patricia A. *Reforming Women's Fashion, 1850–1920: Politics, Health, and Art.* Kent, Ohio: Kent State University Press, 2003.

Curtin, Kaier. *We Can Always Call Them Bulgarians: The Emergence of Lesbians and Gay Men on the American Stage.* Boston: Alyson Publications, 1987.

Curtis, Scott. "Douglas Fairbanks: Icon of Americanism." In *Flickers of Desire: Movie Stars of the 1910s,* edited by Jennifer M. Bean, 218–41. New Brunswick, NJ: Rutgers University Press, 2011.

DeCordova, Richard. *Picture Personalities: The Emergence of the Star System in America.* Urbana: University of Illinois Press, 1990.

Deloria, Philip Joseph. *Playing Indian.* New Haven: Yale University Press, 1998.

De Pauw, Linda Grant. "Women in Combat: The Revolutionary War Experience." *Armed Forces and Society* 7 (Winter 1981): 209–26.

DeSalvo, Louise A. "Lighting the Cave: The Relationship between Vita Sackville-West and Virginia Woolf." *Signs* 8, no. 2 (1982): 195–214.

Dickens, Homer. *What a Drag: Men as Women and Women as Men in the Movies.* New York: Quill, 1984.

DiMaggio, Paul. "Cultural Entrepreneurship in Nineteenth-Century Boston." In *Rethinking Popular Culture: Contemporary Perspectives in Cultural Studies,* edited by Chandra Mukerji and Michael Schudson, 374–97. Berkeley: University of California Press, 1991.

Dinshaw, Carolyn. *Getting Medieval: Sexualities and Communities, Pre- and Postmodern.* Durham, NC: Duke University Press, 1999.

Doan, Laura. *Fashioning Sapphism: The Origins of a Modern English Lesbian Culture.* New York: Columbia University Press, 2001.

Doan, Laura, and Jay Prosser, eds. *Palatable Poison: Critical Perspectives on "The Well of Loneliness."* New York: Columbia University Press, 2001.

Doherty, Thomas. *Pre-Code Hollywood: Sex, Immorality, and Insurrection in American Cinema, 1930–1934.* New York: Columbia University Press, 1999.

Driscoll, Charles B. *The Life of O. O. McIntyre.* New York: Greystone Press, 1938.

Dugaw, Dianne. *Warrior Women and Popular Balladry, 1650–1850.* Cambridge and New York: Cambridge University Press, 1989.

Duggan, Lisa. *Sapphic Slashers: Sex, Violence, and American Modernity.* Durham, NC: Duke University Press, 2000.

———. "The Trials of Alice Mitchell: Sensationalism, Sexology, and the Lesbian Subject in Turn-of-the-Century America." *Signs* 18, no. 4 (1993): 791–814.

Dyer, Richard. "Seen to Be Believed: Some Problems in the Representation of Gay People as Typical." In Dyer, *The Matter of Images: Essays on Representation.* 2nd ed. London and New York: Routledge, 2002.

Ellenberger, Allan R. "Director Edwin Carewe's Grave Is Marked after More Than 69 Years." *Hollywoodland: A Site about Hollywood and Its History*, September 12, 2009. http://allanellenberger.com/book-flm-news/edwin-carewe-marked-at-hollywood-forever/.

Ellis, Havelock, and John Addington Symonds. *Sexual Inversion.* London: Wilson and Macmillan, 1897.

Emery, Michael C., Edwin Emery, and Nancy L. Roberts. *The Press and America: An Interpretive History of the Mass Media.* 9th ed. Boston: Allyn and Bacon, 2000.

Eyman, Scott. *Empire of Dreams: The Epic Life of Cecil B. DeMille.* Simon and Schuster, 2010.

Fabian, Warner. *Unforbidden Fruit.* New York: Boni and Liveright, 1928.

Faderman, Lillian. "Love between Women in 1928: Why Progressivism Is Not Always Progress." *Lodestar Quarterly*, no. 13 (Spring 2005). http://lodestarquarterly.com/work/281/.

———. *Odd Girls and Twilight Lovers: A History of Lesbian Life in Twentieth-Century America.* New York: Columbia University Press, 1991.

———. *Surpassing the Love of Men: Romantic Friendship and Love between Women from the Renaissance to the Present.* New York: Morrow, 1981.

Fellman, Michael. Review of *Highbrow/Lowbrow: The Emergence of Cultural Hierarchy in America* by Lawrence W. Levine. *American Historical Review* 95, no. 2 (1990): 569–70.

Fiedler, Leslie A. *Love and Death in the American Novel.* New York: Criterion Books, 1960.

Fleeger, Jennifer. *Sounding American: Hollywood, Opera, and Jazz.* Oxford and New York: Oxford University Press, 2014.

Floyd, Nancy. *She's Got a Gun.* Philadelphia: Temple University Press, 2008.

Foucault, Michel. *The History of Sexuality*, vol. 1, *An Introduction.* Translated by Robert Hurley. New York: Vintage, 1990.

Freeman, Elizabeth. *Time Binds: Queer Temporalities, Queer Histories.* Durham, NC: Duke University Press, 2010.

Gaines, Jane M. "World Women: Still Circulating Silent Era Film Prints." *Framework* 51, no. 2 (2010): 283–303.

Garber, Eric. "A Spectacle in Color: The Lesbian and Gay Subculture of Jazz Age Harlem." In *Hidden from History: Reclaiming the Gay and Lesbian Past*, edited by Martin Duberman, Martha Vicinus, and George Chauncey, 318–31. New York: New American Library, 1989.

Garber, Marjorie. *Vested Interests: Cross-Dressing and Cultural Anxiety.* New York: Routledge, 1992.

Garceau, Dee. "Nomads, Bunkies, Cross-Dressers, and Family Men: Cowboy Identity and the Gendering of Ranch Work." In *Across the Great Divide: Cultures of Manhood in the American West*, edited by Matthew Basso, Laura McCall, and Dee Garceau, 149–68. New York: Routledge, 2001.

Garcia, Kelsey. "Elliott Sailors Tells Us about Her Emotional Transition from Working as a Female to a Male Model." *Elle*, October 29, 2013. http://www.elle.com/news/culture/elliott-sailors-model-interview.

Gibbon, Edward. *The History of the Decline and Fall of the Roman Empire.* 6 vols. 1776–1789. London: Electric Book Co., 2001.

Gilbert, Susan M. "Costumes of the Mind: Transvestism as Metaphor in Modern Literature." *Critical Inquiry* 7, no. 2 (1980): 391–417.

Gilbert, Sandra, and Susan Gubar. *No Man's Land: The Place of the Woman Writer in the Twentieth Century*, vol. 2, *Sexchanges.* New Haven: Yale University Press, 1988.

Gilman, Charlotte Perkins. "Bee Wise (1913)." In Gilman, *Herland, The Yellow Wall-Paper, and Selected Writings*, 263–71. New York: Penguin Books, 1999.

————. *Women and Economics: A Study of the Economic Relation between Men and Women as a Factor in Social Evolution.* Boston: Small, Maynard, & Company, 1898.

Gladysz, Thomas. "*Pandora's Box*, 1929." Essay written for the San Francisco Silent Film Festival, July 2012. http://www.silentfilm.org/archive/pandoras-box-2012.

————. "*Wings*, 1927." Essay written for the San Francisco Silent Film Festival, July 2012. http://silentfilm.org/archive/wings-2012.

Goldsmith, Margaret. *Christina of Sweden: A Psychological Biography.* London: Arthur Barker Ltd., 1933.

Graham, Thomas. "Flagler's Magnificent Hotel Ponce de Leon." *Florida Historical Quarterly* 54, no. 1 (1975): 1–17. doi:10.2307/30155893.

Greenwald, Helen M. "Realism on the Opera Stage: Belasco, Puccini, and the California Sunset." In *Opera in Context: Essays on Historical Staging from the Late Renaissance to the Time of Puccini*, edited by Mark A. Radice, 279–96. Portland, OR: Amadeus Press, 1998.

Gregg, Ronald. "Gay Culture, Studio Publicity, and the Management of Star Discourse: The Homosexualization of William Haines in Pre-Code Hollywood." *Quarterly Review of Film and Video* 20, no. 2 (2003): 81–97.

Grieveson, Lee. *Policing Cinema: Movies and Censorship in Early-Twentieth-Century America.* Berkeley: University of California Press, 2004.

Gubar, Susan. "Blessings in Disguise: Cross-Dressing as Re-Dressing for Female Modernists." *Massachusetts Review* 22, no. 3 (1981): 477–508.

Gunning, Tom. "The Cinema of Attraction: Early Film, Its Spectator and the Avant-Garde." *Wide Angle* 8, no. 3/4 (1986): 63–70.

————. *D. W. Griffith and the Origins of American Narrative Film: The Early Years at Biograph.* Urbana: University of Illinois Press, 1991.

————. "From the Opium Den to the Theatre of Morality: Moral Discourse and Film Process in Early American Cinema." *Art and Text* 30 (September–November 1988): 30–40.

————. "Heard Over the Phone: *The Lonely Villa* and the De Lorde Tradition of the Terrors of Technology." *Screen* 32, no. 2 (1991): 184–96. doi:10.1093/screen/32.2.184.

————. "*The House with Closed Shutters*." In *The Griffith Project*, vol. 4, *Films Produced in 1910*, edited by Paolo Cherchi Usai, 141–46. London: British Film Institute, 2000.

Gunter, Archibald Clavering. *A Florida Enchantment.* New York: Home Publishing Company, 1892.

Halberstam, Judith. *Female Masculinity.* Durham, NC: Duke University Press, 1998.

Hall, Radclyffe. *The Well of Loneliness.* 1928. Reprint, New York: Anchor Books, 1990.

Hall, Richard. *Women on the Civil War Battlefront.* Lawrence: University Press of Kansas, 2006.

Hallett, Hilary A. "Based on a True Story: New Western Women and the Birth of Hollywood." *Pacific Historical Review* 80, no. 2 (2011): 177–210.

————. *Go West, Young Women! The Rise of Early Hollywood.* Berkeley: University of California Press, 2013.

Halperin, David M. *How to Do the History of Homosexuality.* Chicago: University of Chicago Press, 2002.

Hamilton, Marybeth. "Mae West Live: *SEX, The Drag*, and 1920s Broadway." *TDR* 36, no. 4 (1992): 82–100. doi:10.2307/1146217.

Hammill, Faye. *Sophistication: A Literary and Cultural History.* Liverpool: Liverpool University Press, 2010.

Hansen, Miriam. *Babel and Babylon: Spectatorship in American Silent Film.* Cambridge, MA: Harvard University Press, 1991.

Hanssen, F. Andrew. "Revenue Sharing and the Coming of Sound." In *Economic History of Film*, edited by Michael Pokorny and John Sedgwick, 86–120. New York: Routledge, 2004.

Hart, James David. *The Popular Book: A History of America's Literary Taste*. Berkeley: University of California Press, 1950.

Hays, Arthur Garfield. *Let Freedom Ring*. New York: Boni & Liveright, 1928.

Heap, Chad C. *Slumming: Sexual and Racial Encounters in American Nightlife, 1885–1940*. Chicago: University of Chicago Press, 2009.

Horak, Laura. "Cross-Dressing in D. W. Griffith's Biograph Films: Humor, Heroics, and Good Bad Boys." In *The Blackwell Companion to D. W. Griffith*, edited by Charlie Keil. West Sussex, U.K.: Wiley-Blackwell, forthcoming.

———. "Queer Crossings: Greta Garbo, National Identity, and Gender Deviance." In *Silent Cinema and the Politics of Space*, edited by Jennifer M. Bean, Anupama Kapse, and Laura Horak, 270–94. Bloomington: Indiana University Press, 2014.

Houchin, John H. *Censorship of the American Theatre in the Twentieth Century*. Cambridge: Cambridge University Press, 2003.

Hurewitz, Daniel. "Banned on Broadway but Coming to a Theater Near You: *The Captive* and Rethinking the Breadth of American Anti-Lesbian Hostility in the 1920s and '30s." *Journal of Lesbian Studies* 17, no. 1 (2013): 40–55.

Inness, Sherrie A. "Mashes, Smashes, Crushes, and Raves: Woman-to-Woman Relationships in Popular Women's College Fiction, 1895–1915." *NWSA Journal* 6, no. 1 (1994): 48–68.

Jacobs, Lea. *The Decline of Sentiment: American Film in the 1920s*. Berkeley: University of California Press, 2008.

———. *The Wages of Sin: Censorship and the Fallen Woman Film, 1928–1942*. Madison: University of Wisconsin Press, 1991.

Jowett, Garth. *Film, the Democratic Art*. Boston: Little, Brown, 1985.

Keil, Charlie, and Shelley Stamp. *American Cinema's Transitional Era: Audiences, Institutions, Practices*. Berkeley: University of California Press, 2004.

King, Rob. *The Fun Factory: The Keystone Film Company and the Emergence of Mass Culture*. Berkeley: University of California Press, 2009.

———. "The Kid from *The Kid*: Jackie Coogan and the Consolidation of Child Consumerism." *Velvet Light Trap*, no. 48 (Fall 2001): 4–19.

———. "'Made for the Masses with an Appeal to the Classes': The Triangle Film Corporation and the Failure of Highbrow Film Culture." *Cinema Journal* 44, no. 2 (2005): 3–33.

Krafft-Ebing, Richard von. *Psychopathia Sexualis, with Especial Reference to the Antipathic Sexual Instinct, a Medico-Forensic Study*. 12th ed. Translated by Francis Joseph Rehman. New York: Rebman Co., 1903.

Lambert, Gavin. *Nazimova: A Biography*. New York: Alfred A. Knopf, 1997.

Landy, Marcia, and Amy Villarejo. *Queen Christina*. London: British Film Institute, 1995.

Latimer, Tirza True. *Women Together/Women Apart: Portraits of Lesbian Paris*. New Brunswick, NJ: Rutgers University Press, 2005.

Leab, Daniel J. *From Sambo to Superspade: The Black Experience in Motion Pictures*. Boston: Houghton Mifflin, 1975.

———. "The Gamut from A to B: The Image of the Black in Pre-1915 Movies." *Political Science Quarterly* 88, no. 1 (1973): 53–70. doi:10.2307/2148648.

Legler, Casey. "I'm a Woman Who Models Men's Clothes. But This Isn't about Gender." *The Guardian*, November 1, 2013. http://www.theguardian.com/commentisfree/2013/nov/01/woman-models-mens-clothes-casey-legler.

Leong, Karen J. "'A Distinct and Antagonistic Race': Constructions of Chinese Manhood in the Exclusionist Debates, 1869–1878." In *Across the Great Divide: Cultures of Manhood in the American West*, edited by Matthew Basso, Laura McCall, and Dee Garceau, 131–48. New York: Routledge, 2001.

Levine, Lawrence. *Highbrow/Lowbrow: The Emergence of Cultural Hierarchy in America.* Cambridge, MA: Harvard University Press, 1988.

Lewis, Jon. *Hollywood v. Hard Core: How the Struggle Over Censorship Saved the Modern Film Industry.* New York: NYU Press, 2000.

Leyda, Jay. *Kino: A History of the Russian and Soviet Film.* London: Allen, 1960.

Lugowski, David M. "Queering the (New) Deal: Lesbian and Gay Representation and the Depression-Era Cultural Politics of Hollywood's Production Code." *Cinema Journal* 38, no. 2 (1999): 3–35.

Lunde, Arne. "'Garbo Talks!': Scandinavians in Hollywood, the Talkie Revolution, and the Crisis of Foreign Voice." In *Screen Culture: History and Textuality*, edited by John Fullerton, 21–40. Bloomington: Indiana University Press, 2004.

Lyly, John. *Gallathea.* London: Printed by John Charlwoode for the widdow Broome, 1592.

MacKay, Anne. *Wolf Girls at Vassar: Lesbian and Gay Experiences 1930–1990.* New York: St. Martin's Press, 1993.

Mahar, Karen Ward. "Working Girls: The Masculinization of American Business in Film and Advice Literature in the 1920s." Paper presented at Women and the Silent Screen V, Stockholm, June 13, 2008.

Maltby, Richard. "'Baby Face,' or How Joe Breen Made Barbara Stanwyck Atone for Causing the Wall Street Crash." *Screen* 27, no. 2 (1986): 22–46. doi:10.1093/screen/27.2.22.

Marcus, Sharon. *Between Women: Friendship, Desire, and Marriage in Victorian England.* Princeton: Princeton University Press, 2007.

———. "Comparative Sapphisms." In *The Literary Channel: The Inter-National Invention of the Novel*, edited by Margaret Cohen and Carolyn Dever, 251–85. Princeton: Princeton University Press, 2002.

Maurice, Alice. "'Cinema at Its Source': Synchronizing Race and Sound in the Early Talkies." *Camera Obscura* 17, no. 1 (2002): 31–62.

Mayer, David. *Stagestruck Filmmaker: D. W. Griffith and the American Theatre.* Iowa City: University of Iowa Press, 2009.

Mayne, Judith. *Directed by Dorothy Arzner.* Bloomington: Indiana University Press, 1994.

McBride, Joseph. *Frank Capra: The Catastrophe of Success.* Jackson: University Press of Mississippi, 2011.

McClintock, Anne. *Imperial Leather: Race, Gender, and Sexuality in the Colonial Contest.* New York: Routledge, 1995.

Mead, Rebecca J. *How the Vote Was Won: Woman Suffrage in the Western United States, 1868–1914.* New York: NYU Press, 2006.

Merrill, Lisa. *When Romeo Was a Woman: Charlotte Cushman and Her Circle of Female Spectators.* Ann Arbor: University of Michigan Press, 1999.

Merritt, Russell. "Nickelodeon Theatres, 1905–1914: Building an Audience for the Movies." In *The American Film Industry*, edited by Tino Balio, 83–102. Madison: University of Wisconsin Press, 1985.

Meyer, Philip. *The Vanishing Newspaper: Saving Journalism in the Information Age.* Columbia: University of Missouri Press, 2009.

Mullenix, Elizabeth Reitz. *Wearing the Breeches: Gender on the Antebellum Stage.* New York: St. Martin's Press, 2000.

Neff, Wanda Fraiken. *We Sing Diana.* Boston and New York: Houghton Mifflin, 1928.

Newton, Esther. "The Mythic Mannish Lesbian: Radclyffe Hall and the New Woman." *Signs* 9, no. 4 (1984): 557–75.

Noriega, Chon. "'Something's Missing Here!': Homosexuality and Film Reviews during the Production Code Era, 1934–1962." *Cinema Journal* 30, no. 1 (1990): 20–41.

Oram, Alison. *Her Husband Was a Woman! Women's Gender-Crossing in Modern British Popular Culture.* London: Routledge, 2007.

Ovid. *Metamorphoses.* Translated by David Raeburn. London: Penguin, 2004.

Paris, Barry. *Garbo: A Biography.* New York: Alfred A. Knopf and Random House, 1995.

Patterson, Martha H., ed. *The American New Woman Revisited: A Reader, 1894–1930.* New Brunswick, NJ: Rutgers University Press, 2008.

Peterson, Jennifer. *Education in the School of Dreams: Travelogues and Early Nonfiction Film.* Durham, NC: Duke University Press, 2013.

———. "'The Nation's First Playground': Travel Films and the American West, 1895–1920." In *Virtual Voyages: Cinema and Travel,* edited by Jeffrey Ruoff, 79–98. Durham, NC: Duke University Press, 2006.

Polenberg, Richard. *Fighting Faiths: The Abrams Case, the Supreme Court, and Free Speech.* Ithaca, NY: Cornell University Press, 1999.

Potter, La Forest. *Strange Loves: A Study in Sexual Abnormalities.* New York: Robert Dodsley Co., 1933.

Potter, Susan Margaret. "Queer Timing: The Emergence of Lesbian Representation in Early Cinema." Ph.D. diss., University of Auckland, 2012.

Prosser, Jay. *Second Skins: The Body Narratives of Transsexuality.* New York: Columbia University Press, 1998.

Rand, Erica. *The Ellis Island Snow Globe.* Durham, NC: Duke University Press, 2005.

Register, Woody. *The Kid of Coney Island: Fred Thompson and the Rise of American Amusements.* Oxford: Oxford University Press, 2001.

Rich, B. Ruby. *Chick Flicks: Theories and Memories of the Feminist Film Movement.* Durham, NC: Duke University Press, 1998.

Richardson, Alan. "Reluctant Lords and Lame Princes: Engendering the Male Child in Nineteenth-Century Juvenile Fiction." *Children's Literature* 21 (1993): 3–19.

Riegel, Robert E. "Women's Clothes and Women's Rights." *American Quarterly* 15, no. 3 (1963): 390–401. doi:10.2307/2711370.

Riviere, Joan. "Womanliness as a Masquerade." *International Journal of Psychoanalysis* 10 (1929): 303–313.

Robertson, Pamela. "'The Kinda Comedy That Imitates Me': Mae West's Identification with the Feminist Camp." *Cinema Journal* 32, no. 2 (1993): 57–72. doi:10.2307/1225605.

Rodger, Gillian M. "Male Impersonation on the North American Variety and Vaudeville Stage, 1868–1930." Ph.D. diss., University of Pittsburgh, 1998.

Rupp, Leila. *Sapphistries: A Global History of Love Between Women.* New York: NYU Press, 2009.

Russo, Vito. *The Celluloid Closet: Homosexuality in the Movies.* New York: Harper & Row, 1981.

Sacher-Masoch, Leopold von. *Venus in Furs.* Translated by Joachim Neugroschel. 1870. Reprint, London: Penguin Classics, 2010.

Sahli, Nancy. "Smashing: Women's Relationships before the Fall." *Chrysalis* 8 (1979): 17–27.

San Francisco Lesbian and Gay History Project. "'She Even Chewed Tobacco': A Pictorial Narrative of Passing Women in America." In *Hidden from History.* New York: Meridian Books, 1990.

Sappho. *The Sappho Companion*. Edited by Margaret Reynolds. London: Chatto & Windus, 2000.

Schmertz, Johanna. "The Leatrice Joy Bob: *The Clinging Vine* and Gender's Cutting Edge." In *Researching Women in Silent Cinema: New Findings and Perspectives*, edited by Monica Dall'Asta, Victoria Harriet Duckett, and Lucia Tralli, 402–13. Bologna: Dipartimento delle Arti—DAR, Alma Mater Studiorum Università di Bologna, 2013.

———. "'Who Dressed A.B. Like a Girl?' Leatrice Joy's Performances of Gender in *The Clinging Vine* (1926)." Paper presented at Women and the Silent Screen VI, Bologna, Italy, June 24, 2010.

Sears, Clare. "All That Glitters: Trans-ing California's Gold Rush Migrations." *GLQ: A Journal of Lesbian and Gay Studies* 14, nos. 2–3 (2008): 383.

———. *Arresting Dress: Cross-Dressing, Law, and Fascination in Nineteenth-Century San Francisco*. Durham, NC: Duke University Press, 2014.

Senelick, Laurence. *The Changing Room: Sex, Drag, and Theatre*. London and New York: Routledge, 2000.

———. "The Evolution of the Male Impersonator on the Nineteenth-Century Popular Stage." *Essays in Theatre* 1, no. 1 (1982): 29–44.

Silverman, Kaja. *The Acoustic Mirror: The Female Voice in Psychoanalysis and Cinema*. Bloomington: Indiana University Press, 1988.

Singer, Ben. *Melodrama and Modernity: Early Sensational Cinema and Its Contexts*. New York: Columbia University Press, 2001.

Slater, Thomas. "Moving the Margins to the Mainstream: June Mathis's Work in American Silent Film." *International Journal of the Humanities* 4, no. 2 (2007): 81–88.

Slide, Anthony. *Selected Film Criticism, 1912–1920*. Metuchen, NJ: Scarecrow Press, 1982.

Slotkin, Richard. *Gunfighter Nation: The Myth of the Frontier in Twentieth-Century America*. New York: Atheneum, 1992.

———. *Regeneration Through Violence: The Mythology of the American Frontier, 1600–1860*. New York: HarperPerennial, 1996.

Smith-Rosenberg, Carroll. *Disorderly Conduct: Visions of Gender in Victorian America*. New York: Alfred A. Knopf, 1985.

———. "The Female World of Love and Ritual: Relations between Women in Nineteenth-Century America." *Signs* 1, no. 1 (1975): 1–29.

Soister, John T., and Henry Nicolella. *American Silent Horror, Science Fiction, and Fantasy Feature Films, 1913–1929*. Jefferson, NC: McFarland, 2012.

Somerville, Siobhan. *Queering the Color Line: Race and the Invention of Homosexuality in American Culture*. Durham, NC: Duke University Press, 2000.

Sova, Dawn B. *Banned Plays: Censorship Histories of 125 Stage Dramas*. New York: Facts on File, 2004.

Spargo, Chris. "Casey Legler, Erika Linder, and Elliott Sailors Are the Hottest New Female, and Male, Models." *NewNowNext*, October 21, 2013. http://www.newnownext.com/casey-legler-erika-linder-elliott-sailors-female-male-models/10/2013/.

Staiger, Janet. *Bad Women: Regulating Sexuality in Early American Cinema*. Minneapolis: University of Minnesota Press, 1995.

Stamp, Shelley. *Lois Weber in Early Hollywood*. Berkeley: University of California Press, 2015.

———. *Movie-Struck Girls: Women and Motion Picture Culture after the Nickelodeon*. Princeton: Princeton University Press, 2000.

Stern, Alexandra. *Eugenic Nation: Faults and Frontiers of Better Breeding in Modern America*. Berkeley: University of California Press, 2005.

Stewart, Jacqueline. *Migrating to the Movies: Cinema and Black Urban Modernity.* Berkeley: University of California Press, 2005.

Straayer, Chris. *Deviant Eyes, Deviant Bodies: Sexual Re-Orientations in Film and Video.* New York: Columbia University Press, 1996.

Studlar, Gaylyn. *This Mad Masquerade: Stardom and Masculinity in the Jazz Age.* New York: Columbia University Press, 1996.

Sullivan, Louis. *From Female to Male: The Life of Jack Bee Garland.* Boston: Alyson Publications, 1990.

Sutton, Katie. *The Masculine Woman in Weimar Germany.* New York: Berghahn Books, 2011.

Taylor, Jessica. "'Speaking Shadows': A History of the Voice in the Transition from Silent to Sound Film in the United States." *Journal of Linguistic Anthropology* 19, no. 1 (2009): 1–20. doi:10.1111/j.1548–1395.2009.01016.x.

Taylor, Leslie A. "'I Made up My Mind to Get It': The American Trial of 'The Well of Loneliness' New York City, 1928–1929." *Journal of the History of Sexuality* 10, no. 2 (2001): 250–86.

Tuite, Patrick B. "'Shadow of [a] Girl': An Examination of Peter Pan in Performance." In *Second Star to the Right: Peter Pan in the Popular Imagination*, edited by Allison Kavey and Lester D. Friedman, 105–31. New Brunswick, NJ: Rutgers University Press, 2009.

Ullman, Sharon. "'The Twentieth Century Way': Female Impersonation and Sexual Practice in Turn-of-the-Century America." *Journal of the History of Sexuality* 5, no. 4 (1995): 573–600.

Uricchio, William, and Roberta Pearson. *Reframing Culture: The Case of the Vitagraph Quality Films.* Princeton: Princeton University Press, 1993.

Vance, Norman. "Decadence and the Subversion of Empire." In *Roman Presences: Receptions of Rome in European Culture, 1789–1945*, edited by Catharine Edwards, 110–24. Cambridge: Cambridge University Press, 1999.

Vasey, Ruth. *The World According to Hollywood, 1918–1939.* Madison: University of Wisconsin Press, 1997.

Verhoeff, Nanna. *The West in Early Cinema: After the Beginning.* Amsterdam: Amsterdam University Press, 2006.

Vicinus, Martha. *Intimate Friends: Women Who Loved Women, 1778–1928.* Chicago and London: University of Chicago Press, 2004.

———. "Turn-of-the-Century Male Impersonation: Rewriting the Romance Plot." In *Sexualities in Victorian Britain*, edited by Andrew H. Miller and James Eli Adams, 187–213. Bloomington: Indiana University Press, 1996.

Viertel, Salka. *The Kindness of Strangers.* New York: Holt, Rinehart and Winston, 1969.

Wagner, Kristen Anderson. "'Comic Venus': Women and Comedy in American Silent Film." PhD diss., University of Southern California, 2009.

Walker, Alexander. *Garbo: A Portrait.* New York: Macmillan, 1980.

Walker, Lisa. *Looking Like What You Are: Sexual Style, Race, and Lesbian Identity.* New York: NYU Press, 2001.

Waters, Sarah. "'A Girton Girl on a Throne': Queen Christina and Versions of Lesbianism, 1906–1933." *Feminist Review* 46, no. 1 (1994): 41–60.

Weiss, Andrea. *Paris Was a Woman: Portraits from the Left Bank.* San Francisco: Harper San Francisco, 1995.

———. *Vampires and Violets: Lesbians in Film.* New York: Penguin Books, 1993.

What Shocked the Censors! A Complete Record of Cuts in Motion Picture Films Ordered by the New York State Censors from January, 1932 to March, 1933. New York: National Council on Freedom from Censorship, 1933.

Wheelwright, Julie. *Amazons and Military Maids: Women Who Dressed as Men in the Pursuit of Life, Liberty and Happiness.* London: Pandora, 1989.

White, Patricia. "Black and White: Mercedes de Acosta's Glorious Enthusiasms." *Camera Obscura* 15, no. 3 (2000): 227.

———. *Uninvited: Classical Hollywood Cinema and Lesbian Representability.* Bloomington: Indiana University Press, 1999.

Williams, Linda. *Screening Sex.* Durham, NC: Duke University Press, 2008.

Williams, R. Ewart. "Film for Women Made by Women." *Film Pictorial*, March 6, 1937.

Wilson, Anna. "Little Lord Fauntleroy: The Darling of Mothers and the Abomination of a Generation." *American Literary History* 8, no. 2 (1996): 232.

Wittern-Keller, Laura. *Freedom of the Screen: Legal Challenges to State Film Censorship, 1915–1981.* Lexington: University Press of Kentucky, 2008.

INDEX

Page numbers in italic indicate photographs.

ABOUT THE AUTHOR

LAURA HORAK is an assistant professor of film studies at Carleton University. *Silent Cinema and the Politics of Space*, an anthology she coedited, won Best Edited Collection from the Society of Cinema and Media Studies. Her work has appeared in *Cinema Journal, Camera Obscura, Transgender Studies Quarterly, Journal of Scandinavian Cinema*, and *Film Quarterly*.